POP SCULPTURE

BY TIM BRUCKNER, ZACH OAT, AND RUBÉN PROCOPIO

SCULPTING AND PHOTOS BY TIM BRUCKNER
ILLUSTRATIONS BY RUBÉN PROCOPIO

SCU

POP SCULPTURE

HOW TO CREATE ACTION FIGURES AND COLLECTIBLE STATUES

Watson-Guptill Publications / New York

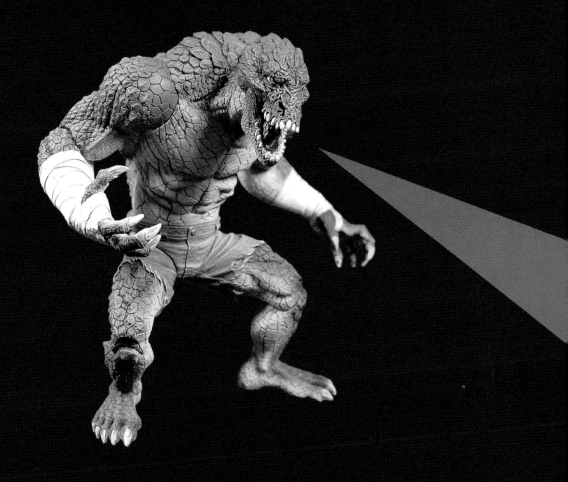

Published in 2010 by Watson-Guptill Publications,
an imprint of Crown Publishing, a division of Random House, Inc. New York.
www.crownpublishing.com
www.watsonguptill.com
WATSON-GUPTILL is a registered trademark and the WG and Horse designs
are trademarks of Random House, Inc.

Library of Congress Cataloging-in-Publication Data

Bruckner, Tim.
 Pop sculpture : how to create action figures & collectible statues / by Tim
Bruckner, Zach Oat, and Rubén Procopio ; sculpting and photos by Tim Bruck-
ner ; illustrations by Rubén Procopio.
 p. cm.
 Includes bibliographical references and index.
 ISBN 978-0-8230-9522-3 (alk. paper)
 1. Modeling. 2. Action figures (Toys) I. Oat, Zach. II. Procopio, Rubén. III.
Title. IV. Title: How to create your own action figures and collectable statues.
 TT916.B78 2010
 731.4'2--dc22

 2009049288

This book contains general instructions and techniques on making sculptures
and action figures. When working with the tools and materials presented in
this book, readers are strongly cautioned to use proper care and judgment, to
follow the applicable manufacturer's directions, and to seek prompt medical
attention in case of an injury. In addition, readers are advised to keep all po-
tentially harmful materials away from children. The author and the publisher
expressly disclaim any liability, loss, or risk, personal or otherwise, which is
incurred as a consequence, directly or indirectly, of the use and application of
any of the contents of this book.

DESIGN BY DOMINIKA DMYTROWSKI
Printed in China
First printing, 2010

1 2 3 4 5 6 7 8 9 / 18 17 16 15 14 13 12 11 10

To M.H.B. Always and forever.
TIM

To Melissa and Hazel,
for constantly reminding me what's
important.
ZACH

To the most important people in life:
my parents, Lidia and Adolfo Procopio,
my sister, Vivian, and fiancée, Jeanne.
RUBÉN

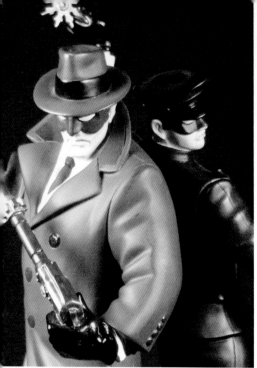

GREEN HORNET © GREEN HORNET, INC. JADE™ © DC COMICS THE VICAR © ALTERTON

SUPERMAN™ © DC COMICS

BLACK CANARY™ © DC COMICS

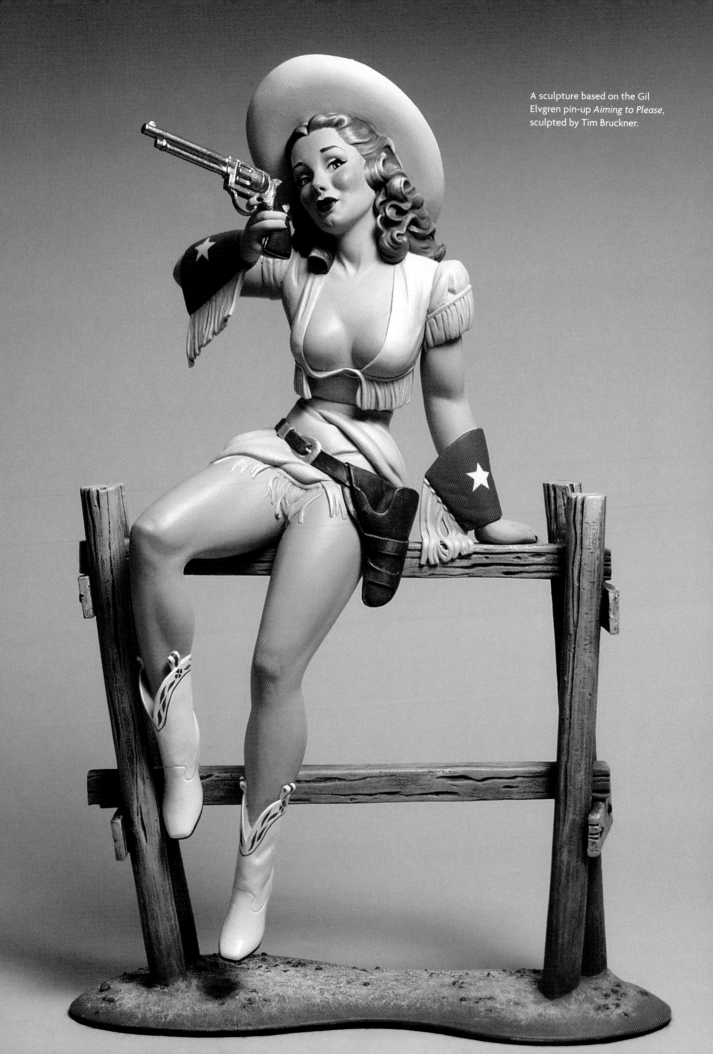

A sculpture based on the Gil Elvgren pin-up *Aiming to Please*, sculpted by Tim Bruckner.

FOREWORD

I'm an inveterate collector. There, I've said it! My collecting started in childhood and has continued as an active passion for these many years.

Back in the day, comic books and toys of cowboys, Indians, and soldiers were central to my interest. With time, I combined my enthusiasms and began to focus on the acquisition of comic strip figurines and statues.

A lot of the stuff that I have dates back to the 1920s and '30s and is made from bisque or porcelain. These pieces represent the more difficult to find and, consequently, the more valuable items that I own. (It should be noted, lest the impression be given that I have armed guards patrolling my display cases, that I also have a rather large number of PVC figurines of comics characters that I'm sure today's five- and six-year-olds possess, as well.)

It so happened that when the Star Trek TV series was cancelled, I was heavily into collecting comic strip characters made of plaster. Since they generally came with only a base coat, and since I suddenly had a lot of time on my hands, I discovered a small talent for working with No. 525 camel-hair brushes and flat-finish model paints. And, oh yes, though it pains me to speak so immodestly, I do confess to having a shelf dedicated to all the Chekov figures from Star Trek and Bester figures from Babylon 5 that were ever produced (to my knowledge).

But more recently, modern companies like Electric Tiki and Dark Horse have begun offering sculptures of some of my favorite old Golden Age characters—like the Phantom, the Spirit, Dick Tracy, and the Green Hornet—that I find irresistible, and they are now in my collection, too. Many of them are sculpted by Rubén

Walter Koenig.

and Tim, whose work you will see in these pages. I have a soft spot for the more esoteric portrayals, so I especially love that these companies are producing characters that no one has thought to make figures of before, like the Alice the Goon from Popeye or Officer Pupp from Krazy Kat. I recently found a bronze statue of the Yellow Kid, the first American color comic strip character, by Bowen Designs, and the detail and the thought put into it are extraordinary.

I like figures that are approached creatively—a hero standing there with his hands on his hips doesn't do anything for me—and this is where sculptors like Rubén and Tim excel. Time and again, the images they produce are executed with such intelligence and craft that I do not exaggerate to say that I consider them works of art.

Now, my collection has gotten so big that I've actually added a second floor to my house just to display everything. I find it very peaceful to go upstairs, sit back in my chair, throw my legs up on my computer desk, fold my hands in my lap and gaze out at the nostalgia-invoking vista before me. Flash Gordon, Alley Oop, Smokey Stover, Mandrake the Magician—all are a testimony to the less complicated, less stressful time of childhood, when there were sure answers for everything and a lot of laughs to boot.

Walter Koenig
ACTOR, WRITER, AND DIRECTOR

INTRODUCTION

We can think of a dozen reasons you might have picked up this book. Maybe you're an aspiring sculptor, ready to learn the techniques that you'll need to be able to create action figures and collectable statues. Or maybe you're an established professional who's hoping to learn a few new tricks. Perhaps you're a collector, intrigued by the behind-the-scenes stories of those fascinating figures on your shelves. Or maybe you're one of our long-suffering relatives, and you only bought this book to make us feel better. (Thanks, Uncle Albert and Auntie Gin.)

What you'll find in this book are different ways of creating three-dimensional objects for reproduction, focusing on our preferred regimen of classic sculpting techniques. We don't claim that it's the definitive way, or the way you should approach it, but it's a means to an end, and hopefully it will answer some of your questions and spark a new way of looking at this field, be you pro, fan, novice, or cousin Tommy.

Even on Easter Island, there are aspiring toy sculptors.

A Brief History of Pop Sculpture

If you're a fan or novice, then you may not realize that action figures and collectable statues are merely the latest playground of a rich tradition of sculptural arts dating back to the Dawn of Man. Since the first time a human grabbed some mud or clay and gave it shape and form, sculpture has fascinated people. Beginning with small totems and idols, and eventually moving into life-size statues of people (and even bigger statues of gods, demigods, and politicians), replicating nature and forging imagination in three dimensions has long been a part of our global culture, be it Michelangelo's *David*, the moai of Easter Island, or that giant statue of Paul Bunyan. Through sculpture, myths became real, and real people were made a heck of a lot more mythical.

Mass production, which began at the turn of the 20th Century, was a game-changer. Suddenly, these little sculpted figures didn't have to be carved one by one out of wood or stone or plaster; they could be poured into molds and taken off an assembly line hundreds at a time. Wooden soldiers gave way to lead ones, fabric dolls were soon made of porcelain, and Cracker Jack boxes poured out whistles, compasses, and decoder rings. There were still idols, but they were a different kind of idol: the heroes of radio and television, worshipped by their young audiences who clamored to dress like them, and, eventually, to own tiny versions of them. Static Syroco statues captured these characters in molded wood fibers until plastic came along, bringing with it Soaky bottles and Aurora model kits, which managed to somehow be fun, despite being full of soap and a lot of work, respectively.

Then, in the 1960s, came the action figure. Not to be mistaken for dolls—or referred to as "dolls" in any way, shape or form, thank you—12-inch action figures took toy soldiers to a whole

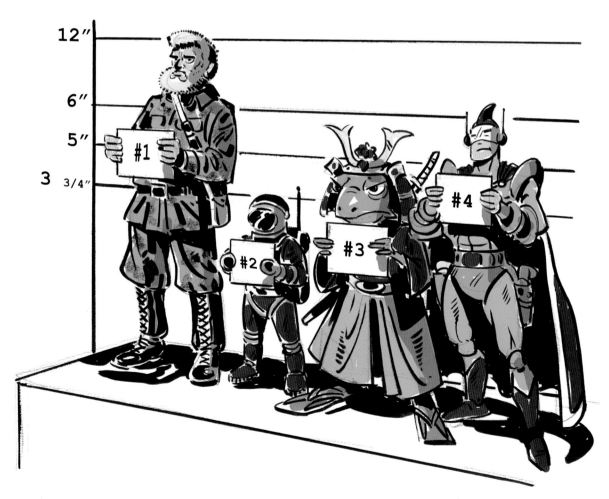

The usual suspects: the four most common action figure heights.

new level by articulating them. G.I. Joe was the first (in 1964), with his scar and inverted thumbnail, and Captain Action came soon after. The Captain first brought pop-culture icons to action figures, with various interchangeable outfits that allowed him to dress up as Batman, Spider-Man, the Phantom, and Dick Tracy. Superheroes would eventually get their own figures, thanks to Mego's smaller (and more affordable) World's Greatest Super-Heroes line, as would characters from television shows like *The Dukes of Hazzard* and *Starsky & Hutch*.

Then, in 1977, Kenner rolled the dice on a sci-fi movie called *Star Wars*, creating fully sculpted 3¾-inch figures that could sit in various-size vehicles, and the game changed. The line did gangbusters, movie licenses became a multi-million-dollar affair, and the height of *Star Wars* toys became a new standard for action figures. Countless imitators sprang up, and even G.I. Joe

was shrunk to that size with great success. When superhero toys returned to prominence in the 1980s, they were made in the larger 5- to 6-inch range, which allowed for more artistry, even the ability to emulate the styles of different comic book artists. All four scales (3¾ inches, 5 inches, 6 inches, and 12 inches) still exist side by side on toy store shelves.

Collectable statues are a slightly more sophisticated—and more expensive—way to display your affection for a character. Picking up where Syroco statues left off, these posed, prepainted sculptures can range in size from six inches up to two feet, and are made of resin or porcelain, not injected plastic. They come in a variety of types, including full-body representations and waist-up portraits called "busts," and they can represent multiple characters as well as partial environments. This makes them ideal for re-creating specific scenes from movies and comic books. Some

DICK TRACY © CHICAGO TRIBUNE

Soaky shampoo bottle of Dick Tracy from 1965.

CAPTAIN ACTION © CA ENTERPRISES

The Aurora model kit of Captain Action from 1968.

of the larger pieces are mixed-media sculptures, incorporating fabric and other materials to create the look of real clothing and accessories.

Today **action figures** exist for nearly anything and anyone you can think of: TV stars, sports stars, rock stars…even public figures like the President. Unfortunately, action figures are often held up as crass commercialism of the highest degree and artistic integrity going out the window. To many, action figures are not art, they're a commodity. We beg to differ.

The action figure may not be a sculpture by Rodin or Michelangelo, but as much artistry goes into them as most works of "fine" art. Yes, most action figures and statues are based on pop culture figures—superheroes and monsters, robots, and TV actors—but that doesn't mean they can't be beautiful to look at, and even express emotion.

LASSIE © CLASSIC MED A

A 1976 action figure of Lassie by Gabriel IND.

BATMAN™ © DC COMICS

Batcycle model kit by Aurora from 1967 (reissued by Polar Lights).

Luckily, with sci-fi, fantasy, and superhero movies and TV shows enjoying an upswing in popularity, it seems like the audience for action figures and statues is constantly growing. Action figures now take up several aisles at Toys"R"Us, and Target and Wal-Mart regularly request exclusive products for their own toy departments. For the more niche properties, much of their merchandise is sold directly to the nation's thousands of comic book shops, and some toys never even see the inside of a real store. Online retailers have been known to sell out of exclusive products in a matter of hours, and the number of toys sold on eBay alone boggles the mind, not to mention the wallet.

Statistically, it's hard to pinpoint how much product is sold annually, but the U.S. market for action figures and accessories alone represented $1.3 billion in sales several years ago. That's a lot of sculpting that needs to be done. Major toy companies continue to employ in-house sculptors, but a lot of the smaller ones don't, and e-mail and rapid shipping methods allow independent contractors to compete for a lot of high-profile work.

The number of sculptors in the U.S. is relatively small compared to the average profession, but there's always room for a fresh talent to make a name for him- or herself.

With the Internet, collectable toys have reached new heights of popularity.

About This Book

This book will walk you through the process of creating action figures and collectable statues from start to finish. To illustrate the process, we'll show you how we created our own interpretations of two characters out of mythology: the Greek goddess Athena (our statue) and the Norse god Thor (our action figure). Our approach is not so much to teach you how to make Athena and Thor per se (although you certainly can), but to apply the strategies and techniques we used in making them to the creation of your own statues and action figures. Starting with the concept and design, we'll take you through the various steps involved in the actual sculpting of both figures, as well as molding, casting, painting, and photographing your work. We'll teach you to employ both conventional approaches as well as our own personal but practical methods, based on years of on-the-job experience. Throughout the book, luminaries of the pop sculpture world offer their insights, special techniques, and tips for successful sculpting.

Whether you're creating a work of your own or, as hands-for-hire, producing work to be mass-produced you'll need to

know how each step impacts the step that follows. A small mistake in your design can domino all the way down to your finished sculpt. Can you say, "bummer"? So you'll notice that we "time travel" a bit in the instructions using our exclusive Future-Looking Glasses. (For example, in Chapter 3, when we tell you how to make your rough sculpt, we also talk about concerns that arise in Chapters 4 through 9, because you'll need to take those issues into consideration in your rough.)

Each chapter in the book covers a stage of the creation process. Chapters 1 through 8 take you through the eight stages of creating a statue (using our Athena as an example). Chapter 9 (using our Thor as an example) shows you how to articulate a figure using the same process covered in Chapters 1 through 8. Chapters 10, 11, and 12 provide you with essential information on how to paint your figure and then take photographs of it, and on how to become a professional pop sculptor and get paid for what you love to do.

The Stages of Creating Pop Sculpture

Here is how the sculpting process usually flows once you have your design and art references. We've noted the points at which you need client (AD—Art Director) approvals:

- Receive control art, review manufacturing methods
- Build an armature and create a rough clay sculpture of the figure—AD Approval Needed
- Determine where to cut the sculpture into parts for reproduction and cut into those parts
- Create RTV waste molds of the clay parts
- Cast the parts in wax
- Refine and finish master wax—AD Approval Needed
- Create new RTV molds from the wax parts
- Cast the parts in resin
- Refine and finish the resin parts
- Prime and paint all parts
- Assemble painted parts into final figure—AD Approval Needed
- Photograph finished sculpture

If you haven't already decided to, we hope you'll join the three of us (and Sculp-Tor, the super-sculptor) on the journey that has been a big part of our lives and brought us a lot of joy and fulfillment.

Tim, Zach, & Rubén

Look for Sculp-Tor to pop up occasionally and provide additional details and anecdotes.

1. Art, Reference, & Design

HOW TO CREATE THE ARTWORK THAT WILL GUIDE YOUR SCULPTURE AND GIVE IT LIFE

2-D or not 2-D...that is a question, by the way. Inspiration for a sculpture can come from everyplace and anyplace. But a lot of it will come in the form of a two-dimensional image, be it an illustration, painting, photograph, or panel from a comic book. Not every piece of 2-D art will make a good sculpture. In this chapter we'll tell you how to choose your art reference and how to use it to inform your choices as you plan and design your figure.

The Joy of Specs: Putting Together Your Reference Art

Before you can begin putting together your collection of reference artwork, you'll need to know the specifics of your project. What size will it be? What will it be made of? What does this sculpture need to do? What's it for? How will it be used? Creating a one-of-a-kind work of art is going to be different than sculpting a piece that will become a limited-edition, prepainted statue, or an action figure that will be mass-produced. Sculpting for a resin piece will require different considerations than sculpting for a porcelain or ceramic one. Being aware of the production material's limitations and production methods will help guide you toward creating a successful piece.

A 2-D character comes to life in 3-D.

BODY OF REFERENCE

Unless you're sculpting a piece of your own original design that takes place in a world of your own creation where none of the physical laws of Earth apply, research is an integral part of beginning any statue. The better your reference, the better the outcome. As a hands-for-hire sculptor, you'll be creating a piece to an **art director's** (AD) or **product manager's** (PM) (depending on the company) exacting specifications, and what they give you for references will vary. In a perfect world, you'll be given a set of

turn-around drawings. They are what the name implies—a set of drawings of the figure as it would appear as it turned on a lazy Susan, showing multiple views of the figure. Four drawings is common; eight is magnificent. In an even more perfect world, you'll get detail views that show close-ups of the facial expression, costume details, and bits and pieces not readily visible in the turn-around. This rarely happens, and when it does, be aware that the 2-D artist may not be used to thinking in three dimensions, so character details may not line up from view to view.

Here's an example of a cartoony turn-around drawing, similar to what you might get from an AD or even create yourself.

This fantasy turn-around drawing is another example that could come from the client or be created by you.

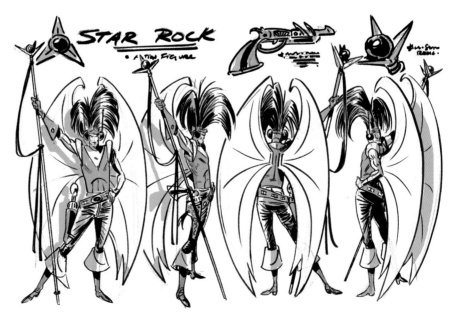

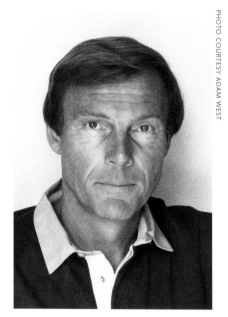

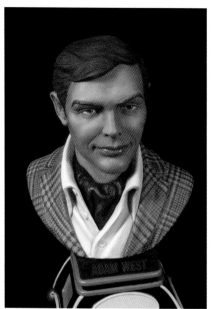

LEFT: The photographic reference art of actor Adam West was used for a photorealistic bust designed and sculpted by Rubén Procopio for Masked Avenger Studio.

BELOW: Tracy Mark Lee created the reference for the statue of his character, *Holly Starlite,* sculpted by Tim Bruckner for Electric Tiki.

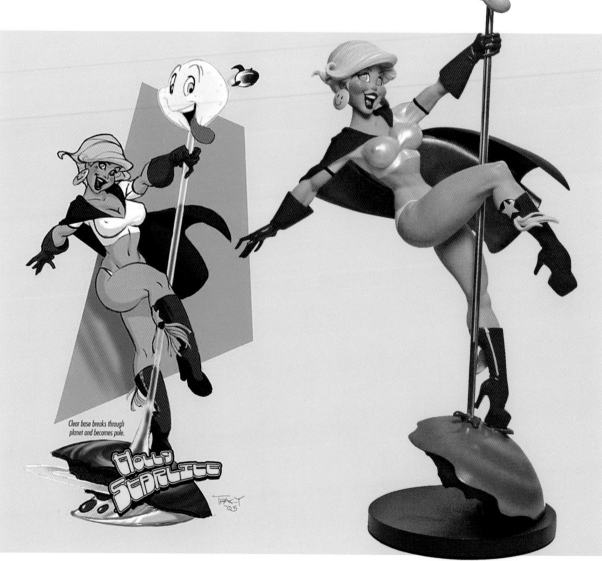

Even at this earliest stage, you should be aware of potential problems that can create difficulties in the manufacturing/production stage, two of the biggest being undercuts and mold locks (see page 20).

Often, all you'll have to work with is a single image (the "money shot") from which you'll need to extrapolate a 3-D figure. But that single comic panel of Superman punching Darkseid in the jaw isn't going to be enough—you'll need that *plus* views of Superman's and Darkseid's heads and outfits from various angles, *plus* a clear shot of the landscape they're standing on. Simply put, one image is never enough.

This is the point when you don your deerstalker hat, fill your meerschaum pipe and become the Sherlock Holmes of Research.

Gather as much support material as you can find, in effect creating your own piecemeal turn-arounds and detail shots. And with the wonder of the Web, finding additional reference is often just a click away. Many search engines (Google, Yahoo, etc.) have a tab called "Images"; this is a direct link to images without text. At a glance you can quickly and efficiently find anything and everything without searching through websites. (Although you may also want to look up an official site or fansite for your character; they often have galleries.)

It helps to remember, especially when sculpting an iconic character, that there's someone out there who knows this character inside and out—probably better than you ever will—and that's the person you're sculpting for. Putting yourself inside the mind of a fan really helps you see the piece from his or her perspective. Dig into the character's history, its development, and various characterizations that will give you a deeper appreciation of why it's a cultural icon. The deeper you dig, the more likely you are to unearth a few jewels of information that will help inform and add depth to your piece.

Of course, as great as the Internet is, there's something to be said for a good old-fashioned book. Build your own library at home with books on anatomy for artists, animals, and master sculptors from the past; technique books like the one you're holding in your hand; and general art books. You'll find that you will refer to them often and that they're a great source of inspiration.

Also, try to find previously sculpted versions of the character; you'll be able to see how another sculptor came up with a solution for certain design elements. In designing our Athena statue, Rubén compiled a couple of hundred images of the goddess as she's been represented throughout history.

"Elementary, my dear Watson."

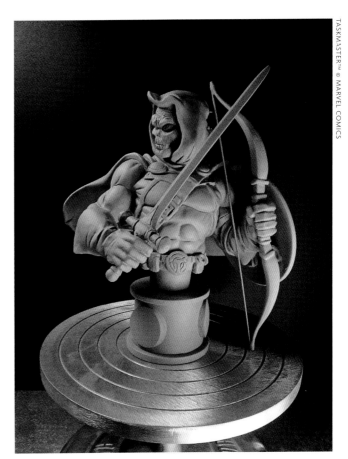

TASKMASTER™ © MARVEL COMICS

Taskmaster bust, sculpted by Rubén Procopio for Bowen Designs.

SCULP-TOR SEZ: AN UPPERCUT TO UNDERCUTS AND MOLD LOCKS

When designing your figure, be aware of two problems that can arise in the manufacturing stage: undercuts and mold locks.

An *undercut* is a recessed area of a sculpture that impedes a mold from being removed in a clean, perpendicular motion. Undercuts used to be the bane of a hands-for-hire sculptor; the traditional solution was to make sure that every recess was sculpted at a 5-degree draft angle. This would guarantee an easy and reliable removal. But with modern methods of manufacturing and more flexible materials, undercuts aren't the problem they used to be. Still, it's important to know how to deal with them in case you encounter them.

When evaluating your design, consider how to artfully fill in any deep recess to prevent a mold-locking problem. A *mold lock* is created when part of your mold is locked into a recess in your sculpture and you can't get it out. Say your character

Undercuts like the crook of an arm are not the problem they once were.

is screaming with his mouth open wide. The space inside his mouth is larger than the opening created by the lips. In a mold with a recess like that, the mold section inside of the mouth is too big to be pulled out past the teeth.

A simple way to avoid this is not to sculpt too deep a cavity inside the mouth—just make a shallow recess that runs directly from the back of the teeth to form a soft U. But, if you need that detail, an easy alternative is to design the jaw as a separate piece from the rest of the head that will plug into position in a clever, discreet way. You can get in there and sculpt the back of the teeth, the palate, the tongue; you can even sculpt that little dingily thing at the back of the throat. The mouth is just one example; in many cases, casting a separate piece will solve the problem.

Avoiding mold lock by way of the two-part jaw.

Now, you may not use half of the reference material that you collect, but it's better to be overprepared and use up some printer ink than to be underprepared and vulnerable to an endless stream of e-mails from disgruntled fans, asking how you could have missed the hankie in Two-Face's blazer pocket. There's nothing worse than being in the middle of sculpting and realizing you're missing a piece of reference, and that you have to stop working and get on the computer. Still, that's preferable to engaging in guesswork.

However, it should be noted that once you start incorporating images of a character from multiple sources, you'll find that not all of your images match up. Details change between scenes in movies, and artists don't always draw their characters the same way from every angle. *Always go with the preponderance of evidence.* If multiple artists do the same thing repeatedly, go with that as opposed to trying to reconcile that one panel where Wolverine's mask seems to shoot out like a pair of antlers from the sides of his head.

TIM IN A BOTTLE: FORMIN' NORMAN

I've always loved the work of Norman Rockwell. The guy was a remarkable storyteller, in addition to being a brilliant painter. When I was getting ready to sculpt the first set of A Christmas Carol busts, I spent a couple of weeks in the evenings after work going through my various Rockwell books for inspiration. There's nothing wasted in a Rockwell illustration; nothing that shouldn't be there and nothing that can be removed without diminishing the story. In designing Tiny Tim, I was liberally inspired by Rockwell's work. Everything from the size of his ears and teeth to his mismatched gloves was a direct response to those weeks of study.

Tim's Rockwellian sculpt of Tiny Tim from *A Christmas Carol.*

DRAWING IT OUT

We've been talking a lot about art, but we haven't really talked about drawing. Drawing is a great tool for the sculptor's toolbox, and can be particularly helpful if turn-arounds aren't forthcoming from your art director. But not everybody knows how to draw, and that's okay.

There are great sculptors who can't draw a straight line to save their lives. Even if you can't draw the sticks for a stick figure, putting pencil to paper is helpful in preparing 2-D art for translation to 3-D and can even help bring a new perspective to your sculpting.

Hey, don't knock stick figures. Zach's crude drawings of Athena still manage to convey the basic pose.

By creating even rough sketches of alternative views, you're bound to discover something about the piece you might not have without drawing. Sketching also helps you visualize in 3-D by understanding how depth is dealt with in a 2-D world.

If you're designing your own piece, drawing can help you figure out your upcoming sculpture's composition. Many of the principles described in this chapter apply to both sculpting *and* drawing—in fact, you'll find over time that they share a number of common principles, such as silhouette and line of action.

If you're actually pretty good with a pencil and paper, create detailed drawings to help you get to know your character's proportions better and visualize your sculpture's composition. They can also be used as a kind of blueprint when it comes to building your armature (see page 78).

Some of Rubén's early designs for Athena.

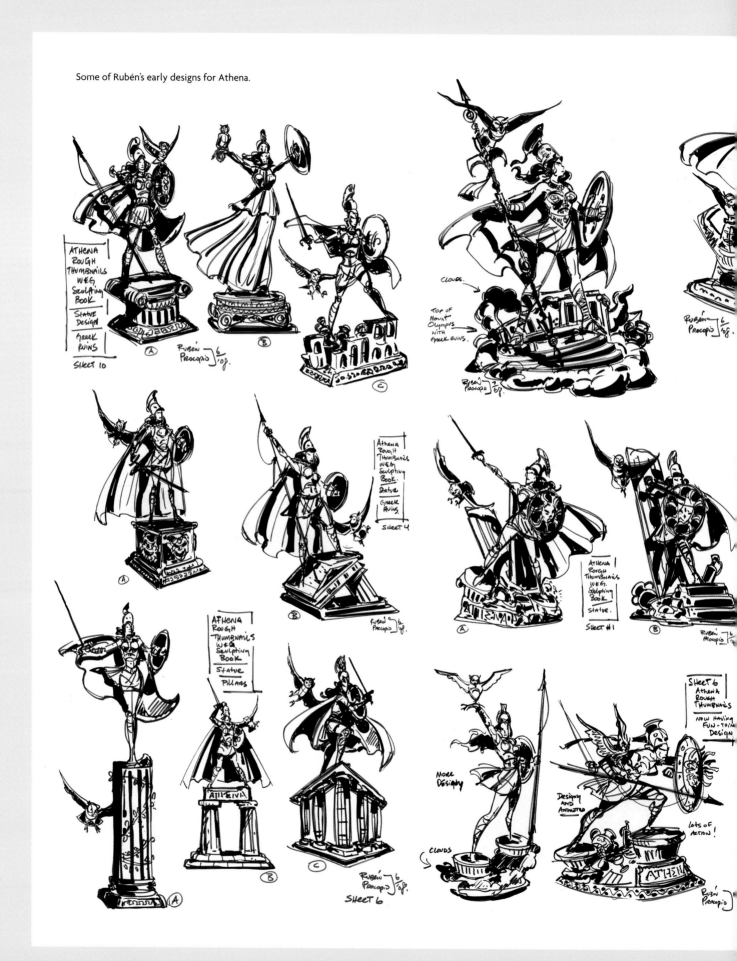

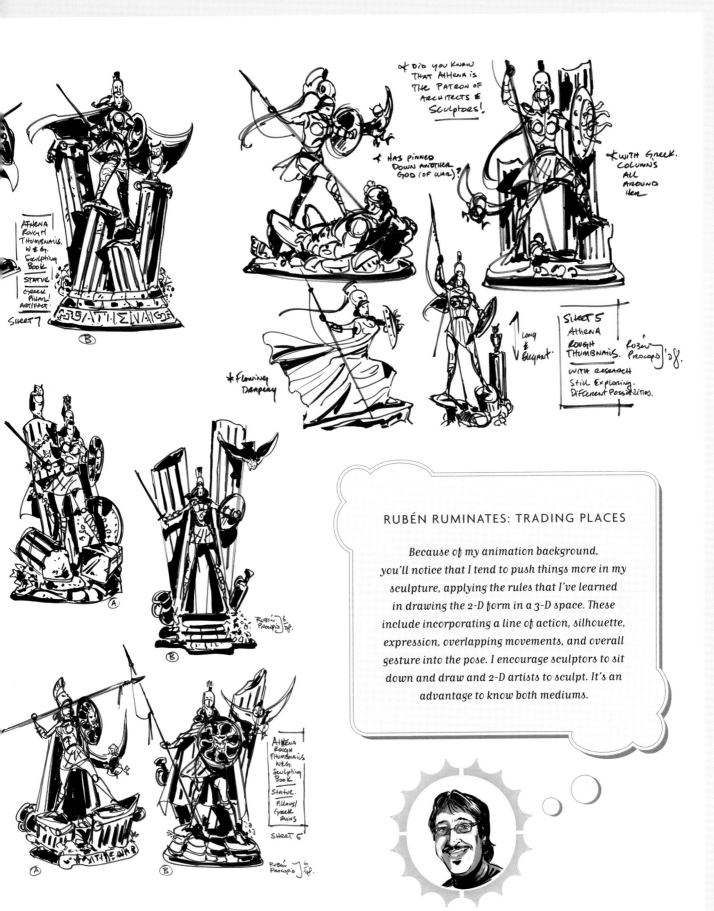

RUBÉN RUMINATES: TRADING PLACES

Because of my animation background, you'll notice that I tend to push things more in my sculpture, applying the rules that I've learned in drawing the 2-D form in a 3-D space. These include incorporating a line of action, silhouette, expression, overlapping movements, and overall gesture into the pose. I encourage sculptors to sit down and draw and 2-D artists to sculpt. It's an advantage to know both mediums.

COMPOSITION OF POWER: ACHIEVING THE BEST COMPOSITION

Once you know that your design is practical, see how it holds up from various angles. Use an action figure or a wooden artist's model (which range from 4 inches to 6 feet tall) to re-create the pose you want to capture. That way, you can rotate a pose you've only seen in two dimensions to see what it looks like from all sides, trying to figure out what the problem areas are and how they can be fixed. A 3-D artist has to consider how his or her work will be viewed from every angle, while still preserving the money shot.

If you're hands-for-hire, you might think the figure needs some slight changes to make the figure look and work better, but even small changes may be difficult to implement, especially if some of what you suggest deviates a little from the all-important money shot. Still, it doesn't hurt to make suggestions—you're probably going to invest much more time creating this piece than your AD will be able to spend reviewing it, and as a good collaborator you'll want to bring as much as you can to the table. The worst the client can say is, "No thanks." But your observations give him or her the opportunity to take a second look, and sometimes that's all it takes.

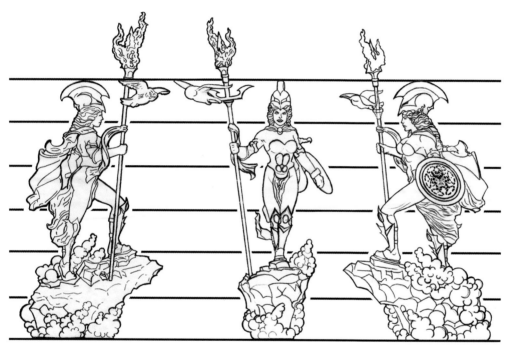

Athena turn-arounds by Anne Bruckner.

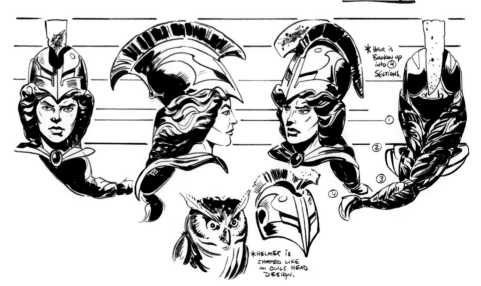

Athena head detail by Rubén.

Here are a few things to keep in mind when assessing your composition.

TELLING A STORY: Some of the finest statues are the ones that describe a scene, even if there's only one character present. Looking at a piece, you should be able to know what happened before this moment, what's happening now, and what will happen next. Take this scene, for example:

A guy's in a fight, say in a saloon. You can tell he's been fighting because his eye is starting to swell up and there's a cut on his cheek and his knuckles are raw. There's no gun in his holster. Must have lost it somewhere in the scuffle. On the table in front of him we see two hands of cards laid face up. The hand on the far side of the table shows four aces. The hand nearest him shows two. By his body gesture, we can see he's just thrown a punch and has taken a step back. On the table behind him is a bottle of whiskey. We see his left hand, fingers spread wide, begin to reach behind for the bottle.

From this scenario, we know what has happened, what is happening now, and what is likely to happen next. In other words, tell a story with your piece whenever possible—be the writer/director/producer of your sculpture. Lights, camera, action…it's all about the tale you tell and how well you tell it.

And remember, there's more than one way to tell a tale. Most people are familiar with the Bible story of David, who defeated the Philistine champion Goliath using only a rock and a sling. His story has been told by sculptors many times over the centuries; two of the most famous statues of David are by Michelangelo and Bernini, (see page 26).

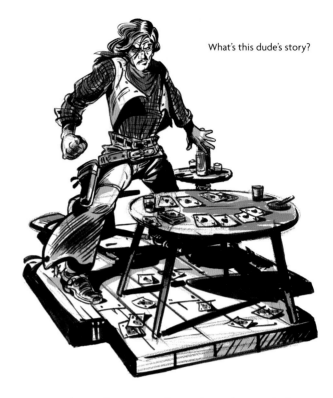

What's this dude's story?

Bernini's David is stepping forward, simultaneously fitting a rock into his sling and preparing to wind up and let fly. Now, there's some debate as to whether Michelangelo's David is posed prebattle or postbattle, but if we look at his body language, with the slight turn of his torso and his advancing right foot, he seems on the verge of the action clearly evidenced in Bernini's piece. The battle is about to begin!

SILHOUETTE AND BALANCE: Trace over the 2-D art of your statue and blacken the interior. Without all the interior detail, does your statue still tell the story you want it to tell?

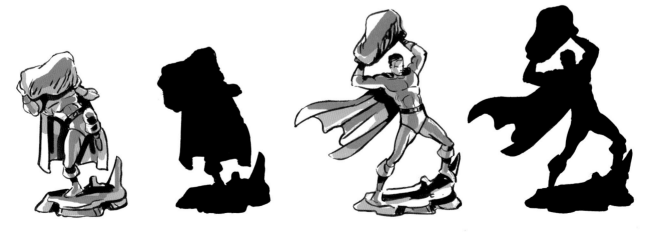

If you can't tell what's going on in silhouette, you may want to revisit your pose.

Does the action read well? If you move an arm or a leg, will it read more clearly?

Doing the silhouette test will also help you to see if the figure is well balanced. Not just in the "Will it fall over?" sense, but in the "Does it look like this figure can actually do the thing you have it doing?" sense—a statue design that's heavy on one side and light on the other can give the statue a feeling of being off-kilter. Try to distribute the mass so the piece feels solid and steady. This isn't to say the piece needs to be symmetrical; if that were the case, we'd only sculpt people waiting for a bus. You can balance a piece by using a combination of negative and positive space. What you don't see often carries as much weight as what you do see. You can also create balance by doing something as simple as breaking up a preponderance of verticals or horizontals.

LINE OF ACTION (FLOW): Just as in viewing a compelling piece of 2-D art, the eye will travel over a piece of sculpture. You can help direct this travel path by the way you construct your shapes and have them relate to each other. The eye looks for continuous lines and follows them where they will go: For example, a character with the left leg extended and the right hand raised with a sword pointing to the sky creates a strong diagonal line the eye will follow. In creating this dynamic, you imbue the figure with energy and intent of action. If the figure is in a more reflective pose, one way to direct the eye is through the way folds in fabric work up through the body to the head.

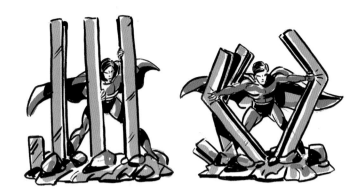

Break up boring verticals.

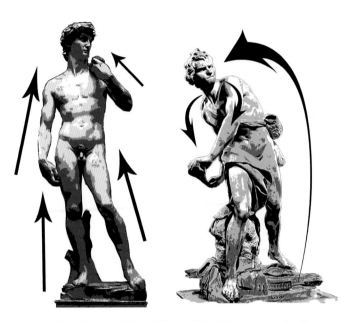

LEFT: Everything about Michelangelo's *David* leads the eye upward to his face. His oversized hands and feet give him a sense of strength. The tree trunk provides structural support for his right leg and sets a context for location. RIGHT: The more dynamic lines of action in Bernini's *David* lead to the expression on his face, then curve down to his ready sling, catching a moment in action.

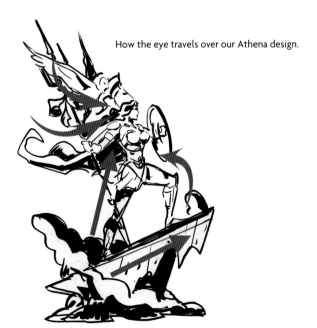

How the eye travels over our Athena design.

Another example of differing approaches to line of action is shown by comparing Michelangelo's and Bernini's *David* sculptures. Michelangelo's David is standing in a reserved, subtly defiant pose, the line of action running straight up his body, directing the eye to his relaxed yet determined face. Bernini's more kinetic pose of David, on the other hand, portrays a moment of midstream action in which David is coiling backward, teeth clenched, brow furrowed, preparing to attack. The line of action curves up David's body and then back down his arms, creating tension as we anticipate the fatal rock being launched.

ANALYZING YOUR 2-D ART WITH A 3-D EYE

Okay, you've got your art and truckload of reference, so now it's time to look at the design with a sculptor's eye…and that doesn't mean simply squinting a lot. What the "sculptor's eye" *really* means is seeing beyond the page to how a piece will work in physical space, where it will be subject to the uncompromising laws of gravity. In looking at a piece of flat art, try to imagine building it in 3-D. If the design for the statue shows a character flying over a rooftop or leaping off a building, your first consideration should be, "How will I support this figure? And how can I misdirect the eye so the point of support isn't obvious?"

This is where a sculptor and a magician have something in common—you know, aside from the cape and the girl in fishnets gesturing as we work. A magician constructs his actions so you see what he wants you to see, and a sculptor tries his or her level best to do the same thing. If a character is flying, leaping, diving, or tumbling, where, other than the toe of his foot, can you create a point of support, or several points of support, if needed? So, in evaluating a design for a statue, your first concerns should be practical.

If a design doesn't work, it doesn't work. Say the art given to you shows a character lifting a planet with the tip of his finger—maybe that works in the gravity-challenged confines of a comic book, but not here, on the physics-dominated planet Earth. As mentioned previously, knowing what a given material will or won't do can really help create a successful piece. If you can foresee a problem, offer a solution. With your input, the piece you've sculpted has a better chance of making it to market as you created it. But if the problem has to be solved by the manufacturer, the piece that is ultimately produced may have very little resemblance to the thing you spent a month of your life working on. And that, my friend, is a bummer all the way around.

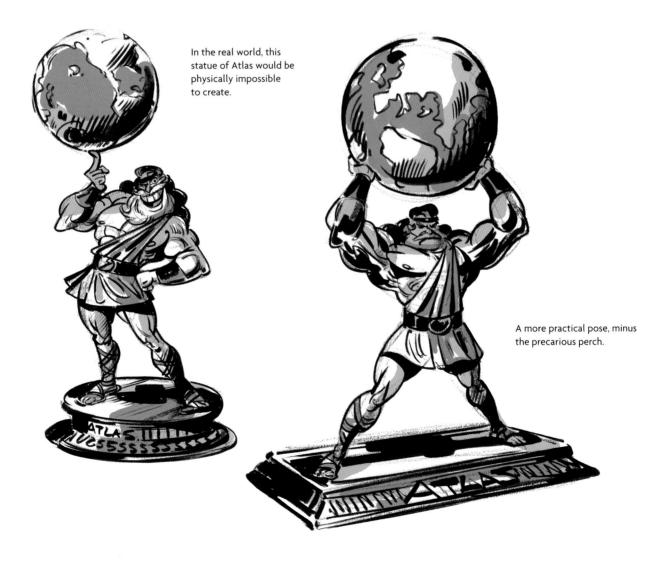

In the real world, this statue of Atlas would be physically impossible to create.

A more practical pose, minus the precarious perch.

TIM IN A BOTTLE: DARE TO DREAM

*I was given a design for a Green Lantern versus Sinestro
statue. They were engaged in a battle amid a massive
amount of stuff that was flying everywhere as they
duked it out. (With all that clutter, the focus of these two
mortal enemies trying to kill each other was lost.) Both
guys were supposed to be airborne, supported
by their feet a yard or so off the ground. I kept thinking,
if they can fly, why not take their fight to the middle
of a wide-open sky? I had an idea about how to do it
and talked it out with DC's AD, Jim Fletcher. He had his
doubts, and I had mine, but he let me try. By breaking
the design down to just the two of them, I was able to
create a much more directed composition. And using
only one point of support for both characters let me ask
the viewer for a moment of suspended disbelief. That
statue led me to apply the concept to my own sculptures,
Belle et la Bête and Afternoon Delight, and another way
of thinking about statue design.*

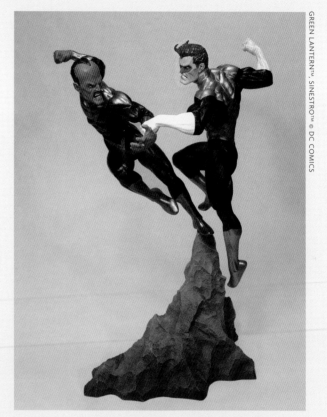

Green Lantern Vs. Sinestro, sculpted by Tim Bruckner for DC Direct.

Bringing Your Figure to Life

We've all seen the famous painting of the sculptor making out
with his lifelike creation. While few of us will ever be *that* happy
with our work (and those that do will most likely end up in a
padded cell somewhere), making the piece appear to come alive
is the ultimate goal of every figurative sculptor. Now, this isn't
easy. Even if your sculpture *looks* exactly like what it's supposed
to, unless it has that spark of life, it misses the mark. You want
to transmit the same spark of life that is in you into the piece, so
that the viewer will look at it as if it is a living thing. A lot of that
work will be done at the sculpting stage, but the life of the piece
really starts here, with the design.

There are things we do as human beings that reveal our in-
nermost feelings, no matter what attitude we're trying to project.
These are the things that help imbue a hunk of plastic or plaster
with life. In designing a figurative sculpture we want to be aware
of the Then, the Now, and the Next. Considering that sequence
of events gives us the opportunity to leave "tells" (to borrow a
poker term) or clues to the life of the piece.

Even with a character doing as little as sitting, things like the
tilt of the head or the details of a hand gesture can speak vol-
umes. Remember, expressions are the result of a progression of
thoughts or emotions that *develop* over the face as opposed to

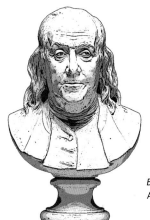

Bust of Benjamin Franklin by Jean-Antoine Houdon.

appearing, fully formed, in one single motion. A wonderful example of a sculptural portrayal of an expression in flux is the bust of Benjamin Franklin by Jean-Antoine Houdon (1741–1826, see above). The set of his mouth and the direction of his gaze represent different stages of thought; you can actually see Franklin think.

Again, compare the two *Davids* (see page 26)—Michelangelo sculpted an expression of confidence, a reserve of power and courage in David's face, while Bernini's sculpture reveals David's anger and determination. Bernini's *David* is a young warrior and his muscles bulge with exertion; Michelangelo's *David* represents a more symbolic struggle.

Silent movies are an excellent way to build our internal library of observations of gesture and expression. Silent film is an art form in which everything was conveyed through the face and the body and the way it moved and emoted. By today's standards those old films may seem comically broad and melodramatic. But in those broad strokes is the essence of realistic movement and posture.

PHOTO FINISH: SHOOTING YOUR OWN PHOTO REFERENCES

Once you have the pose you want locked in, photograph yourself or someone else re-creating it. Shoot the pose from eight different angles—an eight-point turn (see page 92). Photos are incredibly helpful to use as reference. Be sure to photograph the facial expression you want to capture, either on your own face or someone else's, as well as hand gestures, folds and wrinkles in clothing, and any details that will help you while you're sculpting.

Recruit your friends and impose on your family. Get them into the act. Just think of the bragging rights they'll have when they get to say, "You know that statue of Superman? That was me."

TIM IN A BOTTLE: A TWIST OF FATE

In my rough sculpt of the ghost of Marley, from A Christmas Carol, *I had his left hand positioned with his thumb pointing up, in an accusatory gesture. A friend and fellow sculptor Tony Cipriano suggested turning it palm up, and it made all the difference in dealing with the conflict in Marley's visit.*

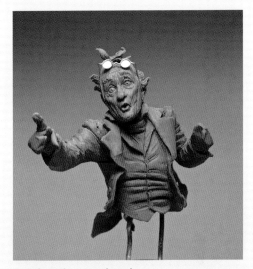

Tim's first take on Jacob Marley…

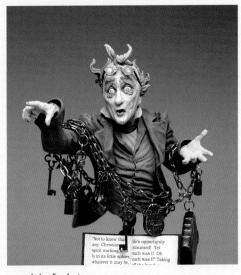

…and the final piece.

Articulate Yourself: Designing an Articulated Figure

Which of the following is true?

Action figures have been a subject of great debate.

Action figures are toys.

The answer? Both. Action figures have been divided into two distinct camps over the past ten years: dynamically posed figures with little to no articulation and highly articulated figures that can be put into many positions. As a sculptor, you will likely have to sculpt both at some point in your career. The ideal number of articulations, as well as where, what, and why of articulations, is as contentious among action figure aficionados as bragging rights among the Hatfields and McCoys, so we won't even dip into that arena; instead we'll simply focus on designing the two general types.

We tell you how to make an articulated action figure in detail in Chapter 9.

Unless you're designing and creating your own action figure from start to finish, your AD or PM will tell you how many points of articulation you will use in your figure as well as the type of articulations you'll use: ball joints, hinges, pivot points, etc. Each point of articulation adds to the manufacturing costs because

Posed vs. poseable: The great action figure debate.

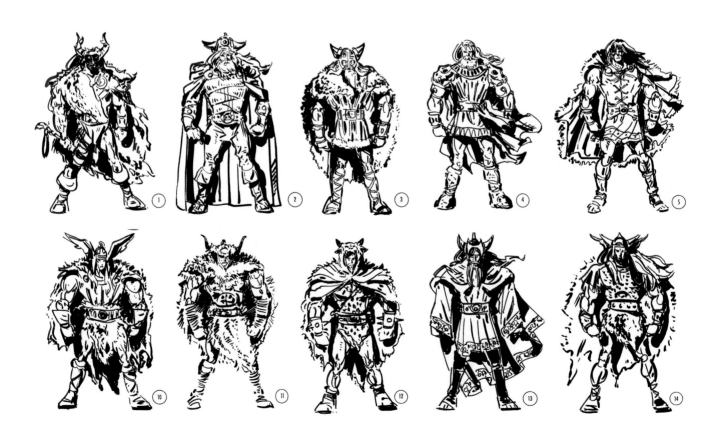

more articulations mean more parts, and more parts mean extra work—i.e, higher cost. (A figure with five points of articulation at the neck, shoulders, and hips has six parts.) When you're producing by the tens or hundreds of thousands, a fraction of a penny can mean the difference between a profitable and a money-losing product. Your AD will send you turn-arounds—or at the very least a set of drawings—that show you exactly where on the figure each articulation point should go.

Posed action figures are essentially mini-statues, so many of the guidelines we've covered in this chapter will apply to them. The challenge is to make the articulations as unobtrusive as possible. (The articulation is generally a "pivot," or a straight cut resulting in two parallel disks that pivot to allow a side-to-side or twisting motion. These are most commonly used in shoulder, neck, hip, wrist, bicep, and thigh articulations.) There's nothing more unsightly than a body part that, when pivoted, doesn't line up with the other half of the part. Since the range of motion will be limited, this is not often an issue, but try to make your pivot point occur in as unobtrusive a spot as possible, or come up with some way to mask it using costume details.

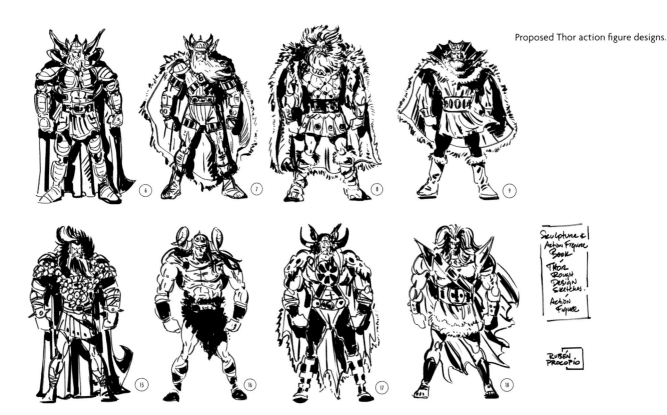

Proposed Thor action figure designs.

Sculpture & Action Figure Book

Thor Rough Design Sketches.

Action Figure

RUBÉN PROCOPIO

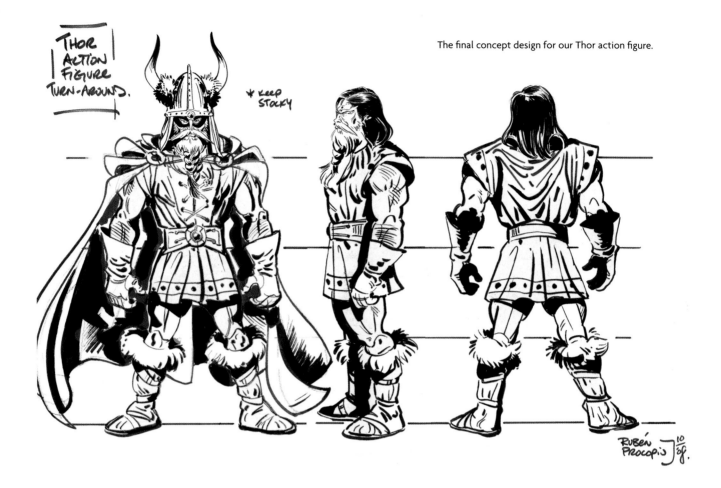

THOR
ACTION
FIGURE
TURN-AROUND.

* KEEP STOCKY

The final concept design for our Thor action figure.

RUBÉN PROCOPIO 10/09.

Articulated action figures are usually designed to have a static, "waiting for the bus" resting pose, but with enough articulation so that the buyer can pose the figure, bringing it to life with a turn of the head or a bend of the wrist, even engaging another action figure in combat. So, while the resting pose may not be a big design concern, facial expression, hand gestures, anatomy, and costume details will be. Whether you're dealing with three or thirty points of articulation, good design is good design and the principles we've discussed in this chapter will aid you in achieving it. It helps to look at your favorite action figures to see how they use articulation—find one with a similar number as you want to use and see what they did right and what they did wrong, so you can avoid the same mistakes and experience the same victories.

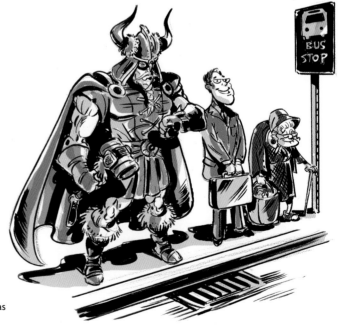

Like many action figures, Thor is capable of dynamic poses as well as a basic "waiting for a bus" stance.

BASES

As the name implies, a base should support the figure, but not just physically—aesthetically, as well. If the base detracts, overwhelms, misdirects, or does anything to compromise the intent of the figure, then it's not doing its job. Of course, there are exceptions—if your statue is of a gnome hiding behind a tree, a more involved and elaborate base is to be expected. But in general, a well-designed base should inform the figure in environmental or thematic terms and showcase it in architectural or decorative terms.

You may want a decorative base, one that makes your sculpture feel like a museum piece—you can find examples of those in art books or architectural journals. Another option is a realistic environment that will put your character in a setting—you'll need to find photos and examples of the specific rock or tile or foliage you want to re-create. A third option is to make the base look like an item associated with the character, either actual size or intentionally and dramatically disproportionate. Again, you'll need to gather reference; in fact, the only time you won't is when you're planning to make your base a black disk or simple block. That's the easy way out, but we won't judge you—you've got a lot of work ahead of you already.

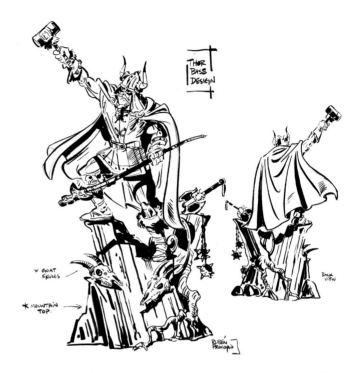

Rubén's proposed Thor base design, which doubles as an accessories holder.

Rejected Athena base design, showing her springing from the head of Zeus.

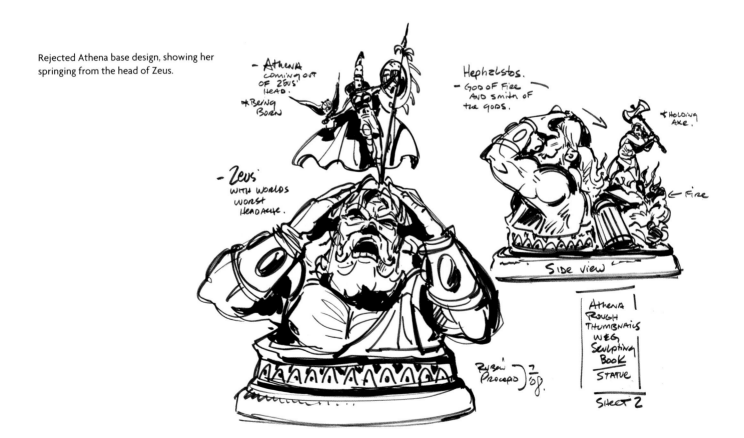

FINISHING TOUCHES: SCALING YOUR ART REFERENCES AND COMPENSATING FOR SHRINKAGE

Once you have all of your references and drawings, reducing or enlarging them all to the actual size of the finished figure is an absolute must. This way you'll be able to compare measurements between the artwork and your armature and sculpture with total accuracy. Do the math, and make copies of the artwork that will show the figure at the exact height you want the sculpture to be.

Another consideration you should have in mind is the amount of shrinkage that will happen to your figure from clay to the wax and from wax to resin-casting stages. Be sure to calculate for this shrinkage in the overall size of your figure design. See page 82 for more details.

FUN: TUNE IN, ZONE OUT

There'll be a point when slogging through this process that time seems to take a vacation and labor tags along. You'll look up at the clock and find it a little hard to believe you've been sitting there for the last few hours completely involved in your work and oblivious to things around you. It's the Zone. It isn't going to happen all the time. It may not happen for every piece. But when it does, there's almost nothing like it. And even though your back aches and your neck hurts, your toes are a little numb and you've got cramps in places you didn't think you could have cramps, you'll realize you had fun. Serious fun. So, enjoy.

Time flies when you're having fun.

The statue I made of the first appearance of Supergirl for DC Direct remains one of my favorite pieces. It was kind of a turning point for me, as it presented the biggest technical challenges I'd faced at the time in statue work and allowed me a lot of interpretive freedom while trying to stay true to the art. Designing the inside of the rocket, figuring out how to get the thing to be reproducible, the clear cast door, the smoke, Superman's expression juxtaposed with Supergirl's expression—all of these elements made creating the statue a pretty enjoyable experience.

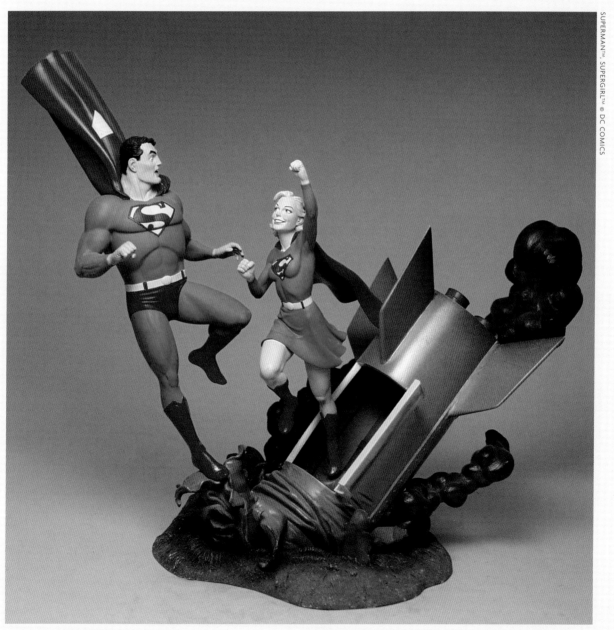

SUPERMAN™, SUPERGIRL® © DC COMICS

The Arrival of Supergirl, sculpted by Tim Bruckner for DC Direct.

2. Materials, Tools, Supplies, & the Workplace

WHAT WE USE AND WHAT OUR FELLOW PROS USE TO GET THE JOB DONE

Now that you have the design for your piece finalized, you'll need to gather the materials you'll use to create it and build a working environment that will allow you to make it quickly and without interruption or distraction. We'll start off with an overview of some of the most commonly used sculpting materials (including two recipes for making your own wax), then detail all the tools and supplies you'll need, and, finally, show you how to set up your workplace for ease of work and efficiency. As a bonus, some of the top professionals in the pop sculpture world will tell you what materials and tools work best for them and why.

Sculpting Materials

Each sculpting material has its own set of challenges, and you'll need to decide which one is the most comfortable for you and which will suit the specific needs of the piece—after all, choosing the right material for the right job is crucial for the success of any project.

Always get your children's permission before melting down their crayons.

36

WATER-BASED CLAYS

Also known as pottery clays, water-based clays have been used for millennia and can be found in the earliest terra-cotta jars and *bozzetti* (3-D "sketches" of statues). There are primarily two different kinds of water-based clays: sculpting clays, which are grainier, and throwing clays, which are creamier; both are available in a limited selection of colors and consistencies. Water-based clays are easy to use and inexpensive, which is why they're often used for large-scale sculptures, especially in the special effects industry. There's a certain immediacy to water-based clay's elastic feel that suits more organic, free-style sculptures. Creating a finely detailed work in water-based clay is not impossible, but it takes a real mastery of the material to achieve that kind of result.

The main disadvantage of using water-based clays is that they must be kept moist to remain workable, and if they dry out they can crack; therefore, they don't lend themselves to long-term projects. They also have a tendency to sag, even with interior support. There are water-based clays that are formulated to air-dry to a very hard finished product, but there are also those that must be baked in a kiln, and working with kiln-hardening clays creates a whole range of other issues. If not dried properly, they can crack and fissure, and if you're making a silicone or urethane rubber mold, the hardened clay needs to be glazed, treated with a sealer, or coated with a mold release agent, as it's inherently porous and will bond to the rubber.

OIL-BASED CLAYS

Also called "plastilina" or "plastiline," oil-based clays are a compound of fine-particle earth mixed with a binder of wax, oil, or both. Invented in Germany in the late 1800s, it's a fairly recent development as a sculpting material. Oil-based clays come in a variety of colors and hardnesses, and they lend themselves perfectly to long-term projects because they don't dry out and they remain malleable for a long time. (However, they will eventually become harder and less responsive as the binder ages.) Like water-based clays, they're good for quick, energetic work, but they can also take fine, precise detail, depending on hardness. Plastilina is especially useful for larger sculpts and life-size pieces. However, oil-based clays are not permanent, and must be molded and cast in a permanent material, such as plaster or resin.

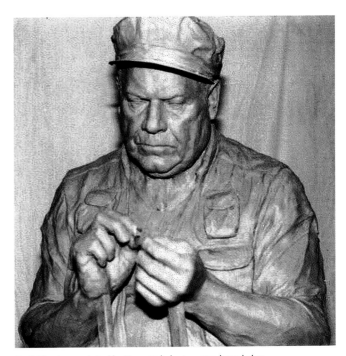

Dad, life-size, sculpted by Karen Palinko in water-based clay.

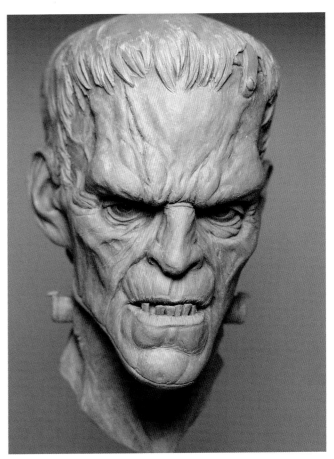

The Monster, a sculpting exercise done in oil-based clay by Tim Bruckner.

A Little Mischief, a sculpting exercise done in oil-based clay by Tim Bruckner.

OPPOSITE PAGE: *Lucifer's Lawyer*, a sculpting exercise done in oil-based clay by Tim Bruckner.

SCULP-TOR SEZ: A WHITER SHADE OF PALE

The color and tone of your clay is purely a matter of preference. Be aware, however, how light interacts with your sculpt. With very light and very dark materials, the relationship between light and shadow can be deceptive, and you may find that you have a tendency to sculpt recesses on your statue less deeply (light clay)—or overcompensate by cutting in too deeply (dark clay)—as a result. If that happens, the finished, painted product can come out looking off.

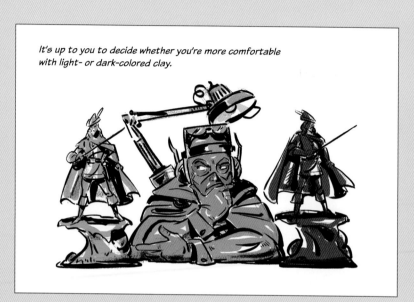

It's up to you to decide whether you're more comfortable with light- or dark-colored clay.

Oil-based clays also come in two basic varieties: sulfur and nonsulfur. With the choice of clays available today, there's no reason to choose a sulfur-based clay, as the disadvantages are significant. For example, RTV (room temperature vulcanized) silicone rubber, from which most molds are made, does not work well with sulfur clays.)

Which type of clay you use will depend on personal preference. Take a few for a test-drive and see which one suits you best. We made our clay rough for Athena (see Chapter 3) in an oil-based, sulfur-free clay, which is very mold-friendly. Tim has road-tested a truckload of the stuff and prefers Chavant's brown, medium-firm NSP non-sulfurated plastiline) for medium-scale work and the hard NSP for smaller-scale work. Chavant makes a variety of clays for virtually any sculpting need.

CASTILENE

The modeling substance known as Castilene is made by Chavant, who also make Tim's favorite clay. It has wax as its base, but it includes other (secret) materials in it that make it moldable like clay. Because of its light weight and its ability to hold detail, it has gained a foothold in the professional sculpting biz. It comes in a variety of hardnesses for different uses and effects.

POLYMER CLAYS

Fimo, Cernit and Sculpey are made from polyvinyl chloride, or **PVC** for short, as well as one or more kinds of liquid plasticizer (additives that increase the flexibility of a material to which they are added—remember that for the pop quiz). If that sounds like a funny thing to make a sculpting compound out of, it is; Sculpey was originally developed as a heat conductor for electrical transformers, but the substance was shelved until someone started playing around with it and realized its potential. Polymer clays usually contain no clay minerals and are only called clay because their texture and working properties resemble those of more traditional clays. For instance, like clay they need an internal support system, and they come in a few different degrees of firmness and

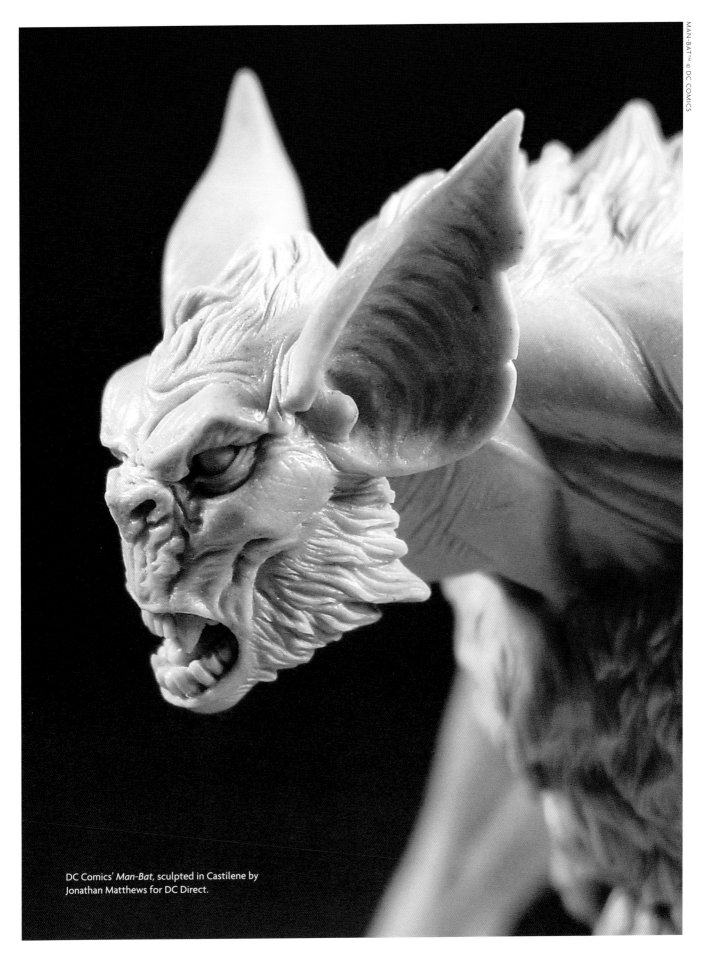

DC Comics' *Man-Bat*, sculpted in Castilene by
Jonathan Matthews for DC Direct.

in a variety of colors. In fact, you can get polymer clay in dozens of colors, which can be mixed to create a virtually infinite range of custom colors, gradient blends, and other effects. A finished polymer clay must be cured by baking in an oven.

Sculpey clay generally comes in 1-pound bricks (and multi-brick boxes). For a 12-inch figure, you may need two to five bricks depending on how elaborate your character is. It's important to treat unbaked Sculpey like fine wine and store it in a cool, dark, climate-controlled environment away from direct sunlight and heat, wrapped in plastic bags. Properly stored, the clay should remain fresh. It does, however, tend to dry out in hot weather. Due to variations in heat exposure on the product's cross-country train journey from its manufacturer, wintertime clay is softer and moister than drier summertime clay. If it's *too* soft, you can leach some of the oils from the clay by placing it in a paper towel.

Follow the clay package directions for baking time, which, generally speaking, will tell you to bake the clay at no higher than 275 degrees Fahrenheit for fifteen minutes per ¼-inch thickness of clay (instructions for different formulations do vary). Rubén bakes his sculptures at 170 degrees Fahrenheit for a longer period of time. Just like with food, higher temperatures for shorter times risk burning the polymer clay piece, which you only need to do once or twice before learning the patience of a lower, slower bake. You may want to use an oven dedicated to baking polymer clay, as the clay releases fumes that you don't want mixing with your food.

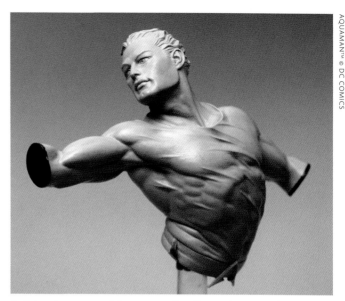

Sculpture-in-progress of *Aquaman*, sculpted in wax by Tim Bruckner for DC Direct.

Bake slowly, or you risk overbaking, as Rubén learned the hard way.

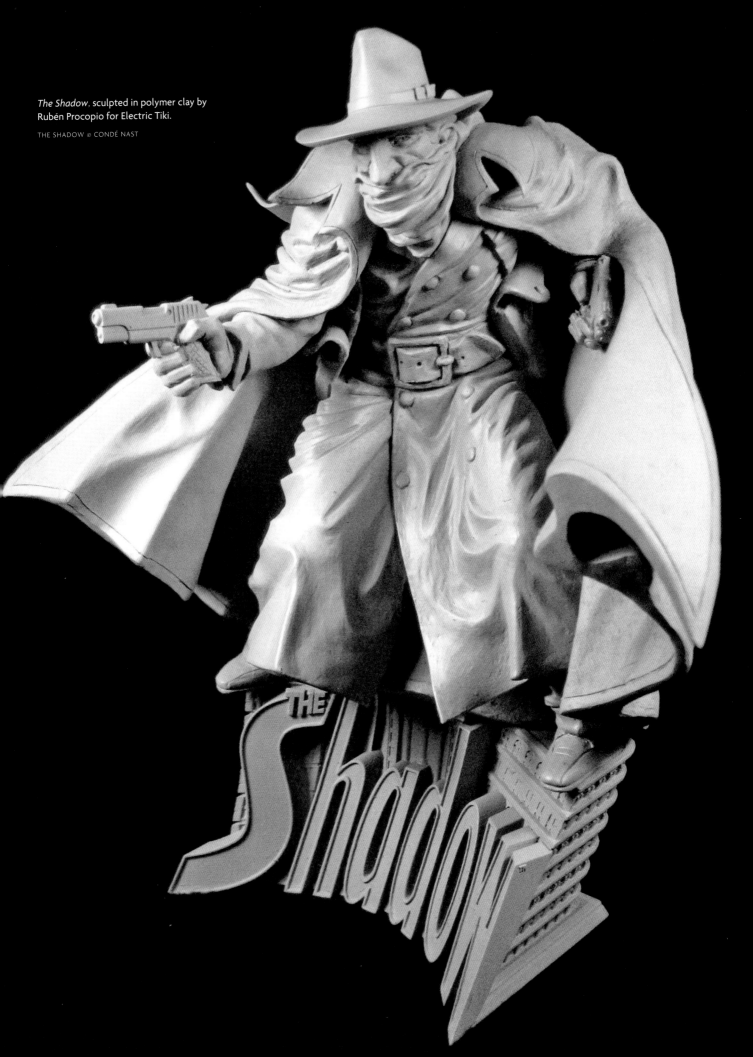

The Shadow, sculpted in polymer clay by Rubén Procopio for Electric Tiki.

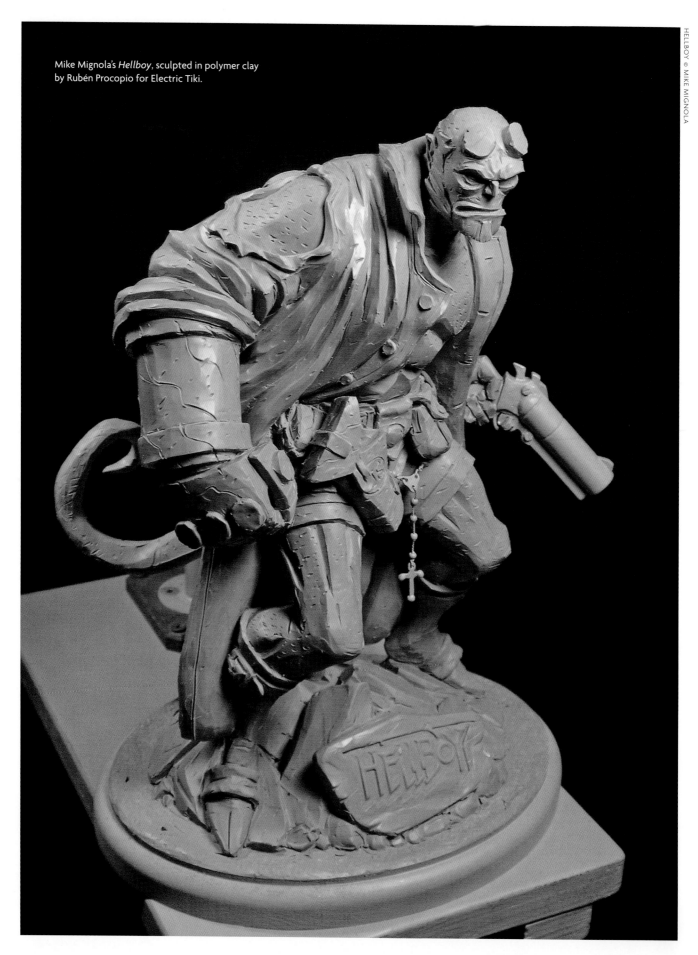

Mike Mignola's *Hellboy*, sculpted in polymer clay
by Rubén Procopio for Electric Tiki.

A sculpture done in polymer clay can benefit from a consistent thickness so you won't burn thin areas and undercure thick areas. A common solution is to build and bake, creating the sculpture in successive layers by fleshing out the figure a little at a time, baking, and adding more clay, baking and adding until the piece has a fully cured core. (Or you can bulk up your armature with compressed aluminum foil shapes.)

EPOXY PUTTIES

Like polymer clays, epoxy putties (Milliput, Magic Sculpt, Aves) are plastic-based modeling compounds. However, like epoxy glues, they come in two parts; when the two components are kneaded together they harden via a chemical reaction in as little as a couple of hours. When fully cured, they have a rocklike consistency that allows for very precise tooling, but their strength can also be a significant drawback. The extreme hardness can make reworking problematic—you can use water to smooth out the surface while it's still pliable, but otherwise you need to work fast, steady, and sure when using this material. If you're working as a hand-for-hire sculptor, the built-in deadline can make addressing changes to the sculpt difficult and time-consuming.

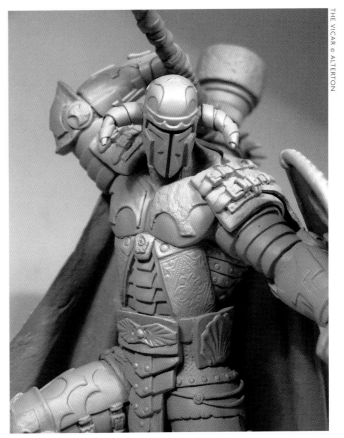

THE VICAR © ALTERTON

The Vicar, sculpted in epoxy putty by Alterton.

RUBÉN RUMINATES: LIKE FATHER, LIKE SON

I've been a champion of Sculpey practically since birth. My father, Adolfo Procopio, was a Walt Disney Imagineer for thirty-five years, and after working with virtually every sculpting material and method known to man, his recommendation to me at a very early age was to use Sculpey. When I revived the maquette process at Disney Feature Animation in the early 1980s, I would build an armature, sculpt it in Sculpey, get the director's approval, bake it, mold it, and bingo! The team of animators had a 3-D model of the character as an additional tool.

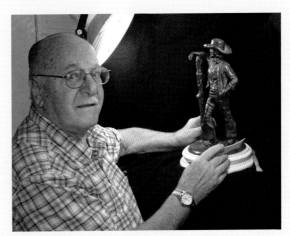

Rubén's father, Adolfo Procopio.

PLASTER

Plaster starts as a dry powder that is mixed with water to form a paste, which releases heat and hardens. Unlike mortar and cement, plaster remains quite soft after drying and can be easily manipulated with metal tools or sandpaper. Plaster expands while hardening, then contracts slightly just before hardening completely. This makes plaster excellent for use in molds, and it is often used for casting.

While not the best material for sculpting figures, you can create a lot of useful elements for your sculpture's base using plaster. Cast different shapes to create architectural elements, or shatter a solid block of it to create rocks and rubble. Mixed properly, plaster will have a puddinglike feel. Hydro-Stone and Hydrocal are two plaster-type products that essentially work the same way, but because they contain cement, they are harder and more dense than plaster. They also sound a lot more futuristic and will impress people you meet at the bus stop.

Plaster can also be used for certain kinds of molds, including waste molds and, in conjunction with silicone rubber, mother molds. For more on molds, see Chapter 4 .

BALSA FOAM

Need a fast, easy, and efficient way to construct rock formations, an environmental set, or architectural elements? We have two words for you: Balsa Foam. Balsa Foam is a rigid foam similar to Styrofoam, but it is made of urethane and will tolerate a number of sealers and primers that can dissolve Styrofoam. It comes in several firmnesses, or densities, including 7 pounds, 12 pounds, and 20 pounds per cubic foot (or soft, medium, or hard). Rubén has used it numerous times to create a rock, a cave wall, or even a couch. Because Balsa Foam is heat-resistant up to 300 degrees Fahrenheit, you can actually put it in the oven at a very low temperature as you cure your polymer clay (if that's what you're using).

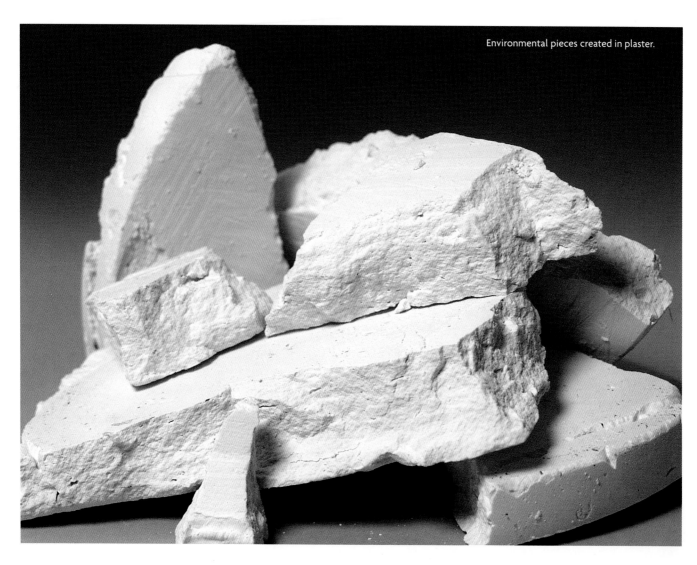

Environmental pieces created in plaster.

You'll need a couple basic tools to work with Balsa Foam: a knife (preferably one with a serrated blade), a hacksaw blade with the end wrapped in several folds of paper towel (secured with a few strips of duct tape), a handheld rasp with a handle, some fine metal tools, and sandpaper. Hot wire cutting won't work with Balsa Foam as it does with Styrofoam, due to its high heat resistance.

With Balsa Foam, you're removing material by carving, rather than adding material like you would with clay or wax. We highly recommend that you work in an area with good ventilation; if weather permits, outdoors is best. Either way, wear a particle mask while using Balsa Foam! Working with Balsa Foam is very messy, so dig out those old work clothes or don a smock.

Have an air compressor or vacuum handy to remove the excess foam dust as you're working. It's also a good idea to have a trashcan handy.

What happens if you accidentally gouge or dent your part, or have a sneezing attack and chop off much more than you intended? You can patch dents and gouges using spackle. You don't want to use a harder patching material like Bondo or plaster, as the difference in hardnesses will be difficult to control when you sand and finish your patch. Hot glue or white glue works great in bonding pieces of Balsa Foam; just make sure that, whichever

Balsa Foam in its natural state.

glue you use, you glue the center point of the addition and don't let the glue work its way to the outer edge. If you have seams you'd like to hide, good old glazing putty will do the job. You can also add texture to your piece by giving the balsa foam a coat of white glue and dusting it with sand or small bits of gravel.

Clean your tools well after using them, especially if they're metal, as the composition of the Balsa Foam will rust your tools if any particles are left on them.

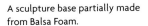
A sculpture base partially made from Balsa Foam.

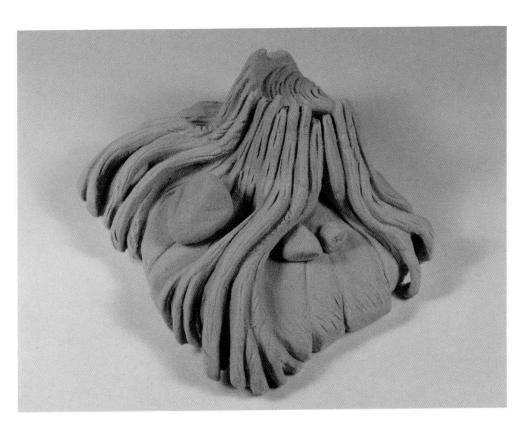

STYRENE

Another great environment-building material is styrene, the type of plastic that model cars and airplanes are made of. It's marketed specifically to model train builders, and you can buy it in hobby stores in sheets, as well as in different shapes like rods, square rods, tubes, etc. "Usually, if I have an element to a sculpture that is either mechanical or very angular, I'll use either styrene or a block foam to build it," says DC Direct sculptor Jonathan Matthews. "This ensures sharp corners, flat surfaces, and an overall realism that I couldn't achieve using Castilene alone."

One piece in particular that Matthews created—a statue of a girl at a desk, based on a Gil Elvgren pinup and shown below—used a lot of styrene, in both the desk and the chair she's sitting on. "Building the desk out of styrene was a lot like building a real desk out of wood...just at a much smaller scale," says Matthews. "You have to cut each individual piece out of the styrene sheet and glue it all together to get the final result."

WAX

Wax has been used as a sculpting material for thousands of years, since the ancient Chinese used the **lost wax** casting process to create finely detailed bronze boxes (a method picked up by the Greeks and Egyptians to make statues and other artifacts). Beeswax was the primary material then, and it's still used as an ingredient in sculpting wax today. All in all, there are few sculpting materials as flexible as wax, which is why our process will include creating a waste mold of your rough sculpt and casting it in wax. A fine finish is what will help define your work and reputation. There are well-known sculptors whose finishes are fairly rough and raw; they've overcome the need for a tight finish by the strong and aggressive character of their work. But these artists are few and far between. For the rest of us, a tight finish is vital to a successful outcome. And if you're hands-for-hire, it's all about getting to the finish line as quickly as possible without compromising the quality of your work—and that makes wax an essential

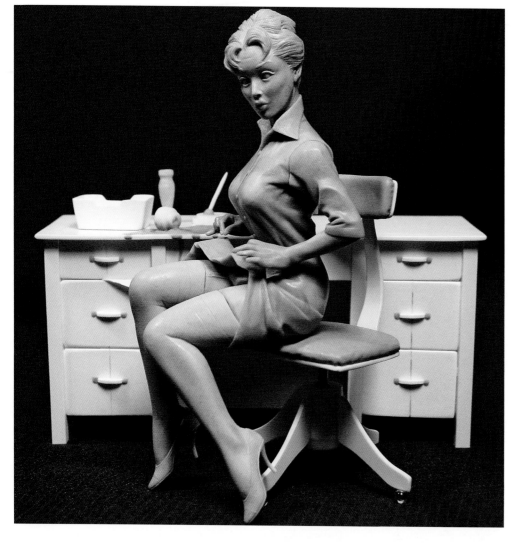

In this unproduced Gil Elvgren pinup sculpture by Jonathan Matthews, the white parts are made of styrene.

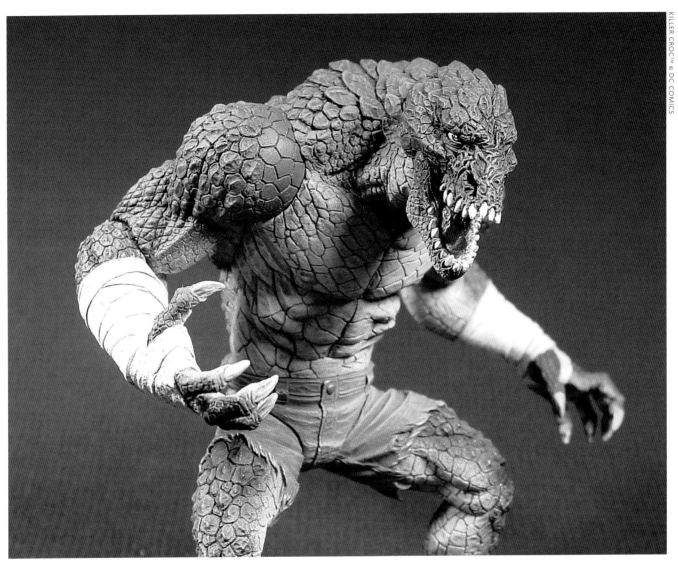

KILLER CROC™ © DC COMICS

DC Comics' Killer Croc, a painted resin casting of a castilene sculpt by
Jonathan Matthews for DC Direct.

sculpting material. It can be easily reworked, it won't dry out, it doesn't need an armature or internal support, and it can take a finish like nobody's business. And a variety of ready-made wax products produced for jewelry makers—sheets, rods, and other shapes—make adding details to your sculpt incredibly easy.

The downside to wax is that you can't bake it; you need to make a mold of it and cast the sculpt in a permanent material, like resin. But an upside of the downside is that wax is very mold-friendly and won't stick to the rubber. And if you decide to become a hands-for-hire sculptor, you'll find that the majority of companies who produce action figures and pop culture statues prefer that their sculptors use wax. There's a pretty big learning curve to working with wax; it has its idiosyncrasies and can be stubborn and intimidating. But once you show it who's boss, it really is just a big pussycat. Rub its belly, figuratively speaking, and it'll follow you anywhere.

▶ Commercially Available Waxes

There are a number of commercially available waxes, ranging from ones with a soft, claylike consistency to a very hard carving wax with the firmness of a fine-grained wood. Regardless of which you feel more comfortable using, they all have one thing in common: They all respond to heat. They can be melted and cast or worked with heated tools like a wax pen, to create loose, free-form studies or highly detailed sculpts. A quick search online for sculpting waxes will result in pages of suppliers. Despite the variety of sculpting waxes on the market, they all, more or less, share common ingredients. Knowing what those ingredients are and what they do can help you mix a wax ideally suited to your needs.

CARNAUBA WAX: Carnauba wax is derived from fan or carnauba palms. It's a very hard wax with a high melting temperature. It has a multitude of uses, for everything from furniture and car polishes to cosmetics. For the sculptor, it adds hardness to the sculpting wax—the more carnauba the harder the wax. But it really shouldn't exceed more than 20 percent of your formula. It usually comes in yellowish or brown waxy flakes. As a high-temperature wax, carnauba wax is more fluid when melted than low-temperature waxes. However, this also makes it difficult to use with rubber molds. Its high melting temperature can allow it to bond to the silicone mold, and if that happens, your mold is a goner.

BEESWAX: One by-product of the fabled relationship between the birds and the bees is the wax the bees use to create their honeycombs. As soon as man discovered beeswax, he found uses for it. For the sculptor, beeswax, which usually comes in blocks of a very pale yellow or a deep honey color, helps bond waxes together as well as adhering to itself. The sticky quality that makes it ideal for mixing with other waxes makes it a pain in the rear when working with it on its own. It sticks to tools and fingers, and its translucent quality makes it difficult to read the surface. But if you're looking for a more claylike wax, beeswax will be part of your formula.

PARAFFIN WAX: Paraffin is a petroleum product and is used in food, cosmetics, and various polishes—yep, it's also the same stuff Grandma used for canning. You can buy it at the grocery store, online, or at arts and crafts stores. For the sculptor, it's a firm, carvable wax with a different hardness than carnauba: carnauba has a more lacquer-like hardness, while paraffin has a more wax-like hardness. It's a good binder for other waxes.

Eventually, Tim learned you get beeswax in stores.

MICROCRYSTALLINE WAX: Also known as Victory Brown, this is a semisoft sculpting wax that can be modeled directly as a sculpting material or cast as a wax model for lost-wax casting in foundry use. It's usually available in blocks, which weigh anywhere from 1 pound to 10 pounds or more. For the sculptor, it adds opacity as well as malleability and alters the character of beeswax by making it more firm and less sticky. Invariably, the two are used in combination.

INJECTION WAX: Injection waxes are synthetic, plasti-clike compounds that remain relatively viscous when melted. In jewelry making, a wax part is cast into a mold by using an *injection caster*—basically a Crock-Pot that keeps the wax at a constant temperature. The pot is filled with compressed air and maintained at a specific psi (pounds per square inch). When the nozzle is depressed, the pressurized melted wax is extruded into the mold, filling even the smallest cavity. All waxes shrink when cooled after melting, but injection waxes are formulated for minimal shrinkage, which makes them ideal when casting very fine parts used in jewelry manufacturing. And, because the wax-cast part is often removed from an intricate mold and the parts are very delicate, injection wax's inherent "give" helps in removing the parts. For the sculptor, the addition of various injection waxes helps reduce shrink when casting wax parts and adds "bendability" to the wax to make repositioning sculpted elements easier.

CRAYONS AND WAX PIGMENTS: Most waxes (even the synthetic kinds), by their nature, have a translucent surface to some degree. Since sculpting relies on the absolute and precise reading of the sculpting material's surface, making the wax opaque is very important. There are a number of commercially available wax dyes in no end of colors; you often find them with candlemaking supplies. Tim has never found anything better for turning sculpting wax opaque than Crayola brand crayons. (He's tried other brands, but Crayola is the best.) The dry pigment they use suspended in paraffin is so fine and dense, it integrates perfectly into the wax. And you've got a choice of so many colors! After you've arrived at your selected combination of waxes, the color is usually a kind of coffee-stained brown, so add enough crayons to bring the wax up to an absolute opaqueness. Tim likes to work in a wax that's kind of a light terra-cotta red color, so

he uses a lot of white crayons and a few red ones, but you may want to sculpt in cadet blue or razzle-dazzle rose. Remember that when adding crayons, you're adding paraffin, so take that into consideration when adding actual paraffin to your wax mixture.

TALC: Once upon a time, your mom used to sprinkle talc on you after she changed your diaper; today, it's used in cosmetics and various drying agents. For the sculptor, its addition to wax gives it a very hard, dense character, bringing it closer to a carving wax. Common solvents often used in finishing waxes work poorly with talc-waxes, as the solvent will dissolve the wax, leaving the talc behind and creating a grainy, gritty surface. But this wax will take a polish and can be sanded and surfaced to a very fine smoothness. Most waxes for toys contain talc.

THE WAX ARTIST'S COOKBOOK

We asked wax expert Gary Overman of WillowProducts.com to provide us with a simple wax recipe that would be easy to make. Our own resident wax expert, Tim, also offers his tried and true wax formulation.

GARY OVERMAN'S SIMPLE BASE WAX

This is my simplest recipe. It's hard to believe that something as simple as this can work, but you'll be surprised at how versatile this recipe is in terms of modeling characteristics. Since it uses mineral fillers to make the wax less sticky and more carvable, it is not manipulated with a wax pen as easily as our commercial waxes (which rely on many harder-to-find materials). But the thick mixture also has a nice feature…it doesn't need filtering, and there are no worries about settling. Please note that the reference to "parts" means unit of weight. I always use weight to measure out the ingredients. It is more accurate that way because the raw materials can vary so much by volume depending on whether they are slab, powder, pastille, etc. Accuracy within 5 grams is plenty accurate for the formula given here.

Ingredients

- 250 parts microcrystalline wax
- 30 parts coconut oil
- 300 parts ball clay

Instructions

Melt the wax at a low temperature. While stirring, add coconut oil. Allow to cool until just barely liquid, then stir in ball clay. The formula will thicken to pancake batter–like consistency and yield a wax that may be worked with metal tools without much need for heat and produce pieces that can be joined easily. The easiest way to modify this wax is to vary the amount of coconut oil. Summer heat may require less coconut oil; winter cold may require more to make it malleable without the use of heat. If you leave coconut oil out entirely, you'll find this blend to be stiff and tough, and it'll require a little heat for additive modeling; a change to fifty parts coconut oil will produce a much softer version. An easy way to test what will work best for your taste is to make up a small batch with no coconut oil and test its modeling characteristics. Then melt the batch and add ten parts coconut oil and test again. Continue in this fashion until you find your favorite mixture. If the coconut oil-free version is softer than you'd like, don't bother testing with the oil, as it'll just make it softer and softer.

COLONEL BRUCKNER'S SECRET RECIPE

The wax I've used for most of my sculpting life has evolved over the years. It started as a bastardization of the formula Cellini gives in his The Treatises of Benevenuto Cellini on Goldsmithing and Sculpture, but I see it more as a recipe than a formula, as it really does need to suit the tastes of the sculptor making it. A couple of friends and I have tried to break it down into ounces and pounds, and we've all arrived at something different, because, I think, we were all looking for different things. So I'm going to give you the basic ingredients and hope you'll set aside some time to cook up your own batch to suit your individual tastes and needs.

First, you'll need a big soup pot (dedicated to melting wax), or a wax melting pot, depending on how much you want to make. If you do your wax melting on a conventional stove, do yourself and the stove a favor, and cover it and the surrounding area with aluminum foil. You may be the neatest and tidiest person alive, but the wax doesn't know that and, frankly, doesn't care. I'm going to describe making the wax in a soup pot, you'll have to adjust it on your own if you make more or less.

Ingredients

- 4 fists microcrystalline wax
- 1½ fist beeswax
- 2 slabs paraffin wax
- 2 handfuls (of each) red and aqua injection wax pellets
- 1 fist carnauba wax (optional)
- Crayola brand crayons (for coloring)—white and red

Instructions

Start off with a big chunk of microcrystalline wax about the size of four fists. (Your fist, not mine.) This is the stock for your wax soup. Next, add a fist and a half of beewax and a couple of slabs of paraffin wax (it usually comes in a pack of four slabs). Let that melt down on a very low flame, then throw in a couple of handfuls each of the red and aqua injection wax pellets. If you have any lying around, throw in about a fist-sized lump of carnauba wax. For coloring, I use Crayola brand crayons. Throw in a handful of white and a few red to get started. Color is a purely personal choice. You'll spend a lot of time looking at this stuff, so it should be easy on the eyes and your aesthetic senses.

When the wax is all melted down, give it a good stir, then test it. Take a square of aluminum foil, fold over a couple of times, then press your thumb into it, creating a depression. Fill it with a little wax and put it in the freezer. After it's fully cooled, take it out of the freezer and work with it until it comes up to room temperature. Play with it using your wax pen and your tools. See how well it sticks to itself. How much does it stick to your tools?

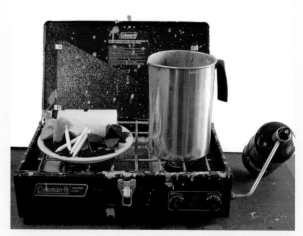

Is it soup yet?

Try roughing out a little head. You'll know more about what you like after doing this than any other test. Mostly, you'll discover what you don't like and will work to correct it. Too soft? Add a little more carnauba with a bit more of the injection waxes. Too sticky? Add a little more paraffin wax. But remember, there's paraffin in the crayons, so if it's too soft and also not opaque, try the crayons first. The wax has got to be opaque; opacity is almost as important as the firmness and malleability. It's impossible to read the surface if you can't tell where it is **(1)**.

When you have something that feels right, give the wax a good stir and pour it into another similar clean container through a section of panty hose that has been stretched across the top and secured with rubber bands. Panty hose make a dandy filter. Let the wax cool on the filter before you remove the filter. Watch the wax, stirring occasionally. When the wax holds its color and has a slightly dull sheen on the surface, it's time to pour it into some waxed 5-ounce kitchen cups. Fill each cup only to about the halfway point. The wax should ladder up the inside of the cup, almost in a spiral. If the wax pours in like water, it's too hot and will bond to the wax of the cup. No fun there. And only pour a handful of cups; leave most of your wax in the pot until the next day **(2)**.

When the wax has fully cooled, the cups can be peeled away easily and, voilà, wax plugs! Here's the thing: When you come back the next day, it's likely, after a little wax-working, that you'll think the wax is too soft or too sticky. Remelt the wax, add whatever you think is missing, and soon you'll have a wax that suits you to a tee. And the best part? The more you use it, remelt it, and use it again, the better it gets.

Wax becomes a compromise between collaborators—the sculptor and the wax. You both need to overlook some of each other's less desirable qualities and combine your strengths. Bon appetit!

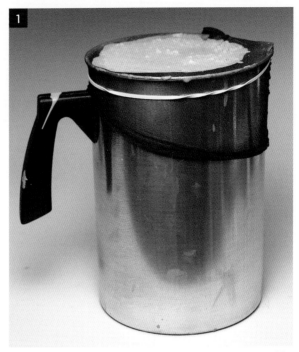

Pouring your wax through a pair of panty hose removes undesirable bits of gunk, but let it cool before trying to handle it.

To portion out your wax supply into easy-to-handle amounts, pour the wax into waxed kitchen cups to form wax plugs.

PRO'S PROSE: **MATERIALS**

We asked wax expert Gary Overman of WillowProducts.com to provide us with a simple wax recipe that would be easy to make. Our own resident wax expert, Tim, also offers his tried and true wax formulation.

JONATHAN MATTHEWS
ON WORKING WITH CASTILENE

Since I began my professional sculpting career, I've used Castilene almost exclusively. I have, of course, dabbled with other materials: Sculpey, Azbro Wax, Chavant clays, but I've always come back to Castilene. I find it to be versatile and malleable with few limitations. I love that it is hard enough to be self-supporting, requiring no armature, yet soft enough for me to work quickly. You can sculpt or even stamp texture into the surface, or sand it to be nearly glass-smooth. It's inexpensive and requires a minimum of equipment to create sculpture with it. It comes in a variety of hardnesses to fit your individual needs. It's opaque and of a middle hue and value, so it photographs well. At room temperature, it remains soft enough to easily make changes to the surface. Basically, it's good stuff!

Despite its versatility, Castilene does have a few limitations. It is hard enough to support itself; however, you do have to be careful when handling your sculpt, as your hand will warm it up enough to soften the material. I've mushed more than my share of detail simply by holding my sculptures while working on them. Castilene also doesn't cast into a mold well. In my experience, solvents don't really work with Castilene, so all the surface finishes I do, I do the hard way: with tools and sandpaper. Finally, Castilene is susceptible to breakage. Small parts of a sculpture such as fingers or wisps of hair tend to break off

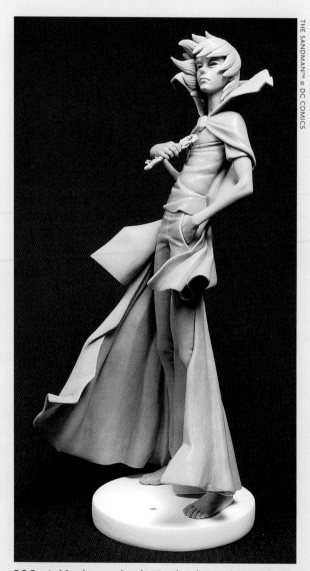

DC Comics' *Sandman,* sculpted in Castilene by Jonathan Matthews for DC Direct.

rather than bend while finishing. All sculptural materials have their limitations, but I find Castilene's pros far outweigh its cons.

WILLIAM PAQUET
ON WORKING WITH POLYMER CLAY

For my first twelve years in the business, all I ever used for figural sculpture was polymer clay—to be brand-specific, Super Sculpey. When a friend gave me a box and told me all I had to do was bake it in a regular oven to cure it, I was amazed. Because of its ease of use, I was able to create a permanent, solid object of art without the need for outside assistance. That's what got me to use it, but why do I still use it?

The clay is soft and it works easily and quickly. Working over a wire armature, a rough figure comes together as quickly as the artist can work. Finessing the material is not so simple, and here is where sculptors who are used to hard clays or wax often become frustrated. Being a semitranslucent and extremely soft material, Super Sculpey is not well suited to rendering fine details on small sculptures. I'm not saying extreme detail and finesse is impossible, but it simply takes experience and a very gentle hand. It took me several years of working with just Sculpey to learn all of its quirks and characteristics, and in turn to learn to draw on its strengths and attempt to tame its unruly qualities.

Super Sculpey can be sanded and polished, carved, cut, and added to. It can be baked dozens of times, and, in fact, it becomes increasingly more stable and durable the more it's baked. When adding fresh clay over baked clay, it is recommended to add a smear of petroleum jelly to the surface of the fired clay and then wipe most of it off, leaving a sheen on the surface. Because Sculpey is a petroleum-based material, the jelly allows the fresh clay to stick to the baked clay and acts as a kind of glue.

For novice artists, I would say it's actually the preferred medium over all others for this reason: Fledgling sculptors with very little initial expense can produce work for their portfolio right in their kitchen.

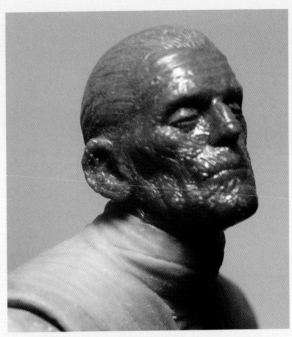

The Mummy, sculpted by William Paquet for Geometric Design.

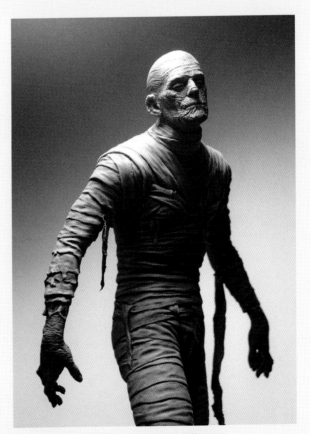

The Mummy, painted and assembled by William Paquet.

TONY CIPRIANO
ON WORKING WITH POLYMER CLAY

I'm pretty opinionated when it comes to Sculpey vs. wax. I swear by polymer clay. Maybe it's just because I'm a crotchety old man and I'm opposed to change, but I've tried everything and Sculpey is just the most versatile. You can bake it in the oven so it's rock-hard, you can sand it, you can use a grinder and remove large bits right away, then add large bits right away and re-bake it. With wax, you gotta sit there with the pen and drip, drip, drip and build up areas and it takes forever, then it's rock hard and you gotta scratch and scrape. Sculpey stays really soft so you can work at your leisure, and you don't have to bake it until you're ready to bake it. With wax, you still have to rough it out in clay, make a waste mold, and pour the hard wax. So it's an extra step, and an extra expense.

Sculpey just doesn't hold detail as well on tiny pieces. You take a really sharp tool to the hard wax, and you get really crisp detail. The only thing I use wax for nowadays is if I'm doing a tiny action figure (6 inches or smaller) with a whole lot of really, really tiny detail. On 12-inch figures I might do the head, the portrait, or the hands in wax, only because a lot of times people want to see the pores of skin, crow's feet around the eyes, etc. If the client wants that really realistic detail, you pretty much have to go to wax.

Super Sculpey's great stuff. If you look at guys like Clayburn Moore and Randy Bowen and Mark Newman, these guys are all polymer clay guys, and their work is the top in the business. Lately I've been doing the whole figure in Sculpey and maybe I'll do the head in wax—if I want to get crazy.

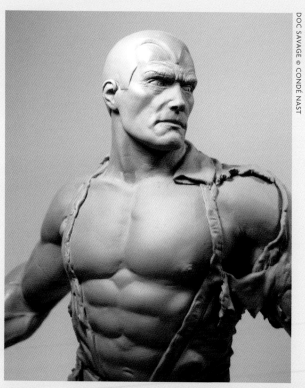

Doc Savage, sculpted in polymer clay by Tony Cipriano for ReelArt Studios.

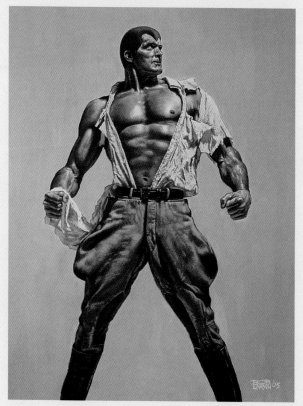

Tony's sculpture is based on this painting of Doc Savage by Bob Larkin.

ALTERTON
ON WORKING WITH EPOXY PUTTY

When I first started to sculpt, epoxy putty was the only choice available to me; after all, it's found in nearly every hardware store and art store. It actually gives you a pretty wide range of working techniques and effects. Since epoxy can take from five minutes to twenty-four hours to cure, depending on the brand you buy and the needs you have, you can play with the different curing stages, from soft and sticky to a malleable rubber texture, before it cures completely. As a result, it can be built up using different methods—with a brush, with a spatula, as putty, or even poured into a silicone mold.

Like any material, epoxy putty has positives and negatives. On the plus side, it accepts texture stamps and molds well when fresh, but you have to try to be as fast as you can, depending on the effect you want to achieve and the curing time of the piece. Epoxy doesn't expand or shrink when cured. You can speed the curing time with the heat of a simple lamp.

The hardness epoxy has once it is fully cured is amazing, but it's also easy to sand with sandpaper or sanding sponges, or to carve and drill with a Dremel rotary tool. When you go to add more epoxy to what you already have, the fresh material blends perfectly with the cured epoxy, with almost no visible parting line. Just remember to use a mask when you sand, drill, or cut the cured material, as it leaves a lot of dust in the air.

Maybe I wouldn't use it for big, massive projects because of its weight, but otherwise I think epoxy putty would be my material of choice for any project, no matter what.

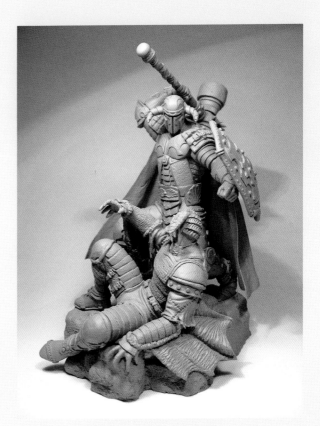

The Vicar, sculpted in epoxy putty by Alterton for his own Minions line.

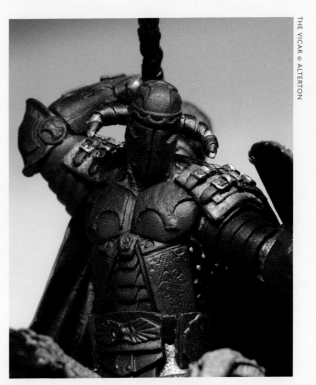

The Vicar, after being cast in resin and painted.

THE VICAR © ALTERTON

KAREN PALINKO
ON WORKING WITH WAX

When I graduated from art school, I worked in water-based clay. I liked how the naturalness of it conveyed flesh, and I liked that I could get two clays for the price of one, so to speak. When I began working in the action figure industry, I found that the beloved water-based clay I had been using for fine art was…better suited to fine art. In spite of its many attributes, its impermanence doomed it for me—mine reverted to dirt when it air-dried and I couldn't carry a paper towel-wrapped wet blob to a client. I searched quite a while for my material and soon felt as though I had tried sculpting in everything except bubble gum. I was looking for flexibility and familiarity—it was really important for me to work with a material that allowed me to sculpt on autopilot, that meditative stage where muscle memory takes over and the piece sculpts itself.

Tim was generous enough to share his wax formula with me, and I was thrilled to find that it behaved like clay, in that it had different characteristics depending on the degree of heat it was exposed to. Warmed under a heat lamp, it was soft enough to do roughs, and, when cooled, it took detail beautifully. For superfine detail, I put the sculpture in the freezer for a few minutes. I tinkered with the formula, and altered it until it was a perfect fit for me. I keep multiple copies of my version around the house because I live in fear of losing it.

In a lot of ways I work in wax the same way I did in clay; much of the wax build up is done with my hands. Working that way keeps the softness, especially when sculpting female figures.

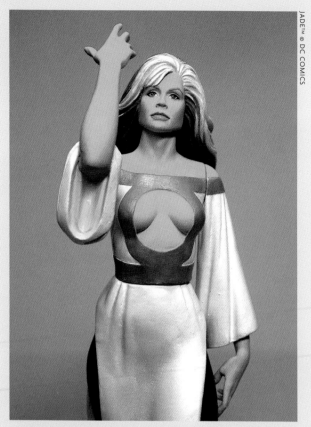

Kingdom Come Jade, a painted resin casting of a wax sculpt, by Karen Palinko for DC Direct.

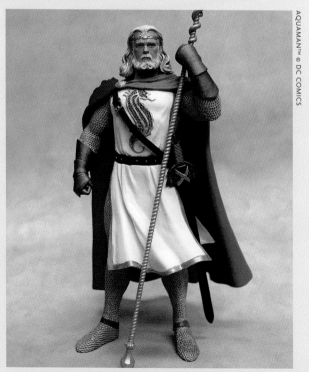

Kingdom Come Aquaman, a painted resin casting of a wax sculpture, by Karen Palinko for DC Direct.

WILLIAM PAQUET
ON WORKING WITH
WAX

Learning wax was difficult after
using Sculpey only for over a
decade, but there are tech-
niques and finishes wax offers
that Sculpey simply does not.

It was through necessity that I picked up wax for
the first time. A longtime client decided they wanted all
prototypes to be produced in wax, not Sculpey. I enlisted
the help of the best wax guy I knew, Tim Bruckner, and,
generous fool that he is, I suckered him into teaching me.

Tim's wax is formulated so that the hardness can be
controlled, and by making it softer I found a balance that
acted much like clay when warm. But my initial attempts
to use it as I had Sculpey were beyond frustrating. I had to
relearn my approach to sculpting; the days of whipping out
a nice rough figure with ease were done for. I worked with
the wax, but it remained difficult. Evenutally, things started
to click. I can actually remember the point at which I got it,
the point where it started to make sense, where the variety
of techniques used for wax all had their place, and I knew
which to draw on at every particular stage.

Using the wax pen drip method and gradually build-
ing the forms is a bit slow, but I like the control, and in
time I learned to speed the process tremendously. Carv-
ing the cool wax to refine and detail was also a challenge,
but when I saw the results of this part of the process,
I knew wax would remain in my arsenal. Detailing with
wax instead of Sculpey is like walking, instead of running,
a marathon. Being able not only to hold the work in my
hand, but to use normal hand pressure was just amaz-
ing. There will always be elements of sculpture better
suited to either material. If I need to sculpt a head with
super-crisp detail, I'll use wax. If I have a figure with lots
of drapery, I'll use Super Sculpey.

The Ghost of Christmas Present, designed and sculpted in
wax by Tim Bruckner.

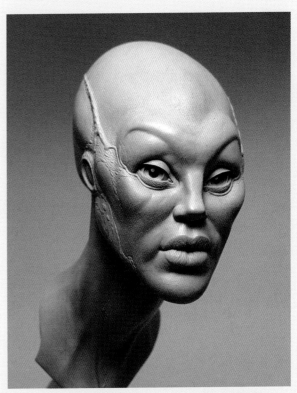

Anne Phibian, designed and sculpted in wax by Tim Bruckner.

Be Cool to Your Tools

It may sound like a cliché, but having the right tools for the job is just as important as using the right materials. Most sculpting tools fall into two basic groups: modeling tools used for adding and shaping sculpting material, and loops or rakes used for removing that same material. In addition to those, there are cutting, piercing, and pattern-making tools. While it's always helpful to have a wide selection of tools for every occasion, you'll likely find that only a handful will jump out of the pack and become the tools you use most often—Rubén has a set of three favorites he's been using for 25 years! Let's take a look at the most commonly used and readily available tools, discuss what they do, and why you'd want to use them.

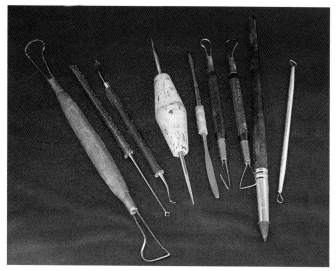

Some of Rubén's favorite Sculpey tools.

MODELING TOOLS: The first and most responsive modeling tools you'll ever use are right there, at the end of your wrist, holding this book. Fingers! The second most important tool will be some variety of what is essentially a stick. Wood, metal, or plastic, sticks come in every size and configuration. They're designed to do what your fingers can't: create shapes, blend, poke, prod, and form the clay in a more precise and detailed way. And when we say they come in every size and shape, we aren't kidding. They can be as big and wide as a two-by-four or small enough to pick the lint out of a gnat's belly button. How you use them and for what is entirely a personal choice.

There is a rule of thumb in sculpting (albeit a pretty broad thumb): Use the largest tool you can for the job. If you're trying to move a lot of sculpting material around, use a large, broad tool; the finer the detail, the smaller the tool. This may sound as obvious as using a hammer to drive a nail, but you'd be surprised how easy it is to lose sight of the obvious when deep in concentration. Sets of wooden modeling tools are readily available from any number of hobby shops, art stores, and online suppliers. You can purchase sculpting tools in starter sets, which are inexpensive, so try out a few. It won't be long before you've identified your favorites. Those favorites will tell you what you like in a tool and might eventually lead you to making your own (more on that later in the chapter).

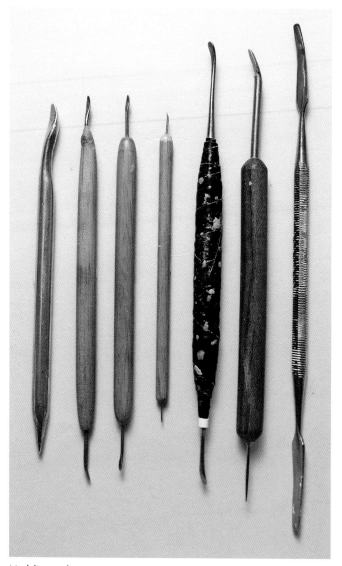

Modeling tools.

Some of the best modeling tools, especially for smaller-scale work, are **dentist's tools**. They're most often made from polished stainless steel, so they can work soft and very firm clays equally well. We're all painfully aware of the various picks a dentist uses, but there are also a wide variety of small spatulas that make fine modeling tools as well. Our motto? "Whatever works."

LOOPS, RIBBONS, AND RAKES: These are tools designed to remove and shape sculpting material. As with modeling tools, they come in a wide variety of shapes and sizes. The basic design is common to all. A wire, either flattened (ribbon) or round (loop), is formed into a circle, oval, triangle, or wedge, inserted into a brass ferrule and mounted onto a wooden handle. By drawing the wire end across the surface of the sculpt, you can remove a little or dig deeper to remove a lot. It's a tool with a number of useful applications. Turn the wire on its end and the tool can draw or score. Angling the tool will create various channels, grooves, and depressions. Need to dig out some pupils or nostrils? These are the tools for you.

Clay, especially oil-based clay, has a tendency to be…*inconsistent* in its consistency. Even the best sometimes have hard spots. A *loop*, often made from spring steel wire, will bend up over the hard spots making it difficult to get a nice, tight, smooth surface. Enter the rake! The *rake* is a wire tool that has been grooved with a series of notches, which cut the clay like a garden rake works through the grass. It comes in handy after you've laid up the clay and given the sculpt a shape with your fingers. The rake tool can level the clay surface, working through those hard or inconsistent spots, taking away the unnecessary bumps and giving you a uniform consistency that takes the sculpt to the next level where the shape becomes form.

Rakes come in a variety of shapes and sizes for broad shaping work or tight finish work; they can also be used to texture or "color" the clay by creating surface variations. Another type of rake is the *wire-wound loop tool*. Try them both and see which one you prefer. This family of tools is a little more difficult to make on your own; this isn't to say you can't, but to start, we recommend you pick up a few of the various commercially available ones and give them a try.

Loop tools…

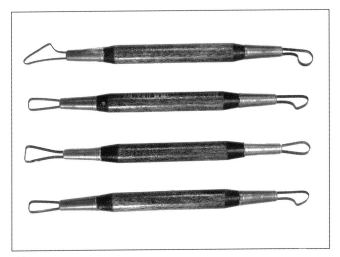

ribbons…

and rakes from Tim's collection.

SCRAPERS AND WIRES: A *scraper* is usually a piece of flexible stainless steel cut into a variety of shapes…and yes, sizes. You use them, just as the name suggests, by scraping; think of them as planers for clay. Because they're flexible, you can bow them between your fingers and draw them across a sculpture's surface to bring it to a nice, workable evenness. These also come with notched ends, kind of like the teeth of a miter saw. They can cut, gouge, score, and shape. They're generally used for large-scale work, but they can also be handy for small-scale pieces. There are also wooden and plastic scrapers, and, depending on the sculpting material you're using, they're also easy to make from brass, copper, or a styrene sheet.

Wire tools are generally a length of wire secured at each end to a short wooden dowel. They're not often used with oil-based clays unless the clay is very soft, but they make a fine cutting tool through water-based clays.

DO-IT-YOURSELF: We also encourage you to make your own tools or repurpose existing ones, if the tool you need is hard to track down or simply doesn't exist. You'll be sculpting away and you'll want to do something specific, maybe get into a tight spot, or create a particular shape or define a nostril or scales. (If the latter, you have our sympathy.) You'll take a look at your tools and realize…you don't have what you need. That's when inspiration strikes, and you'll find yourself rummaging through the kitchen junk drawer or the toolbox to make your own. A good tool is one that gets the job done, be it a clay rake or cheese grater, and you'll become super-conscious of items in your everyday surroundings that have the potential to be the next inventive tool you can add to your sculpting arsenal. Toothpicks, toothbrushes, chopsticks, kitchen utensils, screwdrivers, leather-working tools, Legos, cookie cutters…anything and everything that will get the result you're after is fair game. Just ask before you use your grandma's antique gold-and-diamond hatpin; otherwise, go for it.

The more you refine your process, the more you'll see what you don't have and the more you're likely to make it. Homemade tools are often the best. Not usually the prettiest, but the best. In fact, one of the tools Tim uses most frequently is a hammered and filed finishing nail mounted in a wooden dowel. The old saying "necessity is the mother of invention" applies very nicely here.

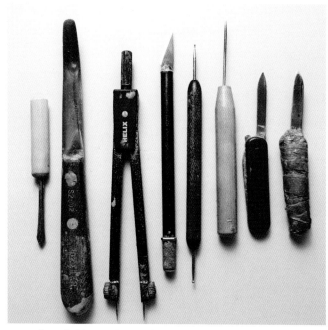

Various household items that Tim has sculpted with at one time or another.

WAX TOOLS

All of the tools mentioned above can be used for sculpting in wax, but they need to be modified to handle the stress of a harder material. When using a loop tool with wax, the constant pressure exerts stress at the tool's weakest point and will eventually bend it to the breaking point, so loop tools need to be reinforced at the ferrule where the wire is inserted. One method of reinforcing the tool is to wrap a length of thin copper or steel wire around the base of the loop, shoring up the join point, and then adding a few drops of Superglue to secure it in place. Even with this added support, loops will break—often when you can least afford it. If you can, always buy more loops than you think you'll need…you'll need them.

Unreinforced and reinforced loop tools.

WAX PEN: The wax pen is a wax worker's best friend. A wax pen is, essentially, a pen with a tip that heats up, the temperature controlled with a rheostat. A wax pen can be used for sculpting and shaping, whether it's moving a lot of material from place to place or adding wax to an eyelid on a head the size of your thumbnail. Now, there are fancy wax pens, with digital readouts, pedals, and chrome pen-holders. We're sure it won't be long until there's a wax pen with an iPod dock. But the truth is, the more a wax pen does, beyond heating up, the more that can go wrong; with wax pens, as with most tools, the simpler the better.

The common feature all wax pens share, aside from heating up, is that they all come with various interchangeable tips. The tips range from broad spatula types to narrow, pointed ends. Sculpting with a wax pen (i.e. using the heated spatula tip to shape the wax) is like using a hot knife to shape a stick of refrigerated butter. You can add and remove a lot of material. The bigger and broader the tip, the more material you can move. The smaller the tip, the less material you'll be able to affect, but for fine, exacting work, that's just what you want. The tip can be modified by filing and sanding it, but you need to be careful not to refine it so much that you break the loop (the tip of a wax pen is basically a loop of wire through which heat passes)—otherwise, the tip won't heat.

Experiment with how your wax works at different temperatures; with exceptions, the harder the wax, the more freely it flows when it melts. If your wax flows very easily with the wax pen, then it's important to let gravity assist you in getting the wax just where you want it. In fact, whether it's watery or syrupy, watching what your wax does at various temperatures will really help you refine your process and give you much greater and more reliable control. In Chapter 5 we'll discuss, in depth, how to use a wax pen—the dos, the don'ts, and the maybes.

RECOMMENDED TOOLS AND SUPPLIES: A CHECKLIST

There are many other tools and supplies you'll need in your sculpting process. While we'll cover them in more detail in later chapters as you use them, here is a quick checklist of what you'll regularly use (painting supplies are covered in Chapter 10):

- 5-ounce kitchen cups
- Alcohol lamp
- Aluminum foil
- Apron/smock
- Armature wire
- Calipers
- Compressor
- Cutting mat
- Dowels and rods
- Dremel
- Dust mask
- Electric drill
- Fan (for air circulation)
- Files
- Heat lamp
- Hot glue gun
- Imaging software
- Jeweler's saw
- Kromekote
- Lazy Susan (optional)
- Lighting
- Magnifying lens
- Measuring devices
- Mixing buckets and containers
- Mixing sticks
- Needle-nose pliers
- Old sheets or tarp
- Paintbrushes (for finishing, not painting)
- Permanent markers
- Pizza stone
- Pressure pot
- Resin(s)
- RTV (for molds)
- Rubber (latex-free) gloves
- Sandpaper and sanding pads
- Scissors
- Sculpting stand (optional)
- Storage boxes or bins
- Stove (or camper's stove)
- Wires of varying gauges
- X-Acto knife

Tim's Giles Precision Waxer, one of three he's owned in his career.

PRO'S PROSE: **TOOLS**

Here's where our honored professionals weigh in on their favorite sculpting tools, giving advice and tips on getting the most out of them.

KAREN PALINKO
ON TOOLS FOR WAX

I have tons of tools. But my primary tools are two mini-loop tools purchased from Ken's Tools, an arrowhead spatula, and a very fine awl. The awl is a great all-purpose tool: The tip is good for sculpting eyes and minuscule details; laid on its side, it's good for roughing in fabric folds. The spatula and loops I use pretty much the same way, for refining the surface. I occasionally use a wax pen tool, but sparingly—mostly for soldering parts together or for "drawing" hair strands. I also use small, flat, soft bristle brushes for areas that I can't reach, and where I want to keep the look of soft flesh. For unusual circumstances, like sculpting miniatures, I've occasionally made a tool specific for the project (usually a sewing or upholstery needle mounted on a handle) but I find that I tend to go back to my favorite four or so tools.

TONY CIPRIANO
ON TOOLS FOR POLYMER CLAY

I have this one tool that I picked up at a flea market in Florida, a long time ago, and it's an old dentist tool. One side is pointy, and the other side is rounded, like a spatula, and I use that tool on everything. I've used it for maybe fifteen years. If I ever lost it, I'd be dead, because I've never seen that same tool again. I use those tiny loops occasionally, but mostly I would say that I use five or six tools, tops. I have a drawer overflowing with tools, some that I made myself with guitar wire, a lot of rakes and stuff, but I just keep going back to the same four or five tools.

JONATHAN MATTHEWS
ON TOOLS FOR CASTILENE

Although I have the overflowing tool chest of a professional sculptor, I only end up using a couple work lamps, a tealight candle, and three or four tools. I have a 100-watt lamp set up on a timer hovering above a plate of castilene chunks, and when I wake up in the morning, the timer has had the lamp warming up the Castilene so it's ready to go when I get in the studio. When heated, Castilene is very soft and pliable, if somewhat sticky, so I can just grab pieces of soft Castilene and block in a figure in no time at all. I'll add sharper details with dental and sculpture tools, using the open flame of a tealight candle to keep the tools hot so the Castilene doesn't stick to them while I work. I smooth areas with sandpaper and refine smaller areas with dental tools. The bulk of the time I spend on a sculpture is during the refining and finishing stage, so after I rough in a figure, I'll put on my headphones, kick back in my chair, and settle in to the tedium!

ALTERTON

ON TOOLS FOR
EPOXY PUTTY

When I'm working with fresh
epoxy, I use metal dentist tools
with Vaseline, liquid dish soap,
alcohol, or water to smooth and
blend. My favorite tools are the PKT3 (a dentist tool with
rounded endings) and the Hollenback (one with blade-
shaped endings). When I'm working with cured epoxy, I
like to use a Dremel rotary tool and sandpaper. I also use
a combined technique, where I do some effects with the
material in the fresh stage and then finish those effects
with the rotary tool when it's cured and hard as rock.

WILLIAM PAQUET

ON TOOLS FOR
POLYMER CLAY

For Sculpey, I have one tool,
shaped like a pointed, concave
ski on one end with a sharp,
pointed stylus on the other.
Quite honestly, if that were the only tool I had, I could
do everything I needed with it, with the single exception
of smoothing small areas, which requires a very small
paint brush. For areas of great delicacy, like small faces or
hands, I usually utilize very fine steel wool, torn into small
pieces and rolled between my fingers to form pointed
tubes. These are not unlike the pencil burnishers used by
illustrators. An amazing amount of control is achieved
with these tiny sanding pads.

3-D Scanners and Digital Sculpting Programs

Technology is an amazing thing. Just as a photocopier can repro-
duce a two-dimensional image, there are computer programs
that allow us to reproduce three-dimensional objects. Gentle
Giant Studios in California does data collection for movies, going
out on location to digitize actors, props, and sets to use as a
database for everything from special effects to camera tracking,
and they were the first to take that 3-D data and use it to make
toys. "In the world of toys and collectibles, using that real ge-
ometry allows us to get the true form of that actor or prop and
reproduce it at a scaled size," explains Gentle Giant founder Karl
Meyer. "A lot of people like an artist's interpretation and flair, but
when you're going for actuality, using the scanning systems and
the data from them really gives you a foundation where a lot of
the guesswork is taken out of it."

He compares a sculptor learning ZBrush to a pianist learning
the saxophone; the music is inside them, but they need to train
their hands to accommodate a different instrument.

PRO'S PROSE: **DIGITAL SCULPTING**

One of the premier digital sculptors in the business talks about working in 3D.

JIM MCPHERSON
ON DIGITAL SCULPTING

Working in high-poly modeling, or "digital clay," has completely changed my workflow from when I sculpted traditionally. Working in real clay, one has to do the steps of the sculpting process in a given order, so the client can "sign off" on each stage of the process, but the client can't really make a good judgment until they see the final piece. So the faster the artist can illustrate his final intention, the better. This is where the advantages of digital clay modeling come in. I use the program ZBrush. Some people prefer Mudbox, but either high-poly program will work. From the first day I started in digital modeling, I found the process as comfortable as picking up my familiar sculpting tools.

A high-poly model starts from a simple computer model made of polys, or rectangles, joined together to make a three-dimensional virtual object. Each rectangle is then subdivided in length and width to achieve a higher level of detail, and when the polys are subdivided enough times, you no longer see the boxes—you see a claylike object. You can then modify each divided level separately, providing the final finish on the highest level. And, by moving the points of the simpler lower levels, you can shift the detail on higher levels. In this way, you can completely detail the digital sculpt, *then* change the proportions and positions of the larger forms, and the details follow automatically. You don't lose the finished detail when you change the form as you do with traditional sculpture.

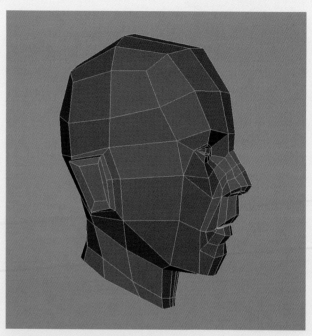

A simple 3-D computer model of a man's head.

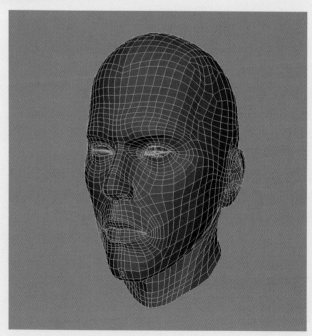

Polys are subdivided for a higher level of detail.

When the polys are subdivided enough times, you see a claylike object.

The man's head has now morphed into a gorilla's head, thanks to the magic of ZBrush.

To me, the biggest advantage with digital sculpting is the ability to paint while I sculpt. I can look at the proportions of the areas of color (critical), and can even include simulated matte or shiny surfaces. You can also make spinning movies of your digital sculpture, called turntables, to show your client the work from different perspectives. All of this means you're able to give a good indication of the final product before any molding takes place.

Additionally, you can easily rescale and reproportion parts of the model (and mask the parts you don't want to change). How many times have we heard, "Make the head 10 percent smaller?" In order to accomplish this through traditional sculpting, you have to physically redo it. With digital modeling, the model can be whatever size you desire in only a few minutes.

There's also the ease of making a completely s ymmetrical figure and being able to pose it in an infinite number of ways. Imagine sculpting one side of a figure and being able to completely duplicate it on the other side with no additional work. And you've all heard of the "undo" button? It's not as easy to "undo" things in traditional sculpting, but it's part of the freedom of working digitally.

A statue created entirely in the virtual world, by Jim McPherson.

A Happy, Safe (and Efficient) Workplace

Since moving your work back and forth from the kitchen table is a pain in the neck (as well as potentially lethal to your sculpt), set aside a place for your workspace, be it a closet, back bedroom, or a corner in the garage. Ideally, your workspace should be comfortable, if not downright cozy. You'll be spending a lot of time there…a *lot* of time, so make sure you have a comfortable chair with good back support.

Try and situate the things you use most frequently near you. If you have the room, set up a few separate workstations: a sculpting station, a molding/casting/finishing station, a painting station, and a photography station. (See the respective chapters for breakdowns of workspaces other than for sculpting.) But no matter how hard you try, stuff travels. Before you know it, there's clay in your wax, resin dust in your clay, and primer overspray on everything, and your space is so crowded that it threatens to engulf you. A few big cardboard boxes or plastic storage tubs that can hold your clay and clay tools, another for your wax stuff, another for painting supplies, and one for your casting and resin finishing can go a long way toward helping keep them separate. A couple of old sheets or tarps draped over work in progress when moving from one activity to another also helps make sure ev-

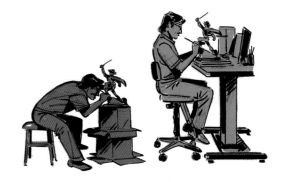

Unless you want to become a hunchback, sit up straight while you're sculpting.

eryone minds their own business. When Tim and his wife moved to Wisconsin, his entire studio was in a small back bedroom. It looked like a warehouse worth of stuff stacked to the ceiling in a clothes closet. But it was a *well-managed* clothes closet.

SCULPTING STATION: No two setups are the same. And believe us, the space you set up today, you'll change, alter, add to, and subtract from over the years. As your needs change, so will your setup.

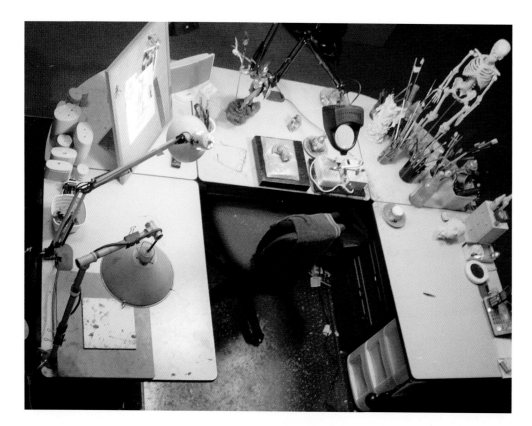

Tim's U-shaped sculpting workstation gives him three work areas and ample drawer space: sculpting at the bottom of the U, his tools to the right, and the warming station to the left.

Establish your workplace near available electrical outlets. A power strip is a must, since you'll be running lights, a wax pen, possibly a Dremel tool, a drill, a fan, a computer power adapter, a phone, a back-massaging chair (hopefully), and an alpha-wave machine (possibly). And for geezers like Tim, a lighted magnifying lens.

An all-purpose desk is a great place to start, as desks often come with a roomy top and a few drawers. The amount of table space and how you lay it out will be critical, because the work area will fill up before you know it. You'll want a place to view reference—you'll be surprised how much room this will eat up. You'll have books open, magazines propped up, pictures and printouts taped to every vertical surface…and don't think the floor won't come into play, as well. You can buy small plastic cones with slots in them that hold up sheets of paper, and you may also want to set up a computer laptop stand, so you can have numerous color images at your fingertips. It'll save space *and* printer ink, you can zoom in whenever you want, and if it has Internet access, you'll be able to get new references on a whim!

Drawers are very helpful for keeping desktop clutter to a minimum. Those plastic drawer units you can get at the hardware store, old nightstands, stackable bins…you can't go wrong with anything with drawers. In fact, the more drawers, the merrier! Your tools will start out in an old jar or soup can or a ceramic pot, but before long they'll be spread out among the reference materials or piled up somewhere, defying you to find the one you need among the clutter. You'll want a place for your brushes, your coffee mug, the stereo remote, your alcohol lamp, wax pen, a lazy Susan. Did we mention reference space? And room for lights and lenses.

Sculpture stands make it much easier to sculpt. These stands pivot, which is a big plus, and they're pretty sturdy and steady. (No one wants to be working on a piece and accidentally push the whole thing over.) With a tabletop model, you can duct-tape the armature base to the top of the stand and turn as needed, giving it extra weight and wide leg support. Tim uses both tabletop and freestanding models, often in conjunction. In our dimensions for building an armature, the base size we use accommodates both the table stand and the full stand. The placement of the support rod, which is ordinarily about a inch from the back, was moved to two inches to accommodate a piece of duct tape to hold the base to whichever stands are being used.

Tim's sculpting stand.

Rubén sculpts on a motorized architect's table that goes up and down, so he can work on different sections at different heights. (Just watch out for that second button, because it tilts everything forward—not a pretty sight.) Behind him, he has a traditional animator's table where he can draw out the blueprints for his sculpts, such as armature info and even the initial designs of a piece.

Wherever you set up and whichever setup you use, remember this: You'll make a mess. It can't be helped; sculpting is not a job for the obsessively tidy. One of those plastic floor guards will come in handy. But even the best of intentions won't stop material from taking up permanent residence on the floor, tables, and the bottom of your shoes. And the mess will travel. It really isn't a bad idea to have a pair of studio shoes, slippers, or flip-flops. If you share your living quarters with someone, be kind and contain. Or at least try. And after each project, clean up and rearrange your space for the next one. Trust us; it's time well spent, and you'll feel much better going in for the next challenge. If you don't, someday someone might find you under a pile of reference!

Rubén's sculpting workstation has tools to his right and reference materials and his computer in front of him. Larger tools go to the left, with one lamp on each side for even light distribution.

Tim's warming station.

WARMING STATION: One of the most important factors when you begin sculpting is how quickly and easily your material responds to decisions based on instinct and emotion. The clay should be an extension of your creative energy, and not something you should have to battle to get its cooperation. Most polymer clays are soft and pliable and respond to the sculptor's touch with immediacy, but unless you're using a soft plastiline, one that's easily malleable at room temperature, you'll need a means of making your clay soft, pliable, and responsive.

An easy way to warm medium or even firm clays or waxes to make them easy to use is a heat lamp suspended above a pizza stone using a few lengths of threaded pipe and a spring clip. A little trial and error will show you how high above the pizza stone to position the heat lamp. Start off at around 18 inches and see how it works for you. If the clay gets too hot too quickly, move the lamp up. If it's too slow and not warm enough, move the lamp down. The beauty of the pizza stone is that it retains heat and helps warm the clay from the bottom as the lamp warms it from above. It should be noted that you may need to reposition the clay now and then to prevent it from getting too soft, unless that's what you're after.

LIGHTING: Lighting is one of the most important parts of any setup, and yet, like the setups themselves, no two lighting layouts will be the same. Consistency is key. It's a good idea to try and set up your lighting so that night or day the overall effect is the same. If your setup relies on daylight, make sure your lighting set up replicates daylight when you're trying to meet a deadline at two in the morning. Sculpture relies on the relationship of light and shadow, and how you see your work will, in large measure, affect the way you work with that relationship. Maintaining a consistent lighting system, day to day, week to week, will give you a reliable frame of reference. The direction and intensity of the light you sculpt under should be similar to the lighting you'll use for photography, especially if you're working with an AD or PM. You want them to evaluate your work under the same conditions that you created it, which means under the same lighting, so they can see the same lights and shadows you saw while sculpting.

With lighting, there's no need to get too fancy. A single light source can work great, as long as there is some ambient light to even out the contrast. Every once in a while, take the piece you're working on and look at it under a different light source

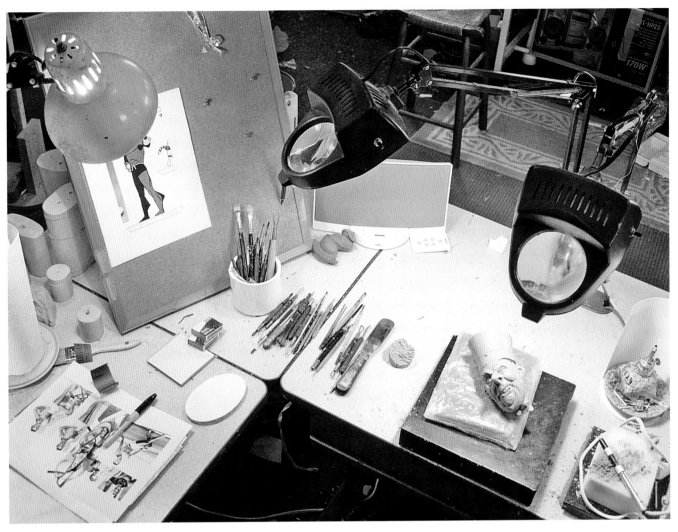

Tim's lighting setup.

for a different perceptive. Although you'll be as consistent as possible with your lighting throughout the process, looking at your work under different lighting can tell you how it will look in different locations so you can adjust your working lighting as needed. Rubén uses two ring fluorescent lamps with 60-watt halogen bulbs in the centers on either side of the piece he's working on. Tim uses a daylight-corrected, full-spectrum, 60-watt bulb, which is slightly biased toward the red spectrum. That's what works for them, but we encourage you to explore and experiment to find out what works best for you—it could be one light source or five!

Distractions: This comes under the "whatever works" category. Whether you prefer to work in monastery-like silence or with the TV blaring, it's up to you. But with whatever ambient noise you create in your working environment, keep in mind that anything that distracts you from your work will come back,

eventually, and bite you in a place that would make sitting down highly uncomfortable. So, keep in mind that if you've got the TV Game Show channel or NPR playing in the background, it should be there to help your work, not distract you from it.

There are going to be things you just don't want to do—some sculptors, for example, are not fond of sculpting feet, bare feet in particular, and when faced with the task, they'll create distractions of a dazzling variety just to put it off. But every time you work your way through a problematic situation, you increase your confidence and give yourself fewer excuses.

Speaking of work, it's time to move on to Chapter 3, which is all about…hey, something shiny!

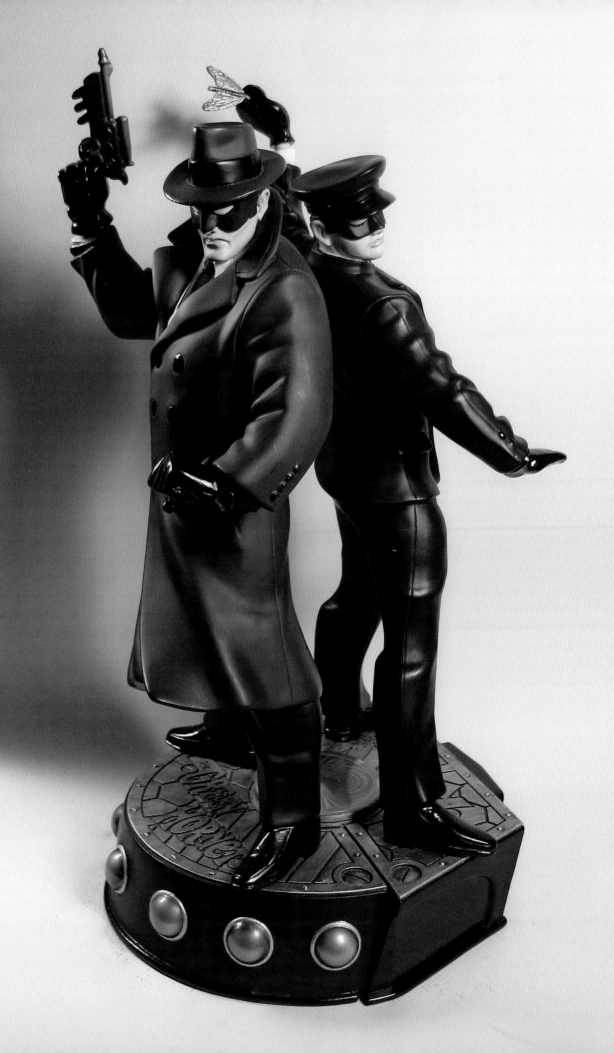

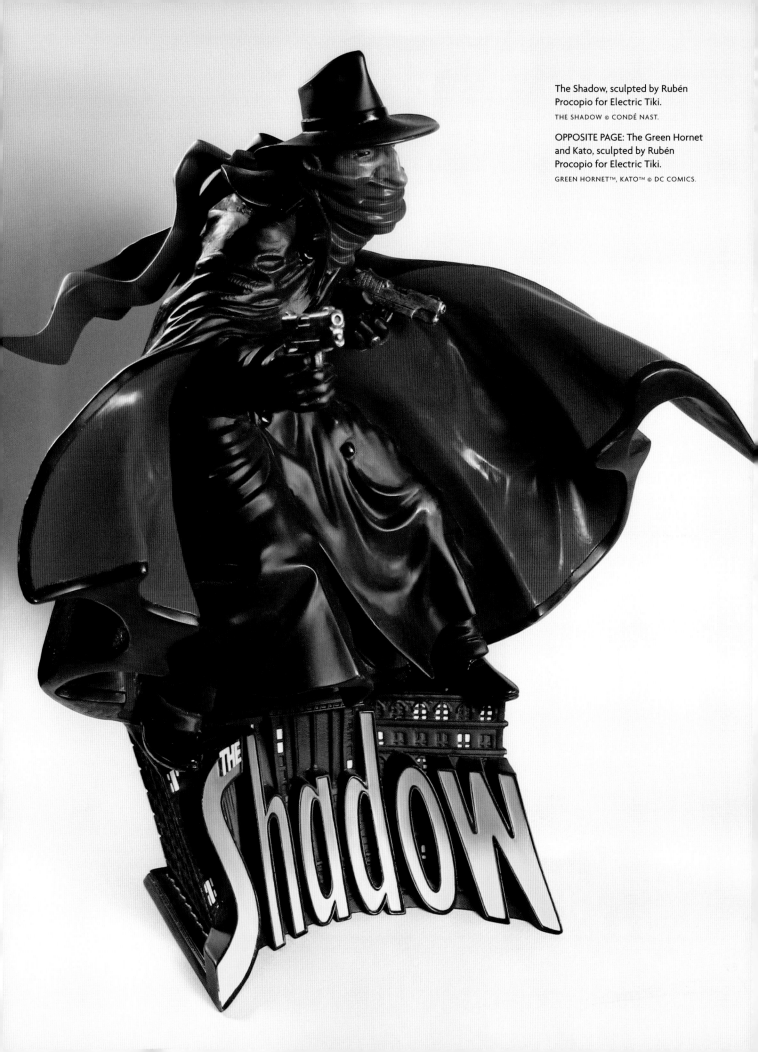

The Shadow, sculpted by Rubén Procopio for Electric Tiki.

THE SHADOW © CONDÉ NAST.

OPPOSITE PAGE: The Green Hornet and Kato, sculpted by Rubén Procopio for Electric Tiki.

GREEN HORNET™, KATO™ © DC COMICS.

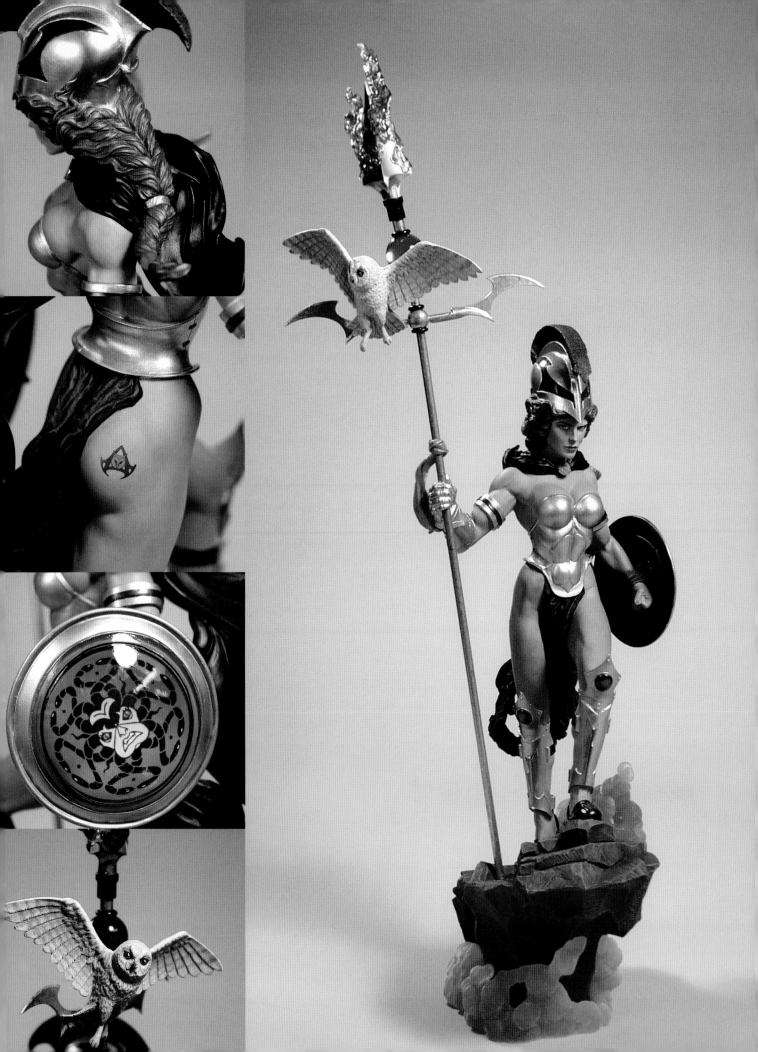

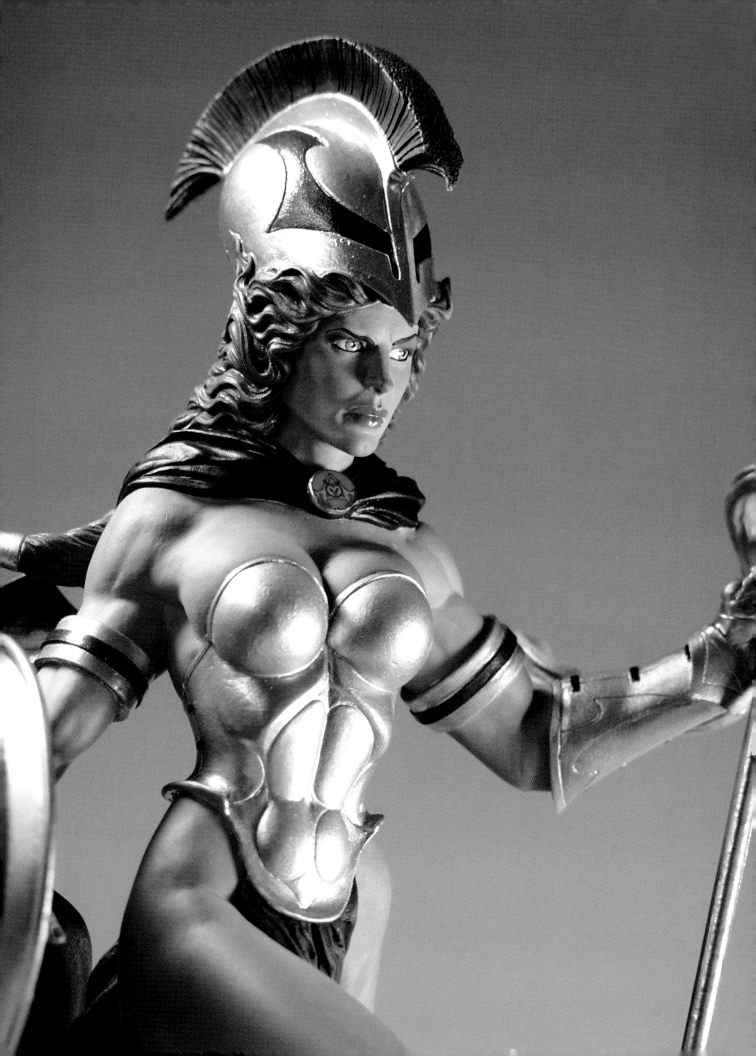

3. The Rough Sculpt

SHAPING YOUR CLAY INTO THE PERSON OR THING YOU WANT IT TO BE

Now that you have your references and your design and your supplies and your workplace, you're finally ready to start sculpting. And it's only the third chapter! We're making good time. This chapter will focus on how to create a rough clay sculpt for a posed statue, or an action figure with limited poseability. If you're sculpting a more poseable action figure, and you're planning on incorporating articulation into your sculpt from the beginning (which we recommend), you should read Chapter 8 before entering the actual sculpting phase in this chapter. But if you've got a single pose in mind for your statue or figure, then you can start right here, and the first thing we're going to talk about is making an armature—the basic framework on which you build your rough clay sculpture.

Before an internal support system…

and after! Thanks, armatures!

It's What's Inside That Counts

Why do you need an armature? Well, why do you need a skeleton? Without a skeleton, you'd be a pile of organic matter doing the Jell-O jiggle on the floor, and it's the same with a clay sculpture. Most clays are not self-supporting, so any sculpture that has arms, branches, or a tail will need a well-constructed form to keep everything where you want it and allow repositioning. Otherwise, you'll be limited to sculpting snowmen, or anthills, or a snowman on an anthill.

You can't just twist a few coat hangers together and call it an armature. Working up (laying up) a piece of sculpture in clay involves a lot more energy than any other part of the process. Rather than taking your time and contemplating every precise detail, as you will in the finishing stage, you'll be working quickly and forcefully to capture much of what your sculpture will become in a relatively short time. You might get aggressive and physical—pulling, bending, scraping, cutting, but most of

all *pushing* clay onto a wire form that must be able to take the abuse and keep smiling, so to speak. If finishing is ballet, laying up is like boxing, and the armature is your heavy bag. So the importance of building a strong, sturdy, and solid armature can't be overstated.

You can buy ready-made armatures in a number of places. They come in fairly standard sizes, from 8 to 36 inches, and they range in price from about $18 to $130. This is a recurring cost, as the armature itself is usually unrecoverable. (When you cut up your clay rough to cast it, you'll cut up the armature inside, as well; in working with polymer clay or epoxy putties, the armature is permanently embedded in the piece.) Learning to build your own armatures will save you time, money, and frustration. It also helps you in the critical planning stage, when evaluating your statue, its needs, and practical concerns.

Now, there's nothing fun about building an armature—some have equated it with a visit to the dentist. (No offense intended, if there are any dentists reading this.) But as little fun as it is, it pales against trying to add clay to your sculpt with one hand while trying to hold up your statue with the other. Making a flimsy armature is one of the most common mistakes people new to sculpture make, but they rarely make it more than once, because the disappointment and frustration from working on a wobbly, unsteady sculpture is not an experience you'd want to repeat. A little time and effort at this stage will save you having to buy antacids by the case.

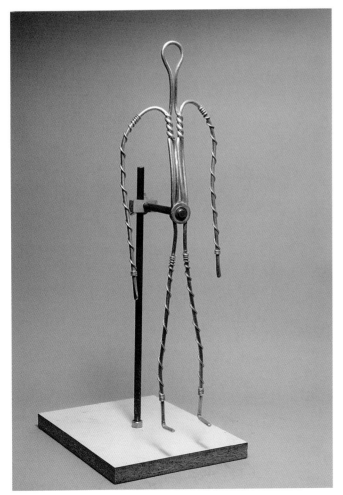

If you're not so mechanically inclined as to make your own, you can buy a premade armature like this one.

If you don't build your armature sturdily…well, don't expect to win any major awards.

BUILDING AN ARMATURE

Okay, sculptors, it's time for fun! And we're not talking Velcro-jumpsuits. We're talking armatures, baby! We've told you why you need one. Now, we're going to show you how to build one. What follows are step-by-step instructions on building an armature from materials found at your local hardware store, as well as a few things from an art supply store. Ready? Set?

Everything starts with the art, and silhouetted art of the subject will really help you to build a useable armature. You can create silhouetted art from any picture using imaging software. Print it out at the actual size of the figure. If it's too big to fit on one piece of paper, tape a couple together. We could have used our final Athena design, but Rubén drew her in a basic pose, without armor. Take the shrink rate of wax and resin into account when making this scaled, silhouetted guide. See page 82 for details **(1)**.

Armature wire is a soft aluminum, easily bendable, noncorrosive wire. It comes in various lengths and diameters and is available at hobby, craft, and art stores, and online. We're using $1/8$-inch diameter wire to construct the armature and $1/16$-inch diameter wire to wrap that armature. There are other types of wire that come in similar sizes, but stick to armature wire. You'll be glad you did **(2)**.

On top of your art, take a length of $1/8$-inch wire and loop and twist out a head in the center of the wire length. Use pliers to hold the loop, and make a tight twist. Bend the wire at the shoulders and then straight down to below the feet **(3)**.

Straighten out another piece of $1/8$-inch wire and, before cutting it, lay it along one arm to the finger tips or a bit beyond. Mark where the wire hits the shoulder, add three or four inches and cut. Cut another wire the same length and transfer the shoulder mark. Hold the wire against the shoulder at the mark

and twist those extra inches around the vertical wires as shown. Use pliers to twist both wires tightly together. Repeat. Voilà, two arms **(4)**!

Using the art as a guide, bend a waistline into the armature with the pliers. Note how much room we've left around the wire. It's better to use more clay to build up your sculpture than to have to work around a wire that's too close to the surface, poking out where it should be poking in. After positioning the wire, lay your armature on something sturdy and hammer the waist section flat, to $1/16^{th}$ of an inch or so. (If the waist gets bent out of shape, the pliers will help you bend it back.) Hammer flat the ends of the wire where the hands and feet will be. (About the hand and feet parts: you *may* use them as supports for your clay hands and feet, but you may end up cutting them back or making them more narrow. It's a rare armature that doesn't go through some ch-ch-ch-ch-changes as clay gets involved.) **(5)**

Let's get the base done. We suggest a piece of wood around 10 × 7 inches and about $3/4$ to 1 inch thick. (Particle board, pine, oak, whatever you have lying around in the scrap pile, will do.) Sand the top and the sides and give it a few coats of a gloss varnish to give a nonporous working surface, making it easy to clean up and to roll out clay. For the rod, we used a $1/4$–inch-diameter brass rod about 14 inches long, but you can use, steel, iron, or whatever, as long as it won't bend or droop under the weight of the clay. Mark off 2 inches from the end of the varnished wood, centered, and drill a $1/4$-inch hole through the wood at the marked spot. Place the rod in the hole and hammer-tap it down to the bottom of the hole. There you have it, a no-frills armature base **(6)**.

This is a family portrait of the hardware you'll need to attach the armature to its base (see page 81), all available at hardware stores. Each part works with a $1/4$-inch, coarse-thread 20 rod,

5

6

which you will also need. All of these parts come in different sizes and threads, so whatever you end up building, make sure that all the parts work together. Thread them up at the store **(7)**.

Time to set up our armature. Using a hacksaw, cut the ¼-inch threaded rod to the length you want. Ours is about 7 inches long; you don't want to go much beyond the base. At one end of your threaded rod, screw on the set collar, position the hammered waist section against it, then the washer, and then the nut **(8)**.

Sandwiching the armature wire between the hardware gives a firm and steady support, so use those pliers to tighten it down good. If you're one of those aggressive clay pushers, you might want to encase that assembly in some epoxy putty **(9)**.

The cable grip comes with two nuts—no jokes, please. We're going to replace one of them with the longer nut. Either one. You choose **(10)**.

Slide the grip down over the vertical support rod and slightly tighten the short nut. That will keep the thing in place

while you screw the threaded rod into the long nut. You'll have to loosen and tighten here and there, but with a few adjustments you now have an armature that's ready to be used **(11)**.

Wrapping a length of ¹⁄₁₆-inch wire around your form, over the ¹⁄₈-inch wire as shown, gives the clay more to hold on to so the clay stays put as you work. The downside is that if you want to, say, make longer legs or shorter arms, you have to remove the clay from the armature and resculpt that section. (Rubén calls this "major surgery," and boy, has he had a lot of those.) Without the wire wrap, you can cut the clay at the lengthening/shortening point and slide it down (or up) along the armature wire, keeping your sculpt largely intact. It's a matter of personal preference. Sometimes, you feel like a wrap, sometime you don't **(12)**.

Okay, your armature is built and can withstand gale force winds. Check your form by laying it flat on the actual-size silhouette you prepared earlier, as shown. (Make sure to save this silhouette art—you'll need it again.) If the pose is pretty extreme,

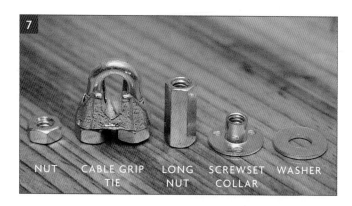

NUT CABLE GRIP TIE LONG NUT SCREWSET COLLAR WASHER

you may not be able to get an accurate gauge of how your armature works within the body of the figure, but do the best you can. The beauty of a well-constructed armature is that you can make adjustments anywhere along the line. It's never too late to be right **(13)**.

Here we are with our armature assembled, posed and ready for clay. Sculptors, start your warming stations **(14)**!

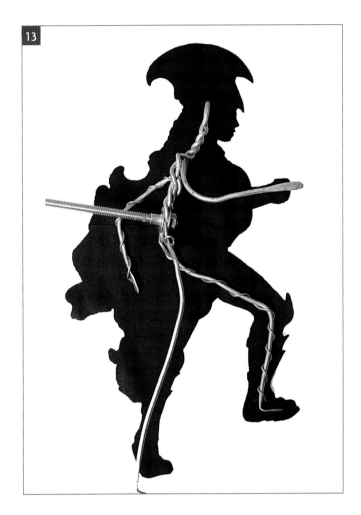

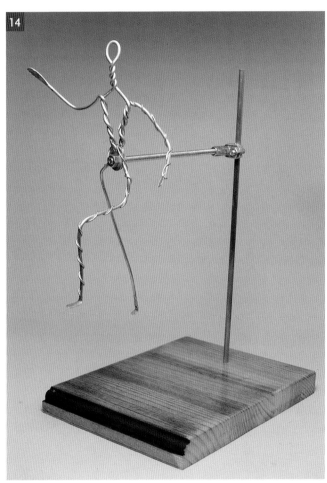

WILLIAM PAQUET: SCULPTING POLYMER CLAY ON A WIRE-WRAPPED ARMATURE

To begin a sculpture, I make a wire armature using ⅛-inch aluminum wire, and I wrap the body of the armature with 24-gauge wire to give the polymer clay something to grip; otherwise it would simply slip off the bare wire as I work. I mark the joint placement on the frame with a Sharpie to be sure the proportions remain constant, and then I add clay to the torso, head, pelvis, and upper and lower arm and leg areas, leaving the joints open. This is then baked, and I have a poseable armature, similar to an illustrator's wooden mannequin. I then work this to achieve my desired pose, and when that's done I add more clay to build the body up a little more (still leaving a generous area to continue adding clay), and I fill in the open joints. I then bake the figure again, locking the pose in place, and from there I add clay until the figure is basically complete.

Going In for the Layup: Creating Your Rough Clay Sculpt

Welcome to the most important part of the book. This is the big-picture stage where you'll create the foundation on which your statue will be built by laying up—i.e., putting the clay onto the armature. You'll build mass, decide proportion, create attitude, and review composition. This is where you make all the choices you'll have to live with for the next few chapters. This is where you get to change your mind—and be prepared to change your mind in service of the statue. This is where you'll finally roll up your sleeves and get to work. Did we mention you were going to need sleeves? Too late, keep moving!

THE BASE: With your posed armature placed on its support system, you'll need to establish what the base will look like. Of course, if you're making a standing figure, you can simply put it onto a flat base once you've finished. But if your figure has a foot raised—be it resting on a rock, a shattered column, or a fallen adversary—you need to gauge the height and angle of the raised foot from your art and create a placeholder, something to stand in for the actual base to ensure your figure is correctly positioned. So, rather than sculpting the base out of clay right away, you're going to build a mock-up out of foam core, balsa wood, or any sturdy material. You sculpt the figure first to make sure it works how you want it to before you lock in its environment.

SCULP-TOR SEZ: SHRINKING WAISTLINES AND OTHER BITS

While laying up your rough sculpt, keep in mind that you're eventually going to be casting this piece in wax, which will cause it to shrink a little bit, and then you will cast it in resin, and it will get even smaller. This is a major issue, because sculpting statues and action figures is size-sensitive. Clients want their particular projects to be within a certain size range, especially if the piece you're contracted for is part of an existing line. So it's important to try and anticipate the shrinkages you'll confront as your sculpture moves through the process, from clay, to wax, to resin, to client.

Wax formulas vary, and so do their shrink rates, but the general rule of thumb is to allow for 3- to 5-percent shrinkage. Castable resins such as polyurethane, polyester, and epoxy all shrink as they cure, and those shrink rates will vary depending on the size of the casting and the heat it generates, but factor in an additional resin shrink rate of 4 percent to 7 percent. It's often best to err on the side of caution. Assume that large-scale pieces will shrink at the top of the scale and that smaller scale pieces, say a midsize statue or action figure, will be more inclined to shrink at the bottom end of the scale. Being off by a few percentage points one way or the other is to be expected. Even as the sculpture goes to manufacture, the piece will undergo an additional stage of reduction, especially in prepainted, resin-cast statues. So plan ahead as best you can. After carefully considering the shrink rates inherent in your process, increase the size of your rough clay overall in compensation. An easy way to adjust the size is to increase your guide art by an appropriate percentage and use its adjusted measurements.

Always take shrinkage into account when determining the overall size of your figure.

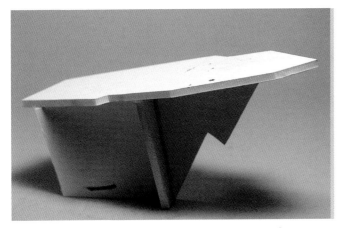

Foam core mock-up of Mount Olympus. Not so impressive, is it?

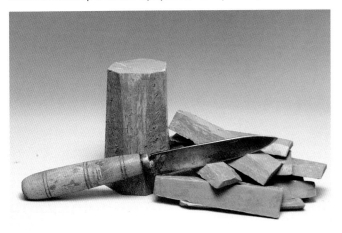

Cutting up your clay for the layup.

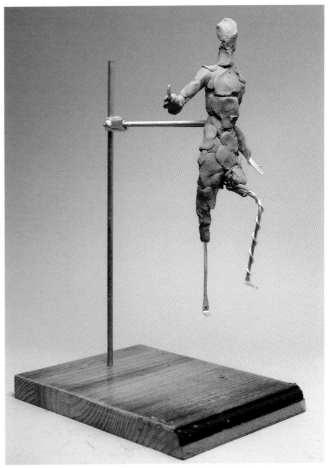

Laying up the figure.

CUTTING CLAY: With your warming center conveniently located within reach of your workspace, cut your brick of clay into strips (as shown) and arrange on the pizza stone. Keep an eye on how long the clay is under the lamp and how hot it gets and make adjustments accordingly. If you're using one of the softer oil-based clays or plastilines, you may have to reduce the heat by increasing the distance between the stone and the lamp. And be careful not to handle too-hot clay, or you can expect a lot of clay-baked fingers to result.

LAYING UP THE CLAY: Now add, or lay up, clay to the armature, building up the figure and referencing your art frequently. Use your calipers to check and recheck your proportions—we all have aesthetic biases, and those biases can creep into our work without us even knowing it. In some circles, this is known as style. In and of itself, it's not a bad thing, unless you're hands-for-hire, and you're getting paid to capture someone *else's* aesthetic biases. This can be especially problematic when the art you're following is highly stylized, so check often.

NOT NECESSARILY A NUDE: START WITH THE NATURAL FORM

In figurative work, it's best to start building a statue the way nature brought us into the world: naked. (That is, the statue should be naked, not you—but feel free to wear as much or as little as you like.) Even if your figure is ultimately going to be dressed, having the understructure of the body helps whatever costume you eventually add to make sense. One informs the other. The viewer may not see this extra, underlying work and may not be able to identify *why* the piece works, but without laying this foundation, the viewer often senses something is wrong, without being able to say why.

Eventually, you'll extend parts of your statue beyond the basic armature shape (Athena's skirt, for instance). **Armature extensions** are additions of armature wire plugged directly into the clay, deep enough to give them support while we lay up softened clay around them. This method gives you the greatest flexibility in adding, removing, or modifying elements of your statue.

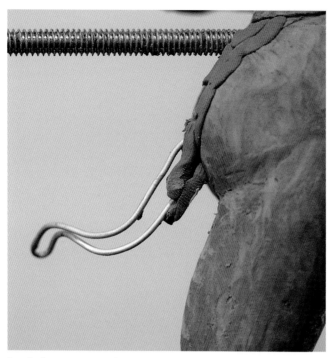

Detail of armature extension.

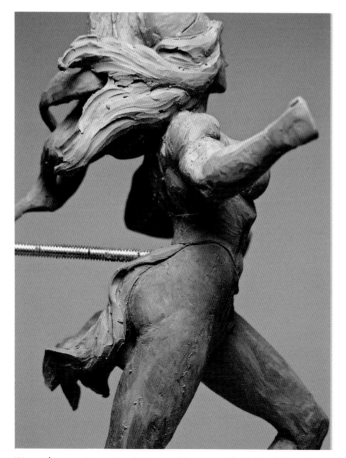

We used an armature extension to provide support for Athena's fluttering skirt.

For the extensions on Athena, we used a loop of $^1/_{16}$-inch armature wire plugged into the body of the clay about ¾ inch deep, as shown. Remember, we're using a medium firmness NSP clay by Chavant; if you're working with a clay that is a little harder, heat the loop over your alcohol lamp (using pliers) to ease placing the loop where you want it, at the depth you want, without bending the extension. Once the loop is in place, lay up clay at the insertion point for greater support, and then press out pinches of clay and fold them over the loop, making sure to press the clay in between the wires (as shown). When the clay cools a little, you can go ahead and lay up onto this extension as you would if it were part of your original armature, taking a little more care not to be too forceful.

Keep sculpting, laying up clay, adding extension armatures as needed, until you've "completed" your rough sculpt. Use the same technique of armature extensions to construct Athena's skirt, her hair, and part of the helmet.

I NEED MY SPACE: CHECKING THE ROUGH SCULPT

As your statue comes to life, be aware of how the piece works in physical space. Things that may hold up on paper often fall apart in the three-dimensional world. Look at the silhouette the statue creates, and see if it serves the composition without all the interior detail. Look at it in a mirror—or even upside-down—to spot discrepancies. Check it from every angle and try to make each view of the statue support the whole. Although there's going to be a "money shot," no part of the statue should be in compositional debt because of it. A good statue works in its environment and encourages the eye to move around it and over it in the physical space it occupies.

Don't be afraid to tinker with your composition—this is the last time you'll be able to do it easily. You'll really want to take a look at the planes of your sculpture from various angles to see how many of them line up. Sometimes a statue looks great from the front, then as soon as you turn it around it's as flat as a pancake. If the chest lines up with the stomach, which lines up with the legs, and the arms are parallel to the chest and stomach, you've got a pretty flat-looking sculpture—it's a portrait of a guy waiting for a bus. If no bus terminal is part of your composition, it's time to break up those planes so the sculpture conveys the same action from all sides that it does from the front.

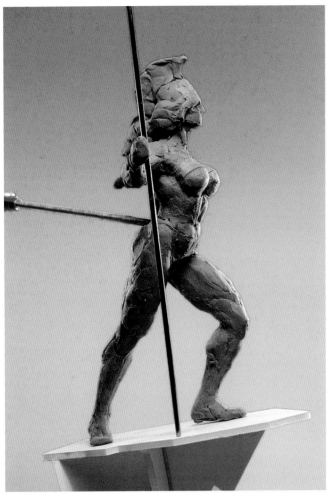

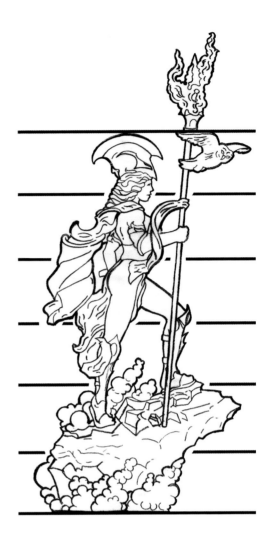

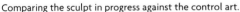
Comparing the sculpt in progress against the control art.

Sometimes all it takes is a change in the bend of knee or elbow, or a twist of the waist or turn of the head. As we mentioned earlier, not all 2-D art works as a straight translation to 3-D, so a little artistic license now and then may be necessary to help make that 2-D design blossom into the fullness of the Garden of Three-Dimensional Delights. If an arm's position looks wonky, change it; try moving it here and there until it works. Legs look like your character is ready to trip over itself? Move them until they look like they'll support the body and convey a sense of the action. Be brave! Be bold! Be the world's finest even! Your motto, at this stage—and for life in general, perhaps—should be, "Don't be afraid to screw up." It's only clay, after all.

Listen to the piece—it may sound a little "crystals and moonbeams," but each sculpture has a voice and will tell you when things are right or wrong if you're open to hearing it. When you've got the piece fully laid up, and all the elements are in place and in proportion, take a series of pictures and have a look at your work. This will help distance you from it and give you an alternative perspective. If there are parts that just don't look like they work at this stage, it's important to try and resolve them now. From this point on, your work will be judged through 2-D images, whether on paper or on a monitor.

BASES: HOW LOW *CAN* THEY GO?

Now that your figure is completely roughed out, it's time to start working on your base. Because of the way our armature is built (as with many commercially available armatures), your figure can be raised, lowered and moved from side to side, making it easy to position on the base. As you sculpt the base, move the figure onto and off of the base frequently to make sure the figure and base fit together.

Depending on your comfort level and working method, *finishing* your figure before you begin work on your base may be an option. Having a resin copy of your completed figure makes it

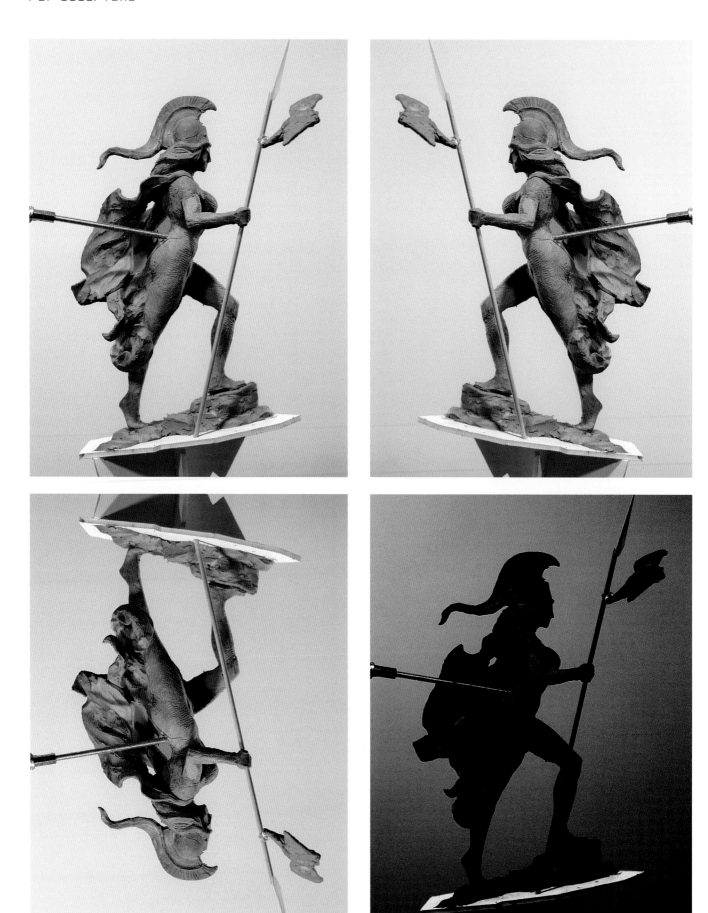

Look at your rough sculpt in various ways (reversed, upside-down, and silhouette) to spot problematic areas.

Art of our Athena base…

…the sculpted rock…

…and a few clouds.

much easier to "fit" your figure into its environment, especially if the figure needs to "key" into a very specific place in the base. (A key is a kind of peg on the bottom of the foot of your completed figure—see illustration below—that fits into a recess in the base, so that the foot plugs into the base reliably and consistently. We'll cover keys and pegs in more detail in Chapter 6)

Feel free to incorporate various and sundry "real life" found objects into your base. If your base calls for a rock or a gnarled tree branch, those elements may not be any farther than your backyard. Tim has scoured his gravel driveway for jagged pebbles that will become small boulders in the context of his sculpture. If your base design shows bits and pieces of mechanical-looking elements, take your art to the hardware store and be on the lookout for things in the right scale that could be incorporated into your sculpture. Rubén visits craft stores and even pet stores to find the right items.

With a resin figure, you can easily key the feet into position on the clay base with a little pressure.

Found objects to be incorporated into a base.

The trick in making found objects work is scale and detail. It's not what they are, but what they'll *become* that determines what to use and how to use it—remember, you'll be able to modify these elements in the wax stage to get the overall look you desire. But ultimately, the level of detail between your sculpture and the objects you incorporate should be the same. A figure that is moderately detailed on a base with hyperdetailed elements draws attention away from the figure and compromises the piece in general.

Uniformity of finish and style are essential to any successful piece of sculpture, especially when you're integrating found objects, and tying all the various elements together will help you to read the entire piece as a whole. So if you use found objects, it might be a good idea to give the completed rough base a coat of gray primer.

RUBÉN RUMINATES: BASE FIRST!

There may be times when a sculptor will need to sculpt the base first, especially if the figure and base interact extensively, such as with a staircase or a rooftop. Doing so places the figure securely in foot placement and balance and avoids the need for later adjustments.

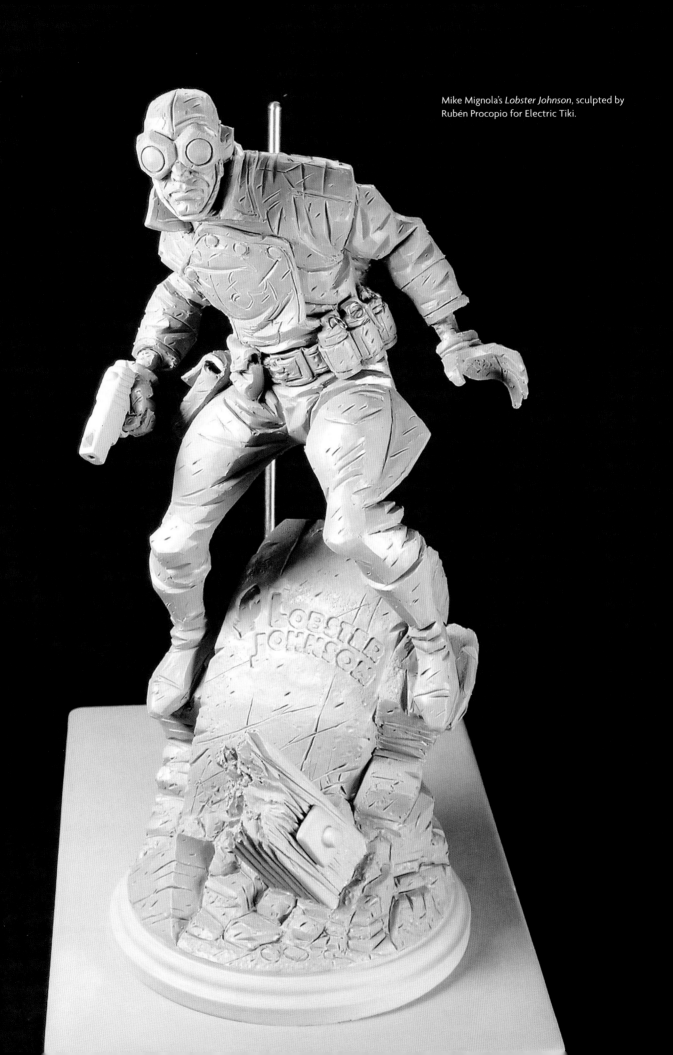

Mike Mignola's *Lobster Johnson*, sculpted by Rubén Procopio for Electric Tiki.

REFINED TASTES: FINISHING YOUR ROUGH SCULPT

Refining your sculpture is kind of like focusing a camera; the image starts off blurry and becomes sharper as you bring the image into general focus. The temptation at this stage is to focus your attention on one part of the piece, usually the head. But whichever part tickles your fancy, avoid the temptation to work on it while neglecting the rest, because the first thing that will suffer is proportion.

Say you've worked on the head (for example) and refined it, bringing up detail. You like it. You've done a pretty good job. You've spent a lot of time on it. Then you start bringing the body into focus. Things start to get pretty wonky, pretty quickly. Before you know it, the head looks too small or the shoulders too big. Something isn't right. But, because you've put all this time and work into it, you're reluctant to make the painful changes that need to be made to make it right.

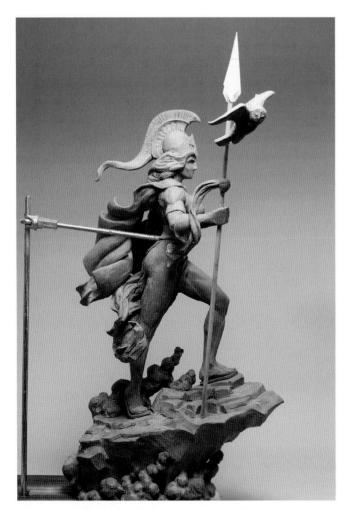

The more we refine Athena, the less we have to do in the wax stage, but don't do too much, or else you'll find yourself doing the same work later.

Keep moving—don't stay on one area for too long. If you catch yourself getting stagnant in one spot, snap out of it and come back to it later. Work the entire sculpture (even the parts you don't enjoy sculpting) and bring the piece up as a whole, making sure to keep a steady eye on your reference and being careful not to indulge yourself in finish work.

TWEAKING: It's time to focus on the details. Turn your revised 3-D model around—if you move around past the money shot, what else is going on? If the answer is "not a whole heck of a lot," then what can you do to bring interest to those alternate views? These additions don't necessarily have to alter the basic composition, they could be as little as pulling an elbow back to breach a hipline, or curl the end of a cape to make it move a little farther around the back. Even subtle changes can make a piece seem much more interesting.

Refining is not finishing. What you're doing is bringing your sculpture toward the finish stage. All the basic stuff should be there, including some details that you may end up redoing in the wax stage. Your art director will want to see the essentials of the piece; everything in its place and brought to a stage where, with a little imagination, the finished piece is visible. There's a direct correlation between how tight your rough clay is to how much finish time you'll have to invest in the wax. The tighter the clay, the easier the finish work will go, and the more quickly you can get to your deadline. And, as is often said, especially by anyone who is going to write you a check, "Time is money."

TIM IN A BOTTLE: THE PERSISTENCE OF TIM

*When I worked at a jewelry store in my late teens, sculpting wax models, I was told, "An hour on the wax saves the jeweler three hours at the bench. He makes three times what you make. You do the math." It's the same for clay rough to wax—the only difference is, it all comes out of **your** pocket.*

A Journey of the Self: Review, Reflect on Your Sculpt

Now it's time for some self-reflection. While we encourage self-reflection in everyone, here we mean reviewing your work with a critical eye before submitting it for approval. Even if you're not going to run it by an AD for their review, this is the time to really try and be as objective as possible about where you are and where you'll have to go from here. How much work have you left yourself when you take your statue to wax? Sometimes, major revisions are unavoidable in the wax stage, especially if you're hands-for-hire and there's been a significant design change, but ideally your focus should be on fine-tuning, detailing, and finish work. You don't want to have to spend hours adding large sections in wax when you could have created them in a few minutes in clay.

Take a set of pictures of the full sculpture from eight views, also called an eight-point-turn: full front, three-quarters left front, profile, three-quarters left back, full back, three-quarters right back, profile, three-quarters right front. (Since the armature support obscures the back at this stage, a seven-point turn is perfectly acceptable. See photos on page 92.) Take costume detail shots, waist-up shots, head shots from different views, and a full shot next to a ruler, to indicate scale. Make sure that the image you see through the viewfinder is the image you want to produce—often, there's a bit of a difference between evaluating the shot in real, dimensional space and what you see through the viewfinder; this variable is sometimes just enough to throw the picture off.

Take at least one shot that matches your reference art as closely as possible. Make sure your horizon line in the camera matches the horizon line in the reference art. Be mindful of lens distortion, which often happens when the lens is too close to the sculpture. Then overlay the two images on the computer to see how well they match up. (This is a technique some art directors will use to measure accuracy, so it's good to be prepared for it.) You can also compare measurements between your piece and the scaled-up art using a pair of calipers. They can be especially helpful when it comes to stylized artwork, where standard proportions don't apply.

The same methods you used to evaluate your rough can now be used to evaluate the refined piece: look at the silhouette of the piece from a variety of angles. Check out your sculpture in a mirror or flip the image on your computer; turn it upside down and give a critical eye to anything that seems not quite right. Even removing the color from a picture and looking at it in black and white can help give you a different view. Our aesthetic biases are strong and deeply seated; anything that can help us gain a little objectivity is a good thing.

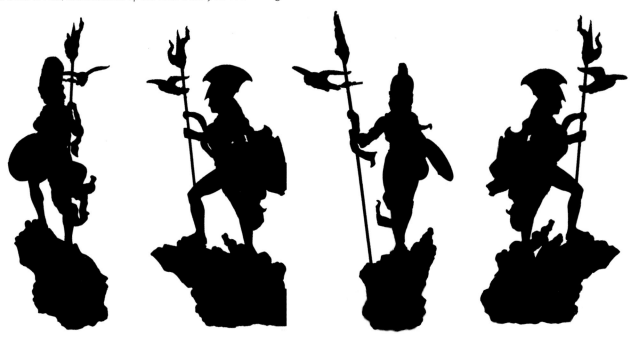

A final look at silhouettes will make sure everything works the way it's supposed to.

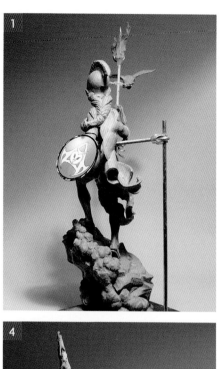

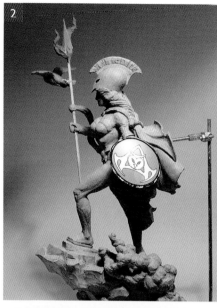

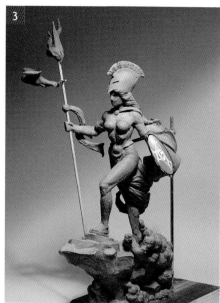

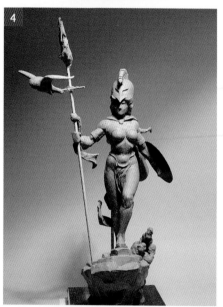

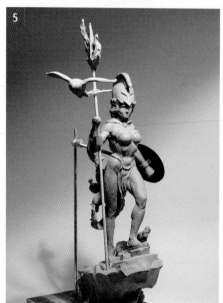

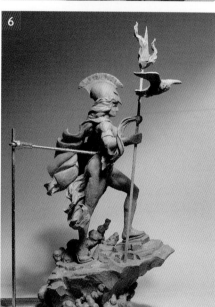

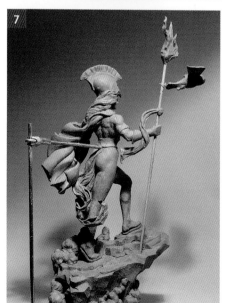

To capture every angle of your statue, do a seven- or eight-point turn and take pictures from each side. (The back of this sculpt is obscured, so we did a seven-point turn here.) These will be sent to your art director for approval, along with some detail shots.

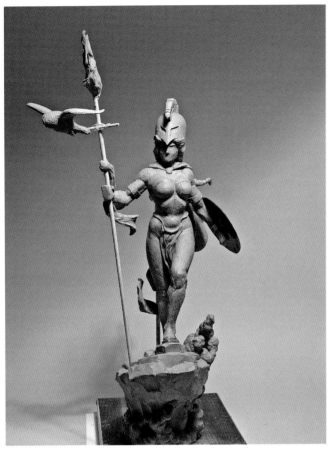 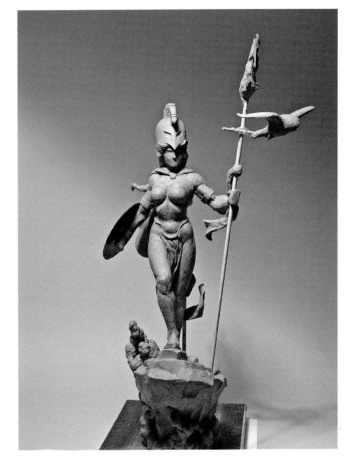

Check mirror images, too.

FRIENDLY FEEDBACK: WORKING WITH ART DIRECTORS AND PRODUCTION MANAGERS

All artists have a gut feeling when there's something off with the piece they're working on, but they may not always know how to fix it. Getting criticism can help you resolve that. Show your sculpt to a family member, a friend or a colleague to get a "fresh eye" view of your sculpture before presenting it to your AD or PM. (Some companies have ADs, some have PMs; the positions are interchangeable for the most part. We'll just say AD from now on, though the same strategies apply to dealing with a PM.) Be open to any criticism that will help make the piece better. Contrary to some beliefs, your AD is not your adversary. In fact, he or she can be an invaluable resource in helping guide you to a successful statue.

Sooner or later you'll work on a piece that'll hit a roadblock or two. Whether it's a difficulty in translating what's on the page into 3-D (the ever-popular "What the heck does that mean?") or a compositional problem that just won't resolve itself, your AD

can help you see what you don't and offer solutions. Remember, this is *collaboration*, with both of you working toward a successful statue. This is also the place you check your ego at the door. That doesn't mean that you leave your talent, judgment, creativity, and inventiveness at the coat check. It just means you've accepted your role as facilitator of another person's vision, even though you may disagree with some of the direction.

And this, my friends, is what it means to be a professional: finding value and appreciation in a project you may not be thrilled with, yet giving everything you have to make the best piece of sculpture you know how to produce. (More on being a professional in Chapter 12.) Good work comes and goes; bad work takes root and seems to crop up when you least expect it. It's like that picture of you at your sister's wedding when you had a few too many, put on the lampshade, and did the hula on the coffee table without your pants. You know the one.

Hopefully, your AD likes your sculpt. Maybe not all of it, but a lot of it, and he just wants you to make a few changes before you go to wax. Here's where it can get a little tricky. Language is

such an imperfect means of communication. "I think the statue's nose is a little too long," may actually mean that *the distance between the upper lip and the bottom of the nose is too short.* Try and understand what it is your AD wants to accomplish with the changes. If it's off-model, it's off-model, but specifically why? When you know *why* the problems exist, you might be able to offer a couple of ideas on how to solve them. It never hurts to offer your two cents…as long as you understand that the buck stops with your AD. (So does your paycheck, by the way.)

Make the changes with grace and enthusiasm, and in as timely a manner as you can. The faster you get the reworks done, the more quickly you can move to finish. It should be noted that rework time is very rarely incorporated into your schedule. Your due date will not magically adjust because it takes you three days to deliver reworks that should only take you an afternoon. That's two and a half days out of *your* schedule. A deadline is a deadline.

Once you've made the changes, take another batch of pictures showing the changes you made as well as shots of how those changes affect the piece as a whole. Create an image page showing the sculpt before and after the changes so your AD can compare them side-by-side and evaluate them easily and quickly. Send them off, and if you hear back that you're good to go, you're ready for waste molds, then wax. If you still need to tweak here and there, well, you know what to do. We'll be waiting for you in the next chapter…

RUBÉN RUMINATES: COGITO, EGO SUM

I got a great piece of advice from my Dad when I started at Disney many years ago, and I carry it to this day: "As you walk into a job, check your ego at the door. Go inside and do the job they're paying you to do. This is not Rubén Procopio Productions, this is Walt Disney Productions. If you disagree, or have a suggestion, remember that you're part of a team and you have to work together. At the end of the day, pick up your ego, go back to your studio at home, and do what you want to do there."

Rubén checks his ego at the door before meeting with a client.

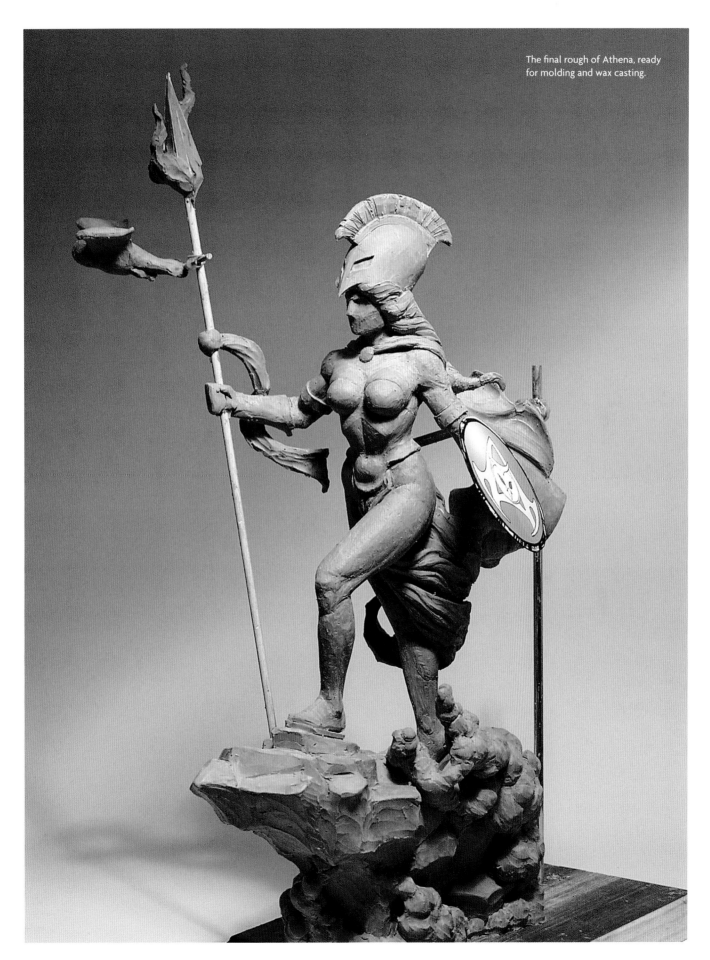

The final rough of Athena, ready for molding and wax casting.

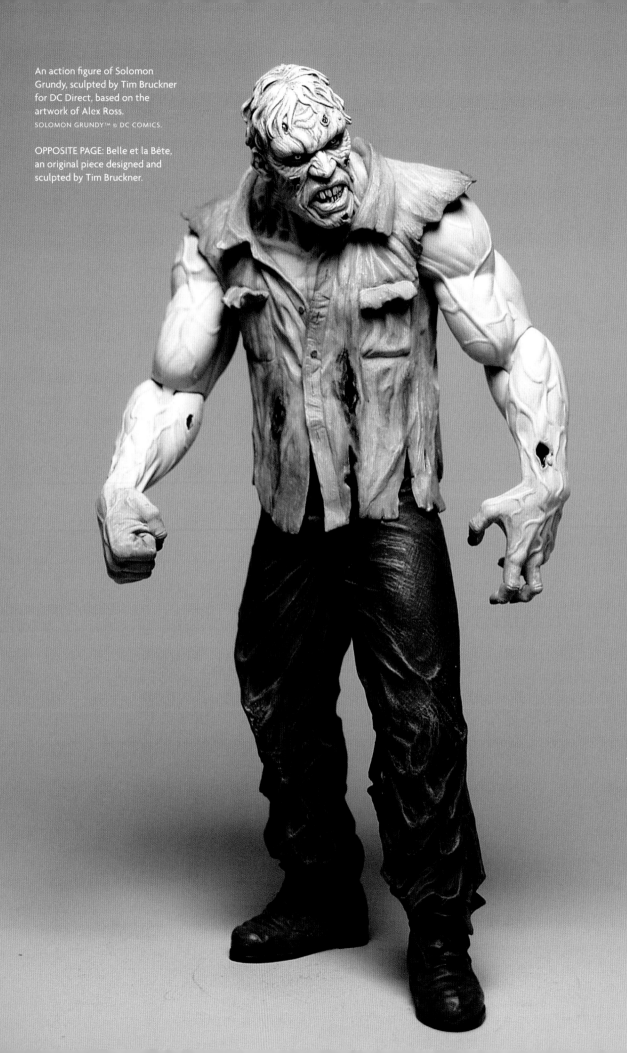

An action figure of Solomon Grundy, sculpted by Tim Bruckner for DC Direct, based on the artwork of Alex Ross.
SOLOMON GRUNDY™ © DC COMICS.

OPPOSITE PAGE: Belle et la Bête, an original piece designed and sculpted by Tim Bruckner.

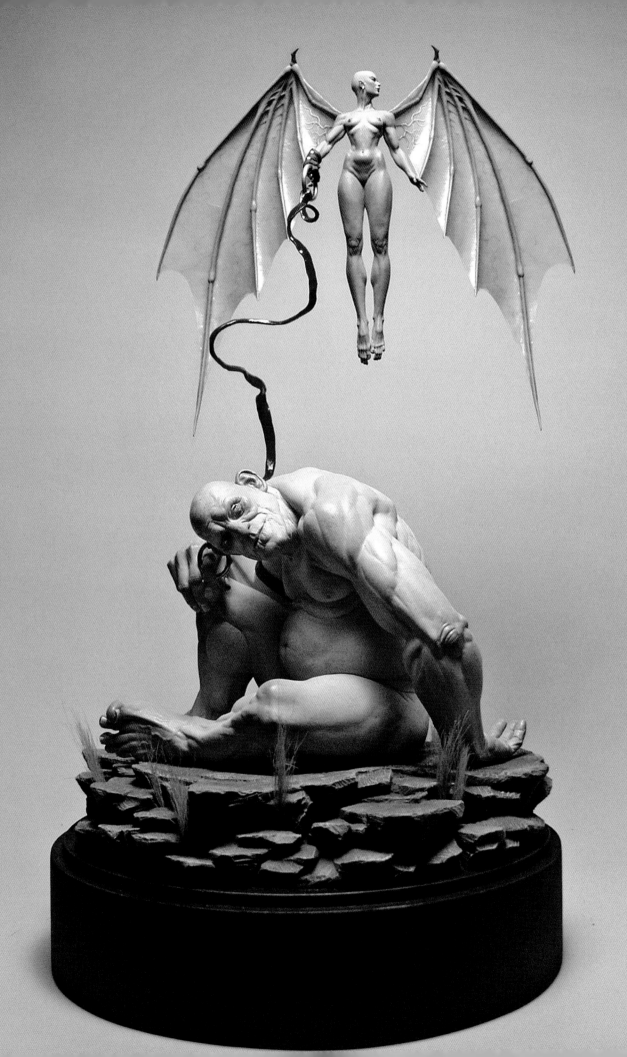

4. Casting in Wax

HOW TO CREATE MOLDS IN ORDER TO MAKE A WAX COPY OF YOUR SCULPT SO FAR

If you're sculpting for hire in the pop culture statue and action figure business, you will most likely be asked to finish your sculpt in wax. That means you'll need to know how to cast a copy of your rough sculpt so you can take it the rest of the way home. Luckily, waste molds, which are recyclable molds used to cast single wax copies, are relatively easy to make, not to mention good practice for learning how to make master molds later on.

Waste molds are not meant to be perfect. They're just a way to make a wax duplicate, which is why you make this copy while your clay rough is still...well, rough. Of course, you can take your piece as far as you like before reproducing it in wax, but we're going to stop short of putting in any fine detail, as we'll just end up refining it anyway. Still, you should make sure that your surfaces are *well toleranced*—meaning they're refined to an even, consistent surface—and that you've created markers for where certain details will go, such as armbands, shin guards, and armor construction. This will help you knock hours off of your wax sculpting time.

An old master creates molds the old-fashioned way.

Making the Waste Mold

There are several types of moldmaking materials, each with its own strengths and weaknesses. For our purposes we're going to concentrate on using **RTV** (room temperature vulcanized) silicone rubber. (See page 102 for a list of the additional tools, supplies, and materials you'll need to make a waste mold.) RTV is made up of two parts—a syrupy base and a liquid activator—which are mixed at a ratio of about 10 to 1 by weight. Why use RTV? In a word, it's flexible and also more adaptable. It can be used for waste molds or master molds. The cured rubber can be chopped up and added to new molds as filler, and you can cast just about any material you want in it. Using other mold materials such as latex, plaster, or urethane elastomer will limit the kinds of casting materials you can use, or require you to use a mold release agent or mold support housing (known as a mother mold). You'll also be saddled with leftover material that can't be integrated into your combined process.

Speaking of leftovers, if you haven't made an RTV mold before, you're kind of at a disadvantage starting a waste mold. Waste molds may be better described as "recycled molds," because you use some of the cured, leftover RTV from previously made molds as a filler in them. If you've never made a mold before, you'll have to use only fresh RTV with no cured rubber filler pieces.

There are moldmakers who can estimate the exact amount of mold material they're going to need to make a mold—that

There is no formula to tell you exactly how much mold material you'll need.

isn't us, and, more than likely, that isn't going to be you, either. It's always a good idea to overestimate; it's better to have some material left over than not enough, to save you having to go back and mix up another batch. Experience will train your eye to evaluate how much RTV you'll need to do the job. There are a number of RTVs available, from very firm to soft, for virtually every kind of casting need, and their hardness is measured using Shore durometer ratings. For our needs, we use an all-purpose RTV with a rating of 32 Shore A. An online search will bring up many commercially available RTVs.

SCULP-TOR SEZ: WHAT IS A MASTER MOLD?

A master mold is the perfect mold you will create based on your finished (or "master") sculpture. This mold will be used to create exact copies of the final piece in resin, or whatever material you choose, which will then be sent to the factory so they can create their own molds, or get painted up to be used as "paint masters"—paint guides for the factory to see how color should be applied. For more on master molds, see Chapter 7.

TOOLS OF THE TIRADE: PRESSURE POTS AND COMPRESSORS

Your main tool in molding and casting is going to be a pressure pot—a pressurized canister that will force the air out of your molding and casting materials as they solidify. You can special-order a Teflon-lined pressure pot made specifically for the job at hand, or, for less money, you can go to your local hardware store or home center and buy a paint pot, used for holding the paint that's fed into a roller or sprayer, and convert it for casting use. They come in various sizes, from 2½ to 15 gallons—the smaller size should be plenty for someone just starting out.

▶ Converting a Paint Pot to a Pressure Pot

Modifying a paint pot for use as a pressure casting pot is easy. Regardless of make, model, or size, all paint pots are essentially the same: Compressed air is forced into a pot full of paint, and paint is forced up a metal tube into a sprayer or roller. The size of the conversion adapters required will depend on the size of pot you use. It's a good idea to take the lid of your paint pot with you to the hardware store to make sure you have all the pieces you need and that they all fit as they're supposed to. Follow the diagram below and use the parts as indicated:

A metal tube descends into the body of the pot from the lid, almost to its concave bottom. There is a **port (A)** on the top of the lid where the tube comes through. The tube has to be removed and this port (A) closed up. Some pots will let you screw the tube off. Others will make you saw it off, as we've had to do on this one. However you get the tube off, you'll have to plug it with a plumber's plug designed just for a job like this. After you get the right size threaded plug, make sure to wrap the threads with a couple of rounds of Teflon tape for a good, no-leak fit. In fact, tape-wrap all of your connections.

This **(B)** is your **release valve**. Some come with handles, and some come with pull rings like this one. To depressurize the pot, you'll close off the air-feed valve (E), open the close valve (C) and pull the ring. A stream of compressed air will rush out from both the release valve and the close valve. With some setups, all you'll need is the close/release valve (C).

This **(C)** is your **close valve**. Before you pressurize the pot, you'll need to close this valve off, to prevent air from escaping and allow the pot to pressurize. It's also a release valve. As mentioned above, you may only need this one valve, depending on your setup.

A pressure pot.

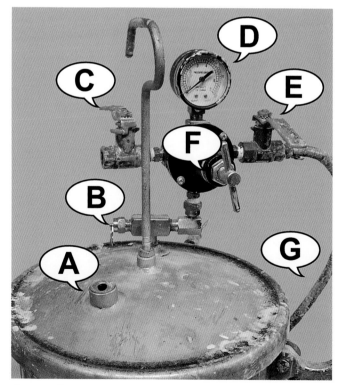

The parts of a pressure pot.

This (**D**) is your **pressure gauge**. Use it to monitor the pot's pressure level, making sure it stays within the manufacturer's recommended PSI (pounds per square inch) setting.

This (**E**) is your **fill-up-the-pot-with-air valve**, sometimes known as your F.U.T.P.W.A. valve. (Sometimes, but not very often, because it sounds a little dirty if you say it out loud.) With your close valve closed, opening this valve will fill the pot with compressed air, making your pot, uh, well…a pressure pot.

Speak of the devil, here it is, your **pressure set valve (F)**! Use it to set the pot's pressure, carefully following the manufacturer's recommended PSI setting.

All of the mentioned parts above are useless without one critical member of the pressure pot team, the all-important **air hose (G)**. This connects your pot to your compressor. And they come in nifty colors, too!

A conduit handle, used to tighten lock-down keys on larger pressure pots.

A cutaway of a pressure pot with an artificial level base.

You'll need to create a level "floor" for your pot, as most paint pots have a concave bottom. A foam-core disk or a piece of Masonite will do the trick (see above)—the foam core will need to be replaced regularly, while the Masonite will need to be covered in aluminum foil, which will need to be changed regularly. Why? Because, after a short time, the inside of the pot is going to resemble a silicone/resin war zone. Make sure the lock-down keys (not shown) are well-lubricated. For larger pots (10 or 15 gallons), use a short length of conduit to turn the lock-down keys (see above right). They need to be tight—pretend

they're lug nuts on the family car, and tighten the nuts across from each other first. Don't tighten the nuts in sequence, or one side may be tighter than the other and result in air leakage. After you've tightened all the nuts, check them again.

▶ Compressor

The other piece of equipment you'll need is a **compressor**, which is the machine that actually forces the air into the pressure pot. There are two kinds: oil-less, self-lubricating compressors and compressors that need lubrication maintenance. Oil-less compressors are easier to maintain and less expensive. Compressors that need to be lubricated are slightly less noisy and last longer. (If you sometimes forget to water your plants, you may want to get the self-lubricating kind.)

A compressor.

Whichever kind you get, you'll want your compressor to have a compressed air storage tank that's at *least* twice the capacity of the pot. So, if you have a 10-gallon pot, get a compressor with a 20-gallon reservoir or more. If you've got a 10-gallon pot but only a 5-gallon reservoir of compressed air, half of the pot will fill instantly, but the other half is going to have to wait until the motor can pump enough air to finish the job. And while you're waiting, your poor mold or casting can take a turn for the worse.

Make sure to follow the manufacturer's guidelines for setting the gauges at the proper PSI settings. If you're using more than one pot or want to use the compressor for other things, such as an air hose to blow away debris (a very handy item to have in your studio), you can construct a multiport hookup.

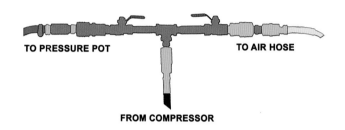

TO PRESSURE POT **TO AIR HOSE**

FROM COMPRESSOR

Diagram of a multiport hookup.

▶ Vacuum Chamber (Optional)

Now, some sculptors use a **vacuum chamber** along with their pressure pot. A vacuum chamber does one thing and does it pretty well: It degasses RTV, removing air bubbles that were created during the mixing process. But even using degassed RTV, you'll still need to use the pressure pot to force the fresh RTV through the precured RTV chunks when making a waste mold. Although the RTV will be less viscous after being catalyzed, it's still fairly thick and not likely to work its way into every nook and chunky cranny using gravity alone. If you're planning to do a lot of resin casting, having both a vacuum chamber and a pressure pot could make sense—RTV takes anywhere from a couple of hours to a dozen or more to fully cure, so your pressure pot is tied up while waiting for the rubber to set up. Degassing only takes a few minutes. Degassed RTV can make one dandy mold, but making a mold under pressure gives you the added advantage of not only forcing the air out of your RTV, but also forcing the RTV into every little potential air trap that could otherwise

remain void. Since a pressure pot can degas RTV *and* prevent air bubbles from perverting your cast wax and resin parts, it's cheaper to just buy the one device.

▶ Tools and Materials for Making Waste Molds

Here are the tools and materials you'll need to make a successful mold:

- Alcohol lamp
- Apron/smock
- Compressor
- Cutting mat
- Electric drill
- Felt-tip marker(s)
- Foam core (or something similar) for the base of your mold case
- Hook (for hanging lid)
- Hot-glue gun
- Jeweler's saw
- Kromekote (or something similar, like styrene sheet) for the outside of your mold case
- Mixing bits (the pinwheel kind)
- Mixing buckets or containers
- Mixing sticks
- Newspaper
- Paper towels
- Permanent markers
- Pressure pot
- RTV (all purpose with a rating of 32 Shore A)
- Rubber bands
- Rubber (latex-free) gloves
- Scissors or bread knife
- Vacuum chamber (optional)
- Wax pen
- Wax sprues and gates (in a variety of sizes), or alternatives like PVC tubing or wooden dowels (Preformed wax rods will work better overall.)
- X-Acto knife
- A refreshing beverage of your choice

The Casting Couch (and Chair, and Table...): Setting Up Your Workplace

Successful casting is all about speed and efficiency—especially later on, when you'll be casting with resin (see page 160), which cures a heck of a lot more quickly than wax. A poor layout of materials will cost you valuable seconds and can often result in poor casting. We'll show you how to set up a reliable initial working environment, but don't be afraid to experiment with variations. Everyone works differently, and you may find a method of setting up your working area that suits you better.

To start, you'll need a good-size table: at least 5½ or 6 feet long and 2½ or 3 feet deep. An inexpensive, assemble-it-yourself desk with a couple of drawers is best; if using a folding table, purchase a set of plastic drawers to fit under the table or to the side. The drawers are essential for storing rubber bands, gloves, mixing sticks, cups, markers, etc.

A good casting is all about speed; often, your sculpture won't wait for you to get it right.

The same space can work for both molding and casting, seeing as they'll both be using the pressure pot. Try to place the pot at one end of the table so you don't have to work around it. Keeping the pot lid on the table eats up valuable space, so secure a sturdy hanging hook above the pot to keep it out of the way until you need it. And let's be absolutely clear, this table, the one you'll cast on? You will trash it. It's unavoidable. Cover the table with full sheets of cardboard, duct-taped down, and have a pile of old newspapers handy. You'll try *not* to spill or overfill, but some molds require that you open them to fill them, and that overfill

must go somewhere. The floor will get a fair amount of abuse as well. We just wanted you to know, so that you didn't make any promises to your mom or significant other that you just can't keep.

You're also going to need a place for your compressor and casting and molding supplies. While some are quieter than others, all compressors are incredibly noisy. N-o-i-s-y! If you live in a part of the country that doesn't see a real winter (or as Midwesterners like Tim like to call it, Heaven), then you can keep your compressor outside, under some weather protection. Otherwise, if you can keep it in another room, so much the better.

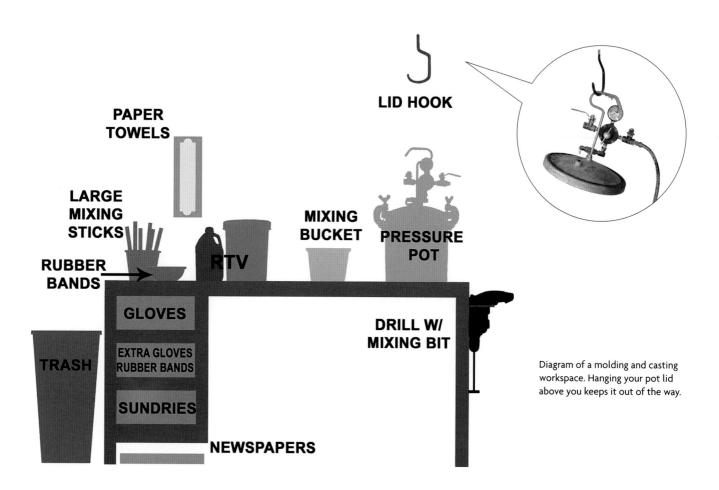

Diagram of a molding and casting workspace. Hanging your pot lid above you keeps it out of the way.

The First Cut Is the Deepest: Cutting Your Figure into Parts

It's often easier to deal with several small molds than one large one, so, to make the job more manageable, cut your clay rough into sections (parts). To do this, use a jeweler's saw, which is available at jewelry supply houses, some craft or hobby stores, and online. It's a tool with many uses, and the saw cuts through clay and armature wire easily. The blades are very small and thin, and the throat of the saw is deep, which makes for a thin cut and easy access to small, delicate spaces. (Just remember, the blade goes in with the teeth pointing down, so the downstroke is your cutting stroke.) As you'll see in our pictures below, we've cut off the head using a V-shaped cut through the collarbone, the arms off at the biceps, and the legs off at the middle of the upper thigh. Since you'll work your wax to a finish in sections anyway, this arrangement will get you that much further ahead.

GATING PARTS

So, now you've got a collection of body parts ready for molding. You need to consider each part and how best to get the melted wax to fill the mold cavity, which will determine the placement of your **gate**, or **sprue**. A gate is the channel through which the melted wax, or any castable material, is poured into a mold. Gates can be made from a range of materials, from armature wire to PVC tubes. We like using premade wax rods, which are

A grasp on the principles of plumbing isn't necessary to understand gating, but it certainly helps.

available from some sculpture or jewelry supply stores as well as online. We like them because they're mold-friendly (they won't stick), they come in a variety of shapes and sizes, they're bendable, and they're easily bonded to our clay part using a wax pen. Always use the largest gate you can without obscuring or eroding important details.

Cutting Athena's legs at middle of the upper thigh.

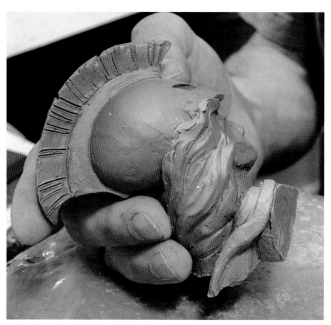

We cut Athena's head off with a V-shaped cut through the collarbone.

Gate placement is critical, especially when gating up a part for a master mold, but for now you're looking to get as much wax into the mold as quickly and as easily as you can. Also, you'll be supporting your part on the end of it, so where you place the gate has to make sense from a balance viewpoint as well as a casting one. There's a point of balance with almost any gated piece, and it just so happens that the point of balance is often also the most advantageous placement for a gate for casting. Not always, but often enough to take notice. So if the part stands up on its own on the gates you've welded into place, there's a good chance that that's also the best position for it to be in, in terms of casting.

Sometimes, the point of balance will create an air trap—a place where, once the mold has been created, air bubbles will get caught during the casting process. So, you'll need to angle the piece a bit out of balance to get the best material flow. If it won't stand up in that position, you have to add a support gate whose main function is to keep the part upright during the molding process.

Notice how we've gated Athena's head from the bottom of the V-cut as shown below left. We could have gated her from the crest of her helmet, but we would have had to use a smaller gate. At this stage, it's all about getting a good wax casting, and since we'll resculpt the head anyway, this was a better gate location. Because you're gating from the bottom, add a small gate from your larger feeder gate to the bottom of her chin to vent the air and to allow the melted wax to fill in.

Note: In gating any part, for any purpose, remember a gate does two things: It lets the material in while letting air out. Think of it as if it was plumbing, but without the water, the exorbitant hourly rate, or the plumber's butt crack peeking over the waistband of his pants.

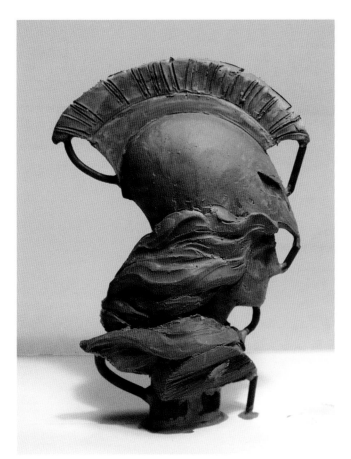

While a large number of gates means more to clean up, it also ensures that wax gets into all of Athena's nooks and crannies.

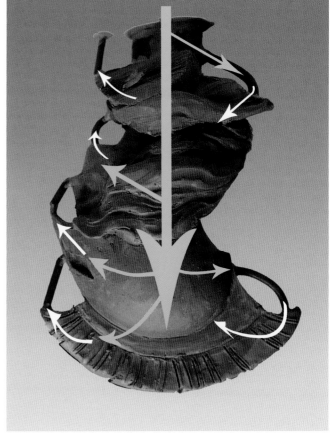

Here you can see how wax will flow into the head cavity, and how air will flow out.

Once you've established the gate positions, cut your gates to length. When casting wax, a tall gate means it's more likely the wax will build up in the gate and cause it to narrow or close up, making it necessary to open the mold and pour in the wax beyond the gate. But too short a gate will mean the wax will contract below the gate and maybe not fill the very top of the mold. Tim tries to go about a half an inch from the bottom of the part to the foam core base.

We gated Athena's arms from the bicep cut. As there's no need for a vent gate, we used a ⅜-inch **wax sprue** secured directly to the cut. Her legs are gated at the thigh cut, with a vent gate from the top of her foot to her shin to make sure no air gets trapped in her toes, and her torso is gated with a ½-inch wax sprue at her left thigh cut with a ¼-inch vent/feeder at her right thigh cut, as shown at top right.

Now you need to attach your gates to your parts. This is very important and can ruin the entire process if not done correctly. Use your alcohol lamp to melt the end of the gate, and then stick it to the part as shown at below right. Gate wax is kind of sticky, and it will bond well to the part. Holding the part in place and making sure there's a good connection, use your wax pen and some sculpting wax to "weld" the wax gate to the part.

Once the gates are welded to the part, it's time to secure the gated parts to the foundation of your mold. Use sections of ³⁄₁₆-inch standard foam core: It's strong, lightweight, nonporous, easily cut with an X-Acto knife, and it works great with a hot-glue gun. You can use other kinds of cardboard, pieces of Masonite, or a heavy styrene sheet; just be sure its nonporous and can stand up to the pressure pot. Hold your part over a piece of foam core and guesstimate how much base you'll need once you've hot-glued the casing in place. Whatever the size of your part, you'll want at least half an inch of RTV around it on all sides, and then another inch of workspace, so it's wise to cut your foam core base an additional 3 inches in diameter. So if your head is about 2½ inches thick, you'll want a foam core base about 5½ inches square.

Once you've got all your foam cores bases cut, secure the parts to them. Once again, use your alcohol lamp to melt the end of the gate, and then stick it in the center of your foam core base. Holding the part in place, weld the wax gate to the foam core. Remember, the clay is heavy, so take your time and make

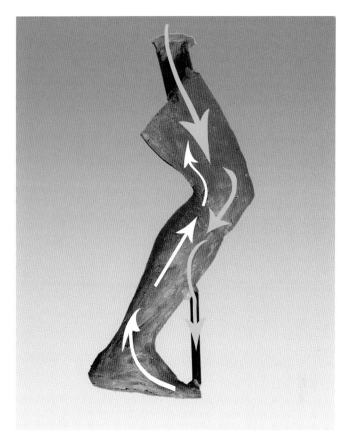

The gated left leg.

Attaching a gate to a part.

the weld incrementally, allowing one side of the weld to cool down before you finish the other side. Otherwise, the part will fall over from the wax being too warm at the weld point.

Now, all your parts are secured to the foam core and ready to be marked for cutting. After the head is in the mold, surrounded by a solid mass of RTV, you'll need a cutting guide…unless you've got X-ray vision. If you're not from Krypton, use a permanent marker to draw a line you want to cut to on the clay part. There's a good place to make a mold cut and a bad place to make a mold cut; here, cut up the back of the head, as shown, so whatever seam line or mold misalignment you get doesn't happen someplace that will end up requiring repair.

Starting at the base, draw a line up the back of the part. Try to make your cut lines on the high points of your sculpture. Why the high points? It makes for an easier cut later on, and cleaning up a seam on a raised surface is easier than gouging out a seam in a recessed area. (Again, it's not as critical at this stage as it will be with the master mold, but thinking about it and making it a force of habit isn't a bad idea.) Looking at your part will tell you where to stop the cut. Cut up just high enough to be able to remove the part from the mold. Where you intend to finish the mold cut, draw a line perpendicular to the cut line, as shown. Then go back to the base and, using a dull pointed tool, score the foam core at the start of each marker line to serve as a guide for your first cut.

All of our Athena parts.

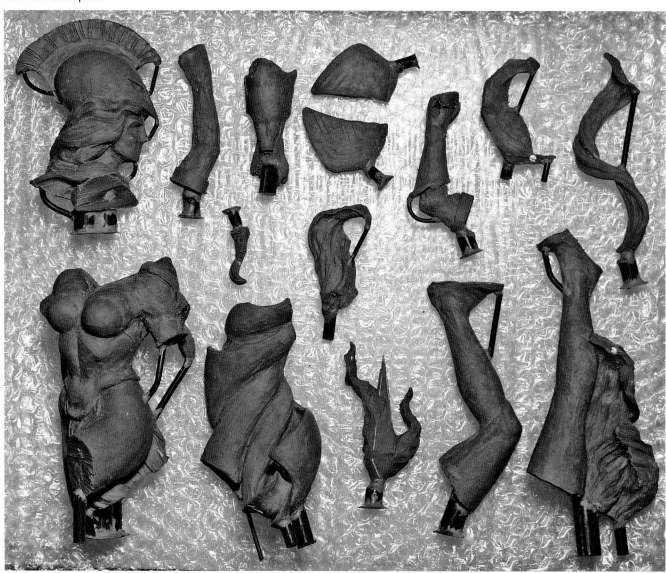

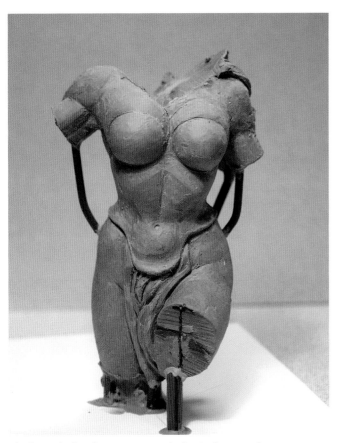

The front of Athena's torso, now attached to its foam core base.

The back of Athena's torso, now attached to its foam core base.

Part being marked with cut line.

Foam core base marked with line for scoring.

MOLD CASE: CLOSED

Head, torso, arms, and legs have all been marked and now you have to create a mold case. The kind of mold you'll be making throughout the book is often called a **block mold**, because, when you're done, you've got a block of solid RTV with your part inside. But *block mold* doesn't mean *square* mold. Because you'll secure your molds with rubber bands (and because of the uneven way tension is exerted on a square mold, applying more pressure to the corners of the mold than the flat sides of the mold), make a mold with nice, comfy curves, like an oval or a cylinder.

For the mold case, use a three- or four-ply coated paper called Kromekote, generally used for pen-and-ink illustration. It can be formed into oval or circular tubes easily, is nonporous, and works well with tape and a glue gun. Kromekote has a grain—in other words, it will bend more easily one way than another. A quick flex of the paper will tell you which is which. You can also use thin sheets of styrene or other coated papers, as long as they can support the RTV without deforming from its weight or the pressure of the pot.

"To private investigator Brick Castwell, this case was open and shut: the sculptor did it."

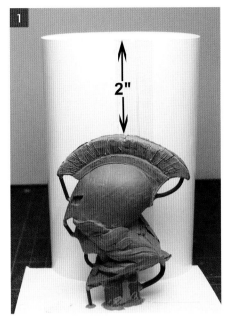

Your mold case should form a tube that leaves at least a half-inch of space around the part and two inches above it **(1)**. Your head, including the attached gate, is 3 inches tall, so create a mold case that's 5 inches tall. Follow the same formula for all the remaining parts. Form the tubes and run a length of strong masking tape over the seam, overlapping the seam by at least a half-inch.

Center the Kromekote tube over your part as best you can **(2)** and, using a hot glue gun, run a bead along the join of Kromekote to foam core **(3)**. To do this easily, turn the foam core base as if you were decorating a cake, and keep the gun stationary. Make sure you've got a good strong join of glue when you're done. You'll notice some bubbling at the join here and there. It's only a problem if the bubble exposes the edge of the case and the foam core. If that happens, hit it with a spot of hot glue and seal it up. Sometimes, while gluing the case up, the force of the glue will push the case out of position, so always monitor the case's position in relation to the part to make sure it stays where you want it. If you're creating an oval-shaped mold case, you may need some additional reinforcement of the shape, using foam core and tape **(4, 5, 6)**.

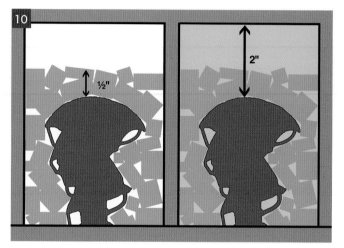

Next, cut up your cured RTV leftovers (if you have them) into ¼- or ½-inch cubes **(7)**. These pieces don't need to be exact. They don't even need to be square. In fact, having a few odd-ball shapes will help the cubes settle into those small, cramped areas. You just don't want them to be too small, or the fresh RTV can't work its way around and through them. Depending on the shape and size of your leftover RTV, you might want to try using a pair of scissors or a bread knife to cut them. Just be careful—by its nature, RTV is a slippery devil and will zig when you zag.

When the glue is cold and set, fill the mold case partway with your chopped-up RTV cubes, then have a look inside the mold **(8)**. Take notice of the space around the part and consider whether the cubes are small enough to fill in some of the smaller spaces.

One of the points to making waste molds is to save rubber when making a mold of limited use. If your cubes leave a lot of the mold unfilled, and you see you'll be using more fresh rubber than precured rubber, cut your cubes into smaller pieces, but try not to go smaller than a quarter-inch square. Too small and the fresh RTV will have a difficult time working its way through the cured rubber pieces and you'll wind up with hollow spaces in your mold. Once the mold cases have been filled with RTV cubes **(9)**, give the molds a few vertical taps to help settle them, and add more if needed, until they settle about a half-inch over the top of your part **(10)**. That half-inch is important, as it gives you an easy way to determine how much RTV covers your part.

VULCANIZE ME!:
POURING THE RTV MIXTURE

Making sure your pot is on a level surface and that its interior floor is level, place your molds into the pot. As long as you ease the air into the pot so the pot pressurizes slowly, it's okay to have a mold case directly under the air induction port when making waste molds.

Now, mix up the two parts of your RTV, ten parts base to one part activator by weight. Weighing the stuff is a drag. Eventually, you'll end up eyeballing it—until then, we've given you a handy-dandy chart (right) that converts weight to a liquid measure. RTV can also be pushed to cure more quickly by adding more activator than the 10-to-1 ratio calls for; however, pushing the RTV changes its character. The more you push, the less rigid the mold, and, over time, the more quickly it deteriorates. Knowing how hard to push is something that will come with time. For now, we recommend you play by the rules.

RTV BASE	RTV ACTIVATOR
32 liquid oz. (1 quart)	5 liquid oz.
64 liquid oz. (1 half-gallon)	10 liquid oz.
128 liquid oz. (1 gallon)	20 liquid oz.

Vulcan, the Roman god of the forge.

With your molds full of RTV bits and pieces, estimate how much RTV you'll need to fill in the voids. This too, will come with time and experience. You'll probably mix up way too much or not enough. Do your best, and don't be too hard on yourself if it doesn't work out the first few times. With your rubber (latex-free) gloves on, pour the RTV base into a plastic paint bucket or food container (the RTV will peel out when it cures). RTV is thick and syrupy and takes a while to pour. When you've poured what you think you'll need, cap it up and get the activator. Generally, RTV activator is clear in its natural state, but some manufacturers add dye to make it easier to tell when you've thoroughly mixed the base and activator together. So, give that activator a good shake, and, using our handy chart, measure out the activator and pour into the container holding the RTV base.

A view of mold cases in the container, ready for the RTV mixture. Don't use cured RTV pieces in molds where the clearance from part to mold wall is a quarter of an inch or less. The savings of RTV isn't worth the risk of the mold not filling completely.

The activator will float on top of the RTV **(1)**. Using a variable-speed electric drill and one of those smaller pinwheel mixing bits (the big spatula-type mixing bits don't seem to work as well) carefully integrate the floating layer of the activator into the top layer of the base **(2)**. When you've thoroughly integrated the activator into the top layer **(3)**, bring that mixture down into the rest of the base, until all of the RTV is completely blended and is uniform in color **(4)**. Using this method will keep the activator in the container and off of you.

Okay, you've mixed, so now its time to pour. Pour the RTV in a slow, even manner **(5)**, filling each mold to the top **(6)**. As the fresh RTV works its way through the cured RTV cubes, it'll bubble like a desert mud pond. When each mold is full, put the lid on the pot, screw down the lock keys, make sure the release valve is closed before *slowly* opening the air induction valve and ease the compressed air into the pot. When the pot reaches its PSI setting, do something productive for ten or fifteen minutes.

Okay, break's over. Close the feed valve and slowly open the release valve. When the pressure has dropped to zero, unscrew the lid and have a look inside. You'll immediately see why the mold casing was made two inches taller than the part in the mold **(7)**. Because you've mixed air into the RTV, when placed under pressure the air will be forced out, reducing the volume of the material. In addition, the pressure also forces the material into all of the air cavities in between the RTV cubes in the mold, further adding to the material's compression. By adding the extra height, you've compensated for both actions: the de-airing and the settling of the materials.

If you don't see any little RTV cubes poking out of the RTV, that means you have at least a half-inch of material over the top of your mold cavity, and you're good to go. If you see a couple exposed tips of cured rubber **(8)**, add some more RTV, close up the pot, repressurize and go do something productive until the RTV is fully cured. How will you know when it's cured, you ask? Because, being human (assuming you are), you'll have some rubber left over in your mixing bowl. When the leftover rubber is fully cured, meaning it's solid and tack-free, so is the stuff in the pot.

Note: Sometimes, when mixing, no matter how hard you try, there's a little RTV left at the very bottom of the mixing container that hasn't been fully integrated. Although, the stuff in the pot is as fully cured as it's ever going to be, the RTV in the mixing container is still a little gooey and soft to the touch. If part of the residue is solid, then take a peek at the molds in the pot. If they're solid and tack-free, you're good to go. If not, repressurize and wait it out. Overnight is a good place to start.

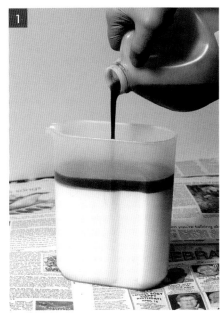

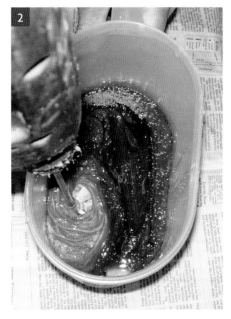

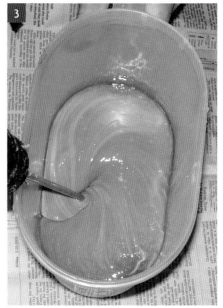

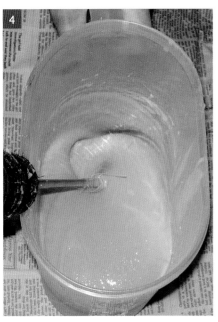

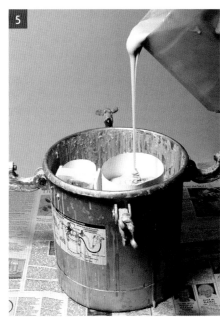

BREAKING (OPEN) THE MOLD

Rise and shine! Time to demold. The molds should be fully cured by this point. Remove them from the pot, peel away the Kromekote, take off the foam core, put a new X-Acto blade into the handle and trim off any excess flashing **(1)**. (Flashing results from the receding RTV leaving a thin film on the inside of the mold case, and will need to be removed so the mold can sit properly.) Turning the mold over, you'll see, in relief, the score mark you made in the foam core **(2)**. That's where you make your first cut. Cut in a zigzag pattern to help the mold lock together. Continue to cut until you come to the clay rough part and see your marker line **(3)**. Now, continue to cut down and around the outside of the mold in a strong zig-zag pattern, but switch to a straight, clean cut against the part; this will make the casting seam as clean as possible **(4)**.

One of the things that makes RTV such a fine molding material is the very same thing that makes keeping it closed after it's been cut open a problem. It's inherently nonsticky. If you were to make a straight cut all the way out from the part to the outside of the mold, there'd be nothing to keep the RTV in its place. It would slip and slide and create some awful seam lines and some shocking misalignment. By cutting the mold in a zigzag pattern, we're helping key the mold into the position it had before we opened up the mold.

Cut the mold in a zigzag pattern until you see your stop mark. Now open the mold as wide as you can—don't be afraid, it can take it—and remove your part **(5)**. This is called a butterfly cut, and it's a cut we'll use often. By opening only one side of the mold, we have a greater chance of the mold assuming its former position. If you think of it, save your wax gates for future use. Recycling gates save you money in the long run, and time, since they're already cut to size. Tim is constantly finding gates that are perfect for his purposes in his gate bin.

Clean out any remaining clay left in the mold. You can use a dull-edged sculpting tool, cotton swabs...whatever gets the job done without ripping up the mold, just try not to use any

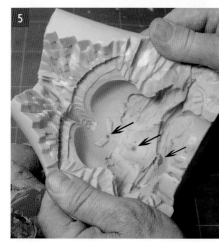

solvents. That air hose you hooked up, the one we said would come in handy? Well, it's handy for blowing out some of the tiny bits of stubborn clay. When the molds are clean, rubber-band them closed **(6)**. Use rubber bands with just enough tension to close the seam without distorting or compressing the mold. It's often better to use two lighter rubber bands together than one heavier rubber band.

> **Note:** The arrows in photograph 5 on page 116 indicate the internal gates that vent the chin, nose, helmet tip, and crest tip. Remove these before casting.

Hot Wax Weekend: Making the Wax Casts

Now it's time to melt your wax. Pull out however many wax plugs you think you'll need (you made wax plugs in kitchen cups on page 53). Overestimate so you don't find yourself with a half-filled mold and no more melted wax. (Don't worry, you can make new plugs with leftovers.) Tim uses a two-burner propane camping stove and a wax-melting pot, which looks like an aluminum pitcher with a handle and a pour spout. Craft or hobby stores that carry candlemaking supplies will have them—they're inexpensive, easy to use, and ideal for our needs. Be as careful as you can to not spill or drip any wax on your stove. Just remember, whether you use a gas stove or an electric one, low and slow is the way to go.

After the heat is turned off, there's a change that happens to the wax as it goes from the glossy surface of hot, fully melted wax to the slightly duller surface of wax that has begun to cool down. You'll notice, after stirring the wax, it holds its color instead of separating into its component parts.

Just as you notice this change, put your rubber-banded molds into the microwave on high for about 20 seconds. Repeat this in increments of 10 or 15 seconds until the mold is very warm to the touch; not hot, but very warm. What you're trying to do is get the mold warm enough to facilitate the *flow* of the wax, without being so hot that it remelts the wax inside the mold, breaking it down to its component parts and causing it to separate.

A wax plugged formed in a 5-ounce kitchen cup.

Always melt your wax plugs on low heat.

POURING THE WAX

When the molds and wax are at the right temperatures, place the molds on a newspaper-protected table and pour the wax into the molds as shown at right. It should fill the molds fluidly and easily. Its okay to give them a quick tap or two to make sure the wax has fully filled them. When the molds are filled, quickly put them in the pot—this time, try not to place any directly under the air induction port. If it can't be helped, it can't be helped. Secure the lid, close off the release valve, and fully open the induction valve quickly. With the pot fully pressurized, wait until the wax is fully set. Since compressed air is colder than non-compressed air, the wax will set up in a few hours, depending on how big the part is. And because the melted wax is setting up under pressure, there'll be a minimal amount of lateral shrink, to which unpressurized wax is prone. So, go away and do something productive. (That can include pouring any leftover wax into new paper cups, to create new wax plugs for later use.)

OPENING THE MOLDS

After a few hours, take a quick peek at the molds, or give them a quick feel to see if they're cool to the touch. If they are, then out they come. Remove the rubber bands and gently open each mold, carefully removing the part. Even with the gentlest, most delicate touch, your wax parts may break as you remove them from the mold. Not to worry—the beauty of wax is that you can easily weld them back together, good as new, with your trusty wax pen.

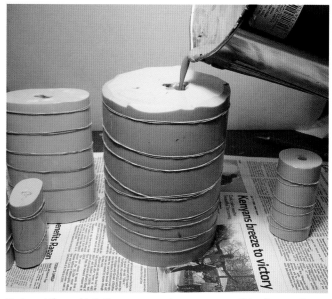

Try to get the molds in the pressure pot as soon as possible after pouring.

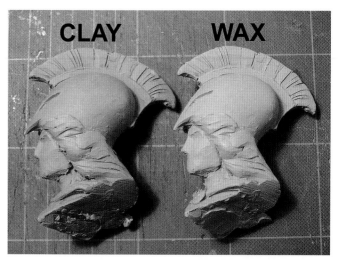

CLAY WAX

As you can see, the shrinkage on Athena is minimal. Thanks, pressure!

Without pressure, your wax copy may end up looking a little… malnourished.

And there you have it…wax copies of your clay rough, ready to begin the finish work. Hold onto your set of waste molds, just in case you need to cast yourself up a new part for whatever reason. After that, you can chop them up to make other waste molds, or use them to make a resin casting of your rough for an in-progress record of your sculpture from start to finish.

Now, wasn't that fun? Are you ready to do some more sculpting? We thought so.

A few of our wax parts, awaiting the next step—finishing.

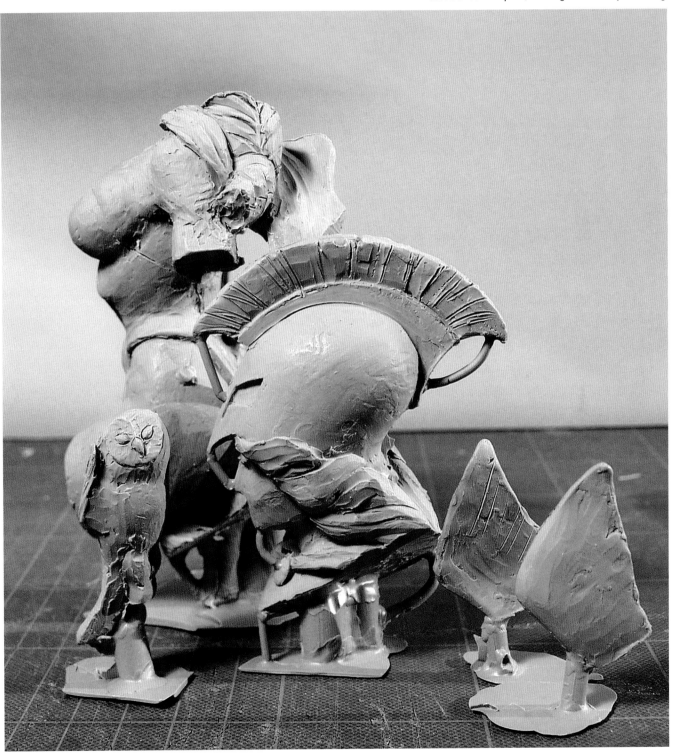

5. Finishing in Wax

USING A WAX PEN AND OTHER TOOLS TO BRING YOUR SCULPTURE'S DETAILS TO LIFE

You've got a wax casting of your clay rough in a bunch of pieces. Now what? You may be tempted to put it back together, but don't. You already know what it looks like as a whole. And if your memory isn't so good, you've got all those dandy pictures to remind you. Working on individual pieces is a lot easier than working on the entire figure. You'll have a lot more control, and you won't be as overwhelmed facing an arm, a leg, or other assorted body parts.

Initially, the wax will feel way too hard, especially if you're used to working with clay. But it's this very firmness that lets you create a tight finish and allows you to hold the piece in your hand, working every angle, without ruining your work. So you should practice working on some extra wax before you put tool to figure, to save yourself the trouble of making a mistake you'll then have to repair or rebuild.

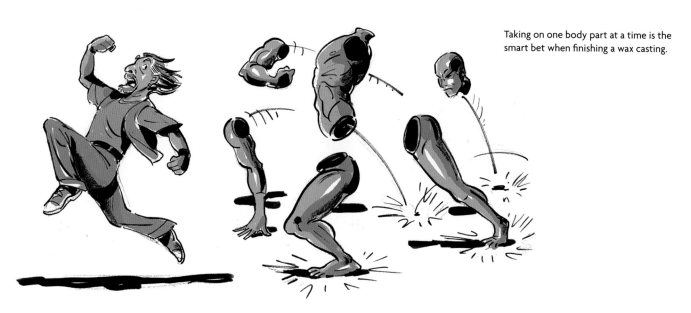

Taking on one body part at a time is the smart bet when finishing a wax casting.

Practice, Practice, Practice: Getting a Feel for Wax

Take one of those wax plugs and see how your tools work with the wax. Which ones work best for removing small amounts of wax, which for large amounts? Which tools are best for intermediate detail, and for fine detail? Try the reinforced loops and wire tools that you've warmed with your alcohol lamp. After a while, you'll know which tool to use to achieve what you're after. It will become second nature.

Now take one of those wax plugs, put it on a glazed 4- x 4-inch or larger ceramic tile and place the tile on the pizza stone under your heat lamp. Keep track of how long it takes for the heat lamp to soften the wax to a claylike consistency. Take a small paring knife, run it through the flame of your alcohol lamp and cut off a chunk of the wax. Roll the wax around in your fingers and roll out a snake, like you did in elementary school. Try to shape a rough head or an arm. Notice how the wax behaves as it starts to cool. Add a little softened wax to one of your cold wax plugs. Blend it, shape it, give it texture. Put the wax back under the heat lamp and see how long it takes to begin to separate. Cut off a little chunk and see how differently the wax behaves when it gets too hot. There'll be a time when you'll want it to work that way.

You'll learn when and how far away to move the wax from under the direct beam of the heat lamp in order to maintain the desired constant temperature for your work. Remember, the pizza stone and ceramic tile will store heat. The warming station will work more slowly when you first use it than it will several hours later, due to the stored heat.

Tim and his BFF, Wax.

The whole point of this exercise is to get comfortable with this new material. The more you know what it does and under what conditions, the more confident you'll be in the problem-solving process of finish work.

A modeling tool shaping wax.

A loop tool at work creating a groove.

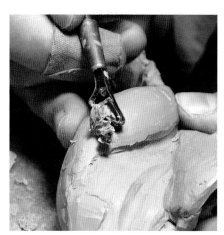

A ribbon tool removing wax.

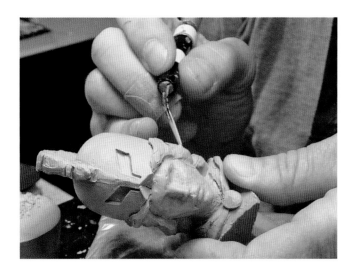

Tim using a Giles Precision Waxer.

Two different tips for a Giles Precision Waxer.

THE PEN IS MIGHTIER: WAX PENS

The tool you use most often will be your wax pen. As discussed earlier, there are a number of wax pens from which to choose, but our mantra is, "the simpler, the better." Save the bells and whistles for a parade or homecoming. We recommend a Giles Precision Waxer. Why? Well, it would be harder for a wax pen to get much more simple—and therefore, more reliable—than a Giles. The family-owned company has been around for over fifty years, and in the forty-some years he's been using their waxers, Tim has only had to buy three. (He uses the downed ones for spare parts for the newer one.)

Use your wax pen to get a feel for the wax and how it works. Try the various tips at various temperatures, and notice how the temperature setting affects the wax. A high setting melts the wax very quickly, making it very runny. Try to collect some wax on the tip of your wax pen, and you'll see it drip off like water. Now, try a medium setting, and you'll see how the wax melts less quickly—but, when picked up with the pen tip and placed at a specific spot, the wax stays where you put it, allowing you to build up shapes. At a low setting, you're softening the wax, not melting it, allowing you to create various textures. By trial and error, you'll become comfortable with your wax pen and learn what temperature does what. Soon, you'll be able to select the setting you want to achieve a specific result.

Let the wax cool a little between additions; you'll be able to add height and bulk more quickly and reliably if you add melted wax to wax that has had a chance to set up a little. Trying to add hot wax to hot wax will just make it spread out, not up, and run somewhere you wish it hadn't. There's sure to be many places you want to build with the wax pen, so hop around, and

come back to each spot after the wax has cooled. It'll keep your frustration level…well, kind of level.

Most wax pens come with a variety of tips, from broad spatula shapes to fine points. Depending on the pen you have, you can modify the tips with a file and fine sandpaper, but be careful not to break the "loop" through which the electrical current (and therefore heat) travels. If you'll be working in fine, small details, a modified pointed tip makes it easier to put the melted wax exactly where you want it. In fact, if you let Giles know, they will modify their tips to your specifications.

Besides the shape and temperature of your pen, there's another thing that will affect the wax getting where it needs to go: gravity. The larger the drop, the more prone it is to be affected by gravity—this is especially true when you're trying to build up wax on a part of the sculpture that is vertical or at an angle. Say you want to build up a cheek or add hair to the side of the sculpture,

Tim discovers gravity, and an irrational hatred of fruit.

and it keeps creeping down off the place you put it. First, watch how the wax behaves on your piece, then angle the part so the gravitational pull puts that wax where you want it. Using the wax pen is generally a process of addition. Although it can be used to remove material, it's generally easier and quicker to use a tool to remove large amounts of wax. As we work our Athena statue, we'll go step by step to show how to use various tools, in conjunction with the pen, to achieve the results we're after.

WAX ON, WAX OFF

Wax gets your tools gunky. The easiest and simplest way to un-gunk is with your alcohol lamp and a small rectangle of clean foam rubber. Keep the alcohol lamp off to the side and away from anything flammable. You'll use it for a bunch of applications, and it, like everything else you use with wax, is going to get grody. Get an old saucer and put your alcohol lamp on it; this way, when you melt the ends of wax rods or heat a small metal measuring cup to melt a little wax, the saucer gets grungy, while your desk hardly notices what a slob you are. The saucer will also act as a used match receptacle, so you're not throwing warm matches into your trash can.

To clean your sculpting tools, a quick warm-up in the flame and a quick poke into the foam rubber will do the trick. (Just remember to let the tool cool before you use it, unless you want to use a warmed tool on your wax.) **To clean your wax pen**, do *not* put the tip in the flame of the alcohol lamp; just give it a quick poke in the piece of foam rubber, and the tip will be clean and ready to use again.

MAKING A CLEANING STATION FOR YOUR WAX PEN

The actual measurements for your cleaning station will depend on the dimensions of your wax pen unit. Ours is for a Giles Precision Waxer with a 4- × 5-inch footprint. Modify the measurements below to fit your unit.

If you want to get fancy, you can run a strip of masking or duct tape around the outside edge of the foam core base unit and spray it with a coat of paint. You'll spend a lot of time with this little unit—a lot of time—so let your freak flag fly, so to speak. Ladies and gentlemen, start your waxers!

An alcohol lamp.

Tim's grody wax pen setup, in need of refurbishing.

Cut two 7- × 11-inch pieces of ³⁄₁₆-inch foam core. Mark vertical centerline, creating two 7- × 5½-inch rectangles.

On one piece of 7- × 11-inch foam core (top piece), mark two 5- × 4-inch rectangles. Cut out rectangles and save them for Steps 4 and 5.

Using spray adhesive, glue cutout top piece to other 7 × 11-inch foam core piece, forming base. Using hacksaw blade, cut a 5- × 4-inch piece of tight-celled foam rubber (no thicker than unit). Do not use a sponge.

Righthanders: Hot-glue 5- × 4-inch foam rubber to one 5- × 4-inch piece of foam core. When glue sets, place foam rubber, foam-core-side-down, into left cutout, and wax pen unit into right cutout.

Lefthanders: Hot glue 5- × 4-inch foam rubber to one 5- × 4-inch piece of foam core. When glue sets, place foam rubber, foam-core-side-down, into right cutout, and place wax pen unit into left cutout.

We suggest that you get a sheet of the rubbery, nonskid stuff you lay under a keyboard or a paper towel holder to keep the cleaner from sliding around when you're in the throes of wax pen passion.

After a period of constant poking and prodding, the foam rubber will begin to break down and get crumbly. When it does, little bits and pieces will get stuck to your wax pen tip. Not good—you don't want those pesky little rubber specks contaminating your wax. Time to pull out your foam rubber section and give it a good 180, put it back in its snug little foam core frame, and there you go, a new poking and prodding playground. When that section starts to crumble, it's time to change the foam rubber. Peel off the old piece, warm up the glue gun, cut a new piece and glue it in place.

WAXY BUILDUP: ADDING WAX TO BUILD UP MASS

At some point in your work, you'll want to—heck, you may *need* to—lay up more wax on your sculpture, to build up mass. Let's say your AD wants your character's biceps to be twice as big or, instead of being bald, he has to have a lion's mane of hair. Now, you could use the wax pen to build up those places, but it would take a really long time, time you probably didn't have even before you started the job. So cut off a chunk of warmed wax and use it as if it were clay to build up those underdeveloped sections.

Note that laid-up wax is not as dense as cast wax. Why? Cast wax has cooled under pressure, with all air forced out by the pressure pot. Laid-up wax hasn't been de-aired, and by kneading it, you're adding more air to it. The difference will become apparent pretty quickly. Your tool will cut through the laid-up wax much more easily than it will the cast wax. It's frustrating, trying to work what should be the same material and have it respond in two different ways, but there are a couple of ways around it:

1. Don't use a loop. It will work okay on the laid-up wax, but when you hit the cast stuff, the tool will spring up a little, leaving divots where the two waxes were overlaid. Use a modeling tool, one that won't give under pressure. It works dandy and pretty darn consistently. Once the laid-up surface is resculpted, go in with a loop and do some tighter surface work. Instead of working the tool in one direction, try it in opposing directions.

2. You can also add a little bit less of the warmed wax than you need, then use your wax pen to go over the laid-up wax, taking it the rest of the way, and creating a more firm top surface.

This isn't as big a problem as it sounds. There are some waxes, especially the harder ones, that won't be as affected. But even they're prone to the phenomenon now and then.

Know Your Tolerance

Your statue is cut up into parts, and it's easier to finish parts individually and assemble them later than to bring the entire assembled piece up to finish. Use your modified loop and modeling tools to tolerance the surface, making it smooth and even. This is the foundation on which you build your detail. You don't want to add detail to a foundation that is uneven and a little rough. No matter how much detail you pile on, a sloppy, uneven foundation will read through.

Now you're ready to tolerance the wax parts. Start with the parts with larger open shapes, like the torso or legs. Remember, there's nothing you can do that you can't undo, but go slowly and cautiously until you get a feel for it. Even though you've studied your reference pictures like you were cramming for the SATs, you'll want them displayed for easy and constant referral. It's easy to get tunnel vision while working on an individual part, so referring to your reference will help keep you focused and working toward a consistent goal.

A word about detail: Not every millimeter of your sculpture requires the same level of fine detail. It's a misconception novice and professional sculptors alike share. The head, hands, and certain costume and compositional elements will need as tight a finish and controlled details as you can manage. Why? Because it's there that your audience will look first and most often. This doesn't mean that you can put a tight finish to the head and leave the back as rough as your clay was; it means you need to focus the work on the areas of the sculpture that tell the greater part of the story. Yes, it's a matter of personal taste, but if you're hands-for-hire it's also a matter of priorities and productivity. If you spend two days on a head and two days on a knee, it might be the best darn knee anyone has every seen, but it'll also be a great knee that puts you two days out of schedule. Okay, that was several words.

Don't spend too much time on one knee if the rest of the piece needs work, too.

TOLERANCING WAX PARTS

We're showing you how to tolerance your wax parts by using Athena's helmet as our example. You should follow these same techniques for tolerancing all of your wax parts. Remember to check your reference art frequently as you work.

First, level the surface of the helmet using a loop tool.

Use a folded piece of 320-grit sandpaper to even out the helmet's surface.

Using several small modeling tools, sculpt in the helmet's eyeholes and decorative side pattern.

Start on the crest. (To make it easier to work on the face, cut the point off the helmet and save it for later. See Step 6.)

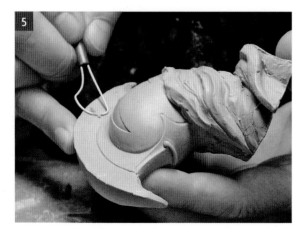

Before adding the brush details, tolerance the crest using a combination of loops, modeling tools, and sandpaper.

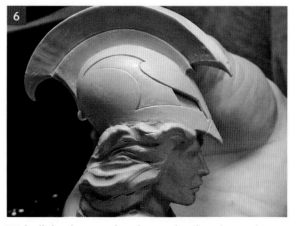

With all the shape work and some detail work complete, temporarily reattached the helmet point to make sure you're still on track.

A WAXEN VISAGE

Okay, you're ready for some face time. More than any other part of your sculpture, this is the most demanding, the most difficult, and the most rewarding. We recommend you use a galvanized nail (10¼- to 5-gauge, depending on the size of the neck). Hammer the pointy end flat about halfway down, cut off the head, and drill a hole the diameter of the nail a couple of inches into a wood dowel. This is your head mount, an alternate point of support that will make it easier to handle and detail your figure's head. Warm the flattened end of the nail in the flame and insert it into the center bottom of the head or neck. Let the nail cool and wax around it to fill in the hollow of the melted wax. Make sure to leave at least ¾-inch of nail exposed from the bottom of the head to the top of the wood dowel, because it helps get that beautifully finished head off the nail without putting undue pressure on it when you pull it off the nail. Put the exposed nail shaft into the flame and heat it just enough to pull the head off easily. When the head is removed, use your wax pen to fill in the hole the nail left behind.

So, with your head mounted—and we do mean the wax head, not yours—use your tools and wax pen to build and refine

Sculpting eyes (and later, painting them) is one of the hardest things for a sculptor to do.

its basic structure. Hopefully, you haven't put a lot of work into the clay head; it's just harder to work over it in the wax. Once you've got the basic head shape, mark out the eyes, nose, and mouth placement. If your art is very tightly rendered and you have it printed to size, this is a simple matter of transferring the caliper-measured distances from art to wax. If not, find a head picture that closely aligns with your art. Make sure the facial features are where you want them when you start refining. Bring up the head in stages, incrementally. You don't want to spend an hour detailing an eye only to find it's too low and deep in comparison to the other eye. When you have the basics of a good, well-balanced head, with indications of eyes, nose, and a mouth, it's time to tighten and detail.

That old adage is true, the eyes are the window to the soul—and it may be even more true for a work of representational sculpture. They also happen to be one of the most difficult elements to get right, especially in a small piece.

Mounting your figure's head on a dowel with a nail in it can make it easier to handle.

Note: We recommend that, if you're right-handed, you work the left eye first (from the sculptor's point of view). Left-handed? Work the right eye first. It will be easier to match, eye for an eye, working opposite your natural inclination. We have a tendency to first work the side of our bias, and it's more difficult to match our opposing side to it. And this goes for arms, hands, feet, and virtually every other part of a statue.

SCULPTING EYES

There are as many methods to sculpt eyes as there are eye colors. Some sculptors use little ball bearings or marbles or any number of round things to act as eyeballs, building the lids over and around them. Some don't. Each, done well, looks great. It's not how you do it, but how it looks when you're done that counts. We're going to show you a way we've found that works reliably for us and doesn't include the use of anything round or shiny.

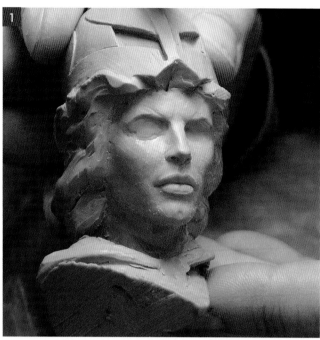

With face structure defined, lay in a convex oval where you want the eye placed. (Note: The sculptor is right-handed, so he begins work on the left eye.)

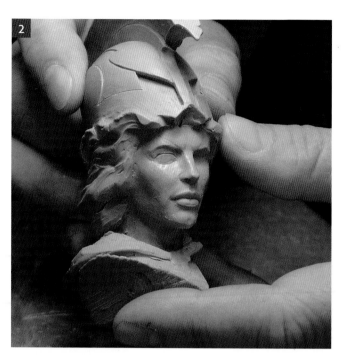

Scribe in the eyelid line.

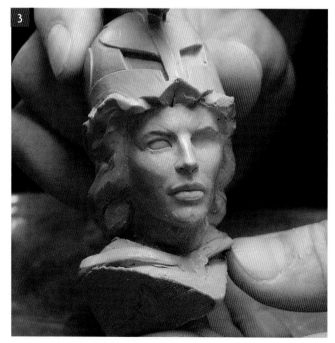

Using your wax pen, build up the upper and lower lids and tool them down a little.

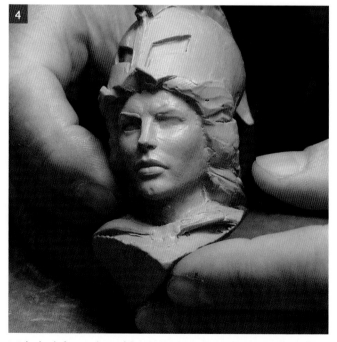

With the left eye shaped, begin work on the right eye, constantly referencing the right eye against the left.

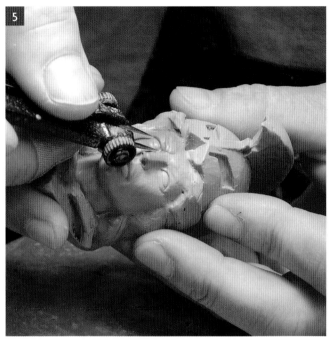

Using a set of calipers and your reference art, double-check the width and placement of the eyes.

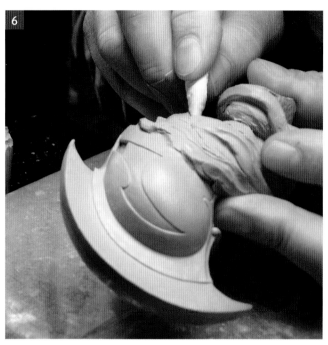

A tightly folded paper towel section and a little turpentine help smooth out the eyes and eyelids.

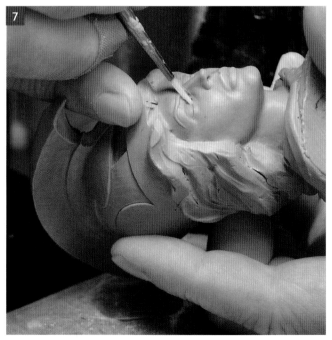

Using a soft, turpentine-dampened bristle brush, further smooth and clean the eyeballs and surrounding areas.

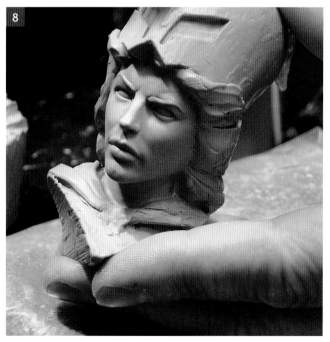

Voilà, your completed eyes!

WAX DETAILING

Wax pens do a number of things really well. You almost can't find an easier way to add veins to your muscle-bound hero or troglodyte. When you know where you want the veins to go, you draw them out, then use a tool to blend them down into the skin, and there you have it! Think of it as three-dimensional drawing. This also works for hair; once the architecture of the hair is done, you can draw out coils and curls to your heart's content. A wax pen makes it much easier to find the flow and dynamics of the hair than cutting it in. You can even create hair so fine that it looks like a helmet full of garden snakes. Hair is, as we know, a collection of hundreds of individual strands that collate into locks that combine to make a full head of hair (or in some cases, a less-than-full head of hair). But just because we know this about hair, that doesn't mean we should sculpt what we know. *Sculpt what you see, not what you know.* If that's your rule of thumb as far as detail goes, you're more likely to have a well-balanced, homogenous sculpture than one that is broken up into areas of effusive fussiness.

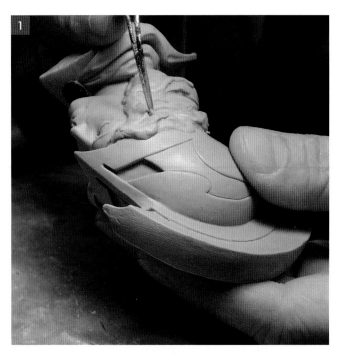

Make sure the hair architecture is in place before adding details, then use your wax pen to "draw" in hair shapes.

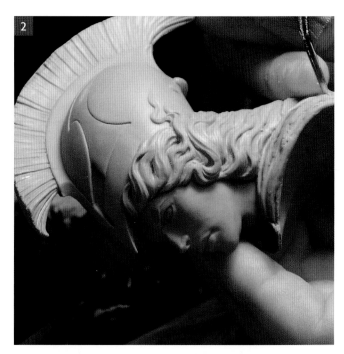

Where the hair interacts with her cape, work both together.

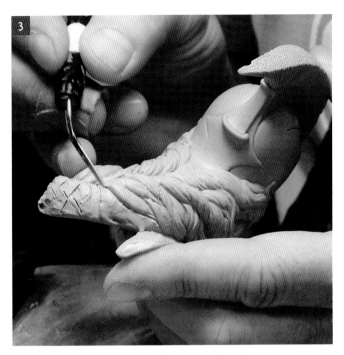

Follow the intent of the rough clay when adding hair shapes.

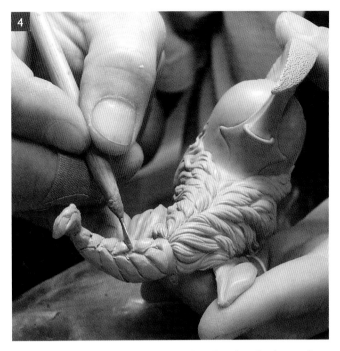

After you've laid in the basic shapes of the braid, go back in with a small modeling tool to define those shapes.

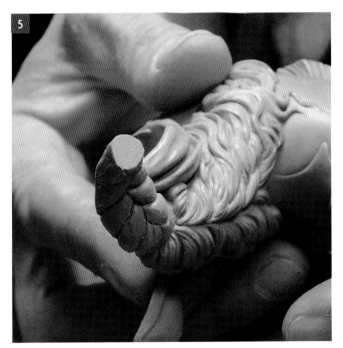

Cut off the end of the ponytail. Make sure the ring shape is perfectly round, then flatten the end with sandpaper. Correct the shape that becomes the end of the hair band.

Using a circle template, determine the diameter of Athena's hair band.

Using the circle template and a stylus, cut a circle of wax sheet to the diameter determined in Step 6.

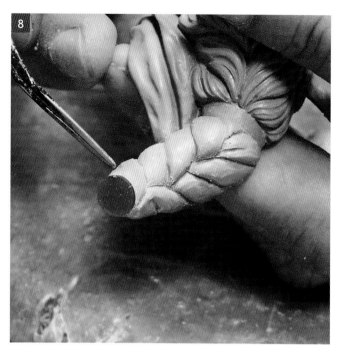

Using your wax pen, carefully weld the sheet wax disk to the hair unit, then wax pen the hair flush with the edge of the disk.

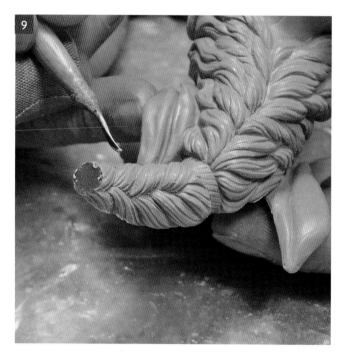

With the disk in place and the hair waxed flush to it, complete the hair detail.

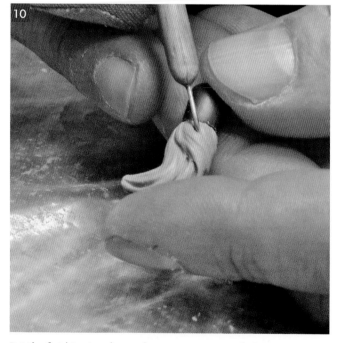

Put the finishing touches on her separate ponytail piece.

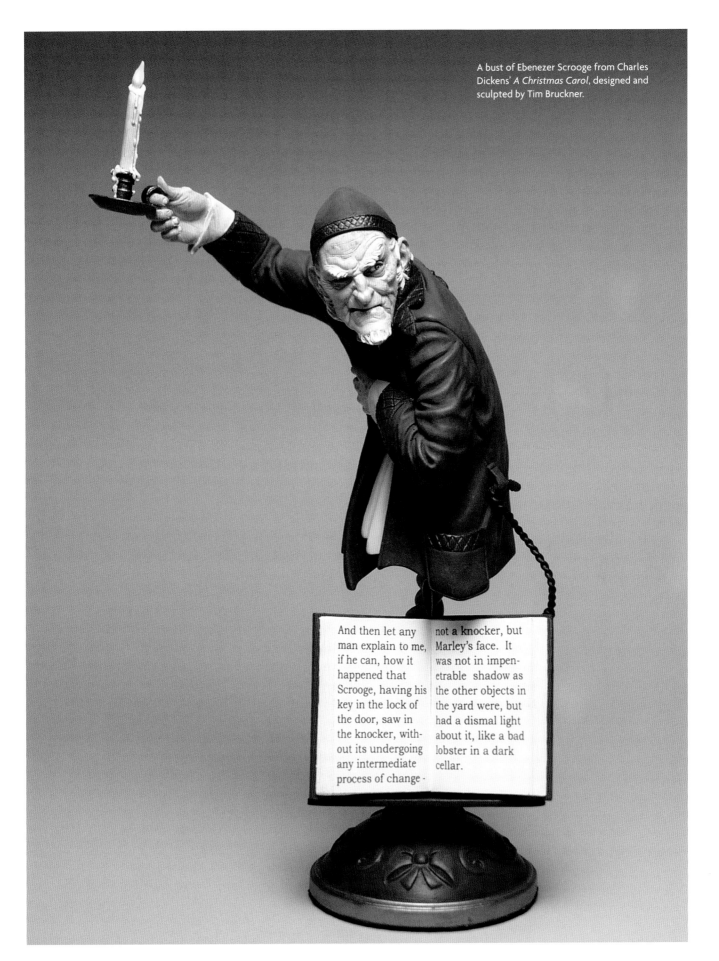

A bust of Ebenezer Scrooge from Charles Dickens' *A Christmas Carol*, designed and sculpted by Tim Bruckner.

And then let any man explain to me, if he can, how it happened that Scrooge, having his key in the lock of the door, saw in the knocker, without its undergoing any intermediate process of change - not a knocker, but Marley's face. It was not in impenetrable shadow as the other objects in the yard were, but had a dismal light about it, like a bad lobster in a dark cellar.

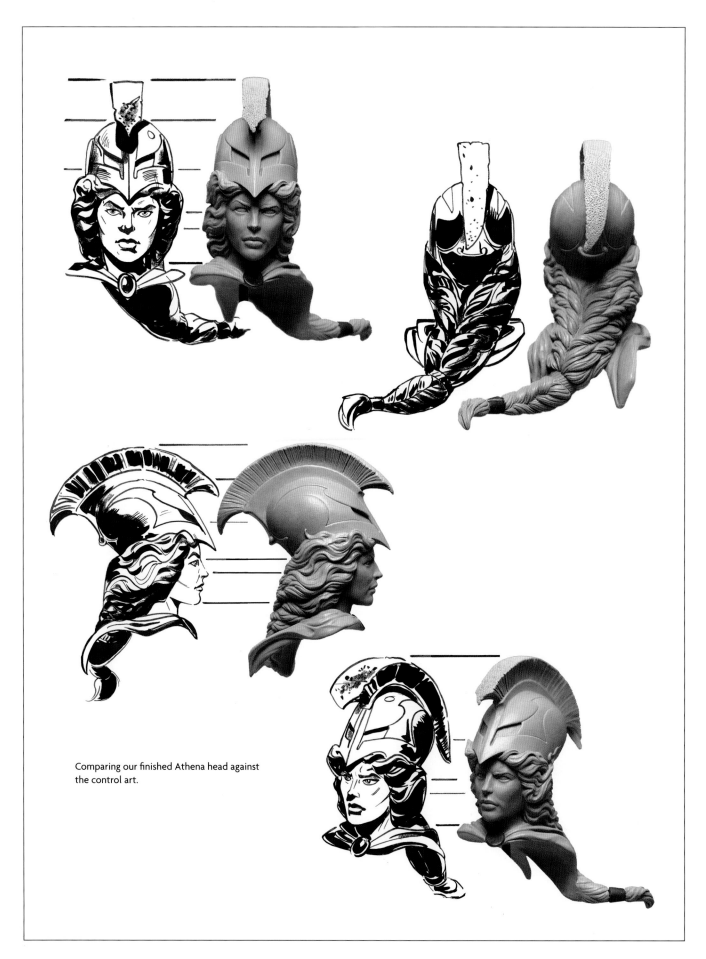

Comparing our finished Athena head against
the control art.

SCULP-TOR SEZ: PINS AND NEEDLES

When you have to weld or reweld two small wax parts together and even your finest wax pen tip is too big, use the tip of a ball-ended sewing pin. This method is particularly useful if you've broken off or have to reposition an ear or finger. First, press together the parts to be welded; small parts tend to stay put when pressed together. With parts in place, hold the pin by the ball end and heat the tip in the flame of your alcohol lamp. There's no need to hold it until the tip glows red; that's overkill. Just a few seconds will do it. Carefully run the tip along the join seam. You may have to do this several times, as the pin will cool and create a channel rather than fill one in. Often, you won't need to do any resculpting, but if the pin leaves a depression, adding a little wax on the end of a tool will do the trick.

SHIELDS UP!

In re-creating Athena as a superhero and pop culture icon, we wanted to give her cool accessories. So when Rubén came up with this menacing Medusa art for her shield design, we knew we had to find a way to present it in a nontraditional way. A little brainstorming and the lens-shield design was born. The finished shield will be clear with painted accents, so the color image can show through, but for now, we'll be creating an opaque version, which we'll later mold and cast in clear resin.

For the shield, we used **wax sheet**. Wax sheet is available in a wide variety of types specifically designed for certain uses; for our purposes, we used one most commonly sold through jewelry supply companies. It's often referred to as a firm green wax sheet and comes in thicknesses from 26-gauge (the thinnest) to 10- or 8-gauge. Wax sheet comes in 3- x 5-inch sheets or 4- x 4-inch squares; you'll get a lot more use out of the 3 x 5 sheets. (Stay away from the pink wax sheet, or any wax sheet that is advertised for its transparency. Although pink sheets may work just

as well as the green ones, it's almost impossible to get a good read on their surface, which will potentially result in a fatally flawed finish.)

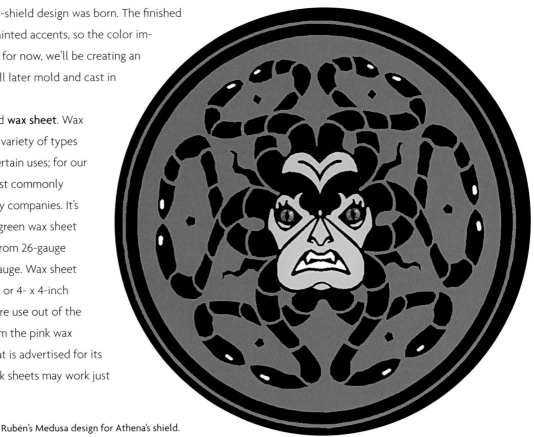

Rubén's Medusa design for Athena's shield.

Use a circle template to cut 14-gauge wax sheet in a round shield shape **(1)**. Warm it slightly with a hair dryer and form it over a sphere. (We used a snow globe.) When the wax cools, level the concave side of the formed wax, mix up a small batch of resin, and pour the resin into it. (See Chapter 7 for more about working with resin.) If the shield were bigger, you might pour the resin in stages to prevent the heat buildup from distorting the wax, but at this size, you can pour it all at once.

With the resin cured, cut a strip of 18-gauge wax sheet and run it around the resin, forming a frame, then use your wax pen to weld it into place and fill in behind it to create a shallow gully **(2)**. Smooth it out using a small ribbon tool, and then rub smooth with a wedge of paper towel and pure gum turpentine **(3)**. Print out a test of the shield art to make sure it fits **(4)**, and then turn your attention to the front of the shield.

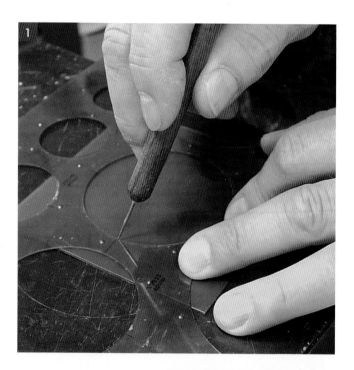

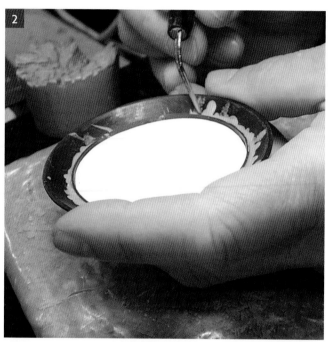

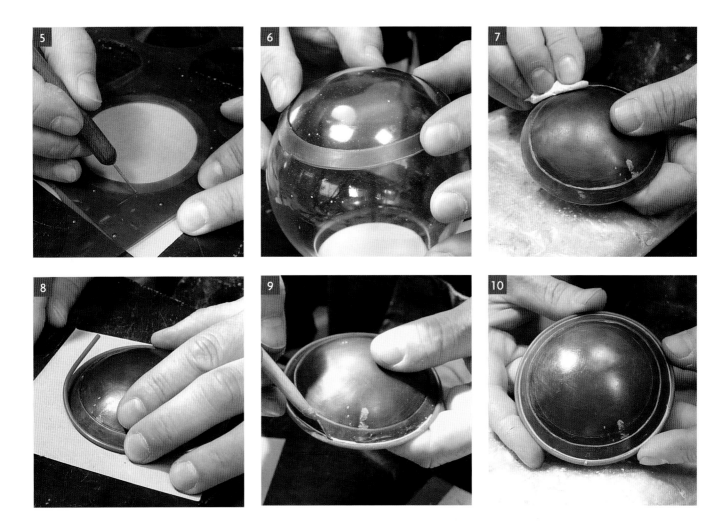

Using the circle template again, cut a ring out of 20-gauge wax sheet **(5)**, then use the same snow globe used above to form the ring **(6)**. Rub a little turpentine on the ring to weld it to the shield, and rub it down **(7)**.

Finish the shield's lip with a length of 10-gauge wire around the edge of the shield **(8)**. With the wire welded in place on the shield's back (not shown), roll out a thin length of warmed sculpting wax to fill in the gap between the wax wire and the shield **(9)**. Give it a final rub down with a little turpentine **(10)**.

SCULP-TOR SEZ:
A STICKY SITUATON

Cutting wax sheets can be problematic since they have a tendency to stick to whatever surface you're working on. Luckily, a box of wax sheets comes with pieces of waxed paper slipped in between them to prevent them from sticking to one another, so we always put one of them down on our cutting surface first, before we start cutting. That way, the sheet comes up quickly and easily every time!

GET TO THE POINT: THE SPEAR

If Athena is going to have a tricked-out shield, then she for sure needs a kick-ass, energy-flame-bursting spear. We could have finished our wax casting of the clay rough with the energy flame as part of the piece, then cast the whole thing in tinted clear-cast and been done, but we wanted it to look like the energy flames were emanating from the spear, around, and over it.

First, sculpt a new spearhead in wax and make a waste mold. Then, cast it in resin and, using 180-, 320-, and 400-grit sandpaper, get that spear blade sharp enough to draw blood **(1)**. (And ours did. Just ask Tim.) The spearhead is going to have to fit snugly on the spear shaft, so cut a section of brass rod and fit the bottom of the blade to it, using wax sheet to create a collar **(2)**. For the final statue, you'll be using nickel rod.

Having cast the rough clay spearhead into wax, you have the basic forms of the flames you wanted to use, so, using a wax pen and sculpting tools, finish the two main flames **(3)**. We knew we wanted to cast the flames in blue tinted clear-cast resin to

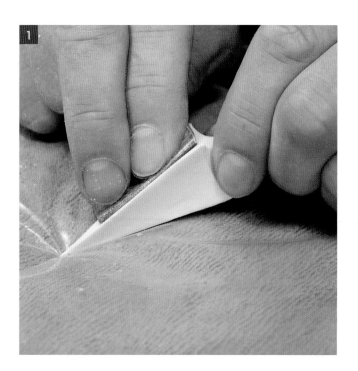

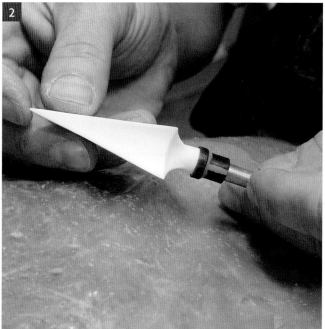

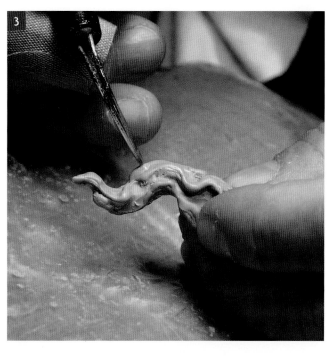

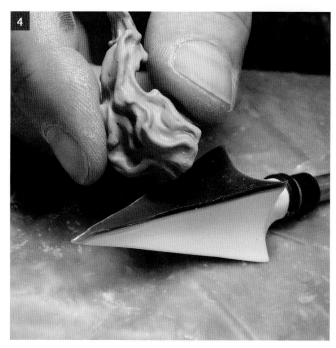

make a separate piece that would fit over the blade, so we had to treat the flames like a case, similar to how we'd build a helmet for an action figure (see Chapter 9). Cut pieces of 18-gauge wax sheet to the shape of the blade **(4)** and attach your completed wax flame sections, adding more flames with softened sculpting wax and defining the shapes with a wax pen and sculpting tools. As you work, cut away the sheet wax case, leaving only the flame pattern **(5,6)**.

Note: When sculpting a part you know is going to be cast in clear or tinted clear resin, it's a good idea to sculpt the recess more deeply than you might ordinarily. The more contrast in surface levels, the more refracted and reflected light will play throughout the cast part, creating the impression of motion within the piece.

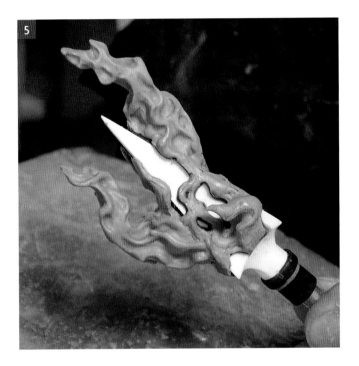

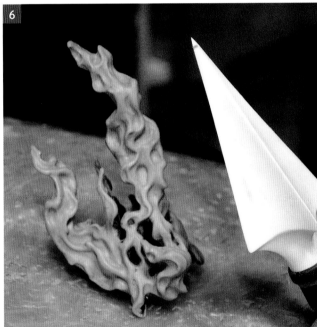

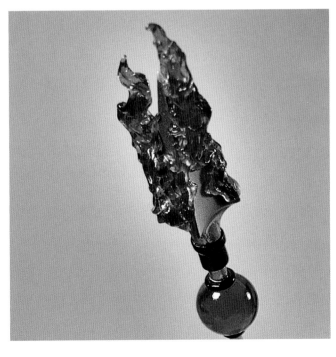

This is how the tip of the spear and the flames will look after they are cast in resin.

NICE GUYS FINISH LAST: FINESSING THE WAX

You've now got sections of your statue **tool finished**. By this, we mean you smoothed and finessed the surface with sculpting tools. But it's not smooth. You could continue to use every tool in your toolbox, and that wax will be pretty darn smooth, but it isn't *smooth* smooth. Now, not everything you'll sculpt needs to be a smooth as a baby's behind. In fact, unless you're sculpting a robot, you'll want a diversity of textures. The soft and supple skin of your cavewoman statue will look all the more soft and supple juxtaposed against the dense texture of her bearskin bikini as she looks off into the distance perched atop a craggy lava outcropping.

But for those areas where you want that *smooth* smooth, there's a pretty easy way to get it. You'll need some cheap paper towels (not the ones that claim they're like fine-woven Egyptian cotton), a pair of scissors, an X-Acto knife, a sealable jar, and some pure gum or steam-distilled turpentine. If you're sensitive to the smell, there's low-odor turpentine. **Note:** Don't substitute paint thinner or any other solvent.

Lay out a stack of paper towels, maybe a dozen or so **(1)**, and cut them into strips about 2¾ inches wide **(2)**. Try to make them all about the same width. Stack the strips into four fairly equal piles and cut them in half, so you have eight **(3)**. Fold the individual squares in half and then fold each of them up into

11"

2.75"

a tight long triangle **(4,5,6,7,8,9)**. Then, dip the tip into the turpentine and, using the damp tip of the folded paper towel, chemically sand the wax to a nice smooth surface.

What you're doing is dissolving the topmost surface of the wax, removing all those pesky tool marks. You don't want to soak the thing, just get the paper towel damp. If it seems too wet, just press it into a blotter of paper towels, or do what Tim does and dab it on your smock. (Tim is extremely flammable.) You'll get a feel pretty quickly about how much turpentine to use and when to stop sanding. But what about the residue, you ask? We knew that was coming. Often, it'll be picked up on the paper towel. But there is going to be gunk left behind now and then. Use a nice, soft sable brush (a No. 8 mop brush is a good all-purpose size for medium to small work, but you'll figure out which size

works best for the job it needs to do) that has been lightly dampened in the turpentine and brush the surface, collecting the wax gunk. It works like a charm.

But we can hear you getting ready to ask, "What about places of my statue that are too small and delicate to use the paper towel method?" Use a small detail paint brush dampened with turpentine and, instead of painting the turpentine on the surface, push and pull the brush, as if mopping the floor, essentially microsanding the wax. And the same residue brush-away trick you used before will work fine now.

Our next step is creating a mold of your sculpture for casting.

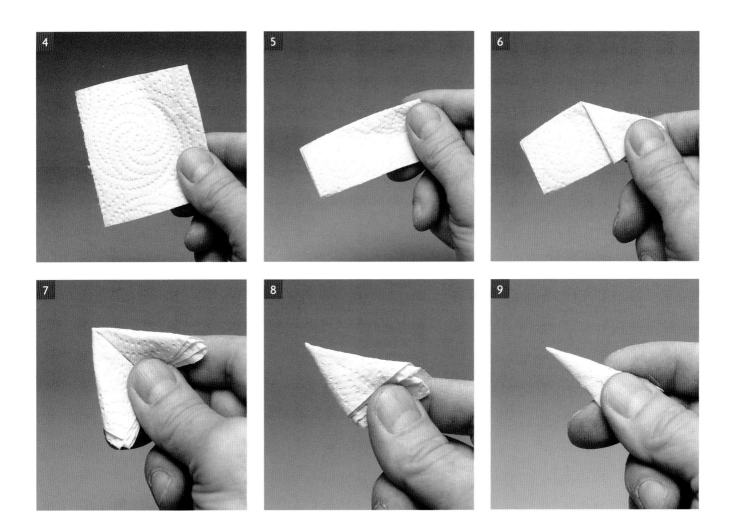

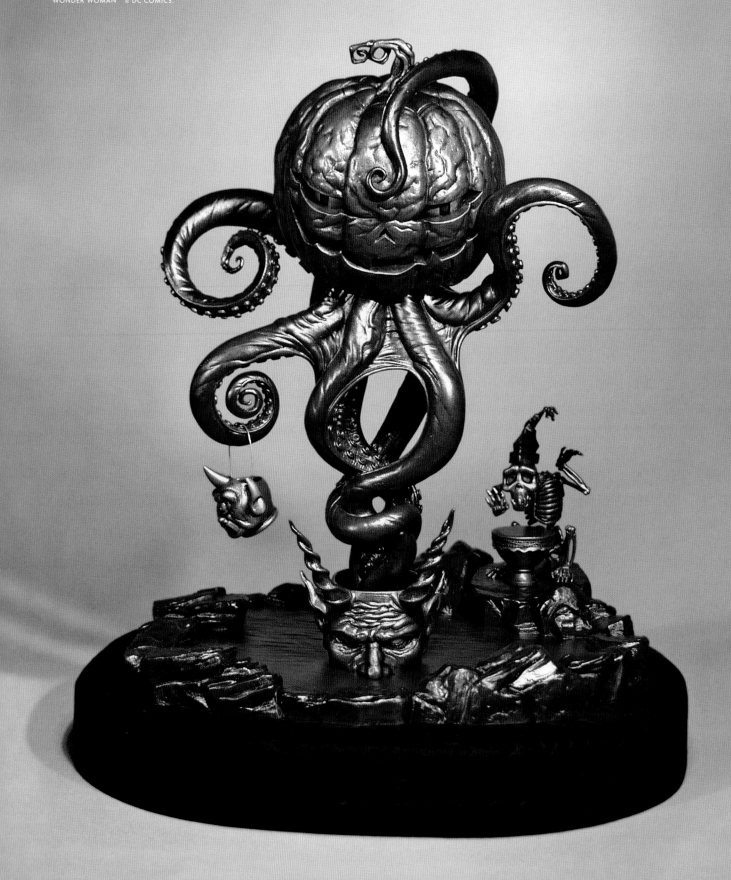

Under Autumn's Tentacled Spell, based on the painting of the same name by Todd Schorr, sculpted by Tim Bruckner and cast in bronze.

OPPOSITE PAGE: A statue of Wonder Woman, sculpted by Tim Bruckner for DC Direct, designed by Adam Hughes.
WONDER WOMAN™ © DC COMICS.

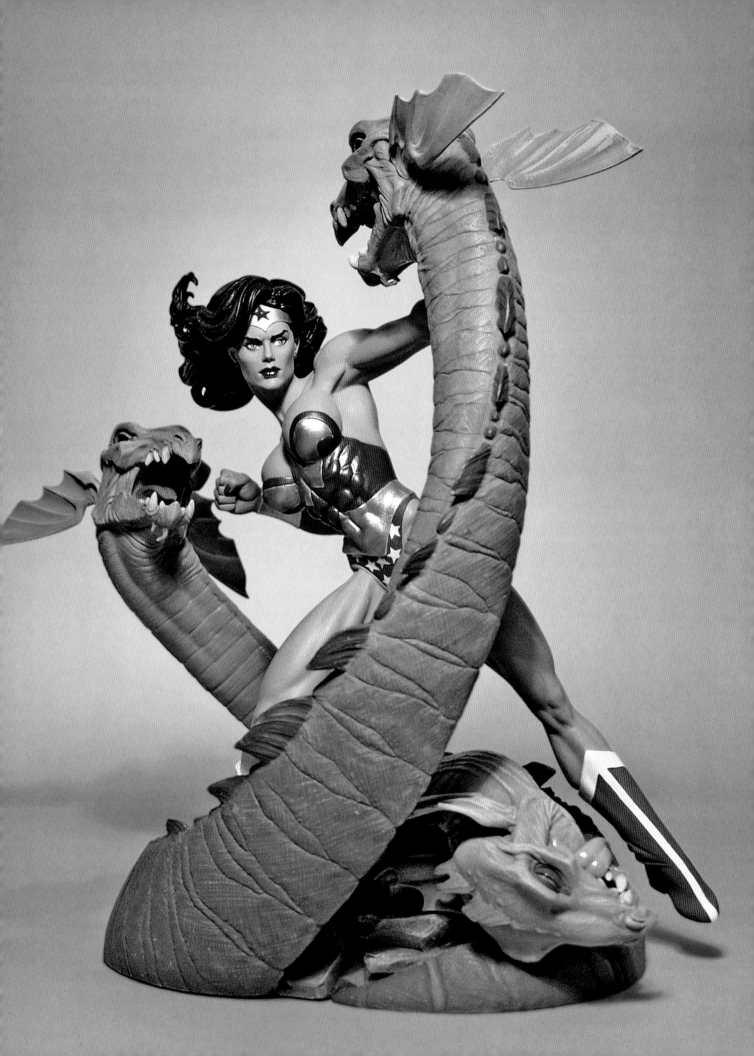

6. Making a Master Mold

THE PROCESS OF CREATING MASTER MOLDS FOR A MASTER CASTING

"Oh, great," you're thinking, "another chapter about moldmaking." Well, yes, but this isn't just any mold. This is the mold that will turn your statue from a one-of-a-kind piece into an international sensation. While you'll use many of the skills you learned in Chapter 5, how successfully you learn the techniques to peg and gate your statue in this chapter will determine how successful your master mold will be. Using our Athena statue as an example, we're going to identify potential problem areas in each section and work to solve them from a purely reproduction/manufacturing point of view.

Sectional Revolution: A Seamless Collection of Parts

Just like your clay rough, the master wax of your statue will be molded and cast in sections/parts. Your goal is to create parts that will combine as a seamless finished product, so planning ahead is key. Choosing which parts fit where and how is critical to how you take your statue to finish. Using Athena as an example, first evaluate the statue for natural breaks where it can be assembled easily and unobtrusively. Here, the most obvious are the arms. She's wearing bicep bracelets, a perfect place to separate the arms into two sections, using the bracelets themselves to mask the join (as shown at right).

You can see here how we finished the bicep cut, essentially making Athena's biceps into large pegs.

Now, you have to be sneaky and clever and a little devious to break Athena into manageable sections that go back together with no one the wiser. The cape presents a problem. It's not all that undulating fabric, it's that wicked mold lock between the cape and her back. You could *probably* make the mold with the cape attached to her body, but you'd wind up with a complicated mold and more resin cleaning. So you need to find a discreet way to make the cape a separate piece. Athena's head will help you out with that one—she is the goddess of wisdom, after all.

Athena's head was V-cut from her body at the rough clay stage and the seam was cleaned up in the wax stage. But that seam will be impossible to hide in resin. So cut the hair and a section of cape from the wax cast of her body, and attach them to the head section (as shown below). With those parts obstructing the seam, Athena's head will fit stealthily into her shoulders, resulting in a cleaner assembly. The very end of her ponytail will also be easier to cast separately, so set that up on its own, as well.

There's a skirt section that curls up and comes around the calf of her right leg. Again, it will be so much easier to cast it as a separate piece, which you'll do. The cloth that flutters from the spear is an easy one; after it's cast, it'll slide it into position on the nickel rod that will be the foundation of the spear. Attach her owl by its tail feathers to the crossbar of the spear and make the owl and cross bar a separate piece. The flaming energy spearhead will be another easy part to cast on its own.

We came up with a cool lens effect for the shield that allows Rubén's art to show through, so cast the shield in clear resin. But you need a way to attach it to your statue. The solution: Create a back plate to trap Rubén's art. To secure that assembly to your statue, cut her left hand off at the wrist, make it part of the back plate, and plug that whole thing onto her left arm, the seam covered by the shield strap (as shown below). Finally, the base will be broken up into three parts: The craggy mountaintop of Olympus, the cloud ring, and the cloud plume, which you'll cast in a translucent resin.

The key to building a statue in sections is to study the statue as a whole, specifically the fit and look of the parts you intend to separate. As Athena's various bits and pieces are brought to finish, you should frequently check them against where they'll attach to make sure nothing gets out of whack. Print out a couple of pictures of the finished clay rough to reference the entire piece and keep the feel and energy created in the clay work. As you make master molds of each piece, cast them up, so that each ensuing wax piece can be perfectly aligned with the resin you've just created. Then, after everything has been cast, you should be able to fit all of the pieces back together like a jigsaw puzzle, without the use of any connectors. The one place you'll need connectors is when you attach Athena's feet to her base. That's where **pegs** come in.

We cut the hair and a section of cape from the wax cast of her body, and attached them to the head section to obstruct the seam when the statue is assembled.

We cut Athena's left hand off at the wrist and made it part of the back plate. The seam covered by the shield strap.

You've Got Pegs, Now Learn How to Use Them

Pegs, or **pins**, are what action figures and some statues use to keep their various parts together, and prepegging is going to be an essential tool in preparing your statue for reassembly. While action figures use round pegs almost exclusively, you'll use both round and square pegs for statue work.

Round pegs, often referred to as dowels, are made of steel, can be purchased in 100-count boxes from a variety of hardware catalogs, and come in a variety of lengths and diameters. We use these standardized pegs to make casting easier, as opposed to making them out of various lengths and gauges of wire. This way, after you have a collection of molds, you won't have to worry which wire you used where. Also, steel dowels are strong and reliable and work great in casting. That's right, you'll cast resin around these pegs—consider it a foolproof way to create a perfect peg (and peg hole) every time.

It is darn near impossible to drill a peg hole in a resin part that will give you a perfectly placed, perpendicular peg. And if by some stroke of luck you manage the impossible, that's just for one casting when, more than likely, you'll need anywhere from three to six copies. The odds are so stacked against you that you have a better chance of winning the lottery than getting it right. Put the pegs in now, during the wax stage, while the material is at its most workable.

Using our Athena as an example, peg the bottom of each foot. You *could* remove the pegs before creating the mold, letting the peg holes fill with RTV rubber, making your peg holes part of the mold, but there's always the danger of ripping or tearing out those little plugs of rubber, especially if the holes are deep. So, make your molds with the pegs in place, making sure there's enough peg exposed so it will sit in the mold nice and steady. When the mold is opened, you'll remove the pegs from the bottom of her feet and put them back in their respective mold holes, then make resin casts with the pegs in place. When the resin is fully cured, use a pair of pliers to remove the pegs. The holes in the casting will be in exactly the same place at the exact same depth, casting after casting, making resins much easier to manage.

Now, if the figure is touching the ground in only one spot (i.e., has only one point of support), use a square peg to keep the figure from pivoting out of position as it could with a round peg. Also use square pegs on interchangeable parts, when the orientation of the part needs to be fixed. (If the part fits into its seats only one way, a round dowel will suffice.)

While not sold in bulk like round pegs, you can make square pegs out of aluminum or alloyed square rods from the hardware store: Cut the length you want, file down the cut edge, and give it

A round peg.

A square peg and sleeve.

a light sanding on all four sides. With square pegs, the fit is easier to set up if you seat a sleeve into your sculpture. So it's a good thing that model and hobby shops carry square brass conduit in a variety of sizes that perfectly fit the standard hardware store rods.

To prepare the wax for a square peg, seat the *sleeve* into the wax part using an X-Acto knife and sculpting tool to dig out a recess. When you've got the recess where you want it and as deep as you want it, warm the sleeve in the alcohol lamp and, using a pair of needle-nose pliers, slide it into place. Wax pen around the sleeve if there are any gaps, let the wax cool, and level the surface. With the sleeve in place, insert your square rod. Why not just seat the rod directly into the wax? Because using the brass sleeve gives you a tighter and more precise fit. Using a small triangle or anything truly square, make sure the peg is perfectly perpendicular to the surface of the wax part. Make your *mold* with the sleeve and peg in place. When it comes to *casting* use only the *peg*, not the peg and sleeve, in the mold. We recommend that you cast both sides of the part with the square peg in the mold so you can use a metal peg for extra strength. Works for round pegs too. Don't worry, it's not as complicated as it sounds. What's that saying about a picture's worth? Yep, we're going to show you with pictures. Let the word count begin!

ATHENA'S HEEL: SEATING ROUND PEGS

Start by pegging the bottom of both of Athena's feet at the heel, where the pegs will have more resin for support. Use a standard ¼-inch-diameter peg, ¾ inches long. Sink the peg only about ⅜ inch into her heel, leaving a good amount of exposed peg sticking into the mold for reliable and consistent placement. But first you need to make sure the foot is perfectly flat. Using a broad loop tool and a little 320-grit sandpaper, level out the bottom of her foot. Using a reinforced loop tool, tool out a hole in each heel for the peg. Don't worry if it's not perfect—you'll fix that. With permanent marker, mark the peg on the side to the depth you want to sink it into the foot. Holding the peg with a pair of tweezers or needle-nose pliers, warm the peg in your alcohol lamp and put it in the hole. The wax will melt and make room for the peg. Hold the part horizontally, so if there's any dripping wax it won't run down onto your part. Don't make the peg too hot; it just has to be warm enough to soften the wax, not melt a hole that will drop the peg into her knee. Once you've got the

peg where you want it, use your wax pen to wax around it, setting it in position. Let the wax cool, and voilà! A pegged foot!

But how do you know the peg is perfectly perpendicular to the bottom of her foot? Good question. Get a 1-inch-diameter wooden dowel and cut off about ½ inch, making sure it's truly level. Then, mark the center and drill a ¼-inch hole all the way through. Test a peg in the hole, making sure it slides in and out easily. Slide the alignment dowel over the peg on the bottom of her foot. When it's flat against her foot, take a tool, press

Carving a peg hole.

Inserting the peg.

through the hole to the peg and push down a little. Carefully remove the dowel and the peg will be perfectly perpendicular to the bottom of her foot. The parts need to fit flush, one to the other. If the pegs are angled a little, the fit will be off, changing the position of the statue and making a secure fit impossible.

How do you handle the other peg locations for Athena? Use the same methods to prepare the head of her energy spear for the brass rod of her spear shaft and the owl/crossbar section. But you won't have to peg her biceps or the fit of her forearm to the wrist/shield assembly, as they're elliptical, and their shape will make for an aligned connection where the particular shape of the parts align to one another for a pegless connection. And you won't need to peg her head, because it should fit neatly into the notch you created. However, to ensure the fit is perfect, mold and cast Athena's head first, and adjust the wax body to match. Then, you'll be able to build the rest of your statue piece by piece, fitting wax to resin, confident everything will fit together just as you intended. Now, to the gates!

Making sure the peg is perpendicular to the foot.

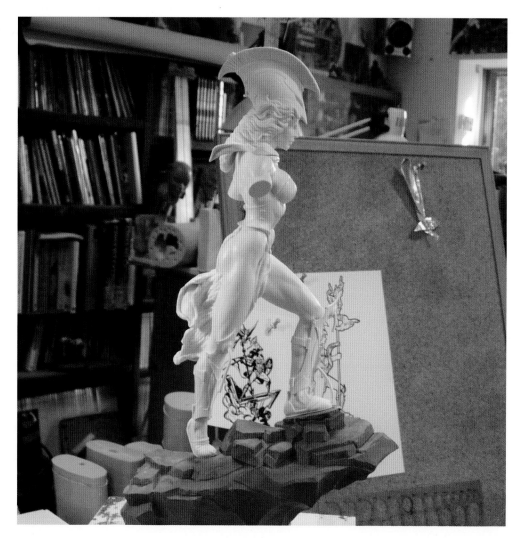

LEFT: The pegged Athena.

OPPOSITE PAGE: Tim Bruckner designed this sculpture of Green Lantern Vs. Sinestro using only one point of support for both characters.

GREEN LANTERN™, SINESTRO™ © DC COMICS

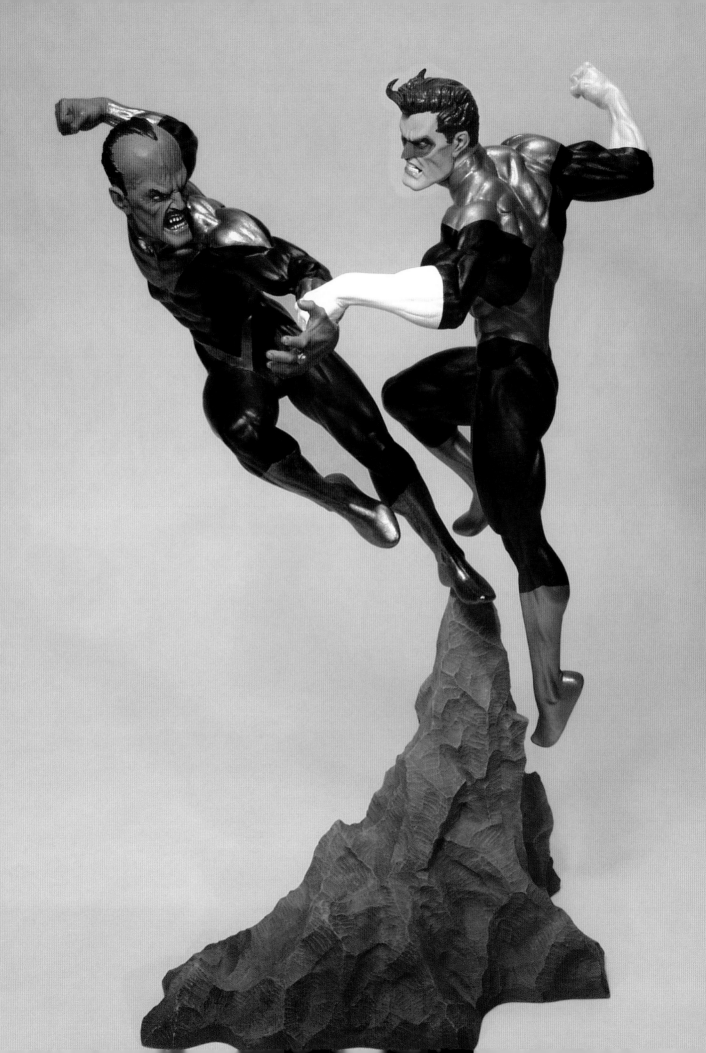

Barbarians at the Gates: Gating Finished Parts for a Master Mold

"Taste hot resin, knaves!"

The difference between gating your rough clay for a waste mold to wax and gating your finished statue for a master mold to resin is all about *placement*. Gating for a waste mold, our goal was to get as much wax into the mold as quickly as possible, and to make an escape route for trapped air. Knowing we were going to resculpt the piece meant we could be a little bolder in our gate placement. That works for a waste mold, but when gating your master wax in preparation for a master mold, you have to be much more circumspect—you need to design the gate system to get as much casting material into the mold as quickly as possible, *but in a way that won't obscure or compromise your detail or finish work.* You can see this difference in the photos of Athena's head (below).

The gated rough clay Athena head for the waste mold.

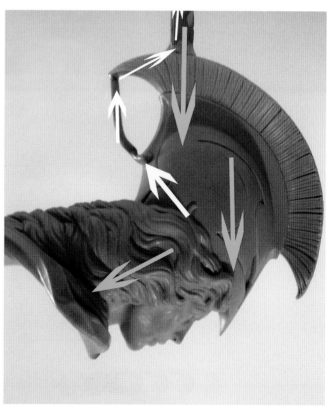

The gated master wax for the master mold.

150

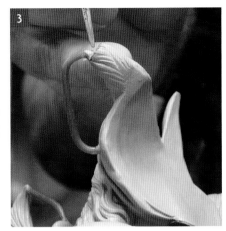

Just as you did with your rough clay parts, draw cut lines on the wax master parts to use as a guide for cutting the RTV. For Athena's head, you will cut down the main feeder gate **(1)**, down the helmet crest **(2)**, down the back of the helmet, and then jog over a little and down the high side of the left side of the pony-tail. You'll cut in the opposite direction along the helmet crest to make it easier to remove the casting. The gate from the cape section to the end of the ponytail will be removed as an internal cut **(3)**. By examining the cut line locations (on this and the other parts), you get an idea of the options in determining the cut lines on your own sculptures. And don't forget—always gate on the high side. We know we've mentioned this before, but it's worth mentioning again—it's easier to clean a seam off a hill than to dig one out of a valley.

SCULP-TOR SEZ: GET AHEAD OF THE CURVE

When gating up a part, curve or arch the gate so it always hits the part at a right angle (perpendicular). Why? Once the part is cast in resin, the perpendicular gate leaves behind a nub that's easy to see and just as easy to remove. When a gate hits your part at an angle, the contact point is longer and not as clearly defined and therefore requires more finish work. If you're lucky, sometimes the contact points are straight across from one place to another, and a straight gate can be used. But that's if you're lucky. Often, you'll need to gate one rounded surface to another, and curving or arching your gate will make less of an impact on your part when it comes time to clean it.

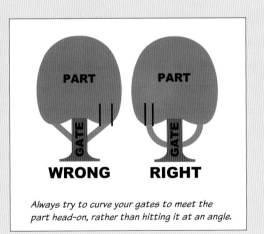

Always try to curve your gates to meet the part head-on, rather than hitting it at an angle.

FITTING A RESIN HEAD TO A WAX BODY: Now, let's pretend. Put on your magic Future-Looking Glasses and see how you've already cast Athena's head in resin. See it? Try squinting. There, that's better. Now it's time (to pretend) to fit the resin head to the wax body.

Using softened wax from your warming station, press a little onto the neck position on the body and then press the resin head into the position you want. You'll have to nudge and cajole the wax here and there, but soon you'll have the head just where you want it. Using a modeling tool and some softened wax, sculpt up to the resin and, where necessary, create elements that will mask the seam, like that section of cape that comes off of Athena's right shoulder.

There are a couple major concerns when fitting wax to resin: a nice, tight seam, wax to resin, and a few good contact points for gluing the parts together. When you remove the head, you'll see where the resin has made contact with the wax; you'll also be able to see the voids where it hasn't. Use your wax pen or a little more softened wax to help fill in the voids. Not every millimeter of wax needs to be flush to its resin counterpart; just make sure you have enough contact points, part to part, for a secure join. Okay, time to remove your Future-Looking Glasses and join us in the Here and Now.

BODY BUILDING

Once Athena's body has been fit to her head, check to make sure you've got well-sculpted attachment points for the cape and the skirt curl, and then set the body up for molding. In choosing the main feeder gate for Athena's body, the neck stump is a perfect location. Why? At the neck stump, you can use a large gate with smaller vent gates at both shoulders. Add a couple of additional vent gates at each toe section to each shin and a couple of feeder/vent gates for the skirt as shown.

The next step is to build your mold case—in this instance, an oval-shaped one; a round case would waste a lot of expensive RTV. The case for your master mold only needs to go one inch higher than the top of the part, since, unlike with the waste mold, you won't have any chunks of recycled RTV for the fresh RTV to work through.

Once the mold case is all set and ready for rubber, put it in the pot and get ready to mix up your RTV. Guess on the generous side in mixing up your rubber—better to have some left over

than not enough. Be sure to pour the RTV around the part, not directly on it, and try not to pour it all from one side. By pouring the RTV around the part, filling from the bottom up, you reduce the stress on the gates that support your part in the mold. Once the part is covered, you can pour the rest of the RTV in without much worry of knocking it off its gates. Close up the lid and open the valve just enough to bring the air pressure up. When the pot is fully pressurized, you can open the induction valve all the way. Now, wait.

When the body mold is cured and a resin copy cast and cleaned, work the wax cape, skirt curl, and arms to the resin body. When you're sure you have a tight and well-sculpted seam fit, mold those parts, as well. Using the same method, fit her left arm to the hand/shield assembly, her shield, spearhead, and flames and voilà! Athena is done. But what is she supposed to stand on as she surveys the mortal world from atop her goddess pinnacle? Her base, of course.

The main feeder gate is set at the neck with gates at each toe and shin.

The gated spearhead.

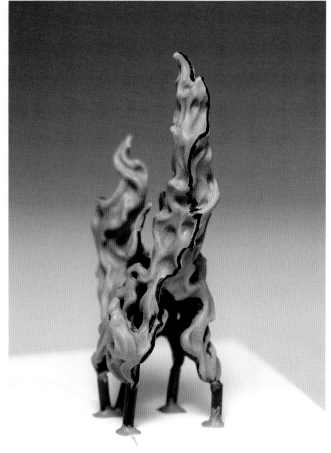

The gated flames.

BASELESS ACCUSATIONS: GATING AND CASTING THE BASE

Before casting Athena's base, figure out where Athena's feet are going to go. Because the figure is already cast in resin and the foot pegs are in place, you can simply position the figure on the base and push down, creating an impression of the foot pegs into the clay (or wax) of the base. Then, using the same procedure you used to seat the foot pegs, seat the base pegs. (A clay base makes it easy to reposition the figure should you want to alter her placement.) To double-check everything's just right, switch out the ¾-inch pegs for shorter pegs and put the figure in place. When she's sitting pretty, so are you. Insert ¾-inch pegs into the base when you're sure figure and base fit perfectly together, then gate it, and build yourself a mold case.

Now, one's first inclination is to glue the base directly to a piece of foam core and then build the case around it. That would work if you had a perfectly level mold in a perfectly leveled pot to cast up a perfectly level base. But none of those things will

Foot pegs go into the base.

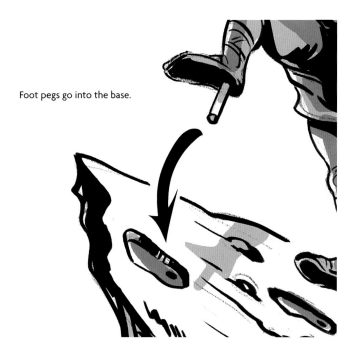

happen. The resin will shrink a little, pulling down into itself, creating a slightly concave surface on the bottom. In grinding the base flat (with a belt sander or another tool), you'll lose some side detail and material.

Solution: Trace the outline of your base onto a standard piece of ³⁄₁₆-inch thick foam core. Using an X-Acto knife, cut out that shape, cutting about ⅛ inch inside the outline, as shown at right. Superglue the foam core to the sculpted base and, using a wax pen, wax the edge of the foam core (it's porous and RTV will sometimes seep into it) and the join of the foam core to the base. Then, superglue that unit to *another* piece of foam core, waxing the join of foam core to foam core, and build your mold case on that.

When casting, you'll have a ³⁄₁₆-inch margin of error. After the resin is cured, you can grind down the excess resin on the bottom of the base, ensuring a flat, level surface.

³⁄₁₆-inch foam core for the base cut ⅛ inch inside the outline of the base.

OPEN, SEZ ME: CUTTING THE MOLDS OPEN

The process for opening a master mold is almost identical to that for opening a waste mold (see page 99), but you need to be much more careful.

Look for the marker stain in the mold, which works as an extra cutting guide. Make your zigzag pattern random, with smaller cuts than you did on your waste mold (but use plenty of zig and zag in the cut) creating a keying system that will make casting these parts much easier.

Speaking of casting, now let's put on our Future-Looking Glasses and peer into Chapter 7! Or, we could just turn the page.

You won't need three wishes to successfully extract your original part from its mold.

Cutting a master mold.

Removing the part from the master mold.

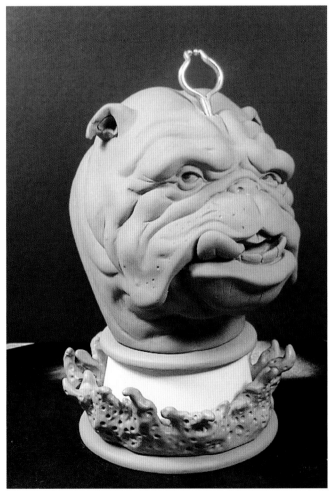

A bust of Lockjaw of the *Inhumans,* sculpted in polymer clay by Rubén Procopio for Bowen Designs.

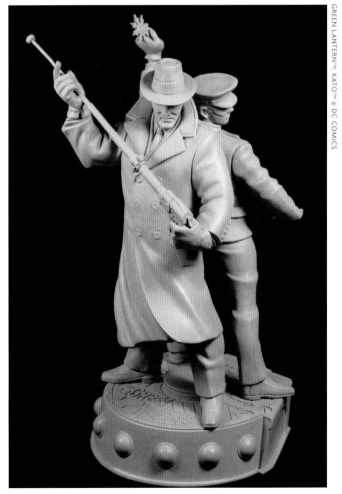

Companion statues of Green Hornet and Kato, designed and sculpted byRubén Procopio for Electric Tiki Design.

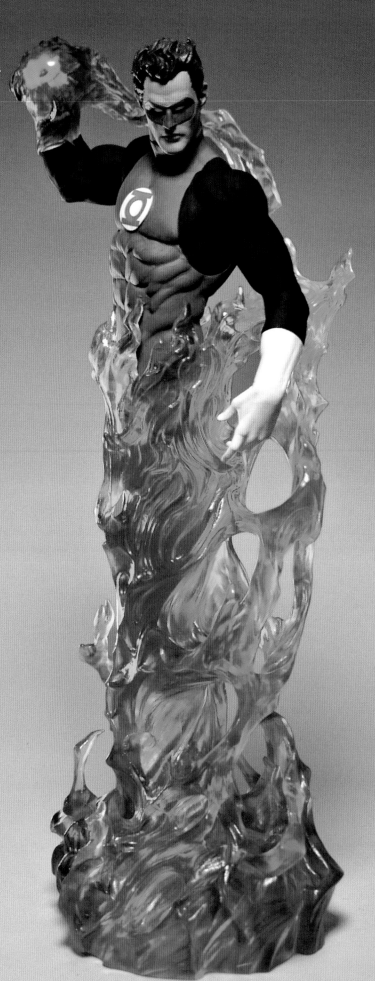

OPPOSITE PAGE: The DC Dynamics
statue of Aquaman, designed and
sculpted by Tim Bruckner for DC Direct.
AQUAMAN™ © DC COMICS

The DC Dynamics statue of Green
Lantern, designed and sculpted by
Tim Bruckner for DC Direct.
GREEN LANTERN™ © DC COMICS

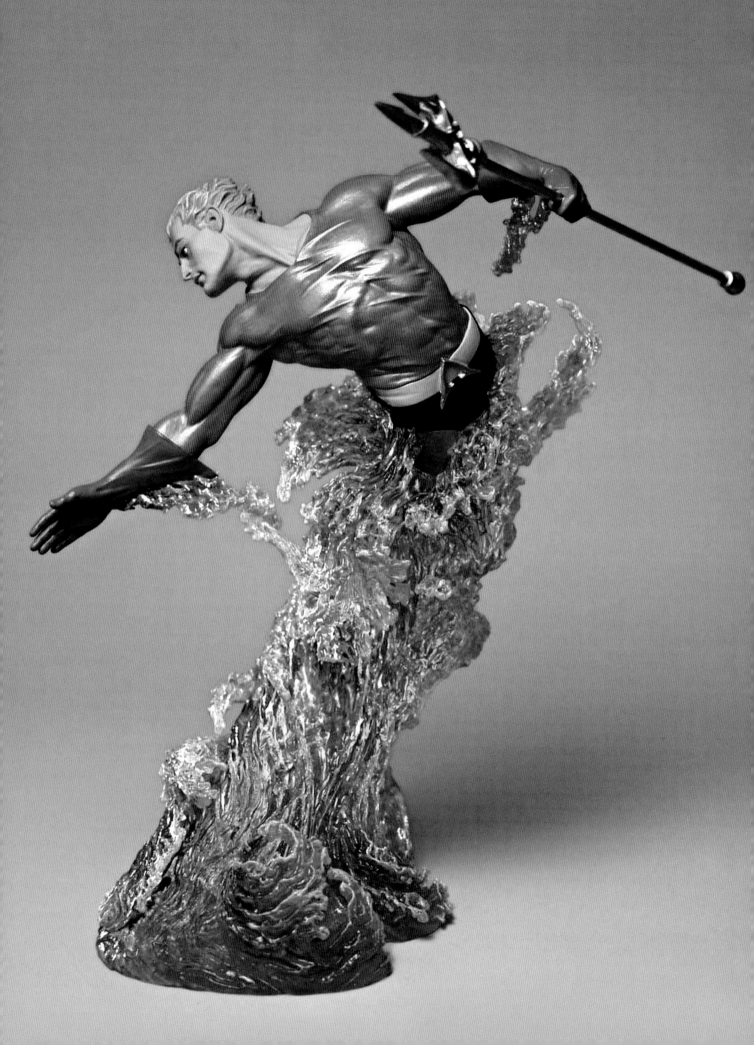

7. Resin Casting & Finishing

HOW TO CREATE YOUR RESIN PARTS AND PREPARE THEM FOR PAINTING AND PRODUCTION

There are a number of material options for casting your final sculpt, but none are as easy to use or as versatile as resins. All castable resins are thermal-cured plastics, meaning that their components are mixed together, usually in two parts (a base and a catalyst), creating a chemical reaction that generates heat and cures the liquid to a solid. Epoxy, polyester, and urethane resins are among the most common, but the urethanes are the easiest to use, and in this chapter we'll tell you why, as well as teach you how to use them.

The Hard Stuff: All About Resins

Epoxy resin is readily available and is one of the hardest cured resins around. Because of its hardness and durability, it can be polished to a glasslike surface, but the chore of mixing the two parts together can be a drag. The components are mixed in a ratio of 2:1 by weight, which means you need a reliable scale that measures in grams. Cure times vary, as they do with all thermal-cured plastics, so you need to be accurate in estimating the amount you'll need. Underestimate, and you'll have to move with the speed of the Flash in order to top off with a quickly mixed additional batch before the epoxy cures.

Only superhuman speed can save you if you underestimate how much epoxy resin you need to fill a mold.

Polyester resin is another of those thermal-cured resins, and is actually what most commercially available statues are cast in, but, again, nailing the ratio of base to catalyst adds to the difficulty of casting it at home. There's an optimum amount of catalyst to use depending on the thickness of the cast part: Too much catalyst and the casting is likely to crack; too little and the casting can take a lifetime to cure and is prone to tackiness and surface.

Another problem is that, of the castable resins, polyester is most prone to lateral shrinking. During production, curing resin can overheat the mold. This can cause the resin to set up more quickly, increasing shrinkage. Adding fillers, such as gypsum, marble, porcelain, bronze powder, or calcium carbonate helps reduce that effect.

Then there's good, old, reliable, easy-to-use **urethane**, the sculptor's friend. It mixes up in equal parts by volume, so a couple of paper cups and a marker make it a no-brainer, and you don't need to use a mold release agent, as you often do with epoxy or polyester resins. It comes in varying degrees of transparency and a variety of formulations (flexible, rigid, foam), it can be tinted or dyed, and there are as many brands as there are kinds of soda pop. It's easy to finish, and can be sawed, ground, and polished, so it takes to finishing like clay to an armature. Shrinkage is minimal, and it's a lot lighter than polyester resin. If you're sensitive to the smell of curing plastic, it even comes in a low-odor formulation. (Although you should still make sure to have proper ventilation, even with low-odor resin.) So, for our purposes, we'll be using good old urethane to cast our statue and action figure parts.

Mo' Molding, Mo' Problems: Repairing Molds

There are a few problems you can encounter with your mold that are easily repairable. Sometimes—not often, but sometimes—the position of the mold case will shift while you're making a mold. The most common reason is lack of wall support. At the base, where the walls are glued to the foam core, it's oval, but the pressure and the weight of the RTV has forced the oval into a round shape toward the top. That collar or wisp of hair, that tendril or horn that extends away from the sculpture (the very reason you went for an oval mold) has now been pressed right up against the mold wall. You won't realize this until you peel off the Kromekote, and there it is, this little spot, which will become a hole when the part is removed. All is not lost. Your first thought is to patch it somehow. No need. Take a piece of scrap Kromekote, longer than it is wide, give it a slight bend to help it conform to the shape of the mold, and rubber band it over the spot as you close the mold for casting, as shown at right. Whether casting resin or wax, this works. With the Kromekote in place over the hole, the pressure of the pot temporarily seals the hole, giving you a useable casting.

Mold release products are most frequently used in large-scale production; with RTV, there's almost no reason to use them. But there are instances when you might want to consider their application. It happens sometimes that a casting will become difficult to remove from an RTV mold—it seems to stick a little

TOP: A hole in a mold. BOTTOM: Kromekote covers the hole and is held in place with several small rubber bands.

to the rubber. The most common reason is a buildup of resin gases permeating the RTV, concentrating on the interior surface of the mold. It's more likely to happen if the mold is used repeatedly and becomes too warm. Casting larger pieces that generate a lot of heat make the mold more prone to sticking. Here are a couple of fixes. One is to bake out the resin fumes in the oven (preferably a work-dedicated oven, and not one that you use for food) on a low temp for several hours. The other is to use a mold release. Make sure the release you choose is one that will service your particular needs. If you plan on painting your casting, make sure the release you choose is paint-friendly. If you've used a release that leaves behind a residue, there are commercially available release cleaning agents with a list of warnings as long as your arm. But a gentle scrub with an old toothbrush and good old-fashioned laundry detergent usually does the trick.

Slightly more difficult to fix is actual **mold breakage**. Say you're casting away, and then it happens…a small piece of the mold breaks away, right at the most inconvenient spot. All is not lost. You can make a temporary repair using a drop of superglue. Carefully put a drop of superglue at the center of the broken part. Be sure that none of the superglue spreads to the edge of the part and that it isn't exposed to the interior of the mold, because the resin can bond to the superglue. If you've any doubt, a quick spray of mold release at the repair can guard against potential bonding. You'll probably get a little flashing at the repair seam, but that's a small price to pay for not having to resculpt the resin. Now, this repair may last through a couple of castings, or it may not last through one, so you may need to redo the repair a few times. But it's a way to get done what needs getting done without having to remake an entire mold.

Urethane, I'm a Thane: Resin Casting

To begin the casting process, you'll need a supply of paper cups of various sizes. If you plan on casting larger pieces, you'll need containers to handle the volume—vertical food storage containers and vinyl pitchers from the discount store work well. (When the resin cures, you can peel it out for easy cleanup and reuse.) You'll need latex-free rubber gloves, a smock or apron, wooden tongue depressors or broad craft sticks, a marker, newspaper, rubber bands, a trash can you can trash, a pressure pot, and, above all, a workspace where you can allow things to spill, drop, and get dirty.

RESIN TEST

Let's do a test so you get a feel for how long you have before the resin sets up, and what it will look like as it does. Before we go any further, put on your gloves and smock. Now, resin cure times vary. This may seem counterintuitive, but since mass directly affects cure time, the more mass, the more heat; the more heat, the quicker the cure. Therefore, the smaller the casting, the longer it will take to set up.

You'll mix your resin from two equal component resin parts, an A part and a B part. To make a measuring cup, take a small waxed paper cup and mark a line on the outside of it, about

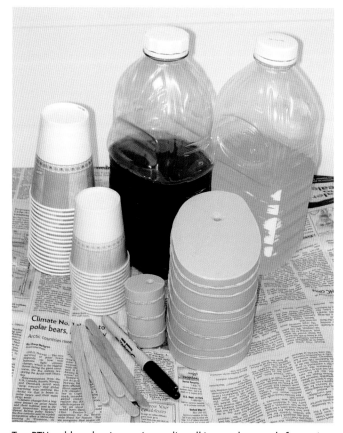

Two RTV molds and various resin supplies, all in one place, ready for casting.

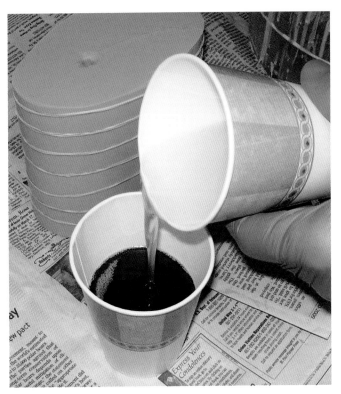

Pour the B part into the A part.

Mix the two halves thoroughly.

a quarter of the way up. Why don't you mark inside the cup? Because the resin will make the marker bleed, discoloring your resin. *Always* measure and pour the *less* -viscous resin component first, because the more-viscous component will leave more resin residue in the cup, which will throw off the mixture by undermeasuring the less-viscous component. Usually, the A part is the less-viscous, but whichever one is the less viscous of your parts, that's the one you measure out first.

Position the measuring cup so you can see the outside mark from the inside and fill the cup to the line with the A resin part, then pour the measured A part into another cup. Measure the B part with the same measuring cup and in the same way, and pour that into the cup with the measured A part, as shown above.

Using the mixing stick, mix the resins together quickly and thoroughly, but not aggressively. You want the resins fully integrated without forcing in a lot of air. Have a look at the clock, and watch the second hand to get a sense how long the process takes. Holding the cup in your hand, you'll soon feel the mixed resin in the cup begin to get warm. Tilt the cup back and forth and notice how the resin is thickening as the heat increases. You'll see a small cloud of opacity begin to form in the resin and spread.

That's the resin on its way to a full cure. Soon, the resin in the cup is fully opaque, but not fully cured. You can give it a little poke with your gloved finger and feel it give slightly. It's a little rubbery. In another few minutes it will be solid, but still not fully cured—there's a difference. In spite of it being able to be sawed, filed, or sanded, the resin isn't actually fully cured for several days. But, for all intents and purposes, it's cured enough for our uses.

Put the cup aside. In a couple of days, do the same test. This time, when the resin has cooled, peel the paper away from both tests and saw the most recent test in half. Now, do the same to the resin test from a couple of days ago. You'll notice the older resin test cuts a more easily, and when you try a file or sandpaper on both, you'll notice the older test sands cleaner and more easily, too. It's a little firmer and reacts more surely to the finish tools because it's had more time to fully cure. Your deadlines may not allow you the luxury of waiting several days, so you'll use the newly solid casting more often than not.

A CAST OF THOUSANDS: CASTING THE PARTS

Start by casting Athena's head. Your mold has been cut, the part removed, and it's rubber-banded (as shown at right) and ready for casting. Use just enough rubber-band tension to keep the mold closed during casting; too much will distort the mold and actually make it *more* prone to leaks by exerting more pressure on the banded parts, forcing open the unbanded parts. In some cases, after you've poured your resin, you'll need to do a "tilt and tap" to dislodge trapped air: Cut a piece of scrap foam core to hold over the gated end of your mold to keep the resin from coming out, turn the mold on its side, and give it a couple of taps. Make notches in the molds marking the problem areas for trapped air. Your mold is now ready for resin.

Before you pour any resin, note that your resins may need to be a certain color, depending on what they'll be used for. **Tool parts** are the castings that the factory uses to create the production molds that will mass-produce your statue or action figure, and many companies prefer them to be cast in gray, opaque resin. There's a method to this madness. Even a standard white or ivory urethane casting resin has a slight translucency to the surface when cured, making reading the surface finish and detail inexact. Add a little opaque black and opaque white pigment to the B or clear part and the casting will set up in a nice, middle-tone grey. The added opacity flattens the surface and reveals every nuance the sculpture has to offer. Remember when adding the black and white dyes that the natural ivory or white color of the cured resin will push the value of the gray lighter. Tim has a container of dyed part B of un-cured resin set aside for his tool parts.

A properly banded mold.

There are a couple of ways to estimate the amount of resin you'll need for your casting. One way is to fill your mold with water **(1)**, then pour the water into a measuring cup and add a little extra spritz of water **(2)**. Pour half of this water into a paper cup and mark the water level on the outside of the cup. Dry the interior of the marked cup, then fill it with your part A (less-viscous) resin up to the line; pour that into a clean, dry cup or pitcher. Using the same marked paper cup, pour out the same measure of your part B resin, pour that into your part A, and mix **(3)**. Our Athena head is going to take about 3 ounces of resin, or 1½ ounces of each component. Make sure your mold is absolutely dry inside before you cast.

If you're going to cast a few molds at a time and don't want to water-measure each mold, you can do what we do: eyeball it. Yeah, it's not as precise, but it goes more quickly and it's just that much easier. Sure, we're going to waste a little resin here and there, but your time is worth more than the few cents of resin you'll save.

Now that we've mixed our resin, we're ready to cast, and we don't have a lot of time. You learned from the test that you have approximately 60 to 90 seconds working time before the resin gets to the point of no return, so speed and surefootedness are essential. The trick to good casting is efficiency, and your table should be laid out so that everything you need is within arm's reach. If the gate is large enough, you can pour the resin into the mold via the direct pour method, as shown below.

The level of the resin should reach the top of the gate hole. When we gated Athena's head, we opted not to gate the end of her cape, so we'll need to tilt (so the cape end points down) and tap to dislodge the air and get resin into that pesky place. Set the mold upright; you may need to top it off with more resin. When the mold is full, it's into the pot, secure the lid, and let the air-feed valve fly! Try not to position your mold directly under the air feed; if you do, the influx of compressed air is likely to blow some of the resin out of the mold or knock it over. Now go and do something productive for ten minutes.

POUR PLANNING: MASTER WAX GATES

In gating a master wax, you should use the largest gate you can without obscuring detail. But sometimes, the largest gate isn't much bigger than a pencil lead, and the resin can get backed up in the gate before the mold is full. That's when **prefilling** or **loading** a mold is your best bet. That means you'll actually be opening the mold to fill it, and it's something you'll do pretty often.

As an example, let's look at Athena's ponytail. The gate is a piece of 10-gauge wax wire, less than $1/8$ inch in diameter. When it comes time to cast the ponytail, butterfly-open the mold just enough to pour in the resin, as shown below, and let the mold close. The mold may need a little topping off, so open just the very top of the mold and add resin until you're certain the mold is filled, then into the pot it goes. Yeah, it's messy, but I think we warned you early on that sculpting and casting are not for the tidy at heart.

Knowing ahead of time which molds can be direct-pours and which molds will need to be loaded helps you set up your casting schedule and cast more than one mold at a time. Out of sixteen molds for our Athena statue, thirteen are direct pours (body, head, cape, right arm, left arm, shield back with hand, shield, owl with crossbar, spearhead, skirt section, base, cloud ring, and cloud plume) and three are loaded (ponytail end, spear flame, and spear banner cloth). You'll be able to cast two, three,

If the feeder gate is large enough for a direct pour, bring the cup close to the pour hole, but far enough away to pour a little stream into the hole.

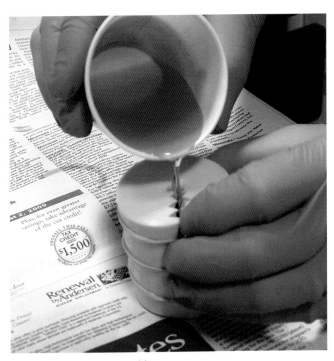
Prefilling/loading a master mold.

maybe four direct-pour molds at a time, but you'll only be able to cast up one or two loaded molds because of the extra time it'll take to get those molds filled.

Let's say you've got a few molds of tiny or slender parts, like our spear banner. We've talked about how smaller casts take longer to cure than larger castings because of the lack of mass, and therefore heat. It's also sometimes true that, even when a small part does cure, it has a softer, less-defined surface than what we sculpted because of the slower cure time. Before casting, put your mold in the microwave for a few seconds until it's warm, like we did when casting wax. It will really help accelerate the cure time and result in a truer casting. If you're checking the temperature with gloved fingers, you're not really getting a true read on the temp. As you'll be heating up the mold in increments of 10 to 20 seconds, you'll get a much truer read of the temperature of the mold by pressing it lightly against your cheek. The mold should never be hot. But a nice, cozy, warm mold is a good thing when casting small parts. The casting process will be the same as casting a loaded mold, just be a little quicker and less ambitious, casting one at a time.

But what about casting large parts, where the mass will reduce our working time? The good old refrigerator really helps us out here. Casting with cold resin gives us more time for mixing and pouring and, more important, more time for the pressure in the pot to work its magic. Store a couple of containers of resin in the fridge for just such eventualities; if you know you're going to cast up a few larger pieces, make sure to put the resin in the fridge overnight. And, please, if you refrigerate your resin, make sure you put the containers in sealable plastic bags. No matter how diligent you are in trying to keep your resin containers clean, you won't be able to keep them clean enough to prevent a little resin from dripping down their sides and making a mess. And even a little resin mess is too big a mess in a refrigerator. Tim has a small bar fridge in the studio whose sole job is to keep resin (and the occasional beer) cold. He's tried to be tidy…but the inside is kind of grody. So unless you have a studio fridge, use sealable plastic bags and keep harmony at home.

If your mold is cold, put things on hold.
If your mold is warm, you're in good form.

OPENING NIGHT (AND MOLDS)

Ten minutes up? It's time to free Athena's head from her mold. (For a mythological feel, pretend the mold is Zeus's skull.) Check the leftover resin in the cup and make sure the resin is cured, then remove the rubber bands that hold the mold closed. You'll notice they don't quite have the snap they did before they went into the pot; if you can salvage them, well, we're proud of you. We generally toss them. Open the mold carefully. Picture in your mind's eye where the gates are and how best to cajole the casting out of the mold without breaking anything. If you do snap off anything by mistake, hold onto it—that's what superglue is for. If you cast a loaded mold, you'll have a lot of flashing (excess resin) hanging off of the seam—even a direct pour mold will have some now and then. Carefully remove the part. Now, clean out the flashing left in the mold with your air hose and rubber band the mold back up (with fresh rubber bands) to be ready to use again.

We'd like to say a word or two about **multiple castings**. When making multiple castings from a single mold, you'll start to notice how the seam line becomes greater and more noticeably off, and that you're getting more pinhole bubbles where you didn't have them before. This is due to the mold heating up from the thermal cure of the resin. As the mold heats up, it expands, forcing the mold cut out of alignment. A hot mold will also cause the resin to cure more quickly, before the pressure pot has time to de-air the resin, creating bubbles at the pour hole. So if you know you'll need a bunch of castings (10, 20, whatever), seriously consider making one or two extra master molds.

Extra molds mean you'll be able to alternate molds, keeping them warm but not allowing them to get too hot and misalign. You can make another mold either by reassembling the master wax—which will certainly break up when it's removed from the master mold (we called it a good thing when we were cutting the mold open)—or you could, and should, make a **master cast**. It's usually one of the first casts you make from your mold, and you'll be able to make additional molds from it. If you don't have the time to make another set of molds right now, and your mold does get touchy, a rest in the fridge will help it cool down. Just be sure the inside of the mold is as cool as the outside.

Cured resin molds, ready to be opened.

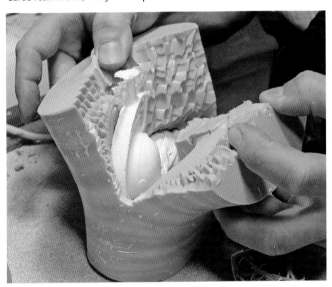

Open carefully and slowly cajole the casting out of the mold.

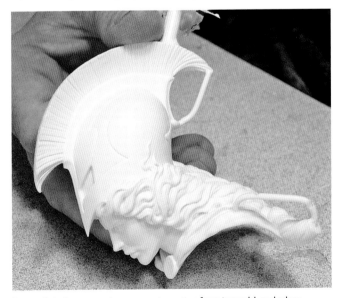

Be careful when removing your resin casting from its mold, and when trimming the flashing from the seam.

ON A CLEAR DAY, I CAN CAST FOREVER: CLEAR-CAST RESINS

Do you want pieces of your statue or action figure to have a see-through effect, like fire, water, glass, smoke, or invisibility? Clear-cast resin can be an effective tool in creating textural or atmospheric differences, and using it is a lot easier to do than painting an opaque resin to look like a translucent substance. It's also going to be the basis of the lens shield for Athena. Clear-cast resin is available in epoxy and polyester versions, and both resins come in a "water" or crystal-clear formula. But the same difficulties in catalyst-to-base measuring hold true. Also, they often require the use of a mold release product, and in some cases they need an external heat source to set up the resin.

Urethanes, on the other hand, offer two kinds of clear-cast resin: **semiclear** and **crystal-clear**. The semiclear behaves just as a normal casting resin and needs no special consideration. Measured out in equal parts by volume, it casts and sets up simply, easily, and reliably. The down side is that the A part of the resin has an amber tint to it, and, although its effect is diluted by half when mixed with the B part, it's still a little yellow in its combined state. In thin casts of about ½ inch or less, it's actually quite clear, and when finished with a clear acrylic spray, it becomes almost water-clear. That's because the spray fills in any scratches or imperfections, restoring the reflective surface and making the imperfections fully transparent again. But in casts thicker than ½ inch, the resin, although still translucent, is not completely transparent.

For almost all your clear-cast needs, the semiclear resin will work great. Tim has used semiclear resin parts in combination with opaque resin parts in his statues for a number a years—most recently on Athena's shield and spear tip—and has found it generally satisfies his needs. In some cases, its translucent quality delivers a perfect effect that would have had to be achieved by applying a dulling or matte finish coat on a crystal-clear cast. You can also tint the resin with transparent dyes, most generally used with polyester resins, and the colors can be as subtle or as vibrant as you like. Tint the B part, or clear part, first, but be aware that the color will be compromised by the addition of the amber A part. Some effects require tinting the semiclear with a very small amount of an opaque dye that gives the resin a kind of foggy or milky look; the level of opacity or translucency can be adjusted by the amount of opaque dye you use.

When you need a resin casting that is **crystal clear**, there are some special precautions you should be aware of. First, crystal-clear urethane takes anywhere from 24 to 48 hours to set up, and another couple of days to fully cure, so preplanning is a must. Since its working time is so long, you can tint the resin after the two components have been mixed, assuring yourself of the depth and tint of color you're after.

Second, it's a very sensitive resin. Its feelings can be easily hurt, by even the most innocent slight. For instance, it doesn't like new molds. RTV generally contains alcohol as part of its formula, and this amount of alcohol, albeit small, can contaminate

FAR LEFT: You can selectively tint your clear-cast resin by dripping dye in at different stages, like Tim did with this fire.

LEFT: The flames of Athena's spear, cast in tinted semiclear resin.

OPPOSITE PAGE: *Prometheus*, sculpted by Tim Bruckner; note the clear-cast flames and smoke.

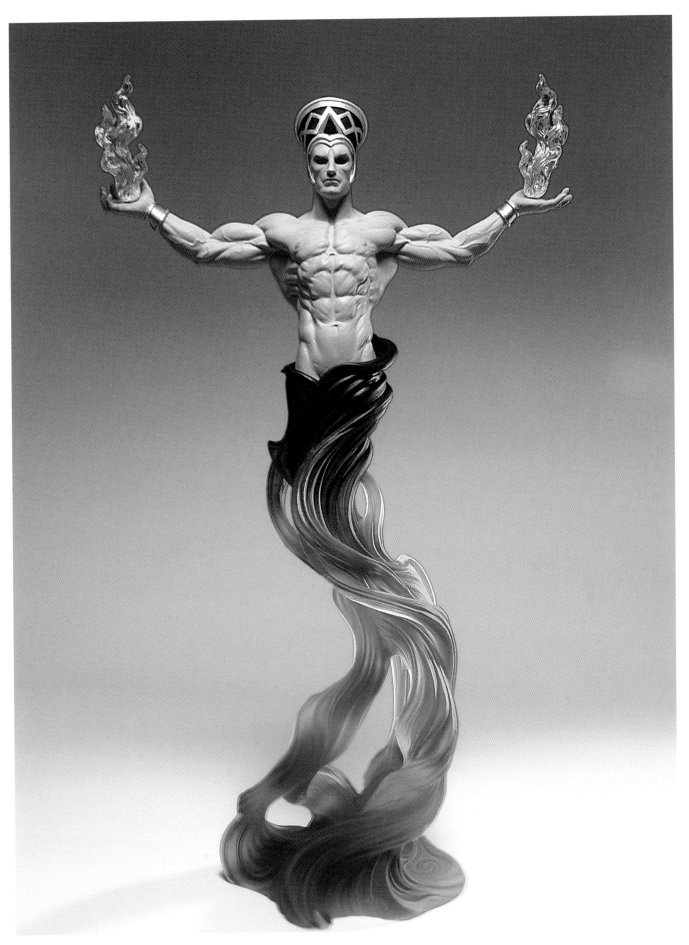

SCULP-TOR SEZ: DYE ANOTHER WAY

If you're having a difficult time finding opaque dye to tint or color your resin—especially when clear casting, where you want to add just enough opaque color to make the resin foggy—you can use artist's oil paint as a substitute. Make sure it's oil-based paint and not acrylic- or water-based paint. Take an ounce or so of the B part, or clearer/lighter side of the resin, and mix in a small dab of oil paint until it's fully integrated.

Essentially, you're breaking down the paint from a thick paste to a syrupy liquid. This will ensure the dye will mix easily and fully into the full amount of resin you want to cast. If you don't break it down before using it, small bits of oil paint will end up as floating, full-color specks in your resin casting. Once you've broken the paint down, you can add it as dye to your full measure of resin. When adding your dye mix to the resin, remember you're adding resin as well as dye and be sure to compensate for the additional resin when measuring out the B side so it's equal to the A side before you cast.

You'll notice that both the semiclear and the crystal-clear resins, once fully cured, are much harder and more resilient than traditional casting urethanes. It takes longer to degate them, sand them, grind them, and clean them in general. This extra toughness can be a benefit when working for a specific effect and allows you to use thinner, smaller resin extensions, like cloud wisps or water trails, than you could if the parts were cast in standard resin. But be aware, if you're constructing a piece for commercial reproduction, the factory will produce that part in polyester resin and so the advantages of a clear-cast urethane part won't translate.

Any finishing work you do will affect the clarity of the surface, either semiclear or crystal-clear resin. To make those sanding marks disappear, a light coat of a clear gloss or semigloss spray, depending on the look you're after, will do the trick.

TOP: Athena's shield, cast in semiclear resin. BOTTOM: With a piece of white paper behind them, the difference between semiclear (also known as clear, or standard-clear resin) and crystal-clear resin becomes more…well, clear.

the clear cast, allowing the core of the resin to set but leaving the surface gummy or tacky for weeks, if not forever. And the mess it leaves behind in your mold can bring you to tears. One way to help guard against this contamination is to bake your mold in the oven at 250 degrees Fahrenheit for six to eight hours, essentially baking out the alcohol and reducing the risk of a partial cure. Also, casting the crystal-clear resin into a warm mold will help set up the surface more quickly. Still, there's always the looming possibility that the part would not cure fully or correctly. The right mold release agent can help as well. Taking these precautions will increase your chances of getting a clear, tack-free part for that water/crystal-clear effect.

Finishing Moves

So, you've finished casting, and all your parts are in a box or laid out on your table. Now it's time to check them all to make sure they're usable. Every casting has its problems: some fewer than others, some *way* more than others. If you're going for a professional-quality paint master, the finished casting has to be perfect—even more so when it's a tool part. Now, there are a number of steps that happen after the factory has your part that will help mitigate some imperfections, but that's a pretty iffy proposition. If the factory is really good, you might get hundreds of copies of your sculpt produced with imperfections you were too lazy or not sharp enough to catch. If not, the imperfections you left behind could be reproduced many times over.

And even if your work isn't destined for mass production, this is no time to slack off. You've put all that hard work, blood, sweat, and tears into this piece to get it as right as it can be, and though this may not be the most fun part of a fun-filled process, it is one of the most critical. No matter how good your statue or action figure is in its original form, if the casting doesn't reflect that work, then all that work was pretty much for nothing.

First on the agenda, **seam lines**. Seam lines happen when the mold slips out of alignment—one side of the mold either slipping up or down, back or forward. Seams lines are a way of life. If they're not too bad, they can be filed or sanded down; if they need to be patched, there are other things in play, and it's your call, based on your appreciation of your time and what it's worth. There comes a point when it might just be easier to spend five or ten minutes to cast up another one than waste an hour or two trying to polish that poop.

Assuming that your seam lines are manageable, let's look for **pinholes**. They happen for lots of reasons: mold too warm, resin too warm, poor gating, not enough jiggle, insufficient tapping, the moon in the eleventh house…they happen and are fixable if not too egregious and in a patchable place. Assuming that you've got both manageable seams and just a few pinholes, let's start cleaning!

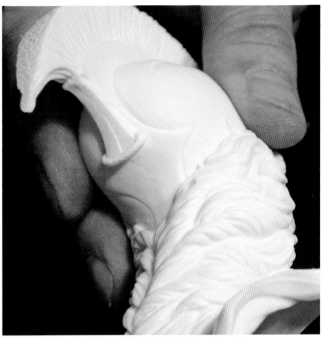

A manageable seam line on the back of the helmet's crest.

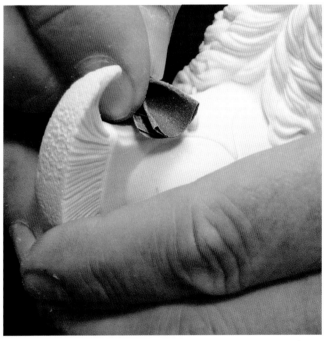

If your seams are manageable, you can sand or file them down with little difficulty.

I GATED, I SAWED, I CONQUERED

First, we want to remove the gates. If the resins are fairly fresh from the mold, you can clip them off using a pair of small-nose wire cutters. Just remember, wire cutters spread what they cut due to the shape of the blade. If you're cutting something small and fine and don't want to snap off a piece of the part when removing the gate, then pass on the wire cutters. If the resin has had time to set up, then pass on the cutters altogether. You're more than likely to snap the part than cut it, and with the resin set, you'll be sending missiles of resin gates all over the place. This is a perfect time to use your jeweler's saw.

You have infinitely more control with the saw then you would with the cutters. You'll be able to get right down close to the part without snapping it, so there's less gate nub and less cleanup time. Remember that your blade should be angled with the teeth down, so the downstroke is your cutting stroke. A lot of jewelers' saws have a vertical line etched at the top of the blade nut. Because the saw uses tension to hold the blade taut, by aligning the blade with that line and then securing the blade into the bottom nut you'll be guaranteed the blade is in the correct position, straight up and down, as opposed to angled slightly back or forward. Use a pair of pliers to tighten the nuts so the blade stays put.

Use the saw to cut off the gates, but be careful not to cut too close to the part. Often, you've gated to something curved or rounded, and cutting too close will take the top of the rounded part off, leaving you with a patching job rather than a sanding

Various Dremel bits.

job. It's always better to to have to remove material than to have to add it, so, when in doubt, cut a little higher on the gate and leave room to shave down that nub with a file, sandpaper, or a Dremel tool. There are a variety of bits available for Dremel tools and other handheld grinders—we'd say a butt-load, but that would be crass—and you'll need a handful to start. A few small or very small, a couple of medium, and a workhorse bit that will do most of what you need to do in terms of removing gate nubs.

What we're after here is to take the gate down within quick and easy sanding range. Some places, like the crest of Athena's helmet, will need to be resculpted with the Dremel. But for now, we're just getting things down within sanding range. It's not a good idea to use a Dremel on seam lines unless you have a grinding stone bit, which can bring that seam down to relatively level easily and quickly. Otherwise, it's better done by hand.

Use a jeweler's saw to remove gates.

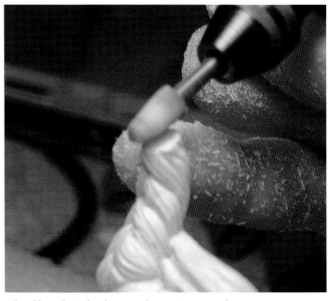

A "workhorse" grinding bit at work removing gate nubs.

CASTLES MADE OF SANDPAPER: SANDING RESIN PARTS

After you grind down the gate nubs to within sanding range as shown, you sand. Just a couple of words about sandpaper: The black, wet/dry, paper-backed sandpaper works best. It holds its grit and, when folded, can give you a nice sharp edge to do some channel sanding. Cloth-backed wet/dry doesn't fold as sharply. You'll find that using small sheets of sandpaper is the way to go.

There are a couple of schools of thought regarding grit. Some folks start off with a heavier, 180- to 220-grit sandpaper and take down the surface quickly, then go back in with a lighter 320- to 400-grit paper, leaving the surface smooth and without sanding marks. Sometimes going right for the 320 is the best choice. Why? It may take a few more back-and-forths, but you have more control, and you won't take the piece down any farther than you need to.

Other useful sanding items: A set of fine-tooth files can come in really handy. There'll be places that you just can't get a piece of sandpaper into, and a fine-tooth file can really do a nice job in those tight places. Sanding pads, those kind of scrubby, spongy-looking things, are great last-pass finishers, but stay clear of steel wool unless you're fond of finding little metal hairs in your piece when you least desire it. And you'll find that a belt sander can come in handy, especially if you're working on a resin casting of a base, and want the bottom to be nice and flat.

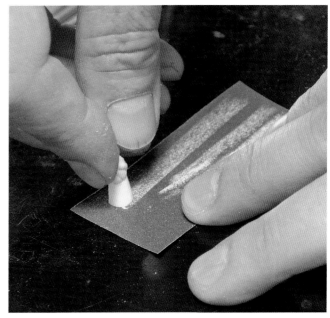

Sanding the tip of Athena's ponytail.

TIP: *Jon Matthews, sculptor par excellence who generously contributed the section on Castilene, cuts the standard 9- × 11-inch sandpaper sheet in half, giving him two 5½- × 9-inch sheets. Then he cuts those in half and then cuts those in half, and so on and so on, until he has thirty-two sheets of about 2¼ × 1½ inches. Folding those in half and using one side and then the other, he really gets the most out of a sheet of sandpaper. It's a perfect size for cleaning resin parts.*

Be careful when using a belt sander, or you may find your statue a lot flatter than when you started.

PATCH AS PATCH CAN: PINHOLES

We've addressed the gates and shown you how to redefine a surface when it needs it. Now, we enter the mystical world of patching! For patching pinholes, you can use epoxy putty, Bondo, toy wax. But your best first line of defense against dreaded pinholes is glazing compound. Or, as it's sometimes known, spot putty! And we aren't talking the glazing compound for windows. It's for rides, dudes! Cars! Wheels!

Glazing compound is an air-drying plastic filler that's used to fill in pinholes on car bodies prior to painting to ensure a smooth, flawless finish. It comes in a tube and is made by several different companies. Squeeze out a little on a piece of scrap foam core and, using a flexible putty wedge, spread the glazing compound across the surface of your part, as shown above. You can also use a gloved finger to force the compound into those pesky pinholes if the wedge doesn't get the compound where you need it. The main thing is to lay down a film just thick enough to fill the holes without filling in the sculpture's detail. Remember, it's a patch for pinholes and small seam fixes; it's not meant for larger areas.

Let the compound dry. You can tell it's dry by the change in color, from a deep brick red to a lighter shade. It doesn't take much to remove the compound from the resin's surface. A little

TIM IN A BOTTLE: PINHOLE WIZARD

One of the first action figures I did for DC Direct was Spider Jerusalem (opposite page) from Transmetropolitan. The sculpt, if I do say so myself, was as clean and blemish-free as a recently wiped baby's bottom. I cast it up, painted it, and sent it in. A month later I saw the poster for it. The 6-inch figure was now a foot tall, and it looked like old Spider had caught a bad case of the pox. The casting was riddled with blemishes so small they had been invisible to the naked eye—mine, anyway—until it was blown up to twice its original size. The primer didn't help, and the paint was no help at all. From that day on, I finished everything under a magnifying lens. Why? Because if it looks good under a 2X lens, it'll look good just about anywhere."

Bondo putty can be used to make big fixes to your sculpt, as well as your car.

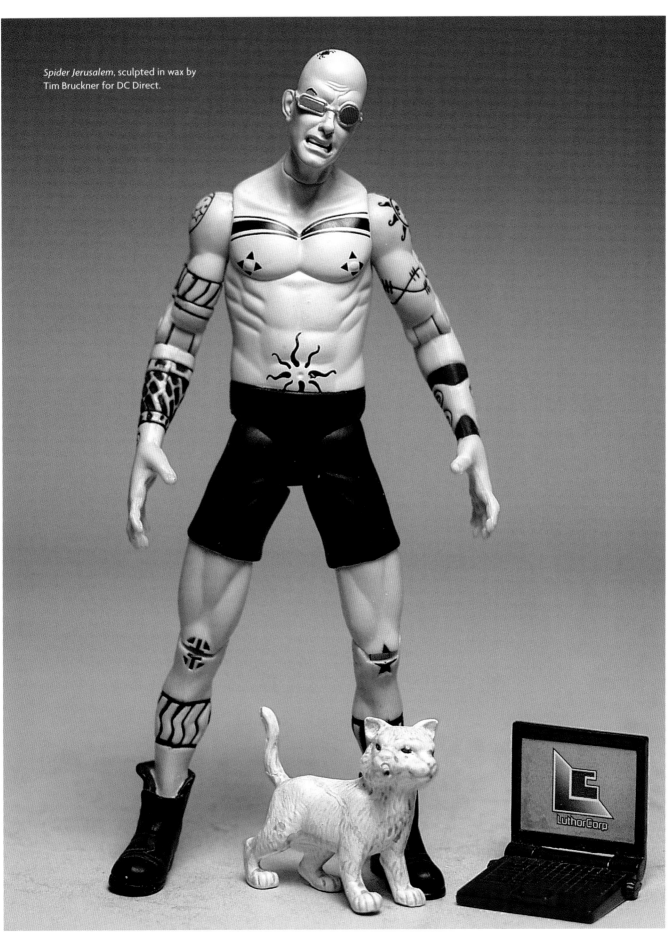

Spider Jerusalem, sculpted in wax by
Tim Bruckner for DC Direct.

320-grit sandpaper or an equivalent sanding pad will do the trick. You might need to reapply and sand the spot putty a couple of times, but when you're done, the pinholes are fixed and ready for primer and paint.

For larger fixes, there's Bondo, the plastic car filler, and epoxy putty; both are two-part compounds, but very different from one another. When the components of **Bondo** are mixed together, you'll wind up with a putty the consistency of pudding. Using a flexible wedge, smooth on just enough to fill the hole or seam and let it set up completely. It may feel a little tacky even after it's set. Here's the thing about Bondo. You use only what you need, where you need it, and no matter how careful you are, it invariably goes where it wants to go, resulting in more cleanup than you'd have if you hadn't used it. It can be Dremeled, filed, and sanded just like resin. It's great for big fixes on even surfaces. For tight fixes, not so good.

Using glazing compound to patch pinholes.

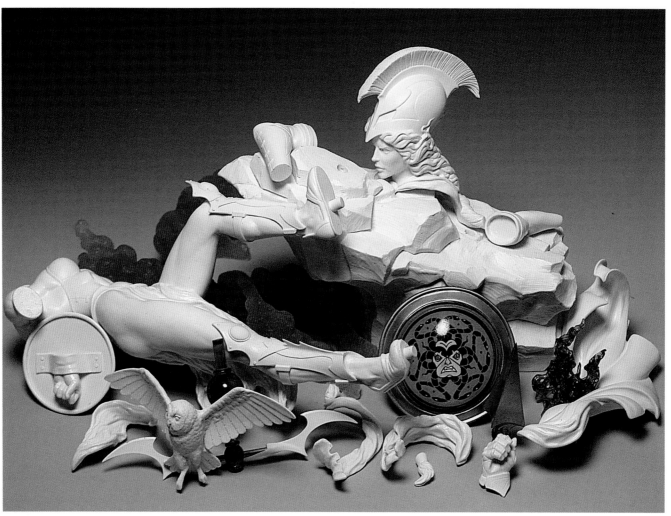

Athena in all her glorious resin parts.

Epoxy putty is good for rebuilding missing detail or filling in casting mistakes that are too big for glazing compound and too tight for Bondo. Make sure your resin is clean and free of any mold residue—a quick wipe-down with denatured alcohol takes off that mold slickness that sometime attaches itself to the cast resin. Then, knead the two parts together and, using a sculpture tool, mold the putty into place. You can smooth it down with a little water or denatured alcohol. When you've got the putty just where you want it, let it set up. This will take a couple of hours, depending on the kind of putty you use. The putty can be Dremeled, filed, or sanded. Be aware that the epoxy putty is often going to be harder than the resin you're patching, so be careful to lighten up your finishing on the transition areas from putty to resin, so you don't take the resin down farther than the putty.

All of the above are permanent fixes, meaning the patching material is similar to the resin in hardness and permanence.

There's an easy fix which is not as permanent, but holds up well in small fixes and especially well if the part is going to be painted: **toy wax**. Toy wax works as opposed to regular wax because of its high talc content, which allows the wax to accept a primer in preparation for paint. Toy wax is not recommended for areas of the sculpture where there'll be a good deal of handling. But for small fixes, it works well and, given ordinary environmental stresses, will hold up just as well as the other methods described. Use your wax pen to put the wax where it's needed and either sand or tool down to match the surface of the resin.

And you're done! You've got your finished parts, and they're totally perfect in every way. But they're still missing something…color! After a brief digression to teach you the ways of articulation and accessories, we'll show you how to paint these bad boys.

Ode to Joy, a portrait of Ludvig Van Beethoven designed and sculpted by Tim Bruckner.

Hellboy, sculpted by Rubén Procopio for Electric Tiki,
based on a design by Mike Mignola.
HELLBOY © MIKE MIGNOLA

OPPOSITE PAGE: Lobster Johnson from *Hellboy*, sculpted
by Rubén Procopio for Electric Tiki based on a design by
Mike Mignola.
LOBSTER JOHNSON © MIKE MIGNOLA.
PHOTO: STEPHEN HORN

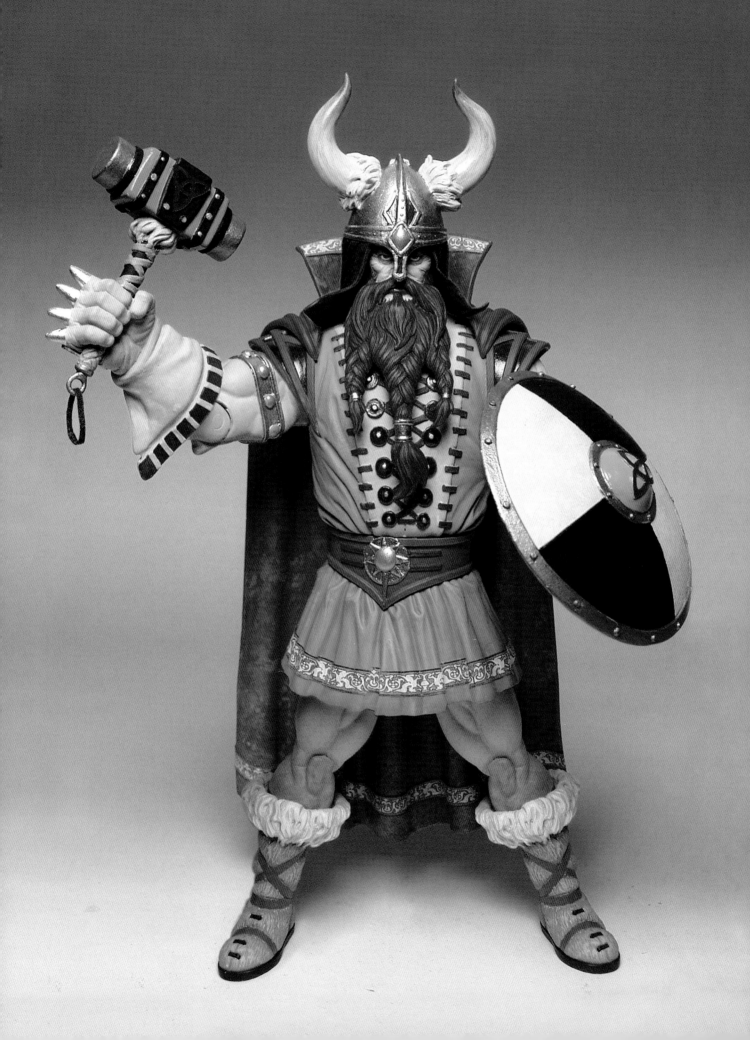

8. Articulation

JOINTS ARE WHAT SEPARATE THE MEN FROM THE TOYS

Among action figure aficionados, there's no subject more contentious than how many points of articulation an action figure should have. Is three enough? Is twenty too many? Every point of articulation compromises the sculpt to some extent, and for some, how well these points are incorporated into the sculpt and how minor the obtrusion is the mark of a well-executed action figure. For others, the number of articulations and the resulting playability they give the figure take precedent. Usually, the number of points of articulation will be decided by budget. What makes the perfect action figure? We aren't going to take sides. We're just going to give you some invaluable information and set you free to do what you will. (We're not stupid, we're cowards.)

One element of controversy we are willing to wade into is when and how to begin articulating your action figure. Some sculptors like to finish the figure and then cut in the articulations, while others prefer to add them as they build up the figure. We're going to stick our necks out here and promote the latter method. Call us imprudent, incautious, or just plain crazy, but there's a method to our madness. Incorporating your articulations as you rough out the figure gives you control over size, proportion, pose, and balance.

After we discuss the basics of articulations, we're going to walk you through how to make them, how to incorporate them into your sculpt, and how to modify them for special applications. Be warned: you'll use everything you've learned about sculpting, molding, and casting so far, which is why we didn't bring up these suckers earlier.

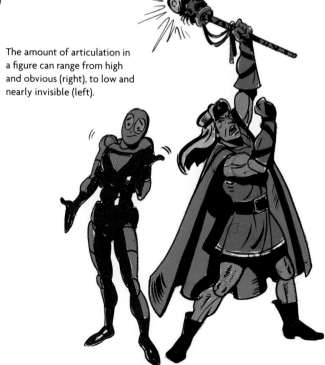

The amount of articulation in a figure can range from high and obvious (right), to low and nearly invisible (left).

Facts and Figures: Articulation Basics

Of all pop sculpture products, action figures are the most expensive to make, due in large part to the higher cost of manufacturing them. Each individual part of the figure has to be cast in resin to make tool parts, which are given to the manufacturer, who will then use them to create two-part, die-cut steel molds into which molten PVC (polyvinyl chloride) is injected at a very high degree of pressure. When the part cools, it is ejected from the mold and another set is cast. The more parts a figure is composed of, the more expensive it is to produce. A figure with nine points of articulation is made of up ten parts (head, two upper arms, two lower arms, torso, two upper legs, two lower legs). Want the wrists to turn? Add two more parts. Pivoting biceps? Add two more parts.

On top of that, each articulated part has to be assembled, so the more complicated the articulation, the more complicated, and expensive, the assembly. There are three basic types of articulations: **pivot**, **hinge**, and **ball joint**. A ball joint is more expensive to manufacture than a pivot joint, because it has more parts. And it really does come down to dollars and cents—a quarter of a penny can determine whether a figure gets a ball joint or pivot joint for the neck. So, try and consider that when you pick up a figure that has fewer points of articulation than you'd like.

Have a look at your favorite action figures. Notice where the points of articulations are, what they do, and how well they do it. For some toy companies, articulation is just a numbers game. They'll advertise "multiple points of articulation" and half of them are useless in repositioning the figure.

For instance, the V-crotch is two pivot joints positioned in a "V" shape at the crotch of an action figure that allow the legs to pivot, at an angle, up and back. Unless you hoped to have your action figure sitting, legs splayed on the ground, there's no rational pose a figure with a V-crotch can adopt. With the addition of a pivot in the thigh and a hinge joint in the knee, a V-crotch can work. But without those additional articulations, the V-crotch is a waste. But it does count as two points of articulation, and in the numbers game, two is two more than none.

Pivot joint.

Hinge joint.

Ball joint.

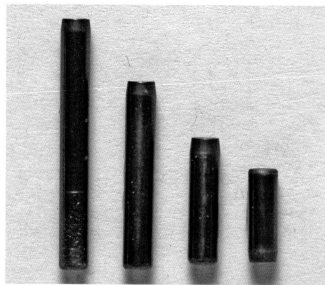

Standardized pins (right) are preferable to pins that will be hard to match later on (left).

GOING FOR THE PIN: THE PINS, PEGS, AND DOWELS THAT HOLD YOUR FIGURE TOGETHER

Pins (or pegs, or dowels) are integral to the creation of an action figure. Every joint requires the assembly of at least two parts for the articulation to articulate. You'll notice when you look at your favorite action figure that the elbow and knee joints are joined by a plastic post. Interestingly, if you look at figures from different companies, nine times out of ten that post will be the same size. It's become something of a standard: a ⅛–inch-diameter post. Standardize the peg size in your figures, as well. There are some sculptors who make their own pegs or posts from lengths of various wires or rods. But even if the wires or rods are consistent in their diameter, their length will vary, even if you try really, really hard to make them all the same. That's not going to be that big a deal…until you come to casting.

Why? Well, let's say you've worked a pivot joint into the neck of your action figure. You need a hole in the bottom of the neck, in exactly the right place to correspond to the hole in the neck position on the torso—especially if the neck has to fit into a collar. Even a little misalignment will affect the way the neck articulates, so you'll want the peg perfectly placed time and time again, both in position and depth. How do you get it right? Make our mold and cast your resin with the peg in place, guaranteeing a perfect placement each time. And that means you'll need to use the same size pin every time, too.

One of the standard-size pins that will hold your figure together.

Our preference? They're called standard alloyed steel dowel pins and are distributed by a company called Grainger (grainger. com). They come by the hundred count and are available in several standard lengths and diameters, but the real beauty is that all dowel pins of a particular length and diameter are exactly the same, one to the other, and make creating and reproducing your action figure that much more professional. Although the size of your articulation joint will change from figure to figure, the peg hole will more than likely not. And that's a good thing. When you get your dowel pins, make sure to wash them off by soaking them in a cup of denatured alcohol, then rinse and let dry, because they come with a coating of lubricant.

THE PIVOT JOINT

The pivot joint, sometimes called a "slider," is essentially two disks with a pegged hole in the center that allows the disks to pivot, one against the other. They're most commonly used for necks, shoulders, wrists, and biceps, but can also be used in waists, thighs, calves…basically, any part of the figure where a pivoting lateral movement is desired. These are also the easiest to make.

The easiest way to make a pivot joint is to get a few lengths of plastic rods in various diameters. You can use wooden dowels as well, but you'll need to make sure to seal them to make them nonporous Mark the exact center of the dowel or rod's face. Start with a length of about an inch or so. Using a drill press or a hand-drill guide, drill a ⅛-inch hole right in the center (1). With the hole drilled, mark off the rod in ⅛-inch lengths and use either a jewelers' saw or a band saw to slice it up (2). Give it a light sanding to make sure it's smooth and level (3), and voilà! A pivot joint! Here's the best part: You only need one good set. Once you have the perfect set of pivot joints, you'll be able to cast up as many as you need.

Here's how you do it. You've got two beautiful disks, each with two perfectly placed holes, each a stunning ⅛ inch thick. Place a ¾-inch peg in the hole so that an equal amount extends on each side (3). Using a ¼-inch wax gate, gate up the disk, tapering the gate so it isn't wider than the edge of the disk (4). Now, setting up a mold as you've done before, draw a cut line up the gate (5), up the center of the disk edge (as shown), build your case, and mold away. When the mold is cured, cut open the mold as you would any other mold, stopping about halfway up the disk (6). Open the mold and, with a pair of needle-nose pliers, twist out the peg. Be sure, when setting up any joint mold or any figure part with a joint as part of it, that the peg extends beyond the joint face by at least ¼ inch. This will become even more critical when we get into hinge joints. You just want to make sure to leave enough exposed peg to make it easy to remove from the mold.

Let's cast up a couple of pivot joints. Put the peg back into the mold. More than likely this will need to be a loaded mold because of the narrowness of the gate. Pour in the resin, pop it

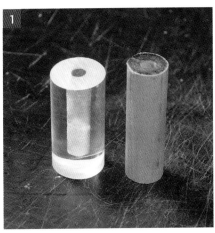

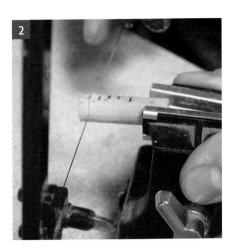

into the pot, and go do something productive until the resin is fully cured. Open the mold and, using that pair of needle-nose pliers, twist out the peg. Cut off the gate, being sure not to flat out the edge, and you have a beautiful pivot joint ready to turn your action figure's head, wrist, thigh, or what have you.

You can even create a **gang mold** to cast up several sets at a time. A gang mold is a mold that allows you to cast several parts at one go. This is often done by casting and cleaning several parts, then gating them up in a kind of flat configuration with large feeder gates. When the mold is cured and opened, you can cast a handful of parts—pivot joints in this case—at one time. It saves time and, since time is money, saves money, too.

You'll want a collection of pivot joints in various diameters. The Hulk's neck is going to be a lot thicker than Supergirl's, so having various sizes on hand will just make your job that much easier. But, as time goes on, you'll end up having to custom-make a lot of joints to suit a particular figure. All the better for you;

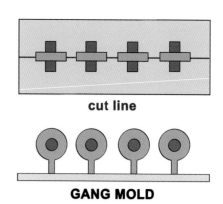

cut line

GANG MOLD

Diagram of a gang mold, with pegs in place.

the more you have to work with, the better your figures will be, the more inventive you can be with placement and motion.

There is, however, another way to make pivot joints, using wax sheet instead of articulation disks. We used this process for Thor's waist joint, and you can see it in pictures 1 through 26.

Pivot joints need to come in all shapes and sizes, to accommodate both thick and thin necks, for instance.

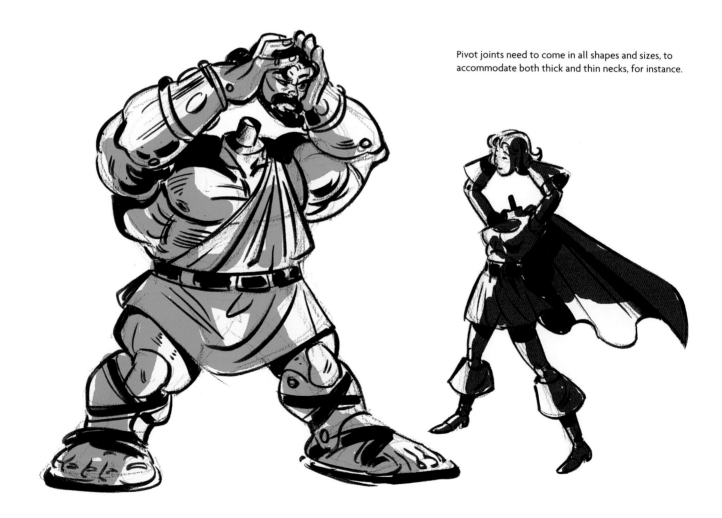

▶ Making a Pivot Joint From Wax Sheet

Start with your sculpted pelvis with T-crotch.

Sand the top with 180-grit sandpaper.

Sand until your waist is perfectly flat.

Find the ellipse on an ellipse template that matches your waist.

Lay the selected ellipse over a wax sheet.

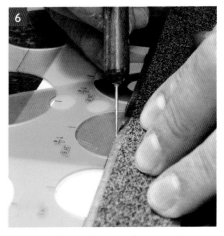

Using a stylus, etch a line that cuts the ellipse in half.

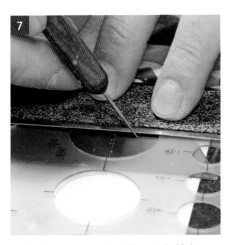

Etch a line, cutting the ellipse in half the other way.

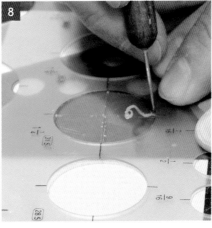

Using the stylus, cut the ellipse out.

The center of the ellipse is marked by the crosshairs.

Use turpentine to smooth the unmarked back of the ellipse.

Attach the turpentine-dampened back of the ellipse to the T-crotch

Using the wax pen, weld the edge of the disk to the T-crotch.

Use a loop tool to carve a ⅛-inch-diameter hole in the center of the disk.

Insert the peg in the hole.

Slide the pivot joint to the base of the peg to make sure the peg is perpendicular.

Get a piece of metal tubing with a ⅛-inch interior diameter.

Using a jeweler's saw, cut a ³⁄₁₆-inch length of the ⅛-inch tubing.

Use tweezers to insert the warmed tube into the center of the hole.

Fill in with wax around the tubing in the hole.

Check again that the peg is perpendicular.

Sand the surface to make sure everything is flat.

Repeat steps 1 through 21 for the bottom of the torso.

The torso and the pelvis should fit together perfectly.

Make sure the waist width works with the temporary wax belt.

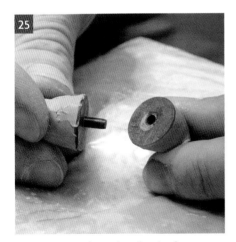

Repeat steps 1 through 21 for the forearm pivot joints.

Make sure the upper and lower parts of the forearm line up.

THE HINGE JOINT

The trickiest joint to make and to use is the hinge joint. Most commonly used for elbows and knees (although they can also be modified for other uses), a hinge joint is made up of three disks— a center disk flanked by two outer disks joined by a contoured bridge. The thickness of the center disk in relation to the outer disks can dramatically affect the look and placement of the joint. As a knee joint, the center disk represents the knee while the outer disks represent the outside of the leg. As the knee takes up more room of the configuration, you want the center joint to be thicker than the two flanking disks. In creating an elbow joint, the center disk will represent the elbow while the two flanking disks will represent the outside of the arm. In this case, all three disks are almost the same size, the center disk being only slightly larger. Of course, there are exceptions. In constructing any joint system, always reference the art so you know you'll be making a set of joints that will work for your particular sculpt, and is best suited to its proportions. But, generally speaking, a knee joint for Superman will work well for Batman, Spider-Man, or Namor.

Making a hinge joint is much the same as making a pivot joint, but where a pivot joint is just two identical disks, a hinge joint is three. Depending on the size you need, you may be able to cast up three pivot disks and sand down the flaking disks to the thickness you need, but it's likely you'll need to start from scratch at some point. Let's assume that's the case.

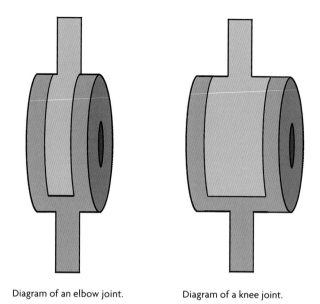

Diagram of an elbow joint. Diagram of a knee joint.

Pick a rod diameter that will work for what you need, mark the center and drill an ⅛-inch hole smack dab in the center. Cut up the rod into three crosswise sections and then lightly sand each one to make sure they fit flush, one to the other. When all three disks are the thickness you want, pin all three together **(1)** and, using a small piece of 16- to 20-gauge wax sheet (depending on the proportions of the figure), create the bridge that connects the two outer disks together **(2)**, leaving the center disk "free". The bridge is essentially a rounded, contoured channel that will

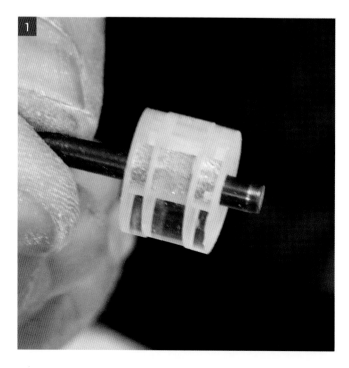

seat the center disk and keep it in the proper place for alignment with the two outer disks. Using a section of 8-gauge wax rod and your wax pen, weld the rod to the center of the bridge, directly under the center disk **(3)**. Be very careful when welding the rod to the wax bridge; you don't want to distort or melt through the wax sheet. Weld a section of the same gauge wax rod to the center disk, in line with the rod welded to the bridge **(4)**.

Now, carefully remove the connecting pin. You should have a two-part hinge joint: a center disk and a two-disk piece that looks like a "Y." Reinsert the pin into the double-disk part (minus the center disk), again being careful not to distort the bridge, and insert another pin into the single-disk part. Make sure the pin extends ¼ inch or more beyond the outside of each disk after it's centered. Now, mount the unit to a piece of foam core, and do the same to the single disk. With both units mounted, draw a cut line on the single (center) disk up the center of the gate to the center of the disk edge **(5)**. Mark the cut line on the double-disk unit to the side of the gate so that the cut line travels up the edge of one disk **(6)**. Build a case for each and make your mold as you would ordinarily do.

When the molds have cured, cut the single-disk mold open, following the cut line to the top of the disk, and remove the part. Cut open the double-disk mold at the top of the selected disk, and continue the cut along the bottom of the bridge and under the opposite disk. Using a pair of needle-nose pliers, re-move the pin and remove the part. You'll end up taking the part out in pieces, so be sure to remove all of it. Reinsert the specific pins into each mold **(7)** and rubber-band them up, ready for casting. These molds will need to be loaded, so be sure to get that resin in there.

When the resin has fully cured, remove the molds from the pot. For the single-disk mold, butterfly it open and remove the part **(8)**. You don't need to remove the pin at this time. For the double disk mold, butterfly it open. Using a pair of needle-nose pliers, twist out the pin **(9)**. When the pin is removed, you'll be able to remove the casting **(10)**.

We know, it sounds like a lot of work. Why not just cut through the RTV in the center, between the two disks? Because you'll want a perfectly aligned part that will accommodate the single center disk when the two parts are pinned together.

It's never a good idea to cut the mold where a pin is embedded; the chances of the pin reseating itself after the mold is closed are too great to risk it. By keeping that RTV plug in place, the pin has a secure nest. With both ends and the middle of the pin held firmly in place in the RTV, you're certain to have a part that will work and work reliably, casting after casting.

When both parts of the hinge joint have been cast, pin them together until you plan to use them, giving them time to completely cure. **Do not cut off the gates!** *Trim* the gates to about ½ inch from the joint. Those gate nubs are going to come in pretty handy. When seating a hinge joint, it's going to go through a lot of tugging and twisting as you position it right where you want it, in a knee or elbow. By sinking that gate nub into the leg or arm part, you're giving yourself a more secure and sturdy joint. Your frustration level can become nearly volcanic when you're putting your sculpted action figure together to take pictures and the hinge joints wobble, sending the figure to the floor and your hard work along with it.

Your finished hinge joint, with ½-inch gates for seating purposes.

SCULP-TOR SEZ: SIZE MATTERS

Always use the largest joint your figure can accommodate, especially for elbows and knees. Both the elbows and knees commonly use hinge joints, and the degree to which the elbow or leg can be repositioned is in direct correlation to the amount of material removed at the bend point. The more material removed, the greater the degree of bend. There's no getting around the physics of this, but there is a way to minimize the visual effect. Using a larger joint, as opposed to a smaller joint, means you'll have more arm to work with, side-to-side and front-to-back. Although you'll need to compromise the sculpt, the look of the arm will appear to be more natural. This is doubly true for a knee joint, where the material must be removed from the back of the leg. By using a larger joint, the profile of the leg at the joint will appear to be more natural, as will the front of the knee, especially when using a hinge joint with a larger center disk to replicate the knee's dimensions.

THE BALL JOINT

Ball joints are most often used in shoulders and the upper thighs for a ball-joint crotch assembly; they're also used on the end of a neck stump to articulate a head. However, if the head/neck relationship is critical, and it would be better for the sculpt if the head and neck were one piece, an **inverted ball joint** (first used by Tim on the Alex Ross Joker figure for DC Direct), in which the ball is on the bottom of the neck post, works great.

Although a ball joint as produced by a manufacturer is a fairly complicated and sophisticated little piece of engineering, incorporating a self-made ball joint into your sculpt could not be easier. Marbles, ball bearings, wood balls…all make great ball joints. Pick the size ball you need, gate it, mold it, cast it, and *voilà*! As with hinge joints, it's a good idea to leave a little gate on the ball to secure it into your sculpt. But beyond that, sculpting a cavity to accommodate the ball is all that's needed for a ball joint to be translated by the manufacturer into a working ball-joint system.

The inverted ball joint is what we used for Thor. We used a wooden ball because it was the right size, but we could have just as easily used a marble or ball bearing, had any of those been the size we needed. We actually opted for the half-ball with peg joint, so we cut a wood ball in half, sanded it flat and drilled a ⅛-inch-diameter hole for a peg. This gave us more control over the dimensions of the neck above the ball joint, allowing us to sculpt a narrower neck with neck wrinkles, which we wouldn't have been able to do using the full ball.

There are other types of articulations, but they all stem from these basic three: pivot, hinge, and ball. The main thing to consider in creating joint systems is to be creative, inventive, and go for what works. Some action figures come with torsos that bend mid-stomach; for the most part, it's just a glorified hinge joint. If an arm is too thin to accommodate a traditional hinge joint, you can modify it by making it a posted pivot joint. Where there's a will, there's a way.

TOP: Seated inverted ball joint; using half a ball gave us more neck for sculpted details. MIDDLE: Half-ball with peg joint. BOTTOM: Full ball joint.

JOINTS OF INTEREST

Since they can drastically affect the look of your figure, we should talk a little about crotches. There are three basic kinds: the V-crotch (which we touched on earlier), the ball-joint crotch, and the T-crotch (which we also touched on earlier). When we mentioned the **V-crotch**, we didn't mean to imply it can't be done well and can't be a useful articulation. Of all the crotch joints, it's the least obtrusive. It is, after all, a couple of pivot joints at an angle. The problem comes from their application. They really don't do much for poseability.

Ball-joint crotch, on the other hand, are highly poseable. They give the broadest range of movement, but they can, by their nature, compromise the sculpt pretty dramatically. If the look of a ball joint doesn't bother you, and you want the maximum amount of articulation, then a ball-joint crotch is the way to go.

Then there's the **T-crotch**. Good old reliable T-crotch. A T-crotch is ostensibly a hinge joint with independent flanking disks. The center disk is stationary and is attached to a posted bridge (as shown). The two flanking disks become the topmost part of the thighs and can be posed independently, one from the other. The T-crotch is probably the most common type of crotch joint and a great middle ground between the V-crotch and ball-joint crotch. The flanking joints will be beefed up with the thigh sculpt, so their thickness isn't very critical, but the width of the center disk of a T-crotch needs to be proportional to the crotch of the character. Needless to say, the center disk of a T-crotch for Supergirl will be a different size than one for Superman. We'll say no more.

You can gauge the size of the T-crotch you'll need from the art. The larger the disk assembly, the more natural the crotch will appear from both the front and the side. Often, the top of the flanking disks will be just below the belt line, making it a perfect place to disguise the joint; if we drop the belt down a little we can mask the joint edge.

Three different types of crotch joints. TOP: T-Crotch; MIDDLE: Ball-joint Crotch; BOTTOM: V-Crotch.

Figuring It Out: Putting Your Figure Together

Our Thor action figure will use all the articulations we've discussed. You've already got all your joints cast and ready to use, so let's get started! First lay out your art. Rough out your figure with the articulations in place. You'll need to build an armature that leaves room for the cast joints. But, with an action figure, your armature won't be much more than a loop or two of armature wire hot-glued to each joint.

Our Thor figure, as designed by Rubén, has fifteen points of articulation (and sixteen parts):

- An inverted ball joint in the neck
- Ball-jointed shoulders
- Hinge joints at the elbows
- Glove pivots
- Waist pivot
- T-crotch
- Pivot joints at the upper thighs
- Hinge joints at the knees
- Pivot joints at the boot tops

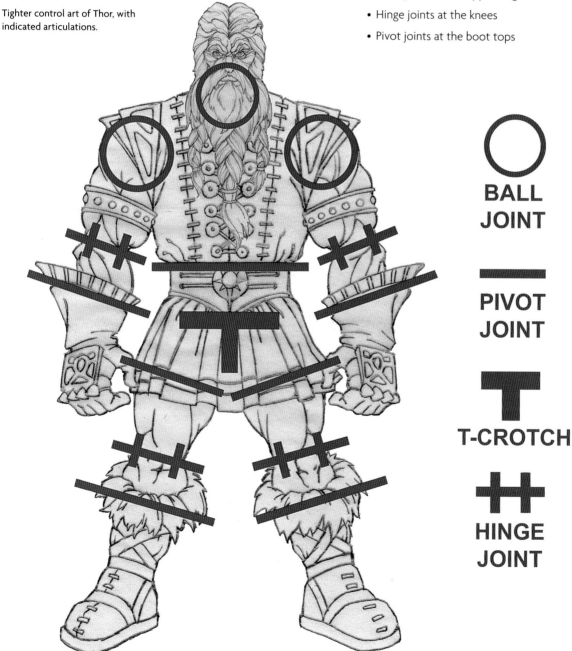

Tighter control art of Thor, with indicated articulations.

○
BALL JOINT

—
PIVOT JOINT

T
T-CROTCH

╫
HINGE JOINT

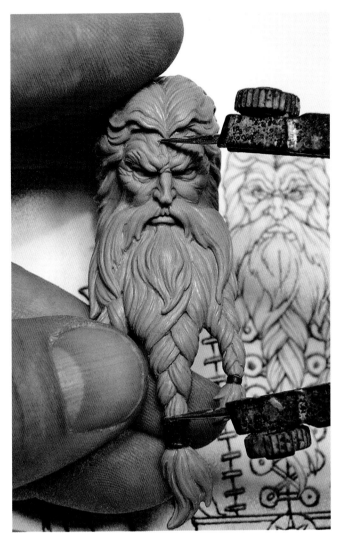

Use a pair of calipers and an actual-size printout to make sure your sculpt matches the art exactly.

Because you're working at a smaller scale, use a firm NSP clay. You'll still be able to use your warming station, just as when roughing out your statue in medium NSP, but the firmer clay will allow you to get tighter at the action figure scale when the clay cools. Just as with your statue, what you want to do is get all the basics in the clay rough, with the addition of the articulations. Repositioning the articulations in the clay will be much easier and will give you more freedom to correct balance issues. Clay is heavier than either wax or resin, so if this piece is well balanced in the rough clay, it's sure to work really well as we take it to finish.

Having reference art to size really helps in getting the scale and proportions right. As you rough out each part, you can lay your rough sculpt directly on the art to make sure you're heading in the right direction. As we discussed in creating a statue, each of us has a visual bias toward a given form or proportion, which can sometimes lead us astray in capturing another's aesthetic, so it's always a good idea to frequently reference the art you're working from. (If you're working on a character of your own design, just go to town.) Our Thor figure is posed in a classic waiting-for-a-bus pose. If he were in a specific "action" pose, getting a true read on his position from laying our rough on the art wouldn't be as accurate as with a standing pose, but it's still a valuable tool in keeping us on the right track.

A Separate Piece: Roughing Out the Figure

Part by part, rough out your figure. It takes some getting used to, to see the figure as a whole, so assemble the parts as you go, to make sure you've got enough movement from your articulations and to make sure you're still in scale. It's not uncommon, when working with articulation, for the sculpt to grow to accommodate them. Here's the tricky part: Sometimes, you'll need to compensate for the joint and stray from the art to make the figure look in proportion. **Proportion** is key to making a figure appear right.

For instance, when using a hinge joint in the arm, the space the articulation occupies has a tendency to make the forearm, from the joint to the wrist, look too short. The same thing can happen with the upper arm, especially when using a ball joint in the shoulder. Thinning the wrist or extending the arm a little can help. We know this may seem contrary to what we've been harping on, but sometimes the eye knows best, no matter how accurate the sculpt is to the art. Michelangelo's famous statue of the Pietà is a good example. Looking at the piece, everything looks right—heck, forget "right," it looks perfect. But if Mary were to stand up, she'd be seven feet tall!

With all your parts roughed out, now you need to consider **balance**. (We're not going to worry about roughing out Thor's skirt; we'll do that directly in wax a little bit later.) So pin everything together and stand the guy up, looking to make sure his stance looks natural and he's steady on his feet. Thor's feet are large in proportion to his body, which gives you a large footpad with which to balance the figure. Check the spread of his feet, the angle of his legs to his body. A common misconception is that the standing body is straight up and down. It might be if you're in the Army, standing at attention, but ordinarily, the hips are positioned a little forward, putting the heels in a drop-line parallel to the buttocks or even slightly farther back and past that line. Our Thor will also have a cape accessory, which is going to add weight to the back of the figure, so push his legs a little farther back to compensate for the additional weight. This way he'll remain upright even when he's all duded up.

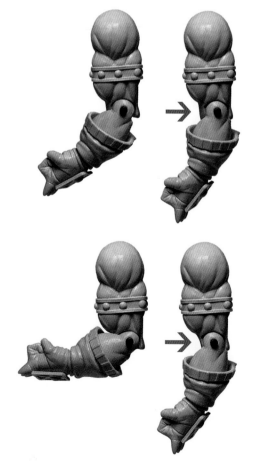

Standing perfectly straight isn't always best, especially for an action figure. Leaning forward will help counterbalance accessories like a cape.

Removing material from the inside of the elbow can give you a greater degree of movement.

So, how's he looking? Standing nice and tall and all heroic-like? Not yet? Just keep at it until he can stand up, all on his own. Check his **range of motion**. If a client wants a character's arms to be able to be bent at right angles, you'll need to remove more material from the inside of the arm to make that happen. With Thor's beard and hair, you'll get a limited range of motion from his head. Sculpting out the underside of the beard will help the up and down movement, while sculpting the hair away from his shoulders and back will give more lateral movement.

Finally, and we can't emphasize this enough, always check the **alignment**. Make sure everything matches up before you finalize anything. If the sculpting on either side of the joint doesn't align, and you have to redo all that work, it will be a nightmare from which there is no awakening.

Know When to Mold 'Em: Fresh RTV Master Molds

Because of the scale of the figure, waste molds really won't be all that practical. The mold cases will be too small to accommodate little RTV cubes, so go ahead and bite the bullet, and make fresh RTV molds.

Make your molds with the articulations in place and pinned for perfect registration. Gate the parts on the clay, not the joint, so gate Thor's head from the top, with a vent/feeder gate at his hair. There are two joints in the upper arm, but since the shoulder is a ball joint, you can gate off the ball of the shoulder. Yes, you will get a little shrinkage, but as you have control over how the ball fits into the socket, it's something you can easily deal with. There are two joints in the torso, so gate from the tops of the shoulders. There are two joints in the upper legs as well, but there's more sculpt than disk and so you can gate at the outside edge of the upper thigh. With everything gated up, build your cases, using just enough RTV for a workable cast, and proceed with moldmaking as you have before.

RESIN displaces the **AIR** in Thor's gloved fist.

Thor's hand will be molded with peg in hand, where the peg represents the diameter of the weapon handles.

Both pieces of the knee joint will be molded with the pin in place.

When the molds have fully cured, follow your cut line, open the molds, and take out the parts. Clean any recalcitrant clay out of your molds, then remove the joints from your clay parts, so that you can cast them into your wax parts. With your wax melted and ready to pour, pop the molds into the microwave, getting them nice and cozy warm, then insert the pinned joints in the molds, rubber-band them up, and fill them with wax. Put the molds into the pot, pressurize, and go do something productive. Be sure to let the wax fully cool; leaving it overnight isn't a bad thing. When it's time to open the molds, do so carefully. Cut off the gates, and you're now ready to begin finish work on your wax-cast action figure parts.

In working on the elbows and knees, do so with the pin in place, for the most part. In trying to make the joint look as natural as possible, you'll be sculpting up and around the pin. This process will require a lot of checking and rechecking. You'll remove the pin and even out the surface around the pin, then replace the pin to make sure the parts fit flush and move easily. Notice how we've worked the knee and the flesh around the knee. In our pictures of the Thor figure in progress, you'll get a good feel for how to minimize or mask the articulations while maintaining the integrity of the sculpt.

One of the last parts you'll finish will be the hands. Thor comes with a lot of accessories, and make sure that they all work with the **C-hand** we're constructing. It's called a C-hand because of the shape the thumb and fingers create. All of the accessories Thor will hold will have to work with the hand you sculpt, so all the handles, be it sword, staff, axe, or hammer, will have to have the same diameter. If your figure were going to be manufactured, the hands would be produced in PVC, which has a little give to it, allowing you to create accessory handles with slightly different diameters. For your resin figure you'll want to keep those handle diameters pretty tight, but even producing a figure for manufacture, you'll still want those hand-to-handle tolerances pretty close together. One of the ways you can do that is to use a ⅛-inch pin wrapped in a length of masking tape. What you're trying to do is create a pin with a slightly larger diameter, so, after you remove the tape, use a standard pin as a base upon which to sculpt various handle details and still have it be straight and fit your C-hand.

In the next chapter, you'll fit your accessories to a resin body, so go ahead and set up all your parts for molding, pinning all articulations. At this stage, gate some of your parts at the

Gating from the pivot joint.

Gating from the hinge joint.

articulations. Since there is a pivoting glove on both hands, you can gate the lower arm from the bottom side of the pivot joint where the gloves attach. Had we had an arm with hand attached, you'd have to gate off the hinge joint.

There's a trick to gating from the double-disked hinge joint. Using a short length of 10-gauge wax wire, create an arch that will be wax-welded to the top of each joint. Then, taking a piece of 6-gauge wax wire, wax-weld that to the top of the arch, creating an upsidedown Y. This gives you a feed into both sides of the hinge to fill the arm. This will need to be a loaded mold, as will many of your action figure molds. In removing the casting from your double-disked hinge joint, after the resin has cured, open the mold just enough to pull out the pin with a pair of needle-nose pliers. This is another tricky part. Using a small pair of wire cutters, slide in, pulling open the mold, to cut off the arched gate. When you've done this, slide the part out of the mold, joints intact and perfectly aligned.

Assembly Required: Putting the Parts Together

A hearty congratulations! All your main action figure parts have been cast, and you've presumably taken the time and care to clean them so that every little detail of your fine work shines through. But now you've got a bunch of cool parts. How are you gonna get all those parts put together to make a paint master? You can't use metal pins. Well, you could, but they'd be sticking out all over the place and make your figure look more like a bird perch than a superhero. What's the solution? Cast resin pins.

Draw a line on a piece of foam core and then divide that line into ½-inch segments. Take the longest pins you have, hopefully ¾ inch or 1 inch, and superglue them right on that line at the ½-inch marks. When the glue is fully dry, set up for a mold. When the mold is cured, open it, remove the pins, and cast it as a loaded mold. When the resin is cured, remove the cast pins. Then, when you go to assemble your parts, simply insert the resin pin into the joint just as you would a metal pin. Now here's the beauty part: Using your jeweler's saw, trim off the excess pin length and add a small drop of superglue right at that spot. We're taking a *small* drop, just to hold the pin in place. More than a small drop could result in the glue running down along the pin into the joint, which would mean goodbye, poseability.

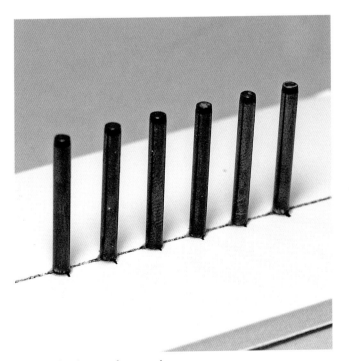

Steel pins lined up on a foam core base.

Taking the resin pins out of the mold.

When the glue's dry, use a little 320-grit sandpaper and smooth the pin down flush to your part. Go in with a Dremel and do a little resin resculpting if needed. Continue until your figure is fully assembled. The only other thing you need to consider is whether To Glue or Not To Glue. If you want to pose your figure in various positions, you're done and good to go. But if you want your figure fixed into position, drop a little superglue into the back or side of the joints and then book a passage to Accessory Island. See you there!

A gang mold of resin pins; arguably the easiest mold you'll ever make.

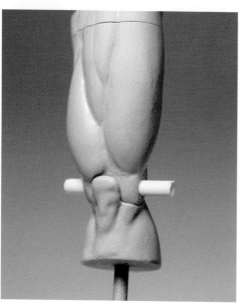

LEFT: A pretrimmed resin pin.

RIGHT: Unlike metal pins, cast resin pins allow you to trim your hinge joints so they're flush with the figure surface.

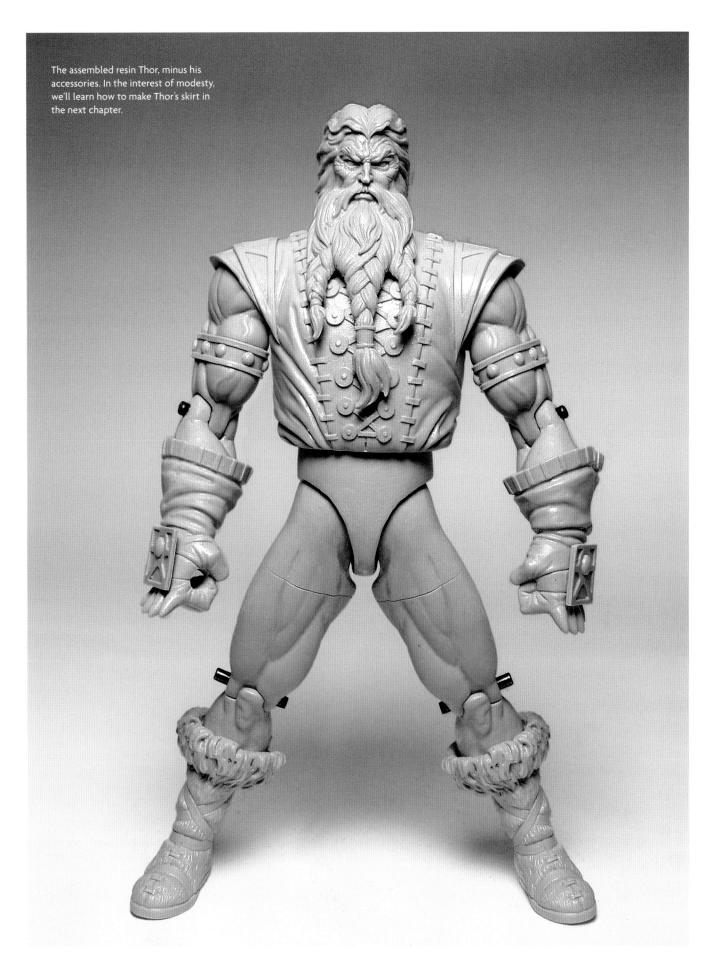

The assembled resin Thor, minus his accessories. In the interest of modesty, we'll learn how to make Thor's skirt in the next chapter.

9. Accessories

CREATING AN ARSENAL OF WEAPONRY FOR YOUR ACTION FIGURE

What would Captain America be without his shield? Green Arrow without his bow and

arrows? Batman without his Bat-A-Rang? They'd all be characters without accessories.

As with articulation, the number of accessories is usually decided by the figure's budget, but, luckily, accessories are a slightly less contentious subject. For some, the number of accessories is what makes an action figure so much fun, but for others, as long as one or two crucial accessories are present, whatever needs to be passed over in the name of keeping down the cost of the figure is fine by them. Since our mythical Thor figure isn't slated for production, we can craft a whole slew of accessories—and a sweet base.

Concept art for a variety of Thor accessories. We won't show you how to make all of these, but we'll show you a few.

Accessories to Kill ~~With~~ For

In some ways, creating accessories can be the most fun of an action figure job. The big stuff is done, now it's time for a little play!

As with most of the sculpture work you'll do, look for things that, when modified, can be the basis for the things you need. For Thor's mace, we would use a cast ball bearing studded with the tips of wax rods, each sharpened with a handheld pencil sharpener and wax-welded into place. Thor's staff would be a sanded wood dowel wrapped in thin strips of wax sheet. A sanded piece of styrene sheet, or a waxed-over section of Kromekote would give us his sword. And don't be afraid to wander the aisles of toy stores or model and hobby shops looking for weapons in scale to what you need; they can make great armatures for your own weapons. A little wax here and there can turn a .44 Magnum into a laser cannon.

Sometimes, there's no other choice but to sculpt an accessory from scratch, and if there's one material you'll use a lot of in this chapter, it's **wax sheet**. Wax sheet is very malleable, a little sticky, and it can be temperamental, but the fact that it's malleable and consistent in thickness makes it ideal for creating accessories. Wax sheet is also great for cutting out emblems or relief decorations, which is good, because they'll play a big part in the creation of Thor's shield and hammer. Follow the instructions, and your Thor will be hammering and getting hammered in no time.

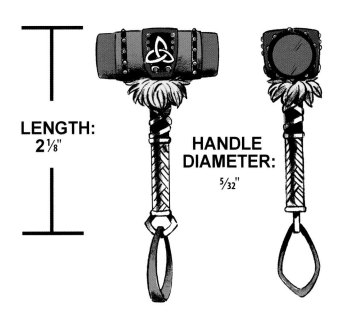

LENGTH: 2⅛"

HANDLE DIAMETER: 5⁄32"

Control art for Thor's hammer.

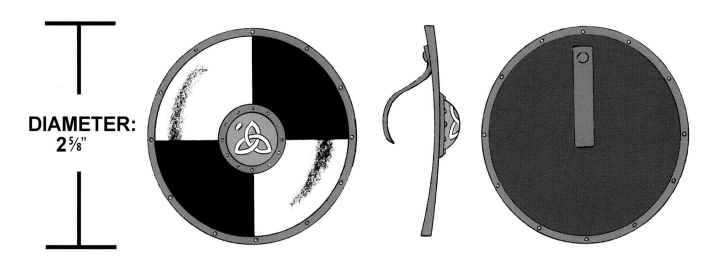

DIAMETER: 2⅝"

Control art for Thor's shield.

THOR'S SHIELD AND THOR'S HAMMER

Score crosshairs inside a large perfect circle, then cut out.

Shape wax over a sphere; add a wax strip around the edge.

Place two concentric disks of differing sizes in the middle.

Build up the wax hemisphere on the inner disk with the wax pen.

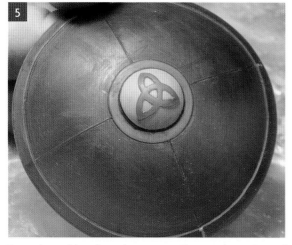

Trace the emblem from the art onto the wax sheet. Cut and wax in place.

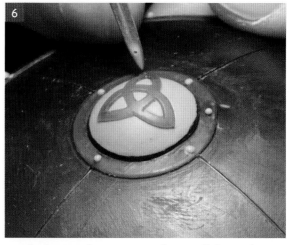

Use the fine tip of a wax pen to place small drops of wax on the outer disk.

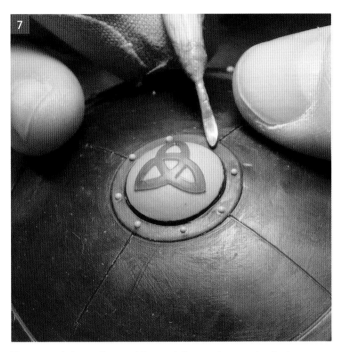

Flatten and shape drops with a molding tool to create rivets.

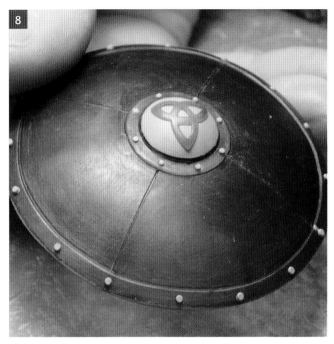

Repeat Steps 6 and 7 for the outer edge of the shield.

Use resin to position the wax arm clip.

Back-fill arm clip, supporting it from beneath and adding rivets.

Mark a ⅛-inch-diameter wooden dowel for the handle; include a bit for the peg at the top.

Build up wax on the handle for detail work.

Pass the waxed handle through a ⁵/₃₂-inch template to ensure consistent diameter.

Sand the wax handle until even.

Make sure the wax handle fits snugly in resin Thor's hand.

Mark start and end of visible handle details.

Draw on diamond pattern as a guide for the spiral wrap.

Etch in details using a small sculpting tool.

The grip of the hammer is finished.

Cut a balsa wood or Balsa Foam length for the hammer head.

Sand the hammer head smooth on all six sides.

Mark the center of one long side and drill a ⅛-inch hole through.

Coat the hammer head with primer to seal, and sand smooth.

Slice a round dowel to create hammer tips. Prime and attach to handle.

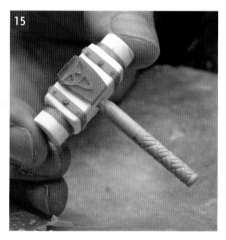

Add straps and an emblem made from wax sheet. Glue the handle and add rivets.

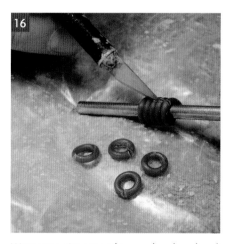

Wrap wax wire around a wooden dowel and cut to create wax rings.

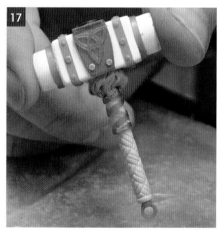

Add a wax ring and straps to handle; sculpt wax fur trim.

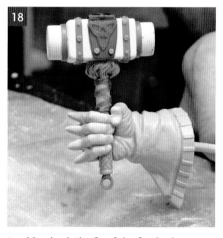

Double-check the fit of the finished hammer.

Planet of the Capes

A few words about capes. They look great on the page, whipping wildly in the wind or billowing majestically on the shoulders of a super hero, but they are a pain to sculpt. The first obstacle is one of tolerance. How thin can you go and still have it be reproducible? The thickness of a cape will depend largely on the material it's going to be manufactured in. Because it'll be made of PVC, a cape for an action figure can be much thinner than one for a statue. There are various levels of hardness or flexibility of PVC, and, since they're injection molded, they can be reproduced in a thinness not possible in resin.

On the other hand, a resin cape needs to be thick enough to be pressure-cast and supported in a way to distribute its weight to minimize sagging or drooping over the life of the statue. There's also the issue of **mold collapse**. When casting a resin cape, even if the cape design calls for it to be wind-whipped and undulating, there are still going to be flat or thin sections. The mold will have a tendency to press together at those thin or flat spots, creating very thin sections of cape, some so thin they become holes. Using a very firm RTV can help minimize that effect, but the easiest and most reliable method is to make sure your cape, for whichever reproducing material, is thick enough to work and work well.

There are several methods for creating a cape. Here's a couple we found work well for either statue or action figure application.

TOP: Batman cape sculpted by Tim Bruckner for DC Direct.
BOTTOM: Supergirl cape sculpted by Tim Bruckner for DC Direct.
OPPOSITE PAGE: Superman cape sculpted by Tim Bruckner for DC Direct.

You don't need to be a magician to get a cape to do what you want it to do.

THREE SHEETS TO THE WIND: MAKING A CAPE FROM WAX SHEETS

The first technique uses wax sheets. For an action figure cape, or a cape for a figure of that scale that you plan to cast in resin, we recommend not using any wax sheet thinner than 16 gauge. For a statue cape, try to keep the overall thickness near $\frac{1}{8}$ inch. To give the impression that the cape is fabric-thin, you can feather the edges to $\frac{1}{16}$ inch while keeping the body of the cape thicker. If you've only got a box of 20-gauge sheet and need a thicker

sheet, wiping down a couple of wax sheets with a turpentine-dampened paper towel and pressing them together will effectively glue the two sheets into one.

If your design calls for the cape to hang majestically from your hero's shoulders, begin by pressing wax sheet around and over the shoulders of your resin casting **(1)**. If the wax sticks, as it sometimes will, dampening the resin with a little water will prevent that. Do this with the upper arm part in place and in position. You don't want to press so hard that the wax indents

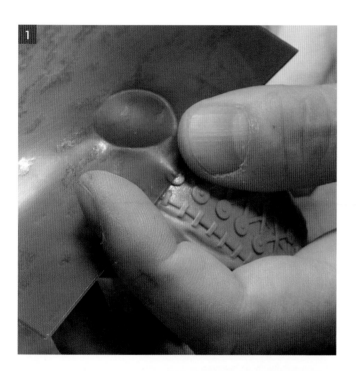

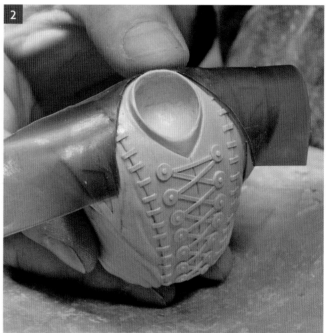

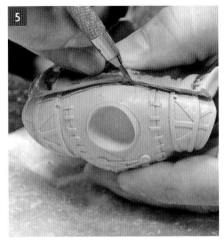

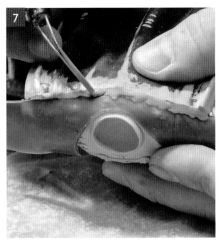

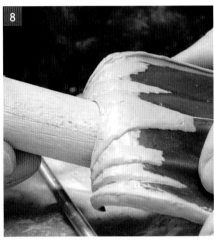

at the shoulder line. What you're trying to do is lay the foundation for the cape as it works over the shape and articulation of the shoulders. Using an X-Acto knife, cut the sheet into the basic shape you need, trimming away the excess **(2)**.

Begin creating the fabric folds by bending another sheet of wax over various sizes of plastic, wood, or metal rods **(3)**. If you look at the bottom edge of the wax, you'll see we created a series of various undulating Us **(4)**. Be careful to vary the sizes and depth of the U folds. Applying pressure to the edge with one of your rods can create the appearance of fabric lift. You may need to weld together two or more wax sheets vertically or horizontally to get the cape fullness you want. Use green wax to weld green wax; if you use your sculpting wax as a weld, the differences in hardness will make it difficult to finish in broad areas.

Now that you've got your shoulder section and your hanging section done mark the start of the hanging cape **(5)**. Using an

X-Acto, first trim the hanging section of the cape into the form you want, and then, holding that section up against the shoulder section for height, trim the shoulder section to the correct length **(6)**. At the top of the hanging section, where it meets the shoulder section, use your fingers to press the folds flat and then weld the two sections together, inside and out **(7)**. You now have the basis of a cape.

The last part you build will be the cape's tall collar. First find a dowel that matches the inside curve of your neck hole **(8)**, then cut out a bit of wax sheet and shape it around the dowel for the collar **(9)**. Secure the collar to the neck of the cape. Once it's secured in place, go in with a wax pen and our sculpting wax, accentuating folds and wrinkles, adding detail work **(10)**. When you've finished sculpting, a good turpentine rubdown will make everything nice and smooth. Be sure to brush away any excess wax residue as you go.

THOR'S SKIRT

Thor's skirt is built much the way his cape is—by creating folds over a series of rods, then building up portions (like where the skirt meets the belt) with your wax pen. The belt details are added, and then it's all suspended from a disk that will fit in between Thor's torso and pelvis. And if you're working on a skirt or cape that's dynamically wind-whipped, you'll still use the same procedure, except you'll use a curved armature wire to create your folds, and you'll build support for the cape as it moves away from the body directly under where it comes off the shoulders and the back of the neck to keep it in position.

Take a moment to really examine your cape or skirt. It might look really cool, but is it reproducible? Look for mold locks, thin parts (by holding it up to a light) or overly complicated configurations. Anything that looks like it might be a problem most likely will be. Those areas will need to be **back-filled**. Back-filling is a method of using a material to fill in mold locks or areas too deep and narrow to be cast. If you have a series of folds that undulate tightly, one against the other, using a little melted wax, and pouring it into those folds will fill them up, eliminating the problem. Be very careful when back-filling a green wax cape that you do it incrementally and don't touch the area until it's completely cooled. When all your problem areas have been filled, you can go back in and resculpt them.

Remember, sculpting a cape or skirt is like sculpting anything else: It doesn't physically have to *be* a cape or a skirt to look like

Create curving folds using a curved bit of armature wire.

a cape or a skirt. Forget about how you know a cape works and what it is; the main thing to consider is, "What does my cape need to do, *visually*?" And we're going for perception, not reality. A good cape will appear to function as a cape as well as physically functioning as a part of your sculpture. This is a good rule of thumb for anything you'll sculpt. Sculpture, like most art, is illusion. An artist thinks like a magician, not a physics professor.

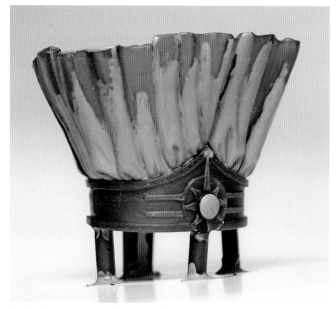

Thor's skirt is also created using wax sheet.

Thor's finished skirt.

ANOTHER FINE MESH: MAKING A CAPE WITH MESH

An alternate method of cape construction involves a fine wire mesh used in armatures. It comes in various sizes and flexibilities, and can be formed into a basic cape shape. You would then either cover it with clay for a waste mold (this method is often used for larger-scale pieces) or dip it in melted wax, giving it a wax coating that can be finished as a wax.

▶ Other Dipping Methods

The dipping method can also be accomplished with resin. Be sure to wear rubber gloves and either wrap your finished resin figure in a sheet of plastic wrap or thoroughly spray it with a mold release. Mixing up a small batch of resin, you'll dip a piece of cloth into the resin and form it over your part, continuing to form as the resin sets up. When it's fully cured, redip the cape into some fresh resin until you get the thickness you want. Using this method, you can wax directly over the resined cloth to add details. You can also cut, sand, and use a hair dryer to reshape the cape if you want to make adjustments.

The basic wax sheet techniques were used to create Thor's cape and skirt.

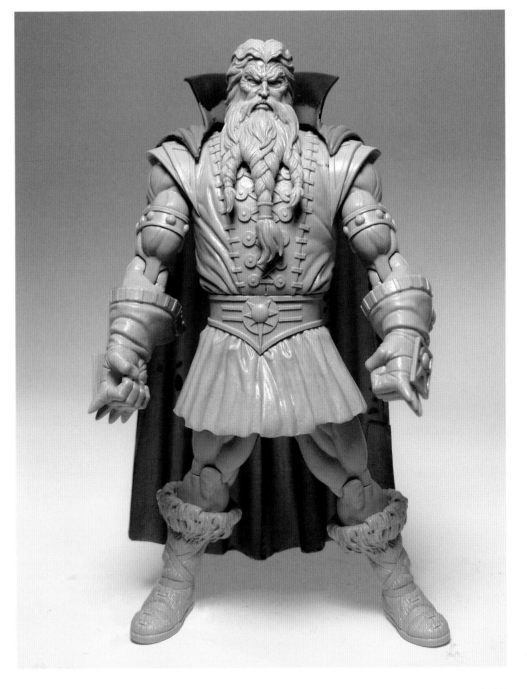

Life's Tough, Wear a Helmet: Making Thor's Helmet

Let's say you've got a gladiator. What self-respecting gladiator doesn't have a helmet? A dead one. So, let's give him one. Unlike capes, helmets actually do have to function. We know, it kind of goes against what we just said. But for every rule, there's an exception. Rule…meet exception. Use wax sheet, some clay, a little mold release product, and some patience. Feel free to apply this method to characters who are less bloodthirsty but still need a helmet, and you can also use this method to create removable armor, masks, or any number of accessories that actually have to fit and work right on your figure.

If the look of your character changes dramatically from when his helmet is on to when his helmet is off (think of the comedian Carrot Top wearing a swimming cap), then you may want to simply sculpt two different heads. It will be more seamless-looking than a removable helmet piece, but it will require more plastic and it takes away an element of realism. Depending on your art director's budget and how important the two different looks are to the figure, this may be the better way to go. A simple ball-and-socket joint (ball joint) is all you need to make the heads interchangeable; if budgets are tight, and extra body parts aren't in the cards, making one of the heads a short-packed variation may be an option.

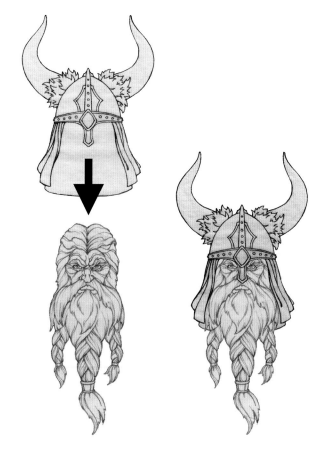

Tim's control art of Thor's removable helmet.

Helmets can come in all shapes and sizes, but you'll usually make them all the same way.

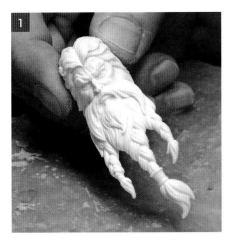

Take a resin casting of Thor's head.

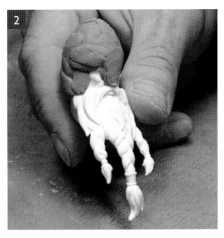

Add clay to the head in the rough shape of the helmet.

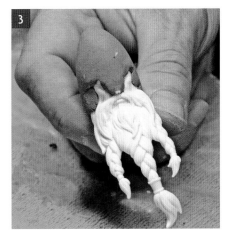

Shave down the clay until the resin starts to peek through.

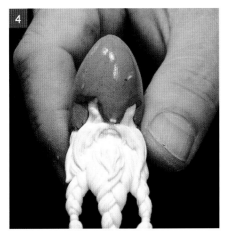

Smooth the clay with turpentine and spray with mold release.

Soften the wax sheet with a hair dryer and shape it around the front of the clay.

Cut off extra wax, leaving the front of the helmet.

Cut another piece of wax to create the back of the helmet.

Shape wax around the back of the head.

Cut out a V shape from the top of the helmet back.

Fold in flaps to finish the tip of the helmet.

Trim away the excess wax sheet.

Use scrap sheet wax and a wax pen to weld the front and back pieces together.

Use a loop tool to take down the seam of the helmet and make it level.

Use 220-grit sandpaper to smooth the helmet seam.

Trim the helmet to expose the eyes underneath. Do not overcut.

See how much higher you can cut the helmet, using small increments.

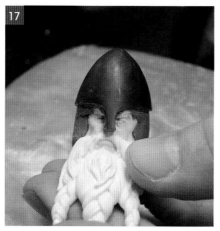

Finalize the helmet length and noseguard width.

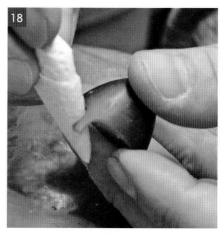

Use a turpentine-moistened paper towel to clean up the edge.

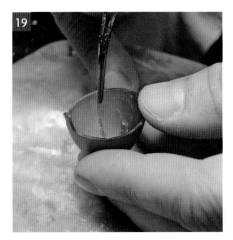

Carefully weld the inside seam where needed.

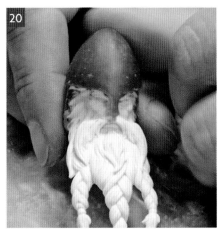

Make sure the helmet still fits on the head.

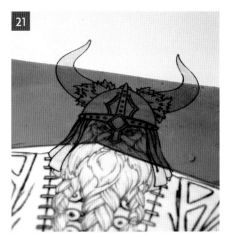

Lay the wax sheet over the artwork to create helmet decorations.

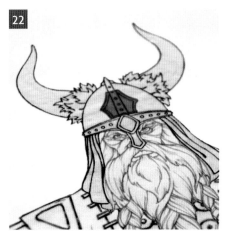

Cut out decorations.

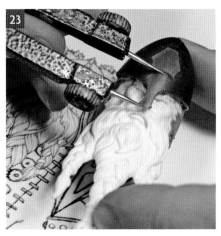

Use calipers to compare the helmet and the art and place decorations.

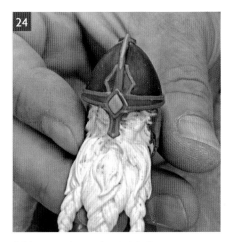

Add wax and wax sheet details.

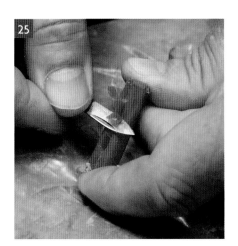

Shave down a ¼-inch piece of gating wax.

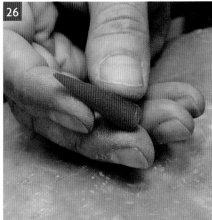

Sculpt the wax into a tapered horn shape.

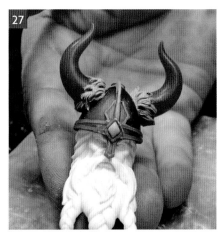

Curve the horn and add to the helmet with fur made by wax pen.

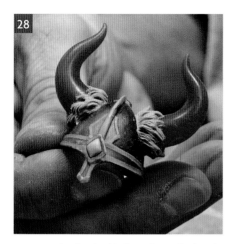

Remove the finished helmet from the head.

Add 24-gauge wax sheet for cloth. Curl the edges to allow for movement.

Create folds using the wax pen; keep moving so as not to melt through wax sheet.

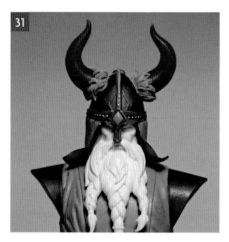

Check helmet with cloth on Thor's finished head and shoulders.

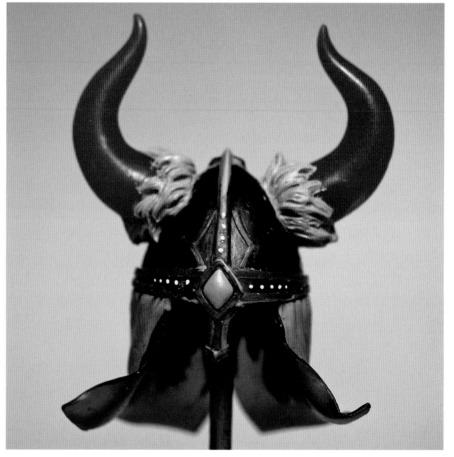

The finished helmet.

All Your Base Are Belong to Us

Not many action figures will come with a base as complicated and well designed (thanks to Rubén) as our Thor's. Generally, an action figure base is a simple display area, something on which the figure can be posed to help it remain vertical, given the tendency of PVC to slump over time. Be it simple or complicated, the figure has to fit the base, but since an action figure has to stand on his own first and foremost, we had to finalize the figure and make sure he stood freely before we could begin to work him into our base.

For a simple disk or architectural base, you'll need to transfer the foot pin position to the base. There are a few ways to do this. Cut a piece of scrap wax sheet to the shape of your base and press the pinned feet of the figure into the wax. Poke through the impressions the pins made. Make a marker dot and use this to drill the holes, using either a drill press or a hand drill-press guide. Plug the figure into the holes on the base to make sure everything is where it should be and, voilà! A base! You can also use a piece of paper and mark around the pins or dip the pins in a little water and wet-mark a piece of paper. Whichever method you use, make sure that the figure is correctly positioned on the base and the holes in the base and the pins in the feet line up.

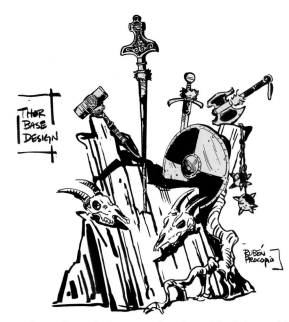

As much as we love Rubén's ingenious base design, it's a little too elaborate for an action figure accessory, not to mention being prohibitively expensive to mass-produce.

For a more environmental or thematic base, use the same method you did in positioning your Athena statue to her base (see page 153). Whether your base is sculpted in clay or wax, or a combination of both, you'll be able to press the feet of your pinned figure directly into the base and remove enough material from the base at the pin impressions for the feet to fit flush to the base. Usually, a pin that secures a figure to a base is about ¼ inch long.

Got to Gate You Into My Life

With the folds and details and intricacies of many of these accessories, gating them will be a challenge. But if you look at how we've set up the gates for each, you can see how we try to get the resin into (and the air out of) all the nooks and crannies.

After some messy molding and casting, your figure, base, and accessories are done. And they look great! True, we can't see them, but we feel it's important to be encouraging. So, wow, good job! Next step, paint!

The **RESIN** is heavier than the **AIR**, forcing the **AIR** out through the gates.

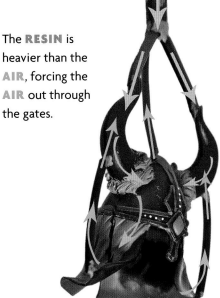

How the gates in Thor's helmet work.

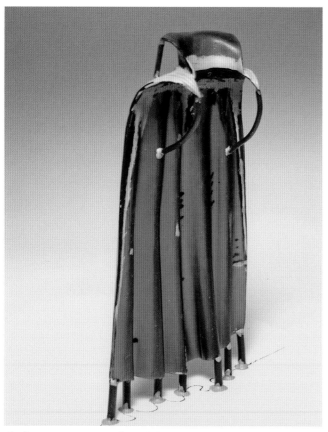

Thor's cape requires a gate for each fold, gates at the shoulders, and a couple of additional gates on the back collar.

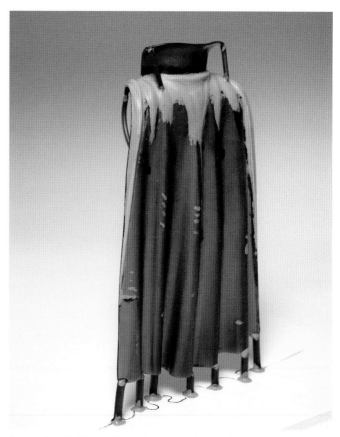

A back view, highlightng the collar gates. Note that they connect to two sculpted, raised folds.

The shield required only a simple gate.

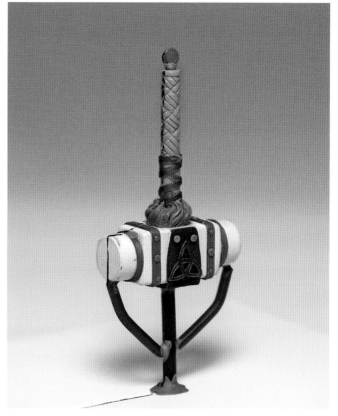

This is how we gated Thor's hammer.

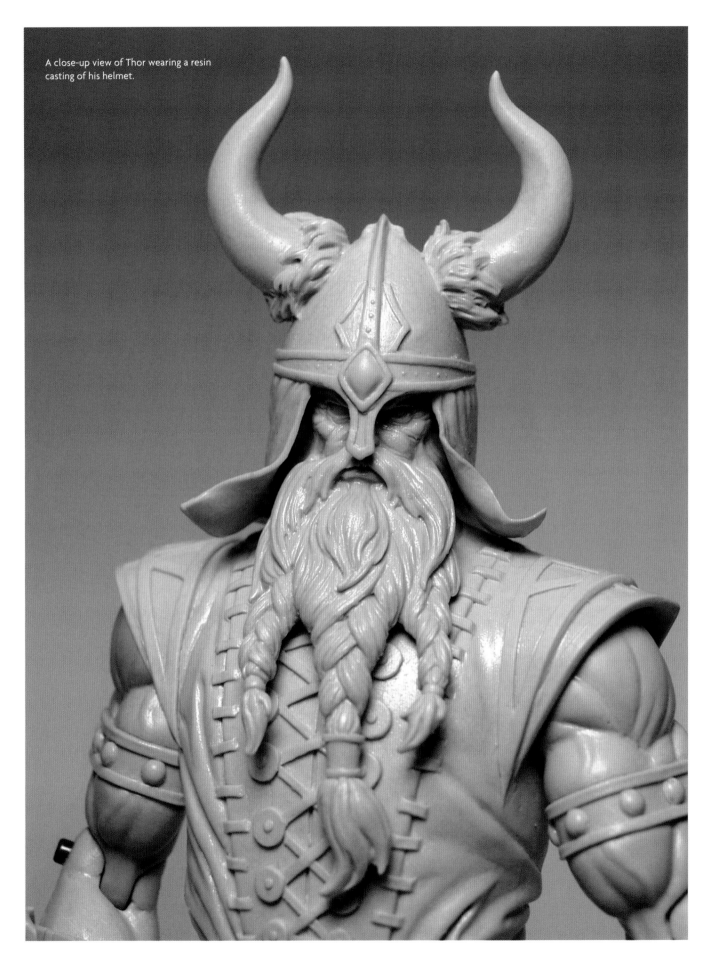

A close-up view of Thor wearing a resin casting of his helmet.

10. Painting

THE FINE ART OF APPLYING COLOR TO A THREE-DIMENSIONAL PORTRAIT

The application of paint can make or break a sculpture. A thoughtful, modulated paint job can save a piece that is poorly sculpted, by bringing out the best qualities of the piece and minimizing its weakness, but an overly aggressive paint job can ruin a perfectly good piece. So it pays to remember that a painter's job is to serve and complement the needs of the statue or action figure, not to showcase his or her abilities. Of course, you want to bring all your skill, talent, ability, judgment, and aesthetic to each and every job you undertake, but never should the paint overwhelm or compromise the integrity of the piece. Or, as master painter Kat Sapene would put it, "A good paint job is one that isn't seen."

A Place to Paint

Your painting area is the last stop on the journey from a rough clay to a finished statue or action figure. Create an environment that has ample light and space and promotes relaxation. A nice flat table is a good work surface and a couple of plastic stacked drawer units work for supplies. As with your sculpting area, you'll want all the things you use most frequently close at hand. If you can't be close to a ready source of water, a water cooler or a jug and basin will work just fine.

Your lighting setup will affect every aspect of how you paint. An environment where colors read true and shadows help define, not overwhelm, the piece is critical, so use a combination of natural ambient light and color-corrected or "daylight" lights in your space.

Professional prototype painter Kat Sapene in her studio. To make sure you get the best advice possible, Ms. Sapene has been kind enough to share a pro's perspective, giving us insight into her process, as well as teaching us some techniques that we'd probably just mess up.

All artificial light has its bias toward a certain color. The more you can reduce this effect, the more efficiently you'll be able to read and mix the color you want. Here's an easy way to gauge the effect of various light sources on color. Take a piece of bright red colored paper. Look at it in full daylight, then under a standard incandescent bulb; notice how the red now has an orange cast to it. Look at that same red under a standard fluorescent light and see how it's acquired a purple cast. Even daylight-corrected light sources will often hype up the red, or cool it down. A little trial and error will help you arrive at a fairly neutral lighting system that will work for you.

Consider light as it relates to shadows. Match the direction and intensity of the light under which you paint the piece to the one you used to sculpt it. That continuity will help you in working the paint to the figure in the way you intended during its creation. But be wary of a lighting setup that creates harsh and overly de-fined shadows that can obstruct important details. Take referenc-ing breaks throughout the paint job to look at it under different lighting conditions. A little perspective now and then is a mighty good thing.

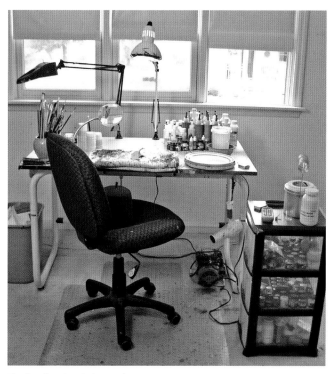

Tim Bruckner's painting workspace.

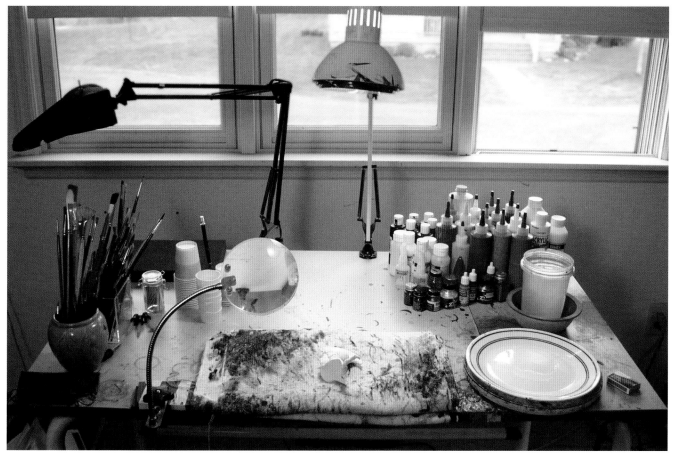

In addition to natural sunlight, Tim also has two lamps with bulbs that imitate natural light.

Good Color References

Matching specific colors is key and your first step will be to get as much color reference material as you can. Ask your client if there are specific Pantone Matching System (PMS) colors you should be using, and request that they send you color chips of those colors if they haven't already. If you are to choose your own PMS colors, give those PMS numbers to your clients, so they can forward them on to the factor.

2-D art is rife with visual effects like reflective surfaces and defined muscles, and it's difficult to decide how many of those visual effects to incorporate into your paint application. If you are a paint-for-hire, communicate with your AD, and if possible, the sculptor, to make sure your paint job delivers the colors, shadows, highlights, and other details they intended. As with your sculpting reference, a preponderance of evidence should point you in the right direction. Prepare color keys like these we created for Athena, Thor, and Thor's accessories.

PMS 721 — Flesh
CHROME — Armor
PMS 478 — Hair
PMS 2925 — Lance, Cloth
WHITE — Owl
PMS 7404 — Mount
PMS 293 — Spear Flame
PMS 270 (50%) — Cloud
BLACK — Costume

PMS 361C — Tunic
PMS 469 — Boot Soles, Belt Laces
PMS 428C — Boot Fur
PMS 2725C — Shoulders, Arm Bands, Glove Detail
PMS 3385C — Belt Jewel, Glove Detail
PMS 1595C — Shoulders, Belt, Boot Straps
PMS 4735C — Boots
PMS 872C — Arm Bands, Belt Buckle, Glove Backs
PMS 473C — Skin
PMS 877C — Knuckle Guards
PMS 130C — Tunic, Gloves
PMS 7417C — Hair

PMS 472C
Helmet, Beard Rings

PMS 2725C
Helmet Detail, Helmet Cloth

PMS 3385C
Helmet Jewel

PMS 473C
Skin

PMS 7417C
Hair, Beard

PMS 272C
Eyes

PMS 7500C
Horns

PMS 7522C (60%)
Lips

PMS 428C
Fur

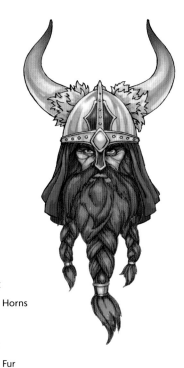

TIM IN A BOTTLE: THE GOOD KIND OF PMS

Often, your AD will give you a set of specific colors to use on a given character, and they can all be found in the Pantone Matching System. Developed in 1962, the Pantone system standardized colors so designers and art directors could precisely match colors at the production stage, regardless of the equipment used to reproduce them. The books aren't cheap, and Pantone recommends you buy a new set every year because the ink fades. However, the guide is also available as computer software, and is included in most versions of Photoshop.

The Pantone color guide.

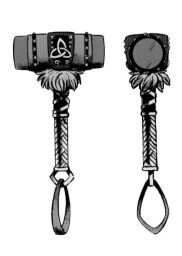

PMS 877C
Hammer, Rivets

PMS 7489C
Green Leather

PMS 1805C
Red Center

PMS 611C
Yellow Symbol, Handle

PMS 7539C
Shield Border, Rivets

PMS 360C
Green Dome

PMS 426C
Black Area

PMS 7510C
Leather Strap

PMS 794C
Yellow Area, Symbol

PMS 179C
Red Back

Prime Suspect: All About Primers

Before we get into the nitty-gritty of paint, we need to get into the nitty-gritty of primers. Resins need tooth—no, not that kind of tooth, tooth that allows paint to adhere to resin. See, resins are water-resistant, and they're kind of slick and cunning. If they can slide out from under a paint application, they will. So we need to overcome their resistance by dressing them up in a coat of primer. A primer creates a surface to which paint can stick and stay stuck; it's the glue that holds them together. Try painting onto an unprimed resin, and you'll see what we mean—the paint slips, slides and streaks, and it ends up looking like a finger painting.

Before you put primer to part, it's a good idea to assemble your figure to make sure everything still fits. It doesn't happen often, but resin, especially small, thin parts, can get a little wonky.

There's no shortage of brands and kinds of primer—nearly every surface that has ever been painted needs one. Stay clear of gray primers. They affect the way you gauge colors—especially in the first stages of a paint job, when you're setting up the color scheme you'll use on the entire piece.

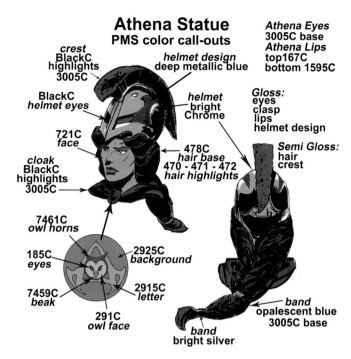

Athena Statue
PMS color call-outs

Athena Eyes
3005C base
Athena Lips
top167C
bottom 1595C

crest
BlackC
highlights
3005C

helmet design
deep metallic blue

BlackC
helmet eyes

helmet
bright
Chrome

Gloss:
eyes
clasp
lips
helmet design

721C
face

478C
hair base
470 - 471 - 472
hair highlights

Semi Gloss:
hair
crest

cloak
BlackC
highlights
3005C

7461C
owl horns

185C
eyes

2925C
background

7459C
beak

2915C
letter

291C
owl face

band
bright silver

band
opalescent blue
3005C base

Color key for Athena's head.

White primer is the way to go. But which white primer? Your choice will depend largely on what you're painting—in particular, the scale of the piece. If you're painting a large-scale figure, say life-size or larger, then an off-the-shelf spray primer like Krylon will work just fine. It takes longer to dry, but it's cheap and readily available. Spray paint is essentially airborne droplets of paint, which come in various size droplets. Krylon drops are on the larger side. A primer with a larger droplet pattern isn't likely to fill in or mask details in a large sculpt.

However, on small scale work, a larger droplet pattern does affect the surface detail and will add a dimension to the painted surface that is out of scale to the piece. Painting a 7–inch figure using a standard primer will read as a rough, blotchy surface under magnification, even if the resin underneath is as smooth as glass. So, use a primer with a very fine spray pattern specifically designed for small-scale work. Primers designed for use on miniature pewter game characters (found at hobby stores) will work great.

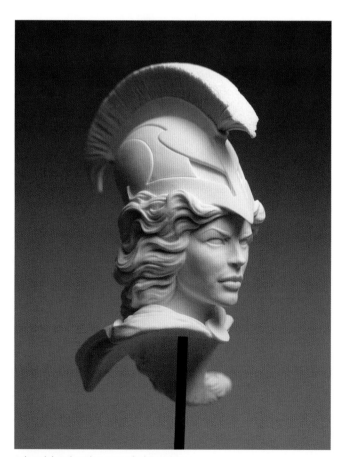

Athena's head, with a coat of white primer.

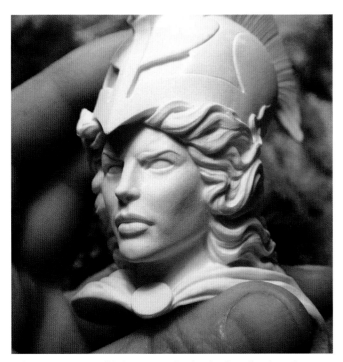

A fine-spray primer will help preserve the details of small-scale sculpts.

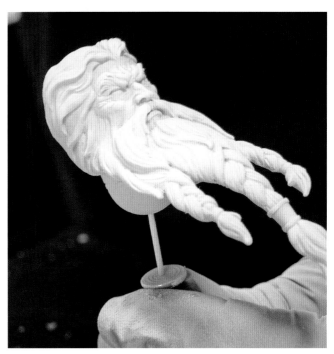

The pushpin method of primer application. Wear a mask and gloves when spraying.

How do you hold the part without having your fingers get in the way? Push a ⅝-inch steel-shaft pushpin, or its equivalent, into the resin to serve as a handle (see above right).

When you can't use the pushpin method, hold the part in your gloved hand and spray half the figure. When *both* your glove and the part are completely dry, turn it over and spray the other half, being careful not to overpaint the middle section.

Keep the Goldilocks Rule in mind while priming. Too light a coat, and there will be sections of the resin where the paint will bead. Too heavy a coat, and you'll soften details and cover up the very work you've worked so hard to create. Spray on just enough primer to cover the entire piece evenly. This doesn't mean that you need to prime until every nook and cranny is pure opaque white; a little shade of resin poking itself through the primer is fine. Luckily, most primers dry quickly and thoroughly enough to start painting in a relatively short time, but if you can let the primed piece set overnight, that's great.

KAT'S PAINT BOX: ONE PART AT A TIME

In general, keep parts separate when painting. While masking is sometimes necessary (more on this later), it's rarely perfect and is fairly time-consuming and tedious. So avoid assembling pieces you will later have to mask.

A Brush, With Destiny: All About Brushes

The most important tool for painting is the brush. Don't let the price of the brush determine its value to you. It's all about the *bristles* . Natural or artificial, what is important is how well they hold the paint and how well and reliably they put it where and how you want it. You'll need a variety of brush sizes, shapes, and firmnesses. Over time, you'll know which brushes work best for you, based on the technique you've developed.

Always use the largest brush you can for the job, even in small-scale areas like the face. Larger brush equals fewer strokes equals a cleaner, more even surface. Paint in the mass of the face with a larger brush, and then use a smaller brush to cut-in in those tight spots around the eyes.

Nothing will help your brushes last longer than a good cleaning. Even though most of the paints you'll use are water-based, a vigorous swish in clean water isn't enough. Paint remains deep in the bristle, especially near the *ferrule* (metal bristle-holder). Squirt a little grease-cutting dishwashing liquid into a jar of water and give your brushes a good scrub and swish to remove most of the trapped paint. (Kat recommends that if a brush gets particularly bad, soak it in denatured alcohol for a bit and then clean it with a brush cleaner.) Make sure to rinse all the brushes thoroughly, repoint and let them dry. When using metallic paints, have a separate water jar. The metallic bits in it don't dissolve; they get on your brush and spread their metallic ways to other parts of your paintwork.

KAT'S PAINT BOX: THE BIG BRUSH OFF

I tend to go for the middle-of-the-road ($2 to $7) brushes. I have been known to kill a brush in a week, so getting something expensive makes me a little nervous. I tend to have a couple extra brushes of my favorites on hand. I generally buy the brushes with white nylon bristles or the golden-colored bristles. Mostly, I am looking for a brush with a little spring to the bristles that will give me a smooth finish. But you will never buy a brush you won't use at some point. In fact, even when you think the brush is ruined, keep it. It can be used as a dry-brushing brush later, or just to shove some paint in a hard-to-reach area, or as a stir stick.

TOP: Kat's palette, or a geopolitical map of Europe? You be the judge!

LEFT: Tim's brush collection.

THE ELEMENT OF SUPPLIES:
ALL THE OTHER PAINTING STUFF
YOU'LL NEED

You're probably wondering what you should mix the paint in and what to use for a palette. What about varnishes and various fancy-pants finishes? One thing at a time, grasshopper.

We use 5 oz. waxed paper cups to mix our paint. We stack three and cut the cups in half with an X-Acto knife. By stacking and cutting in threes, we wind up with three cups of varying depths suited to the amount of paint we need to mix. For a palette, what we're after is a nonporous white surface—do not use plastic mixing trays as you might use for gouache or watercolor, or your paint will stick to it like a lawyer to an ambulance. We recommend a large, plain white dinner plate or a piece of white-backed tempered glass. Whatever you end up getting, to clean it, soak it overnight in water and the next morning all that dried paint will slide off with a little scrubby sponge, and your palette will be ready to be used again and again. (Or, be like Kat and never wash your palette—it looks more like a mountain range now, but whatever works for you!)

KAT'S PAINT BOX: BLOWOUT!

*Blow-dryers are great for drying paint, I've gone through more than a few in my time. This line of work is not easy on a blow-dryer; you'll drop it, you'll spill paint on it, and you'll use it in an area that is often dusty. But **do not** buy a cheap one. It will end up being more expensive in the not-so-long run because you'll have to replace it sooner.*

Kat brandishes a brush, a palette and the always-optional beret.

The Money of Color: All About Paint

Now, we have two words for you about paint: Cel-Vinyl. A long time ago, when the world was young, and animators roamed the earth, cartoons were drawn by hand. By artists. On paper. Those paper drawings were traced onto clear sheets of cellulous acetate or cellulous nitrate by inkers and then colored in on the reverse side by painters, using a syrupy, opaque vinyl paint called Cel-Vinyl. I know it sounds crazy, but it's true. And Cel-Vinyl is what you're going to use to paint your resin statues and action figures. Cel-Vinyl comes in a variety of colors at a price you can afford. That's right—not only is Cel-Vinyl a workhorse of a paint, it's inexpensive—and, you can get it fresh by ordering directly from Cartoon Colour Company, Inc. (800-523-3665). They make it when you order it so it hasn't been sitting on the shelf in some art store until all the pigment has settled to the bottom like a pair of cement shoes.

Bottles of Cel-Vinyl paint.

KAT'S PAINT BOX: THE LAST AIRBRUSHER

There is nothing that will ruin a piece faster than paint buildup, and airbrushing is a good way to minimize it. You get a solid, even color with just a few thin layers. Some colors will take a few more layers, but generally no more than four. Black gets solid coverage with one layer, but it is generally good to do a second layer so that it doesn't rub off with handling. Other colors like flesh tones may take three layers, particularly in the crevices—like the eyes, inside the ears, and around the mouth. If the nooks and crannies appear bright (where they should be casting a shadow) you need more paint there. So, carefully, go back and airbrush a little extra.

A cool effect that's great for painting creatures is figure eights. With a light-colored flesh tone on your figure, take a darker flesh tone, maybe one with a bit of magenta, ocher, or blue added to it, and start airbrushing small and large figure eights all over the figure. This breaks up the surface of the figure, giving a more realistic texture to the skin. I thin my paint with more alcohol than normal (30 percent paint, 70 percent alcohol) so that the paint is less opaque. It takes several layers and a variety of colors, but play around with this technique and you can come up with some interesting textures.

Look, up in the air! With a brush! It's Airbrushman!

Other paints—oil, acrylic, watercolors, gouache—won't do for you what Cel-Vinyl will do. Acrylic paint just doesn't cover and there's always that slight gumminess to it, no matter how long it dries. And oil paint is even worse—it can be really expensive, and it takes forever to dry. Watercolors and gouache have their uses, but their impermanence makes them impractical. Some of the paints you'll need to use won't be water-based. **Metallic paints** come in every conceivable color in a dazzling variety of finishes, from bright silver to cast iron. There are even metallic paints you can buff up with a soft cloth to bring out even more of the metallic effect. Many metallic paints are lacquer-based, and if you paint them directly on a primed part, the lacquer dissolves the primer and makes a mess of the resin, and you can kiss that nice, smooth metallic surface goodbye. So before you use metallics, give the part a coat of Cel-Vinyl, which will create a barrier between the metallic paint and the primer. There are also a wide variety of water-based metallic paints with which no barrier is needed; check your local hobby shop or the Web.

Like any paint, metallics can be mixed to expand their color range and uses. But apply metallic paints last; they often take longer to dry. Don't use a sealer or varnish over them unless you're after a particular dulled-metal effect.

MIXED MESSAGES: MIXING PAINT COLORS

To mix properly, you must learn the color chart and what colors combine to make other colors. Without going too deeply into the mysteries of color theory, we'll cover the basics. Here's a basic color wheel and a simple guide to mixing colors.

Mix one primary color (red, yellow, and blue) equally with one other primary color to form a secondary color (orange, green, and purple). Add a primary color to a secondary color to form a tertiary color (anything with a hyphen). Mix them all together? You get brown.

Mixing paint colors is a lot easier now than it used to be.

Cel-Vinyl comes in every color in the rainbow and then some, but you'll be able to mix up any color you'll need from these basic colors: Red, Vermilion, Flesh, Light Brown, Middle Blue, Blue, Green, Golden Yellow, Magenta, White, and Black (plenty of white and black). On the rare occasions you have to match a certain color and can't quite get there from what you have, go to the Cartoon Colours site, have a look at the color chart and see if there's something there that may help you get the job done.

The single biggest mistake beginning painters make is overmixing. You're happily mixing away, and the color starts to go somewhere other than where you intended. So, you add a little more of this, or a dollop more of that, and before you know it you've got enough weirdly brown paint to cover the garage. Here's how we avoid overmixing.

We lay out our colors around the perimeter of the plate, saving the center of the plate for mixing colors, and have a container of clean water right close by for rinsing brushes.

Adding white to a color will make it lighter, of course, but lightening it softens the intensity. If you want to lighten a color and keep the intensity, you need to mix color with color, using the color wheel as your mixing guide. Need a bright lime green? Have a look at the green, jump one to yellow, mix and voilà! Similarly, adding black doesn't just darken colors, it changes the tonal value. There really is no true black-black—most black colors have a tonal bias: some are blue-biased, some purple-biased. And adding black to darken colors also shifts the color toward the black's base bias. As Ms. Sapene once said, "Adding black does not a shadow make."

Tim's plate-palette, with his component colors around the outside edge.

Tim gets ready to mix up a batch of flesh-colored paint.

So how do you know which colors to add to make a **shadow color**? Have a look at the color wheel. Opposites attract and if you mix in a little of the color directly across the color wheel, you'll get the perfect shadow color. A little trepidation is a good thing; you can always go back later and add a little more to alter and shift the color you're after. But don't go back too many times, unless you're looking to paint the barn after you've finished painting your statue's shoes.

One of the most difficult colors to get right is **flesh**. Yes, Cel-Vinyl makes a Flesh color, but given the variety of tonal values among Caucasians alone, you're still going to need to mix the right shade. A simple formula to achieve your flesh color is to mix White, Flesh, and Light Brown. Start off with a dollop of White, mix in a little Flesh to arrive at the value (the light or dark) of the flesh tone and then add a little Light Brown to knock down the pink. If the tone you're after leans a little rosy,

add a very little bit of Vermilion; if it leans towards brown, add a little more Light Brown with just a hint of Green. The more you experiment with this basic formula, the more control you'll have when trying to achieve more subtle tones with the addition of other colors, like umbers and ochers. By adjusting this basic formula you'll be able to create an entire rainbow of flesh tones.

If a paint job runs into a couple of days, save the paint you've already mixed for use later. Use the smallest containers you can in relation to the amount of the paint you've mixed. A lot of paint, a large jar; a little paint, a little jar; little paint, large jar, lots of air add up to dry paint by morning. Keep the paint in a cool place, preferably a refrigerator. To clean glass jars, soak the jar in water and the paint will peel out cleanly, for the most part. With plastic containers, after a while, the paint will get stubborn and not want to leave home so readily.

Because they're color-wheel opposites, adding a little red-purple to your yellow-green gives you the perfect shadow color for yellow-green. Adding black would just give you a darker green, which isn't the same thing.

Paint Misbehavin': Time to Paint

Right out of the bottle, Cel-Vinyl is kind of like pancake batter, but a lot more colorful. When painting a figure, it's the surface we're creating that matters, and undiluted paint leads to an uneven surface. So, no undiluted, right-out-of-the-bottle paint for us. We're going to need to dilute the paint a little so we can apply it in washes.

Learning when your paint is too diluted and when it's not diluted enough (some colors don't need to be as diluted as others), and how many coats of a diluted color you need to apply, will come with experience and it won't take long. Black and Middle Blue are good for one, maybe two coats. The most troublesome are the reds, which need several coats to build up an even opac-

Note: Paint from light to dark. It's easier to paint over a light color with a dark color, and it also gives you a little more control over the paint's traveling. It's also sometimes wise to wear a rubber glove on your holding hand, which will cut down on the traveling considerably. But if you're mindful of what you're touching and where, this isn't much of a problem.

Cel-Vinyl travels. It hitches a ride on your fingertips and travels to various parts of your figure as you work, depositing the previous color on the color you're painting now. Some colors have more wanderlust then others: Blue and Black almost can't stay put, and reds aren't much better. There's no fix but to paint over it, and that's a drag.

LEFT: Two undiluted coats of Cel-Vinyl creates a streaky and globby surface. RIGHT: Three thin coats of water-diluted Cel-Vinyl creates a smooth and uniform surface.

ity. And even though you're painting on a primed white surface, White Cel-Vinyl will need a few extra coats to get the surface you're after. Some colors, like the yellows, will go on with just one coat, depending how dense you want the color. It's going to be a little trial-and-error. We recommend that you dilute your paint on your palette as you paint. Take a dollop or two of paint, put it on your palette, and then bring a brushload of water to the paint and mix until you have the right consistency. You'll use a lot of watercolor technique in this process, so if you've done a little watercoloring, the learning curve is lessened.

Don't use Cel-Vinyl right out of the bottle; first, dilute it to create a wash.

FACE TIME: TIME TO PAINT THE FACE

Do the most challenging and most difficult parts first. They'll always take longer than you'd planned. And there's no more difficult part of your paint job than the face.

The eyes must clearly reveal the specific point in space where the character is directing their gaze, so use your references for iris placement. The size of the pupil can indicate character. A larger pupil can denote innocence and openness; a small one menace or closed character. The trick is to get them in the same place in both eyes.

Before you paint the eyes, prepare your paint colors. Use true white for the whites of the eyes, except on ⅙- or larger-scale pieces, when you'll add a touch of gray or grayed-yellow to more closely match the human eye. For the iris, mix three shades of your iris color. (Our Athena's are blue, but these principles will work for all eye colors.) We used Middle Blue (first color) for the darkest parts: the ring around the iris and the shadow under the upper lid. For the second color, add a little White to that Middle Blue, enough to lighten it by several shades (second color), and then add more White to the second color for your third color, which we'll use for refracted light. Use gray and White for highlights.

Just as you did in sculpting the eye, paint the eye opposite your dominant hand first.

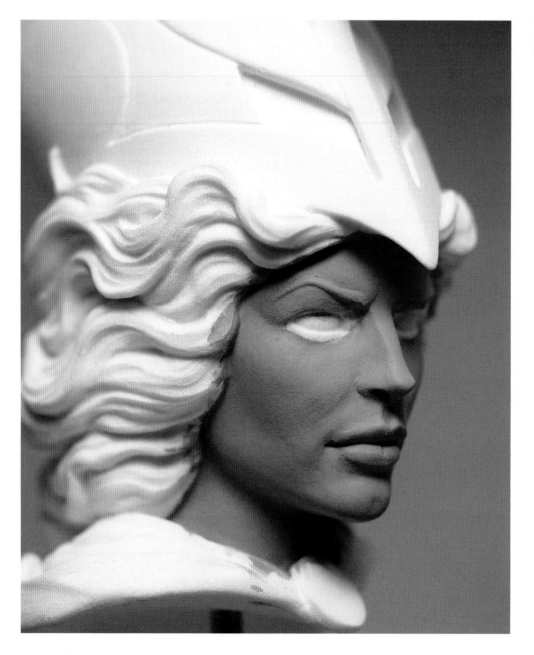

When painting Athena's face flesh-colored, do not get any paint near the eyeball.

TEN STEPS TO PERFECT EYES

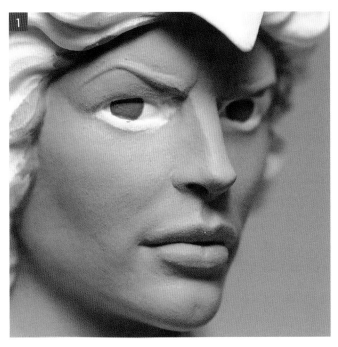

Lightly outline the iris placement in pencil (careful not to scratch resin), then paint in the iris using the first (Middle Blue) color.

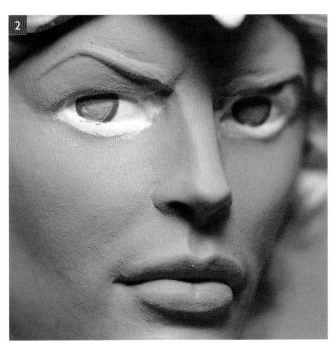

Paint the second color inside the first color, leaving a dark ring around the perimeter and a shadow line across the top, under the eyelid. Then paint in the pupil with Black (not shown).

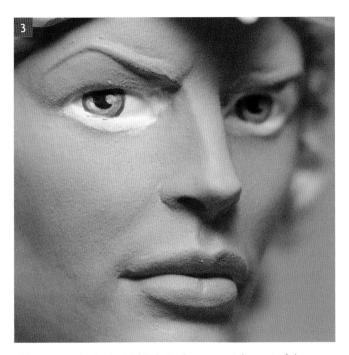

Using gray, paint in the highlight in the upper right part of the eye, under the eyelid. Add the third color opposite the gray highlight as refracted light.

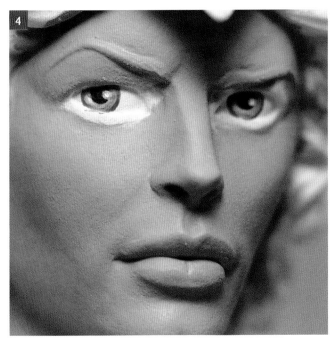

Add a little White to the center of the gray highlight.

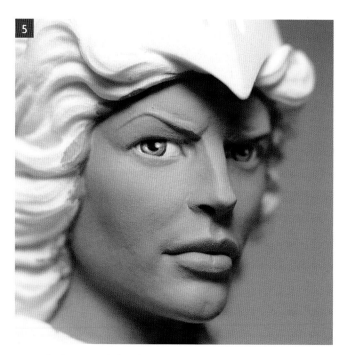

Paint the lower eyelid with your flesh color.

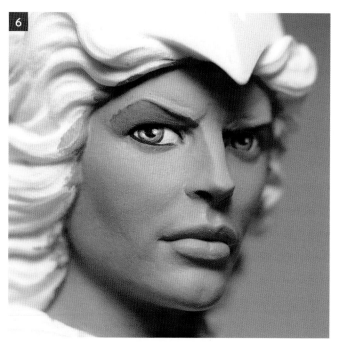

Using Black, paint eyeliner on the upper and lower lids.

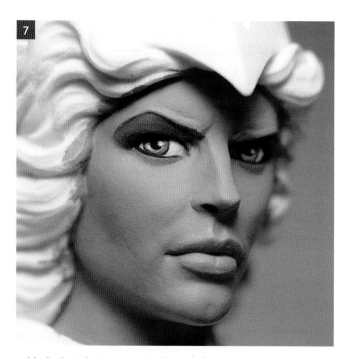

Add a little Light Brown to the flesh color; apply as eye shadow to the upper lid and underneath the eyebrow.

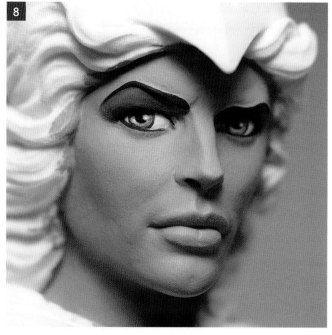

Paint in the eyebrow.

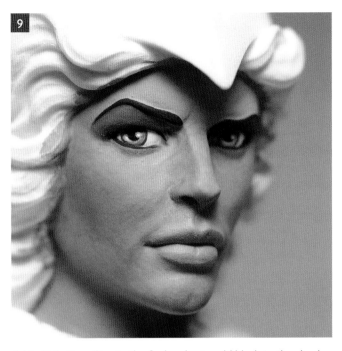

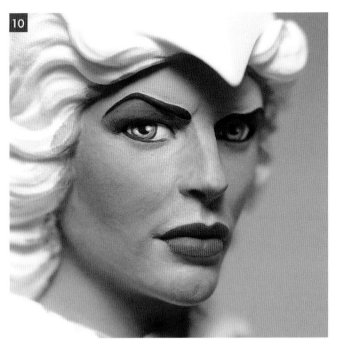

Add a little Vermilion to the flesh color to add blush to the cheeks.

Apply lip color.

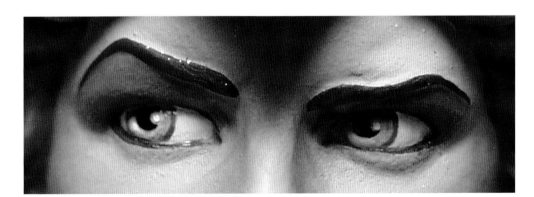

The iris on the right is set too deep in the corner, creating a cross-eyed look, even though the eyes are centered.

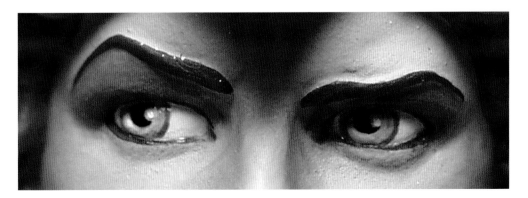

Pulling the iris out a little bit makes it seem more balanced because more of the white of the eye is visible.

EXTRA-SPECIAL PAINT EFFECTS

Drybrushing is the technique of using a dry brush to "scrub" paint across the raised surface of your statue or figure. Want to give that rocky outcropping a weathered effect? Want to bring out the folds and forms of fabric? How about hair highlights or wrinkles on an old, weathered mariner? The answer, my friend, is not blowing in the wind—it's drybrushing. To drybrush, dip the tip of the brush into nondiluted paint and wipe off the excess. A drybrushing color is usually several shades lighter than the base or foundation color and is applied across the *raised points* of your sculpt. You can also use several shades of the color, one over the other, to create even greater depth or alternate colors to create lighting effects, bruises or blushes. Just be aware that you're adding undiluted paint, so watch for buildup.

Kat and her brush collection. (Not to scale.)

▶ Painting Hair

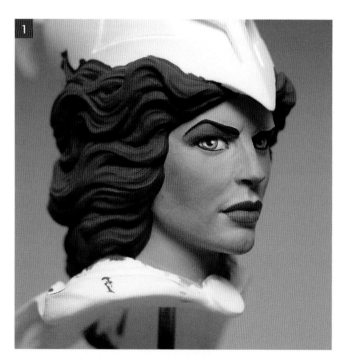

Wash on several layers of a basic hair color several shades darker than the final tone you're after.

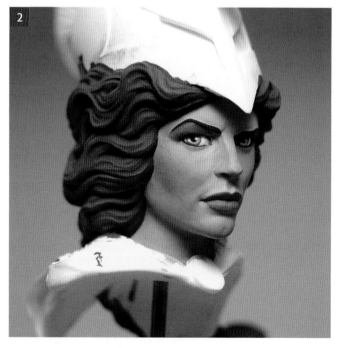

Using your base (basic) color, lighten it a shade and drybrush across the structure of the hair.

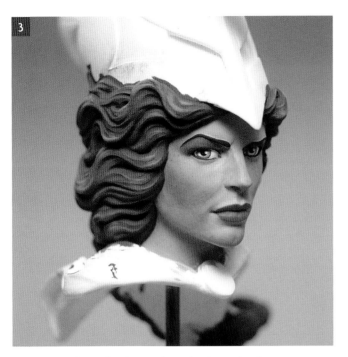

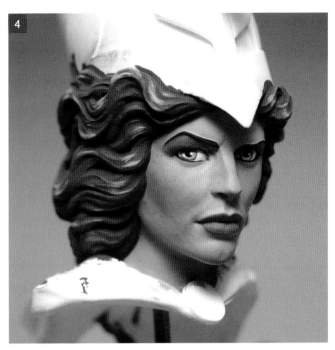

Lighten your drybrush color another value (use only white paint to lighten value). Look at the hair and identify the broader high points of the hair structure. Using a brush, apply (do not drybrush) the color following the contours of the hair.

Lighten (and richen) your painted highlight color once again. Select the very highest points of the hair structure and, using a brush, apply the last set of highlights.

▶ Drybrushing Collar and Crest

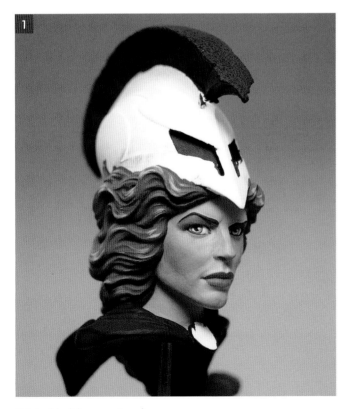

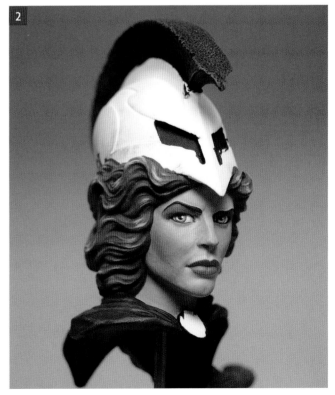

Paint a black base coat as shown.

Drybrush blue over the black base to give the impression of light hitting the folds of the cape and the individual bristles of the crest.

Washes are pretty much the opposite of drybrushing. Instead of painting the raised points on a piece, you're painting the *cracks and crevices*. Once your paint is dry, take a wet, loaded brush full of a diluted darker color and paint over the places where you'd like the recesses to be darker. Then drag a clean, slightly damp rag over the area, removing all of the darker paint from the high points. It's a useful technique for bringing out the details of a sculpt, like links of chain mail or cracks in a stone.

Opalescent or interference paints are used when you want to create that shimmering, iridescent look. There are a couple of ways to do this. Pearlescent makes a series of iridescent acrylic inks that come in a variety of colors and can be mixed to create additional colors. You'll need several thin coats to build up the full effect, and crosshatching your brushstrokes helps alleviate brush marks. The effect is pretty dazzling. The other method is to use a base, clear Cel-Vinyl or a semigloss or gloss varnish, and dry pearl powders. You have a greater range of colors using this method and more flexibility in overlaying. It does require a little more work and experience, but it's well worth the time and effort.

An example of using the wash technique to define and deepen Quasimodo's facial structure.

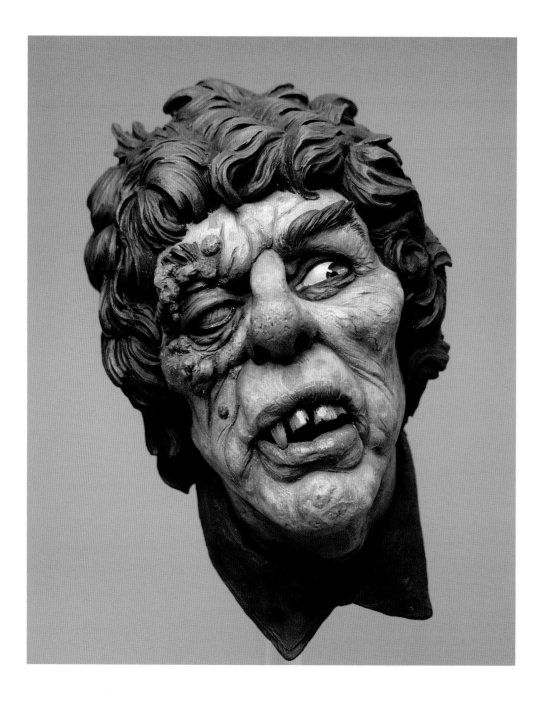

KAT'S PAINT BOX: ASHES TO ASHES,
RUST TO RUST

If you ever need to paint rusty iron, mix a base color of Black and Raw Umber. Put a thin wash of Burnt Sienna over the whole thing, dabbing some off with a dry paper towel. Then, using Sunflesh, add some touches of rust around joints and things like that. And if you need a little extra oxidized rust, just stipple a little ocher over the areas you used Sunflesh on. You can't tell it's not iron. This is one of the few times I will use colors straight out of the bottle.

Believe it or not, this is a toy diorama and not an actual rusty alleyway. Painted by Kat Sapene.

The Varnishing

Cel-Vinyl is a super-flat paint. But the great thing about it being flat is that it takes varnishes well, allowing you to break up the flatness, creating various textures.

Before applying any varnishes—but after you've finished your paint job—seal the paint. We recommend using Testors Model Master Lusterless (Flat) spray. When dry, it seals your paint without affecting the color, as some other flat sealants can do (be sure to test those on a trial piece). Krylon's Matte Spray is a heavier sealer and leaves behind a light sheen.

Warning: Beware of magenta! If you use magenta in a paint mix, especially a wash, be aware that the sealer—virtually any sealer—will bring it to the surface and "magenta up" the color. We don't know why it happens, it just does. So, if you've added a little magenta to a red or yellow or what-have-you, seal with a very light coat, layering the spray to prevent the magenta from busting out.

There are three basic types of varnishes to have on hand: high-gloss, semigloss, and matte. A number of companies make them; Golden and Liquitex are a couple of the most common brands. They're acrylic-based and water-soluble. High-gloss is great for eyes, lips, shoes, anything that needs a glossy, highly reflective finish. Semigloss works well on costume detail, or slightly diluted on hair or leatherlike finishes. Matte will be for those places on your figure where you just want an additional faint sheen. By experimenting, you'll break up the surface with various textures, adding more life to your sculpture.

CHROME ON THE RANGE: ATHENA'S SHIELD AND HELMET

In order to apply the chrome effect to Athena's armor and shield, you need to do a little masking. Use drafting tape, which is less sticky than most and less likely to peel the paint off when removed. Taking more of the tackiness off the tape can't hurt. "I always stick the tape to my arm before applying it to a piece," says Kat. "Sticking the tape to clothing, while less painful, will leave little hairs and fibers on the tape, making the edges of the tape less smooth."

▶ The Helmet

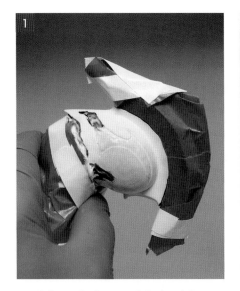
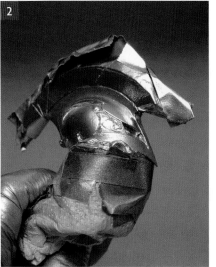

Carefully mask all parts of the head that are not helmet. (You may need stronger tape to secure the masking tape.) Trim the edges.

Spray light coats of Rust-Oleum Bright Coat Metallic Finish. Brush the painted cut out design with Model Color Gunmetal Blue.

Athena's helmet required extensive masking in order to apply the chrome finish, but as you can see, the end result is worth it.

▶ The Shield

Using tape widths from ⅛ inch to 2 inches, mask off the lens on both sides of the shield (as shown). Trim the edges using your fingernail and an X-Acto knife. Spray light coats of Rust-Oleum Bright Coat Metallic Finish to both sides.

Remove masking. Next, spray a "wet coat" on the lens section (front and back) with a high-gloss lacquer varnish, using a masked circle template to protect the chrome paint. (Do not apply a clear-coat varnish on top of a metallic paint; it will almost certainly alter the look of the finish.)

When the lens and chrome are dry, paint a border on the back in a blue that matches the shield art.

On the shield front, paint a thin black border around the blue border to frame the shield art.

Print the shield art to size, cut it out and position it (facing out) on the back of the shield behind the lens. Add the backing plate to hold it in place.

KAT'S PAINT BOX:
WHAT WAS THAT MASKED MAN?

*For areas too small to mask with tape, there's liquid latex—**not** the liquid latex that's sold in the drafting area of your art store; that stuff is too watery. The stuff I buy (made by Laguna) is thick and generally found in the pottery section of the art store. It's ammonia-based, but it can be thinned with water. I use toothpicks and clay smoothers to apply the latex to a piece—do **not** use a brush unless you're looking to ruin it. And don't be skimpy when applying the latex; you need a good coat of latex on there so that it doesn't rub off while you're handling the piece. The latex can be blow-dried in a few minutes and dries clear; you can peel it off with the same toothpick you used to apply it. Generally, the latex doesn't affect the paint it covers, but there are a few exceptions to this rule. To avoid any mishaps, matte-finish the area that you will be covering with latex.*

KEEP IT SIMPLE, SCULPTOR

There's a distinction between the hobbyist who paint kits and figures for the pleasure of bringing a resin to life and the professional painter. This isn't to say that there aren't great painters among hobbyists—there are, and a perusal through the various resin kit magazines will prove it. The difference is less about skill and more about intent. A kit painter will indulge their passion for the hobby with a whole slew of applications: underpainting, over-painting, glazes, washes, varnishes… It's their passion for paint that drives them toward paint applications that become one-of-a-kind showpieces. On the other hand, a professional painter has to carefully consider what is *reasonably reproducible*. Not that pros dumb down their paint jobs, but they are careful not to produce a paint application that's too "smart" for the room, especially considering that that room is in a factory in China.

SCULP-TOR SEZ:
OOPS, I NEED TO
DO IT AGAIN

Despite your hard work, diligence and best intentions, your paint job has turned to crap. It happens. Time to suck it up and start over. An easy way to get that pesky paint off is to soak the part in a bag of isopropyl alcohol. Freezer bags work best, because they're more heavy-duty. Put your part in a freezer bag, pour in enough alcohol to cover it and go do something productive. A little while later, you'll be able to use a soft-bristle toothbrush to scrub off nearly every bit of paint. You might need to use a toothpick here and there to get out deeper accumulations. When clean, give the piece a good wash with dish soap, rinse and you're ready to go again. And a cool thing about it is that it doesn't mess with the primer. It may be stained—actually, it will be stained—but it'll be in good enough shape to paint right over.

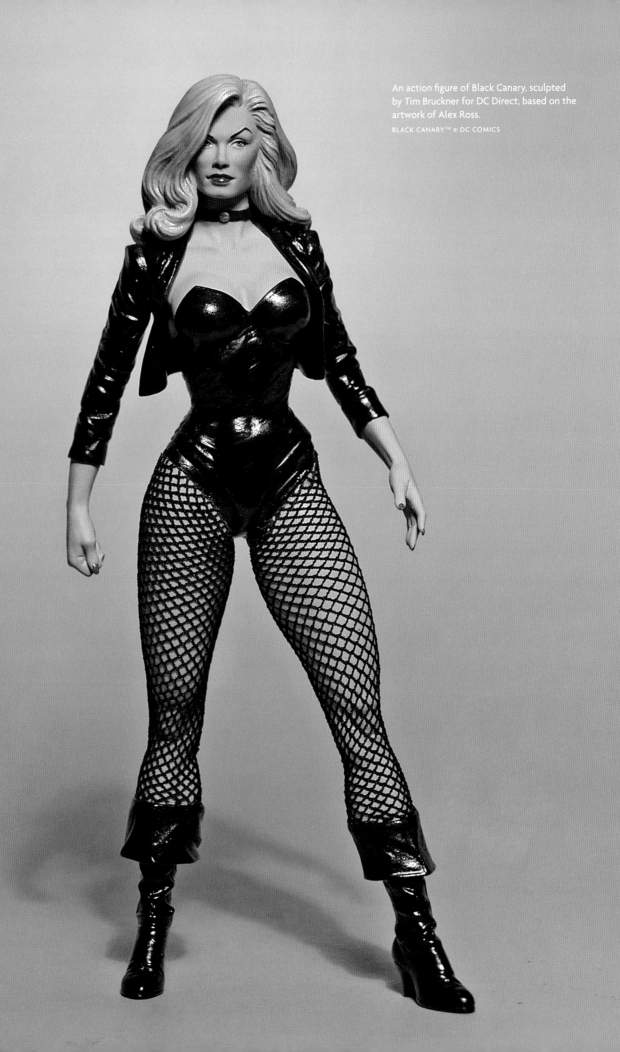

An action figure of Black Canary, sculpted by Tim Bruckner for DC Direct, based on the artwork of Alex Ross.

BLACK CANARY™ © DC COMICS

Asgardians (and Olympians), Assemble!

After all your painting work is done, it's time to put your parts together. Superglue, or one of the various Mercury Adhesives, is about the only way to go for assembling Athena, but caution is the key. First, remove whatever primer or paint managed to sneak its ways onto the glue points. Why? Because, you must glue resin to resin. If you don't clean the parts down to bare resin, you're gluing paint to resin, or paint to paint. Sooner or later, that paint is going to get tired of sticking around and could just as easily separate at the join as not. We'd rather it not, so a little extra care will help their union survive into old age, yours and theirs. Take a cotton swab and twist the fuzzy tip in the direction of the wrap to tighten the tip and prevent any rebellious strands from wreaking havoc on our paint job. Then, dip the tip into a little acetone—a *little* acetone—to dampen the tip, not to soak it. And, very gently, remove the excess overspray or errant paint.

An extra word or two about glue viscosity: Mercury Adhesives come in a few viscosities: thin, medium, and thick. Generally, medium is the way to go. There are times when you'll want a thinner, more watery glue or a more gellike glue. Use extra caution when using either, but more so with the thin glues. When they say thin, they're not a-kiddin'. You'll be gluing your statue's head to her body, and, before you know it, you've glued your thumb to her back. And that doesn't conjure up a very pretty picture. And speaking of pictures, here comes our next chapter: Photography.

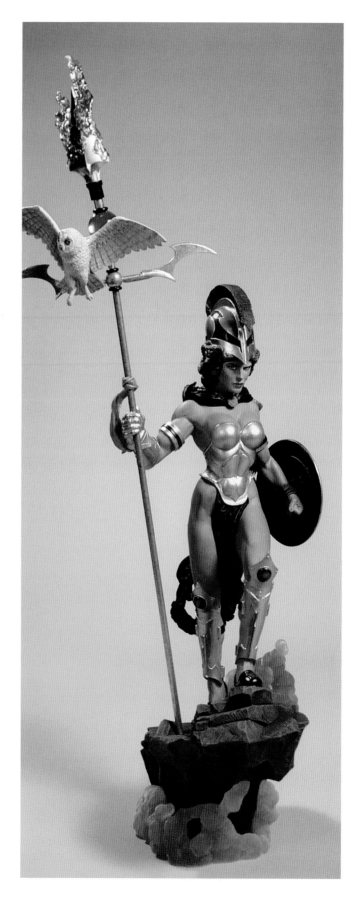

RIGHT: Our finished, painted Athena. OPPOSITE PAGE: Our finished, painted Thor.

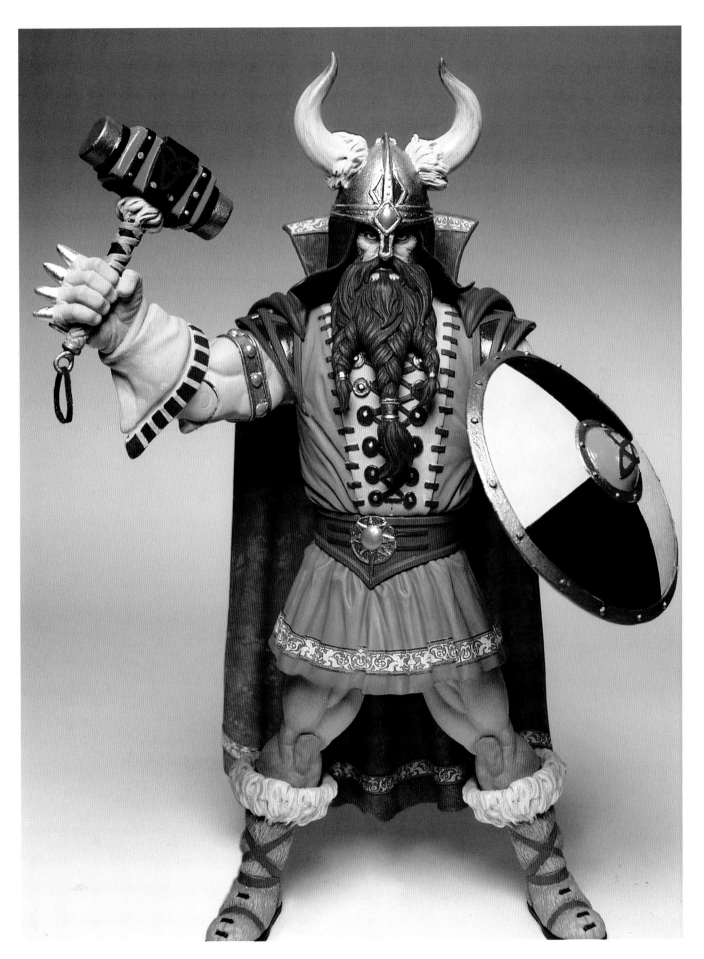

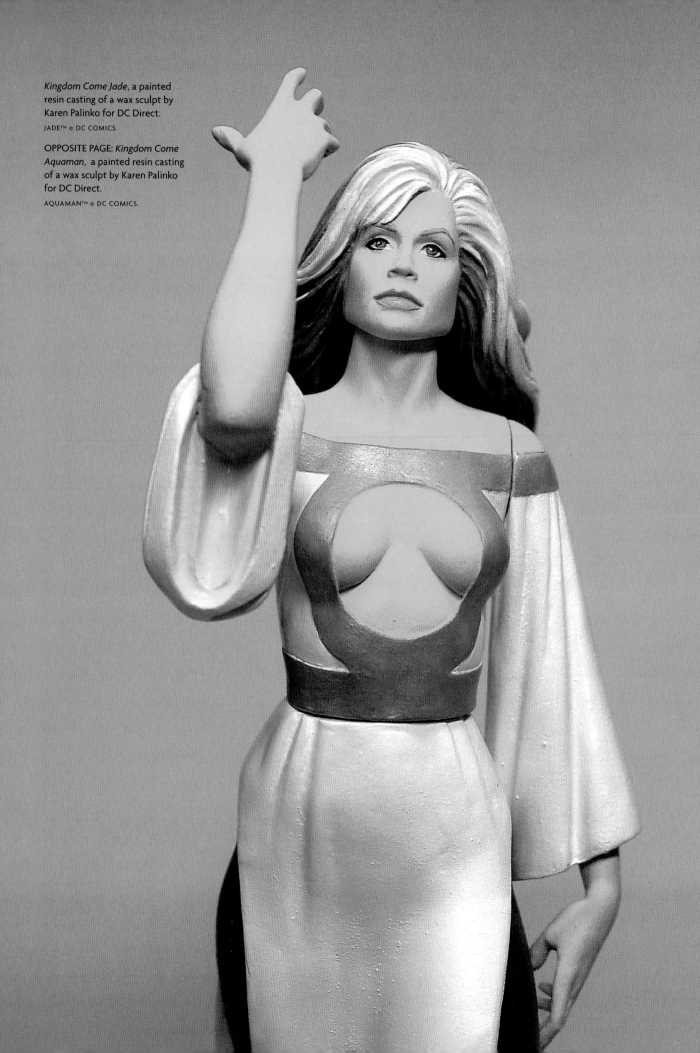

Kingdom Come Jade, a painted resin casting of a wax sculpt by Karen Palinko for DC Direct.

JADE™ ® DC COMICS.

OPPOSITE PAGE: *Kingdom Come Aquaman*, a painted resin casting of a wax sculpt by Karen Palinko for DC Direct.

AQUAMAN™ ® DC COMICS.

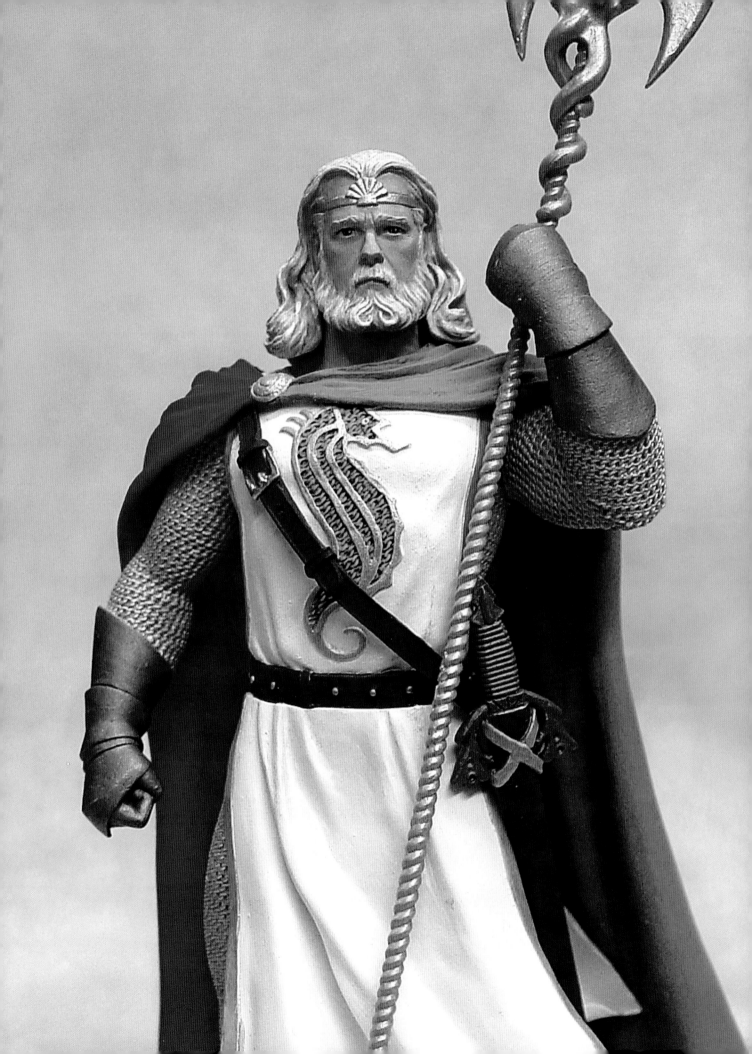

11. Photography

HOW TO TAKE PICTURES OF YOUR WORK
AND MAKE IT LOOK AWESOME

One of the great ironies of being a sculptor is that, after you've toiled, and sweat, and shed
a few tears and—if you're accident prone—a little blood to create a work of sculpture that
lives and breathes in the glorious realm of three dimensions, your work will then be squeezed,
reduced, compressed, and flattened into a two-dimensional image in order to be seen by 90
percent of the public, be it online, via e-mail, or in a magazine. It's kind of like listening to
Beethoven's Fifth Symphony as played by a kazoo band, but that's the reality. And since there
isn't a whole lot you can do about it, you had better get good at creating quality 2-D images
of your work that represent your work the way you want it to be represented.

A photo of a 3-D sculpture is like the music of
Beethoven played on the kazoo; beautiful, but a
shadow of its full majesty.

What You'll Need

The most important thing you need to take good photos is a decent **digital camera**—ideally a **high-megapixel single-lens-reflex (SLR) camera with a macro lens**. Most cameras have a macro or close-up setting, so be sure to read the manual that came with yours.

Aside from your camera, here are a few things to have on hand. Neutral, light gray **seamless paper**; standard size is 6 feet wide by 36 feet long and costs $30. A sturdy **tripod** is a must; nothing fancy, something in the low to moderate price range will do you. Pick up three telescoping **boom microphone stands**, the ones that sell for about $20 a pop. For a light, get a shielded, **ceramic-socket, clip-on light** (ceramic socket because heat from the bulb would melt a regular plastic socket, unless you use a color-corrected fluorescent bulb).

Digital photography works with a variety of light sources. Tim uses a 300- or 500-watt **incandescent photo lightbulb** for most of his shots. They are inexpensive but hot, Beelzebub hot. **Daylight-balanced fluorescent lights** are cool and give more even light than incandescents, but they are expensive and require bulbs twice the size of incandescents for the same amount of light.

A **light diffuser** diffuses or softens the light projected through it, eliminating harsh shadows and hot spots. (Even the newer fluorescents produce hot spots, and standard incandescents create hot spots only a celestial sun could love.) It's also handy to have a **reflecting card**, which is simply a piece of white or metallic cardboard that bounces light from your setup into those hard-to-reach places.

If you computer doesn't have a **card reader** to read the memory card from your camera, you may want to pick one up. They run about $20 to $30 and allow you to more easily view and download your images than directly from your camera.

A collapsible light diffuser folds into a zippered case, is easy to use, and is very durable.

A high megapixel SLR digital camera with a macro lens, the best lens for shooting small objects, especially close-up detail shots.

From left to right: An incandescent photo bulb, a daylight-balanced incandescent photo bulb, and a daylight-balanced fluorescent bulb.

Imaging software is also a must and there are many choices. Tim uses Photoshop Elements 5, but as of the writing of this book, there are already versions 7 and 8. All of them are designed for image correction and enhancement and are easy to use, but whichever one you choose, it's a good idea to pick up a supplemental manual to learn just what you need to do to get the results you're after.

For fill or backlight, get a **clip-on light**—the small, inexpensive kind you can pick up at the hardware store—and a couple of 60-watt mini-spotlights. Add a couple of pieces of **printer paper** (taped together to use as **shadow paper**), some **masking tape**, a **power strip** or **multisocket extension cord** and you're good to go.

Shooting Gallery: Your Photography Station

We highly recommend that you set up a permanent photography station. You don't need space beyond a table up against a wall, away from natural or competing light sources.

Cut the gray seamless paper into a sheet about 3½ to 4 feet wide by 5 to 6 feet long—big enough to provide full background and foreground coverage for figures in a variety of sizes—and mount it. Bend the seamless from the wall to the tabletop in a nice, gentle curve. The more shallow the curve, the less shadow there'll be in the transition from vertical to horizontal.

For the rest of your shooting space setup, refer to the diagram below. There are three boom stands between camera and subject: the first holds the light, which must be very securely attached with clips and duct tape. Next, is the diffuser, which is secured with spring clips. Closest to subject is shadow paper, which can be extended as needed with a dowel or yardstick. Experiment with angles and placement and remember that lights can get *extremely* hot, easily burning diffusers.

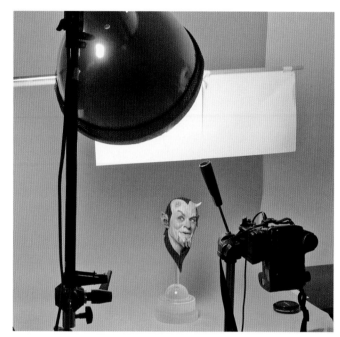

Tim uses shadow paper to create a soft, graduated shadow against the seamless, adjusting the card's placement to make the shadow darker, lighter, longer, or shorter.

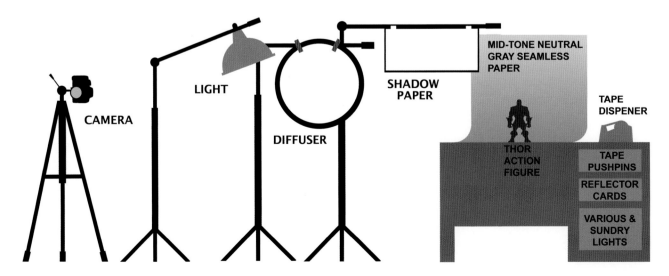

THE DOS AND DON'TS OF LIGHTING YOUR FIGURE FOR PHOTOGRAPHY

Sculpture is defined by its relationship to light and shadow, and bad lighting can make the best work look like a train wreck. Trust your camera's automatic setting for exposure until you have a firm understanding of how to set up a manual shot. But you'll have to manually adjust the auto white balance to reflect the color you see through the viewfinder. It's usually no more than a click one way or the other, but it can really change the color of things.

Don't underlight. With digital photography you don't need a big, elaborate lighting setup. Most digital cameras will adjust their exposure level to match most types of lighting. Look through your camera manual and figure out how to work with the light you have **(1)**.

Don't overlight. Almost as bad as a picture that looks like it was taken in a cave is the one that looks like it was taken on the surface of the sun. Nothing flattens out a sculpture more thoroughly than overlighting **(2)**.

Easy on the contrast. When the shadows are too deep and the highlights too bright, all the subtle modeling and contouring you worked so hard to create gets left behind, and your sculpture ends up looking like a wanted poster **(3)**.

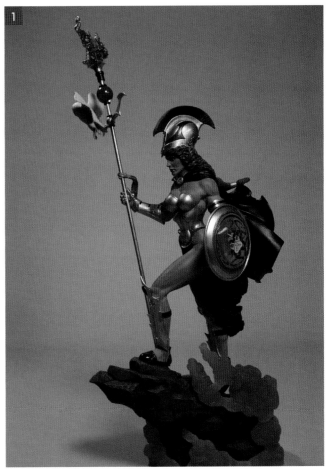

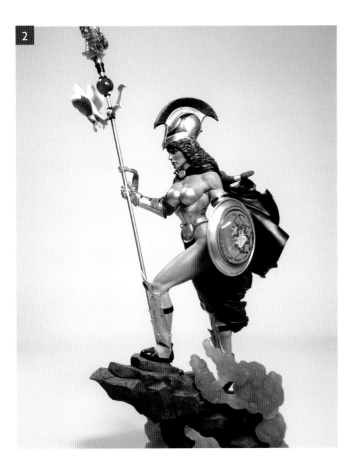

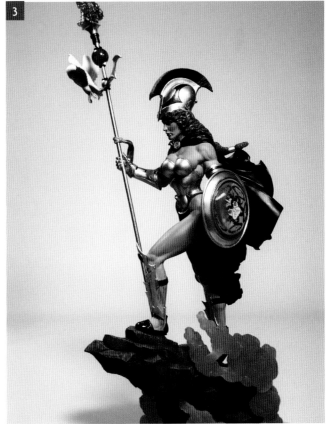

Take the Shot!

The image on the preview screen looks good. Take a couple of tests shots. Check it on your computer. When it looks good on the monitor, you're good to go!

THE EIGHT-POINT TURN

Your art director may have his or her own procedures, but the standard format for submitting reference photography of a sculpture is an eight-point turn. Ideally, one of these shots should show the "sweet" angle (a.k.a the money shot).

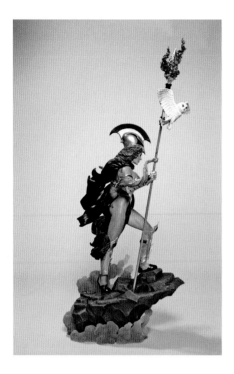
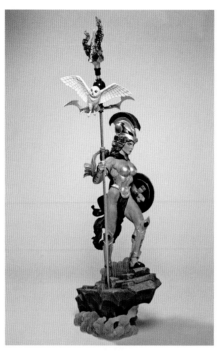
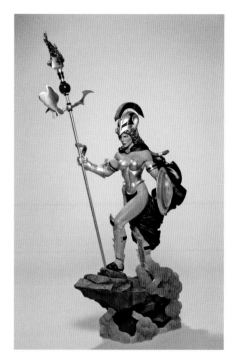
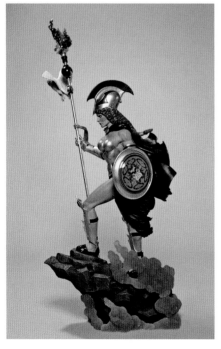
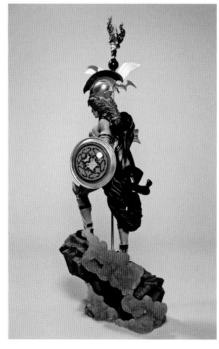
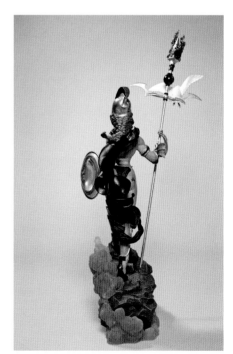

KNOW WHEN TO HOLD 'EM: DETAIL SHOTS FOR YOU AND YOUR A.D.

Once you've got your standard eight-point turn out of the way, take details, angles, shots with mood lighting, diagonals, long shots, medium shots, close-ups, poses, shots with accessories on, shots with accessories off. This may be the last chance you have to make a photographic record of your work, so indulge yourself. And if your AD wants more images, you've got them.

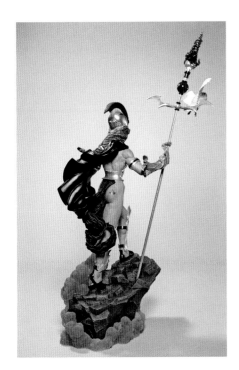

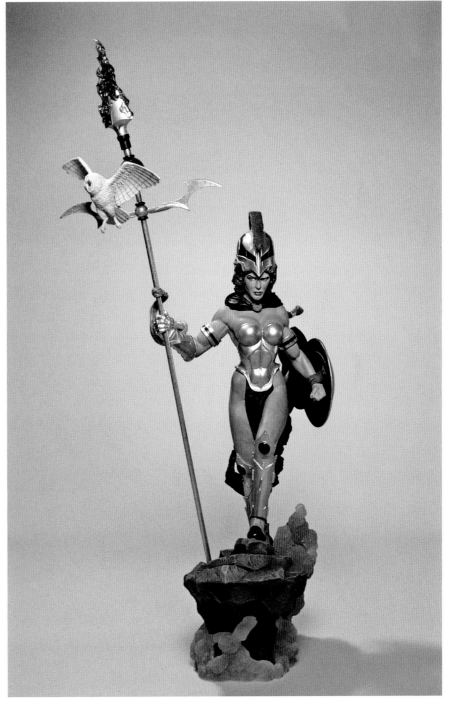

The Money Shot

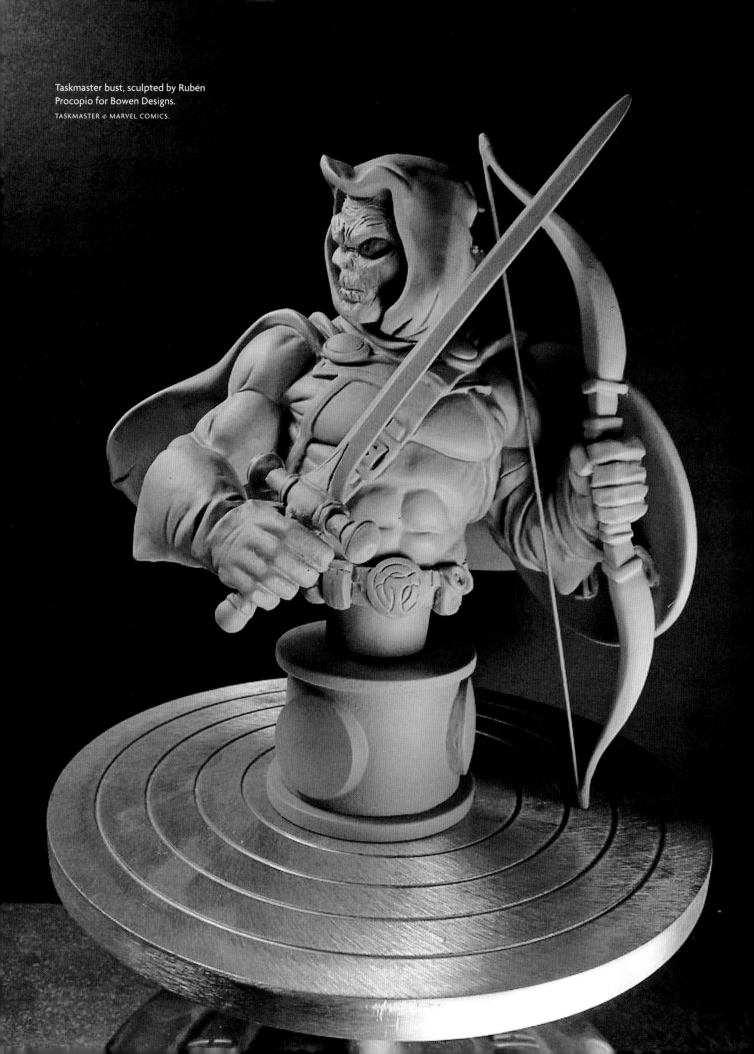

PHOTOSHOP OF HORRORS: ETHICAL IMAGE EDITING

Let's talk a little about honesty in imagery. These days, when you can rework an image to show Abraham Lincoln riding a skateboard while balancing a hippopotamus on his head, it's tempting to "fix" parts of your sculpture you don't like or wish you'd done differently with some kind of imaging software. **Use restraint.** It's okay to smooth out a little paint glob, or even erase a seam you didn't see when finishing the resin. And it's more than okay to adjust the colors so they reflect the paint job you did if it doesn't quite come across in the picture. You can even play with the background so the piece shows up better. But going beyond these basics is kind of like writing a personal ad and describing yourself as great-looking and statuesque when you're more likely to threaten goats from under a bridge. Sooner or later the truth comes out. So, when tweaking, tweak with integrity. You'll be glad you did.

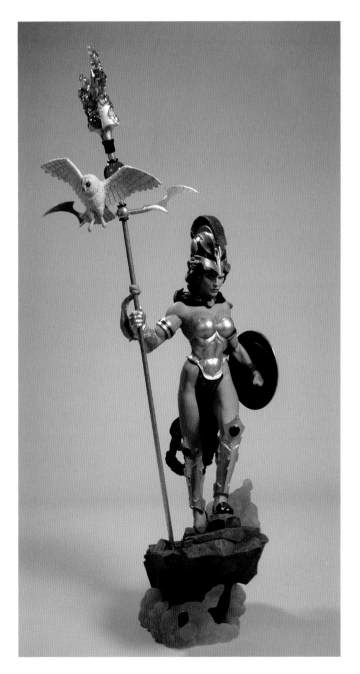
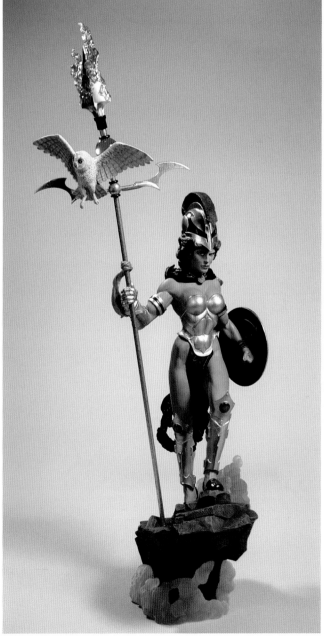

Photoshop can fix colors, clean up backgrounds and remove a missed seam line, but take care not to misrepresent your piece.

In this shot, the blue, clear-cast ball is in focus, so we'll use it in our composite.

Athena's owl and crossbar blade are in focus, and we'll make them part of our composite.

The only element in focus in this shot is Athena, so we'll add her to our composite.

The final composite.

One place where photo manipulation software can be very helpful is when the scale of your sculpt leads to problems with focus. As you take your turn-around shots, using a macro lens or the macro setting on your camera, there's going to be an angle where part of the piece will be in focus and part will not. You can solve this by creating a composite photo using imaging software like Photoshop. Read your manual and go. Here's how we created a really good composite from three flawed originals.

Keep all your raw images in a separate folder somewhere, away from your tweaked images. You never know when you'll want those untouched, full-size pictures, especially if the piece is leaving your hands.

PICTURES AT AN ONLINE EXHIBITION: GUIDELINES FOR YOUR PUBLISHED PHOTOS AND PORTFOLIO

Images destined for print publications, either a magazine article or ad, will need to have a resolution of 300 dpi (dots per inch). The physical dimensions of the file (pixel dimensions) will depend how large the printed image is.

For the Internet, the resolution required is usually 72 dpi. Most message boards and forums have limits or guidelines on uploaded images; rarely will an Internet outlet ever need a picture larger than 8 × 10 inches at 72 dpi.

If you're hands-for-hire and working on a character that belongs to someone else, let the client add the photo credit even if they use your image in print. But if the sculpture is your original design, add your copyright before posting it to message boards or forums or the like.

Don't post anything you've been contracted to do without the client's permission. Some clients are pretty touchy about images of their stuff getting out before they're ready or in a form they're not crazy about.

As a freelance professional sculptor, it is incredibly helpful to have an online portfolio to which you can refer clients and potential clients. You can set up galleries of your work at online image-hosting sites like Flickr, Photobucket, and ImageShack; they'll allow you to control who sees certain images and let you write descriptive captions for them.

You may want to start a blog at one of the many easy-to-use blogging websites. If you want to have more freedom to do your own thing, you can even start your own website. There are several Web communities for sculptors, including the Clubhouse (theclubhouse1.net), Statue Forum (statueforum.com), Sculpture Community (sculpture.net), Alterton's Sculptors Corner (thesculptorscorner.com), and the Shiflett Brothers Sculpting Forum (shiflettbrothers.com), all of which have places for sculptors to share what they're working on. But beware—everybody's got opinions, and they aren't always polite about it, so don't get demoralized.

PHOTO FINISH

Our advice is based on experience. We've screwed up pictures of our work doing all of the above *don'ts* and a few that are too moronic to mention and keep what little self-respect we still have. We just wanted you to know that, so when you shoot a set of pics that look like they were taken with a potato through a screen door, you know you have some good company.

What we've offered here will help get you pictures you can be proud of, but as digital photography evolves, the more you know, the better prepared you'll be.

Now, snap away, Snappy!

When sending out digital images of your sculpture, send them at the right size for the job they'll be doing. But always save a big copy for your records, just in case.

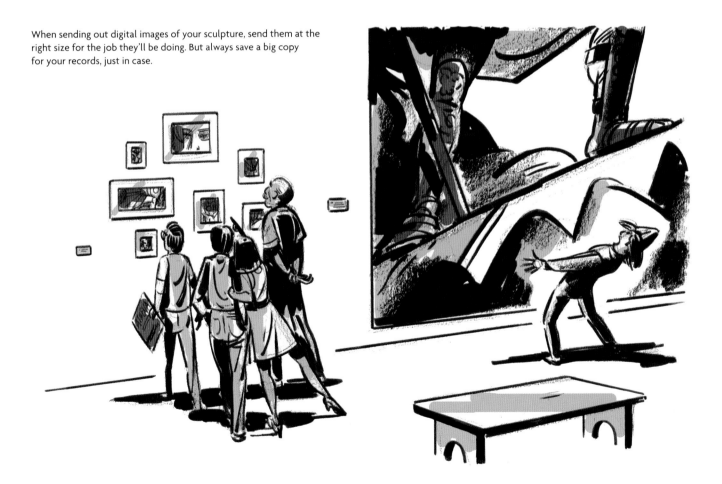

12. Going Pro

HOW TO TURN YOUR NEWFOUND SCULPTING SKILLS INTO A CAREER

Before you build your own toy empire; you'll become a hands-for-hire sculptor. Hiring out your services to the highest bidder, you'll roam from town to town, dispensing wax and justice, until— okay, you'll probably wait by the phone, hoping one of the many companies you've sent your online portfolio to will call you back. We can't help you there, so we'll just assume you've sent out a link to your portfolio, and an art director saw it, liked it, and called you back. Here's where the fun begins.

The freelance sculptor's creed: "Have sculpting stand, will travel."

AD Phone Home: How to Bid on Jobs

When you're offered a sculpting job, there are plenty of factors to consider in determining what to charge. Some companies have a standard starting rate for new sculptors, but no two companies price out the same, even for the same things. Often a company will ask you to bid on a job. When one does, you don't want to lowball yourself and go out-of-pocket to finish the job, or highball yourself out of consideration.

It's not often you'll get to see a design at the bid stage. The product you sculpt today probably won't hit the market for about a year, so you most likely won't get to see the actual job until you have it—confidentiality and all that. Ask the client for a comparable product so you have something solid on which to estimate and plan.

Be sure to get the information below before you offer your bid, and remember this formula: Your Fee = Materials + (Hours of Work × Desired Rate per Hour).

When it's time to talk money, you'd best put on your business hat.

The complexity of a piece can greatly increase the time spent working on it. Time is money, so chargeaccordingly.

MATERIALS: The actual sculpture materials are part of your end of the bargain, so you should never bill for them separately; they are part of your operating costs. But, as the tools of your trade, they are tax-deductible.

SIZE: This not only refers to the height of the piece but to the overall mass. A statue of a 12-inch carrot will price out much differently in materials and hours than a 12-inch watermelon.

COMPLEXITY: Figures that seem simple at first can be more difficult and take more time than expected. Highly toleranced elements, like machine parts, weapons, sand dunes, or ocean waves, will severely impact your finishing time.

SCHEDULE: You need to know the exact date you must deliver the final piece, and when and what the approval stages are along the way.

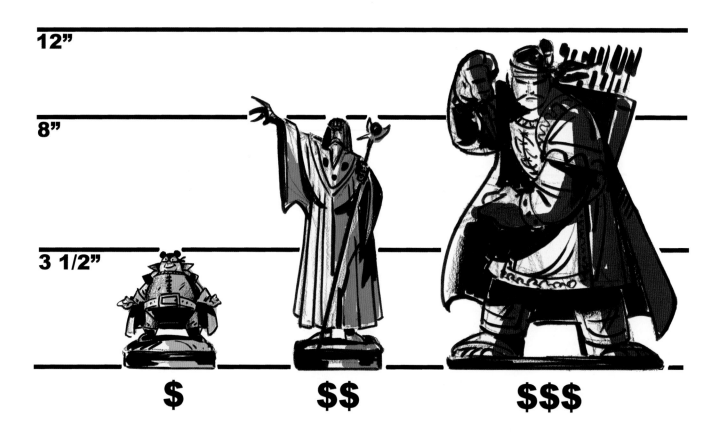

Size, because it directly affects your material costs, is the first variable you need to consider when deciding what to charge.

THE NEGOTIATOR: THE PROCESS OF LANDING THE JOB

When bidding a job or working with a new client, it's always a good idea to simply ask, "What's your budget on this job?" The company has worked out a budget and knows what they want to spend, so this question is a way to say, "I want the job, but we haven't worked together before, and I don't know your pricing. Tell me what you have budgeted, and I'll try to work within it, if I can." Sometimes, an AD or PM will just come out and say, "I've got this much, can you do it for that?" Then you have to ask yourself, "Can I?" There will be jobs you are passionate about, characters you want to work on, clients you want to build a relationship with…whatever the reason, there are times when it's not about the money. It's about taking that next step in your career, even if it doesn't make sense on a calculator. You should *always* negotiate to receive **samples** of the final product as part of your payment, anywhere from one to ten of them. They can sometimes make up for a low paycheck.

GIVING A LITTLE BIT EXTRA: BILLING FOR POSTSCULPTING SERVICES

If the company you're doing the job for doesn't do their own postsculpt work—moldmaking, resin casting, finishing, and painting—and you can supply it, more power (and money) to you. Some clients use freelance moldmakers and painters to finish the job; if you offer the "all under one roof" deal, it's less of a headache for them to deal with. These extra services should all be billed out separately from your sculpting fee, and just as there's no industry standard for sculpting services, there's no such standard for *post* sculpting services. Why would you offer your postsculpt services to a company that already does them in-house, when your price can't compare to what they can get it done for? From *your* point of view: Control, time, and quality. If you do the moldmaking, casting, and painting, you have greater control over the final product you turn in, and you have more flexible time to devote to sculpting, because you don't have to schedule your piece into someone else's time frame. Plus, the fees for those molds and resins go right into your pocket. *Your* pocket. That's got a nice ring to it, doesn't it? We know sculptors who sometimes provide post services for little more than the raw costs of materials, but do not budge on their sculpting fee.

The more hats you wear as an artist, the more aspects of a job you can bring under your direct control. And get paid for!

Building a Rep

In this business, having a good reputation goes a long way. You'll rely on people thinking well of you to get jobs, and that means more than just the quality of your work. It means the quality of *you*. Some of this is common sense, but we've found that not everyone possesses that particular trait.

GIVING YOUR WORD: Contract or no contract, a handshake and a gentleman's agreement goes a long way…if you keep it. In this day and age of phone calls and e-mail, you can't always get everything on paper, and while you can't control what a company will do, you can control what *you* do, and you should do what you said you would do.

DEADLINES MATTER: Ninety percent of what an AD wants is for you to meet your deadlines. To look at it in math terms: Your Reputation as a Sculptor = Quality of Work × How Easy You Are to Work With × Meeting Your Deadlines. Turning in your work late holds up the moldmaker, the painter, the packaging designer, and the manufacturer. The more people you inconvenience, the more quickly your professional status will drop.

Having a good rep as a sculptor can lead to more work, higher pay, and fewer gang rumbles. Can you dig it?

KEEP IN TOUCH: With today's technology there is no reason for you to disappear on an AD. Pick up the phone, drop an email, send a Tweet, whatever, but always stay in contact with your client. You should be sending them in-progress shots as you go for approval anyway, but contact them between updates if there's a long gap.

THERE'S NO "I" IN TEAM: Everyone wants a team player, so no attitude, please. You can be the best artist in the world, and they'll forgo giving you work if you're hard to deal with.

A delay in sculpting means a delay in molding, casting, and painting.

MISCHIEF, MANAGED: AVOIDING AND RESOLVING CONFLICTS WITH YOUR CLIENT

Your AD or PM is not your enemy. You may clash with the person who is dissecting your art and telling you it's "wrong," but you need to remember that you were hired to do a job. "The important things to keep in mind are the deliverables which you are giving your client," says Gentle Giant Studios founder Karl Meyer. "You need do what they want, and sometimes that involves keeping your own artistic embellishments down, to a certain degree. You'll find you get more work that way."

Be proactive when dealing with your AD or PM. They're often running several programs at once, with several items in each program, and can spend only a fraction of the time you will with your assignment. They may want to do a complete job, but just don't have time.

If you see a potential problem with the sculpture you're working on, it's to both of your benefits to call his/her attention to it, in the spirit of collaboration. Compare that critical point of your sculpt against the reference and send both so they can see where you're coming from and why you've made the choices you've made. You may not convince them, but if you try, with respect and courtesy, it shows you're in this with them and, hence, a fragile trust is begun.

Art directors rarely, if ever, stomp directly on your work like this.

Also, every revision your AD requests affects the schedule, so if a change is going to alter the due date, or create significantly more work, they need to know that. If turning the piece in late is going to affect *your* bottom line with either extra work, or money deducted for being late, it needs to be discussed.

And the kazoo band played on...

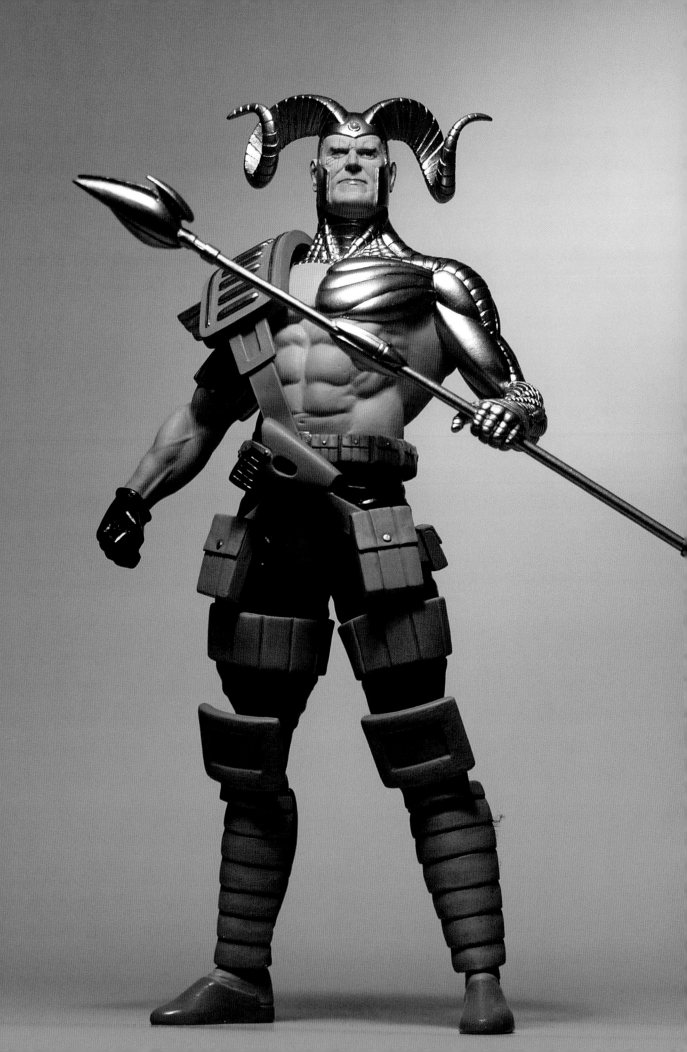

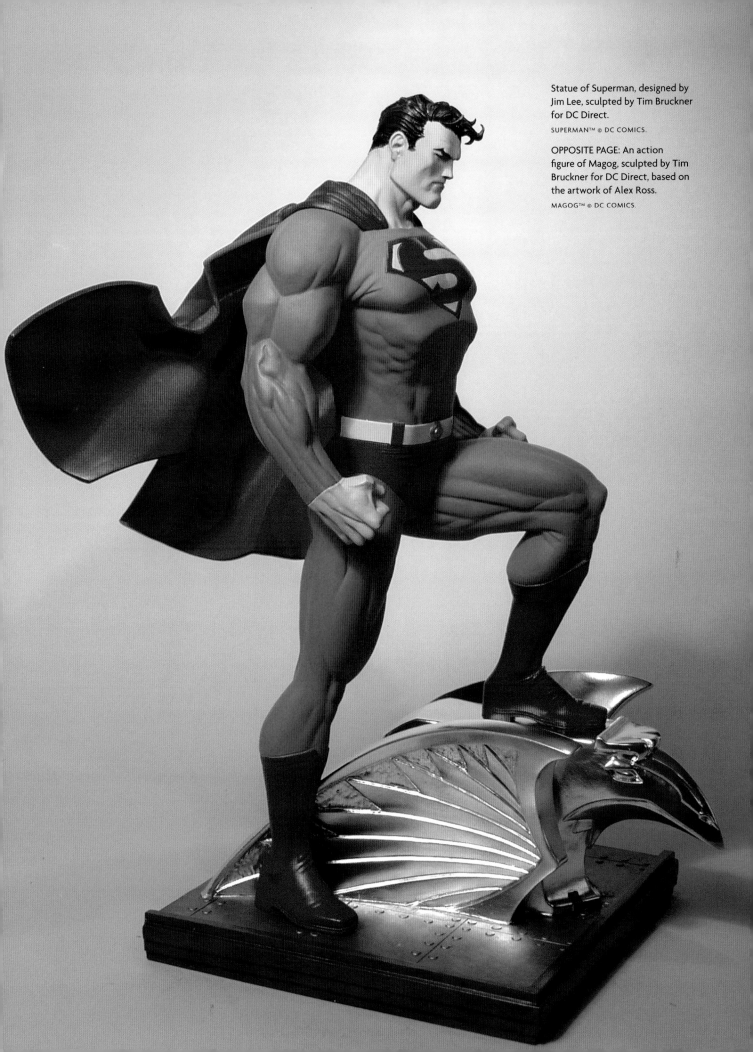

Statue of Superman, designed by
Jim Lee, sculpted by Tim Bruckner
for DC Direct.
SUPERMAN™ © DC COMICS.

OPPOSITE PAGE: An action
figure of Magog, sculpted by Tim
Bruckner for DC Direct, based on
the artwork of Alex Ross.
MAGOG™ © DC COMICS.

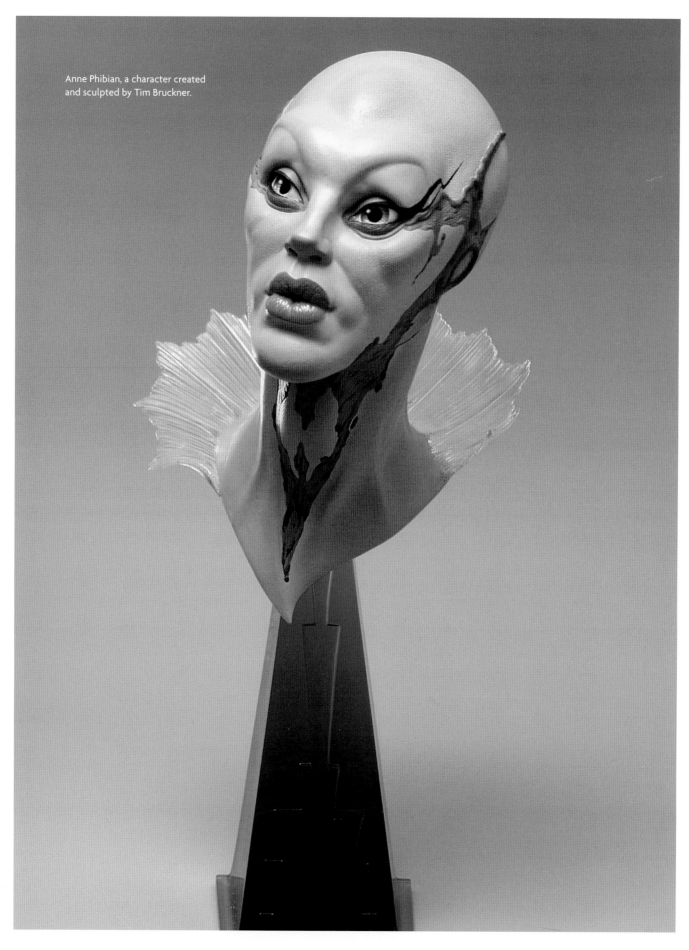

Anne Phibian, a character created and sculpted by Tim Bruckner.

SPECIAL THANKS

TIM BRUCKNER: Thanks to my wife, Mary, for her continued love, patience, understanding, and support, and to her unwavering sense of justice. To our kids, Errol and Anne, who taught me, contrary to a life-long belief, that I am *not* the center of the universe. Thanks to my mom and dad from their miracle child. Thank you, Mike Buonarroti, Pete Rubéns, Ben Cellini, and Johnnie Bernini, some of the best dead friends a guy could ask for. Thanks to Georg Brewer, steadfast friend and collaborator, and all the knuckleheads at DC Direct. Thank you, Arnie and Kathy Fenner. Thanks to my friends and family who continue to show me kindness and affection, even after they've come to know me. Thank you, fellow sculptors. Big thanks to Zach Oat. This book would not have been possible without your hard work and extraordinary patience. To Rubén Procopio, my thanks and deep appreciation. To Martha and Autumn, a sincere thanks to you both. Thank you, the reader, for reading this book. A double thanks if you bought it.

ZACH OAT: Thank you, Melissa, for being so understanding about all of the late-night writing sessions and dinner-hour conference calls that this project required, and for being the most amazing woman I've ever met. Thank you, Hazel, for being too young to say the words "negligent father." Thank you, Mom, for reading to me. Thank you, Lou, for listening. Thank you, Dad, for giving me the gift. Thank you, Ash and Van, for being my brother and sister. Thank you, Joan and John, for giving us a home. Thank you, Rubén, for inviting me to join this project. Thank you, Tim, for giving me so much to work with. Thank you, Candace and Autumn, for your guidance. Thank you, Walter, Karen, Tony, Jonathan, William, Alterton, Karl, Jim, Georg, and Kat, for your contributions. Thank you, Pat, Rob, and Justin, for being so damn funny. Curse you e-mail chain gang, for the distractions. Thank you, Hermione and Jasper, for keeping me company at 3 A.M. And thank you again, Melissa, because I cannot thank you enough. I love you.

RUBÉN PROCOPIO: Thank you to my parents, Lidia and Adolfo Procopio, for setting me on the path that I'm on today, to my sister, Vivian Procopio, for her constant support, and to my fiancée, Jeanne Schanberger, for going through this journey with me. Among my mentors and friends, a few that stand out are Walt Stanchfield, Art Stevens, Jim Willoughby, Eric Larson, Blaine Gibson, and Alex Toth. Thanks to Tracy Lee, head of Electric Tiki, who let me be part of his dream, Kinn Melby, Joe Brandon, Traci Thomas, and Mark Haberman at Enesco. Jim McPherson, thanks for your contribution. Thanks to the fourth person on our team, our editor Martha Moran. Last but not least, the two people who deserve the biggest thank-you and suggested this book in the first place, Abigail Wilentz and Candace Raney—they saw a need and an opening in the market for this book; I applaud them for making this book possible.

DARKSEID™ © DC COMICS

INDEX